Greek
Bronze
Statuary

Greek Bronze Statuary

FROM THE BEGINNINGS
THROUGH THE FIFTH
CENTURY B.C.

Carol C. Mattusch

CORNELL UNIVERSITY PRESS

ITHACA AND LONDON

Published with the assistance of the Getty Grant Program.

First published 1988 by Cornell University Press.

International Standard Book Number 0-8014-2148-9
Library of Congress Catalog Card Number 88-47737

Printed in the United States of America

*Librarians: Library of Congress cataloging information
appears on the last page of the book.*

*The paper in this book is acid-free and meets the guidelines for
permanence and durability of the Committee on Production Guidelines
for Book Longevity of the Council on Library Resources.*

For Harriet C. Mattusch,
writer, archaeologist,
and editor

CONTENTS

PREFACE

Most of the Greek sculptures that are preserved today are made of stone, not bronze. We can count more than 150 large stone kouroi from the sixth century B.C. but fewer than ten large cast bronzes, most of which are fragmentary. With these few exceptions we have only such material as molds for a statue from the Athenian Agora and an assortment of bronze fingers, toes, eyelashes, and locks of hair. The cast bronze statues amount to only about 4 percent of the preserved large-scale sculptures from this period, and the situation does not improve during the fifth century B.C. It is not surprising that scholars have always tended to consider bronzes together with stone sculpture, despite obvious stylistic and technical differences.

It is only by considering all kinds of evidence that we can begin to appreciate the importance of bronze statuary during the Archaic and Classical periods. This book begins with Greek casting techniques, as we know them from the evidence provided by ancient foundries, before discussing the impact of the use of bronze on the styles, functions, and significance of the statuary of the Archaic and Classical periods. In general, I proceed chronologically, but so many dates are arguable that it seems better not to try to adhere too strictly to such a format, but rather to try to provide a sense of a particular period or of a type of statue. Bronze statuettes are prominent in those chapters where they fill a gap in the evidence, and are included elsewhere as technical and stylistic parallels. I do not provide exhaustive bibliographic citations for the bronzes that I discuss. Instead, I refer to those works that are important in the history of scholarship on individual bronzes and to illustrated publications that are readily accessible.

I discuss related contemporary evidence in the form not only of bronze statuettes and stone sculpture but also of representations of statues and workshop equipment by vase painters. The few Classical literary testimonia we have are invaluable, but later authors, particularly Pliny and Pausanias, also provide a

ix

vast amount of useful information. Most of the ancient literary testimonia are much later in date than the works and artists to which they refer. Those that are contemporary have been noted. Not all of Pliny's references to bronze are found in the chapter he devotes to the subject. Pliny and Pausanias give us very different accounts of bronze artists and sculptures. Both are dealing with information from other sources, but Pliny is interested in natural history and Pausanias is writing a guidebook. Cicero and Quintilian, whose interest is oratory, touch on sculpture only when they are looking for a parallel in the arts.

Most of the literary testimonia to which I refer are readily available, but in the few instances when they may be difficult to locate, I have referred to the citations in J. Overbeck, *Die antiken Schriftquellen* (1868). The translations and transliterations are my own, unless I have noted otherwise.

My own interest in Greek bronze statuary began in a seminar during my first semester of graduate study at the University of North Carolina at Chapel Hill. I am greatly indebted to Sara Anderson Immerwahr, who directed the seminar and guided my explorations of the metallurgical workshops in the Athenian Agora. Homer A. Thompson had first recognized the importance of this material and has also been a source of great inspiration on the subject. And so my initial approach to Greek bronze statuary was not the usual one, from the vantage point of style, but developed from observations of casting techniques. Throughout, these observations have influenced my approach and contributed to my conclusions.

The following individuals provided assistance and ideas that have been valuable in the research, writing, and preparation of this book: Nancy Bookidis, Robert A. Bridges, Jr., Diana M. Buitron, Barbara Chabrowe, Jan K. Cohn, William H. Cohn, Steven T. Cook, Frederick A. Cooper, John F. D'Amico, Jan Diamant, George Dontas, Alison Frantz, Evelyn B. Harrison, D. E. L. Haynes, Wolf-Dieter Heilmeyer, John J. Herrmann, Jr., Dorothy Kent Hill, Betsy Hurd, Petros G. Kalligas, Gerhard M. Koeppel, Phyllis W. Lehmann, Grant McClanahan, James R. McCredie, Joan R. Mertens, David Gordon Mitten, Sarah P. Morris, Andrew Oliver, Jr., Elizabeth G. Pemberton, Claudio Sabbione, Thomas Schäfer, T. Leslie Shear, Jr., Muriel Toppin, Evi Touloupa, Michail Yu. Treister, Cornelius C. Vermeule, Michael Vickers, Charles K. Williams II, Nancy A. Winter, and Gerhard Zimmer. I am especially grateful to Elizabeth Cropper,

Charles Dempsey, Caroline Houser, George L. Huxley, Emeline Hill Richardson, Brunilde Sismondo Ridgway, and to Harriet C. Mattusch and Richard S. Mason. At Cornell University Press, Bernhard Kendler and Barbara H. Salazar have provided invaluable editorial assistance.

My research has been assisted by a Fellowship and two Summer Stipends from the National Endowment for the Humanities, a Faculty Study Leave and a Summer Stipend from George Mason University, an Andrew W. Mellon Postdoctoral Fellowship at Duke University, and an Edward Capps Fellowship at the American School of Classical Studies at Athens.

CAROL C. MATTUSCH

Fairfax, Virginia

ABBREVIATIONS

AA	*Archäologischer Anzeiger*
AAA	*Athens Annals of Archaeology*
ActaA	*Acta Archaeologica*
AJA	*American Journal of Archaeology*
AM	*Mitteilungen des Deutschen Archäologischen Instituts, Athenische Abteilung*
Anth. Gr.	*Anthologia Graeca*
Archäologische Bronzen	*Archäologische Bronzen: Antike Kunst, Moderne Technik,* ed. H. Born (Berlin, 1985)
ArchEph	*Archaiologike Ephemeris*
Art and Technology	*Art and Technology: A Symposium on Classical Bronzes,* ed. S. Doeringer et al. (Cambridge, Mass., 1970)
AZ	*Archäologische Zeitung*
BABesch	*Bulletin van de Vereeniging tot Bevordering der Kennis van de Antike Beschaving*
BCH	*Bulletin de Correspondance Hellénique*
BdA	*Bollettino d'Arte*
BDF	J. Boardman, J. Dörig, W. Fuchs, and M. Hirmer, *The Art and Architecture of Ancient Greece* (London, 1967)
Beazley, *ABV*	J. D. Beazley, *Attic Black-Figure Vase-Painters* (Oxford, 1956)
Beazley, *ARV²*	J. D. Beazley, *Attic Red-Figure Vase-Painters,* 2d ed. (Oxford, 1963)
BMMA	*Bulletin of the Metropolitan Museum of Art*
Boardman, *ABFV*	J. Boardman, *Athenian Black Figure Vases* (London, 1974)

Boardman, *ARFVAP*	J. Boardman, *Athenian Red Figure Vases: The Archaic Period* (London, 1975)
Boardman, *GSAP*	J. Boardman, *Greek Sculpture: The Archaic Period* (London, 1978)
Boardman, *GSCP*	J. Boardman, *Greek Sculpture: The Classical Period* (London, 1985)
Bol, *Bronzetechnik*	P. C. Bol, *Antike Bronzetechnik: Kunst und Handwerk antiker Erzbildner* (Munich, 1985)
Bol, *Grossplastik*	P. C. Bol, *Grossplastik aus Bronze in Olympia,* Olympische Forschungen 9 (Berlin, 1978)
Brunnsaker	S. Brunnsaker, *The Tyrant-Slayers of Kritios and Nesiotes* (Stockholm, 1971)
BSA	*Annual of the British School at Athens*
Burford	A. Burford, *Craftsmen in Greek and Roman Society* (Ithaca, 1972)
Carpenter	R. Carpenter, *Greek Sculpture* (Chicago, 1960)
Casson	S. Casson, *The Technique of Early Greek Sculpture* (Oxford, 1933)
Charbonneaux, *GB*	J. Charbonneaux, *Greek Bronzes,* trans. K. Watson (New York, 1962)
CIG	*Corpus Inscriptionum Graecarum*
CRAI	*Comptes Rendus de l'Académie des Inscriptions et Belles Lettres*
CVA	*Corpus Vasorum Antiquorum*
D	depth
Degrassi	N. Degrassi, *Lo Zeus Stilita di Ugento* (Rome, 1981)
Deltion	*Archaiologikon Deltion*
diam.	diameter
dim.	dimension(s)
Due bronzi	*Due bronzi da Riace: Rinvenimento, restauro, analisi ed ipotesi di interpretazione, BdA,* spec. ser. 3 (Rome, 1985)
FdeD	Fouilles de Delphes
Furtwängler, *Bronzen*	A. Furtwängler, *Die Bronzen,* Olympia 4 (Berlin, 1890)
H	height

Heilmeyer/Zimmer/Schneider	W.-D. Heilmeyer, G. Zimmer, and G. Schneider, "Die Bronzegiesserei unter der Werkstatt des Phidias in Olympia," *AA*, 1987, pp. 239–99
Hill, *WAG*	D. K. Hill, *Catalogue of the Classical Bronze Sculpture in the Walters Art Gallery* (Baltimore, 1949)
Houser	C. Houser, *Greek Monumental Bronze Sculpture* (New York, 1983)
IG	*Inscriptiones Graecae*
Imhoof-Blumer	F. W. Imhoof-Blumer and P. Gardner, *Ancient Coins Illustrating Lost Masterpieces of Greek Art* (Chicago, rpt. 1964)
Inst. orat.	Quintilian, *Institutio oratoria*
IstMitt	*Mitteilungen des deutschen archäologischen Instituts, Abteilung Istanbul*
Jantzen	U. Jantzen, *Griechische Greifenkessel* (Berlin, 1955)
JAS	*Journal of Archaeological Science*
JbBerlMus	*Jahrbuch des Berliner Museums*
JdI	*Jahrbuch des deutschen archäologischen Instituts*
JHS	*Journal of Hellenic Studies*
JöAI	*Jahrbuch des österreichischen archäologischen Instituts*
Kluge, *AG* 1	K. Kluge, *Die antike Erzgestaltung und ihre technischen Grundlagen*, vol. 1, *Die Antiken Grossbronzen*, ed. K. Kluge and K. Lehmann-Hartleben (Berlin, 1927)
Kluge, "Gestaltung"	K. Kluge, "Die Gestaltung des Erzes in der Archaisch-Griechischen Kunst," *JdI* 44 (1929): 1–30
L	length
Landwehr, *AGB*	C. Landwehr, *Die antiken Gipsabgüsse aus Baiae*, Archäologische Forschungen 14 (Berlin, 1985)
Landwehr, *Meisterwerke*	C. von Hees-Landwehr, *Griechische Meisterwerke in römischen Abgüssen: Der Fund von Baia* (Frankfurt, 1982)

Langlotz/Hirmer	E. Langlotz and M. Hirmer, *Ancient Greek Sculpture of South Italy and Sicily* (New York, 1963?)
Loewy	E. Loewy, *Inschriften griechischer Bildhauer* (Leipzig, 1885)
Lullies/Hirmer	R. Lullies and M. Hirmer, *Greek Sculpture* (London, 1960)
Master Bronzes	*Master Bronzes from the Classical World,* ed. D. G. Mitten and S. Doeringer (Mainz, 1968)
Mattusch, "Agora"	C. C. Mattusch, "Bronze- and Iron-working in the Area of the Athenian Agora," *Hesperia* 46 (1977): 340–79
Mattusch, "BFC"	C. C. Mattusch, "The Berlin Foundry Cup: The Casting of Greek Bronze Statuary in the Early Fifth Century B.C.," *AJA* 84 (1980): 435–44
Mattusch, "Corinth"	C. C. Mattusch, "Corinthian Metalworking: The Forum Area," *Hesperia* 46 (1977): 380–89
max.	maximum
MonPiot	*Monuments et mémoires publiés par l'Académie des Inscriptions et Belles Lettres,* Fondation Piot
NH	Pliny, *Natural History*
OF	Olympische Forschungen
Overbeck	J. Overbeck, *Die antiken Schriftquellen zur Geschichte der bildenden Künste bei den Griechen* (Leipzig, 1868)
Pollitt, *Ancient View*	J. J. Pollitt, *The Ancient View of Greek Art: Criticism, History, and Terminology* (New Haven, 1974)
pres.	preserved
RA	*Revue Archéologique*
Raubitschek, *Dedications*	A. E. Raubitschek, *Dedications from the Athenian Akropolis* (Cambridge, Mass., 1949)
Raubitschek, "Statuenbasen"	A. E. Raubitschek, "Zur Technik und Form der Altattischen Statuenbasen," *Bulletin de l'Institut Archéologique Bulgare* 12 (1938): 132–81

recon.	reconstructed
RevArch	*Revue Archéologique*
Richter, *Gravestones*	G. M. A. Richter, *Archaic Gravestones of Attica* (New York, 1961)
Richter, *Korai*	G. M. A. Richter, *Korai: Archaic Greek Maidens* (New York, 1968)
Richter, *Kouroi*	G. M. A. Richter, *Kouroi: Archaic Greek Youths,* 3d ed. (New York, 1970)
Richter, *Portraits*	G. M. A. Richter, *The Portraits of the Greeks,* rev. ed. (Ithaca, 1984)
Richter, *SSG*	G. M. A. Richter, *The Sculpture and Sculptors of the Greeks,* 4th ed. (New Haven, 1970)
Ridgway, *AS*	B. S. Ridgway, *The Archaic Style in Greek Sculpture* (Princeton, 1977)
Ridgway, *FCS*	B. S. Ridgway, *Fifth Century Styles in Greek Sculpture* (Princeton, 1981)
Ridgway, *SS*	B. S. Ridgway, *The Severe Style in Greek Sculpture* (Princeton, 1970)
RM	*Mitteilungen des deutschen archäologischen Instituts, Römische Abteilung*
Robertson, *HGA*	M. Robertson, *A History of Greek Art* (Cambridge, 1975)
Rolley, *BG*	C. Rolley, *Les Bronzes grecs* (Fribourg, 1983)
Rolley, *Monumenta*	C. Rolley, *Greek Minor Arts: The Bronzes,* in *Monumenta Graeca et Romana,* ed. H. F. Mussche, vol. 5, fasc. 1 (Leiden, 1967)
Schwandner/Zimmer/Zwicker	E.-L. Schwandner, G. Zimmer, and U. Zwicker, "Zum Problem der Öfen Griechischer Bronzegiesser," *AA,* 1983, pp. 57–80
Stuart Jones	H. Stuart Jones, *Select Passages from Ancient Writers Illustrative of the History of Greek Sculpture* (Chicago, rpt. 1966)
th	thickness
Thomas, *Athletenstatuetten*	R. Thomas, *Athletenstatuetten der Spätarchaik und des Strengen Stils* (Rome, 1981)

Thompson/Wycherley	H. A. Thompson and R. E. Wycherley, *The Agora of Athens,* Athenian Agora 14 (Princeton, 1972)
Touloupa/Kallipolitis	V. G. Kallipolitis and E. Touloupa, *Bronzes of the National Archaeological Museum of Athens* (Athens, n.d.)
W	width
Zimmer, "Giesserei-einrichtungen"	G. Zimmer, "Giessereieinrichtungen im Kerameikos," *AA,* 1984, pp. 63–83
Zimmer, *Werkstattbilder*	G. Zimmer, *Antike Werkstattbilder* (Berlin, 1982)
Ziomecki	J. Ziomecki, *Les Représentations d'artisans sur les vases attiques* (Warsaw, 1975)

Greek
Bronze
Statuary

I DISCOVERIES

Ever since the Renaissance, antique sculptures, whether Greek originals of the fifth century B.C. or Roman copies of the second century A.D., have been of great interest to travelers, collectors, artists, and scholars. The bronze horses of San Marco, for example, have been revered for centuries; much of their past history is known, and they are a familiar sight to travelers in Venice, where they have stood almost continuously since 1204.[1] The bronze Spinario in the Conservatori Museum of Rome, already famous during the early Renaissance, was one of the first antique works to be copied.[2] Only later was it recognized that this work was not an early one but a pastiche, archaistic in style, which had been created no earlier than the first century B.C.[3]

In the latter half of the eighteenth century, the German art historian Johann Joachim Winckelmann (1717–1768) devoted himself to creating a chronological classification of ancient statues. For him, style was the governing factor. About Greek sculpture of the sixth and fifth centuries B.C. Winckelmann wrote: "The more ancient style continued until Phidias; through him and through the artists of his day art reached its greatness. One can call this the distinguished and noble style."[4] At this time scholarly attention was generally focused on aesthetic evaluation, stylistic analysis, attribution, and the problems of relative dating. Surprisingly enough, the materials of which ancient sculptures were made aroused little interest. When a marble copy of Myron's bronze Diskobolos was discovered in 1781 on the Esquiline Hill in Rome, it was recognized as a copy but nonetheless achieved immediate fame in its

1. See G. Perocco, ed., *The Horses of San Marco Venice*, trans. V. and J. Wilton-Ely (London, 1979).
2. See F. Haskell and N. Penny, *Taste and the Antique* (New Haven, 1981), pp. 308–10.
3. For a summary of the problem, see Robertson, *HGA*, pp. 559–60.
4. *Geschichte der Kunst des Altertums* (1764), bk. 8, chap. 1.

own right.[5] Whether a work was a Greek original or a Roman copy was not usually of great concern: any new find was seen as an ancient original, with as much appeal as the ancient ruins that travelers were visiting in increasing numbers.

Although literary sources tell us a great deal about some of the most famous artists who worked in bronze and about the statues they produced, our view of the art has been limited by the small number of extant originals. Fewer than thirty large bronzes of the sixth and fifth centuries B.C. are preserved today. Thus the study of bronze statuary has traditionally been based on Roman copies and adaptations, mostly in marble, of lost Greek originals. To arrive at a sense of the original we must first compensate for the fact that the material of the copy is not that of the original. The struts needed to support the weight of the stone would not have been needed in the bronze. They distort the work's appearance, and the copyist may have made other alterations in accommodating the design to a new medium.[6]

Traditionally, scholars made virtually no distinction between works in bronze and works in stone, except perhaps to comment on the higher quality of the few bronze originals that were preserved. Greek marble originals might be seen as being influenced by contemporary works in bronze; discussions of bronze statuettes might be filled out by brief consideration of larger bronzes. Yet all ancient literary accounts indicate that freestanding bronze statuary was the primary mode of artistic expression in Classical Greece, although it was not until the nineteenth century that any original bronze statues of that period or earlier were known.

Only one ancient large-scale bronze was never really lost, but it aroused almost no interest, probably because it was not exactly a statue. It was a column, consisting of three intertwined serpents, erected and presumably cast at Delphi by commission of the Greek cities that had participated in the rout of the Persians at Plataia in 479 B.C. Dedicated in the next year, the bronze Serpent Column supported a golden tripod near the entrance to the Temple of Apollo. In the fourth century B.C. the tripod was stolen; in the fourth century A.D. Constantine removed the column to the Hippodrome in Constantinople, where it can be seen today, standing nearly five and a half

5. Haskell and Penny, *Taste and the Antique,* pp. 199–200. See also M. Greenhalgh, *The Classical Tradition in Art* (New York, 1978), pp. 35–43, 53–55.

6. See, e.g., M. Bieber, *Ancient Copies: Contributions to the History of Greek and Roman Art* (New York, 1977).

meters tall (fig. 5.6). The top half of one serpent's head is in the Istanbul Archaeological Museum.[7]

The first large-scale bronze to be discovered in recent times which was thought to be early was an Apollo found in either 1812 or 1832 off the west coast of Italy at Piombino, near the island of Elba. It was acquired for the Louvre for 16,000 francs in 1834, but was not cleaned until eight years later. Dated at first to the second quarter of the fifth century and variously attributed to either a Sikyonian or south Italian artist, the statue has since been relegated by many observers to the first century B.C.[8]

Soon after the discovery of the Piombino Apollo, a complete bronze statue of a kouros was found near Tamassos in central Cyprus by peasants digging for water in a dry riverbed. They tied their kouros to an oxcart and dragged it away, and in the process the head, arms, and legs fell off. The head is now in the British Museum, having come there from the Chatsworth collection (fig. 7.1).[9] The rest of the statue is lost, but the alloy of the head is so similar to that of a bronze leg in the Louvre that it has been suggested that the head and the leg belonged to the same statue.[10]

The discovery of five important bronzes in Greece between 1866 and 1897 added immeasurably to our knowledge of the art of bronze statuary of the late Archaic and early Classical periods. Three of those bronzes are heads. The first is of a neatly coiffed youth with inlaid eyes (fig. 5.5), found by chance in 1866 while foundations for the Akropolis Museum were being dug. Dated to the first quarter of the fifth century and probably of Attic workmanship, the head is now in the National Archaeological Museum at Athens. In 1877 a magnificent head of Zeus was found fifteen or sixteen meters to the southwest of the Temple of Zeus at Olympia (fig. 4.15). It, too, is now in the National Archaeological Museum at Athens. Among the ques-

7. W. Gauer, "Weihgeschenke aus den Perserkriegen," *IstMitt*, suppl. 2 (1968), pp. 75–96.

8. Louvre, no. 61; H 1.15 m. Convincing arguments in favor of a later date are given by B. S. Ridgway, "The Bronze Apollo from Piombino in the Louvre," *Antike Plastik* 7 (1967): 43–75. For a date in the second quarter of the fifth century B.C., see M. Guarducci in Richter, *Kouroi*, pp. 152–53.

9. See V. Karageorghis, *Cyprus* (New York, 1982), pp. 158, 195n2; Robertson, *HGA*, p. 196; and D. E. L. Haynes, "The Technique of the Chatsworth Head," *RA*, 1968, p. 102, with references to early sources.

10. Paris, Louvre no. 2191. See P. T. Craddock, "The Composition of the Copper Alloys used by the Greek, Etruscan, and Roman Civilisations," pt. 2, "The Archaic, Classical, and Hellenistic Greeks," *JAS*, 1977, p. 114.

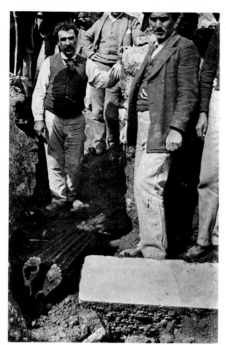

1.1 Discovery of the Delphi Charioteer, ca. 474 B.C. Delphi Museum nos. 3484, 3450. Courtesy of Ecole Française d'Archéologie, Athens.

tions still to be answered are whether it is Aeginetan or Attic and whether its date is 520 or between 500 and 490 B.C.[11] In 1886 the head of a warrior (fig. 5.2) was found on the Akropolis of Athens near the Propylaia. Inlaid eyes were partly preserved, and it could be seen that the head had once worn a helmet. Generally acknowledged to be of Aeginetan workmanship, the head is almost always dated to the period between 490 and 480 B.C.

In May 1896 the discovery at Delphi of a lifesize bronze charioteer (fig. 6.6) aroused great excitement. The statue and other fragments of a chariot group were excavated by the French in fill behind the Ischegaon, a retaining wall built after the landslides of 373 B.C. The Charioteer was found in three pieces: the right arm and hand, holding three reins; the upper torso and head; and the portion from belt to feet. The left arm was not found. A photograph taken at the time of excavation (fig. 1.1) shows a large group of workmen posing in their feast-day clothes in the deep irregular trench they had excavated; from the depths protrude the feet and skirt of their discovery.

Other bronze fragments of the chariot group were found at the same time: the arm of a youth; a horse's left hind leg, a left rear hoof, a right hind leg, and a tail; and a spoke, yoke, withers pad, reins, and various pieces of harness. Part of an inscribed base found with the statue indicates that the monument was erected by Polyzalos while he was tyrant of Gela, after his chariot's Pythian victory in either 478 or 474 B.C.

The Charioteer was immediately hailed as a masterpiece and has maintained its reputation as one of the finest and most important Greek works of any period. One room of the Delphi Museum is devoted to the Charioteer; its appearance is familiar the world over. In the late 1970s, when widespread opposition developed against a proposed traveling exhibition of ancient Greek art, a poster appeared in Athens showing a cracked and broken Charioteer as a warning against any attempt to ship national treasures out of Greece.

In the year after the Charioteer was excavated, a bronze statue of a god was discovered, poorly preserved but almost complete, and remarkable in the fact that it was still affixed to an inscribed bronze base, which identified the figure as Poseidon. The statue was found in shallow water along the

11. Aeginetan, ca. 520 B.C.: Rolley, *BG*, p. 33; Attic: Touloupa/Kallipolitis, p. 23; 500–490 B.C.: Bol, *Grossplastik*, p. 11.

coastline of Livadhostro Bay, near ancient Kreusis in Boiotia. How and why this statue of about 500 B.C. ended up in the bay are still subjects for speculation. Because of its poor state of preservation, the statue remained relatively unknown for many years. But in the 1970s, newly restored (fig. 4.20), it was placed on permanent display in Athens, where the piece should now receive the recognition it deserves.

These discoveries received far more public attention than did an Archaic bronze head purchased in Athens in 1873 and taken to Berlin. Stolen from the Antikenmuseum in 1975, the head was recovered in 1982 and restored and studied with the most modern scientific techniques (fig. 4.18).[12] Similar obscurity was for a long time the fate of a nearly complete bronze statue found in Sicily in 1882. A youth of early-fifth-century date, the statue is reported to have been found buried in a terra-cotta sarcophagus in the vicinity of Selinus. Displayed for many years in the Castelvetrano city hall, the statue was stolen and recovered during the 1960s, then restored and published in the 1970s (fig. 6.7).[13]

In the early 1900s the sea yielded several bronzes of the fourth century and later. Sponge divers found a complete statue of a youth and fragments of a statue of a philosopher amid the wreckage of a ship off Antikythera in 1901, and another statue of a youth was found in the Bay of Marathon in 1925.[14] But the only bronze to rival the Delphi Charioteer in popularity is a larger-than-lifesize god of a slightly later date found in the sea off Cape Artemision in 1926 and 1928 (fig. 6.10). Like a number of other large bronzes, it was recovered by fishermen amid the debris of an ancient shipwreck. That the bronze god was made in about 460 B.C. is not disputed, but whether it represents Zeus or Poseidon is still debated. The statue has been hailed as one "of the great bronze statues of the fifth century B.C.," as "a

12. The most recent technical observations have been made by W.-D. Heilmeyer; see his "Neue Untersuchungen am Jüngling von Salamis im Antikenmuseum Berlin," *Archäologische Bronzen: Antike Kunst, Moderne Technik* (Berlin, 1985), pp. 137–38, and "Neue Untersuchungen am Kopf von Kythera," paper delivered at 9th Internationale Tagung über Antike Bronzen, Vienna, 1986.

13. The most recent publication on the Selinus Youth is A. M. Carruba, "Der Ephebe von Selinunt: Untersuchungen und Betrachtungen anlässlich seiner letzten Restaurierung," *Boreas* 6 (1983): 44–60.

14. Antikythera: J. N. Svoronos, *Das Athener Nationalmuseum*, vol. 1 (Athens, 1908); Ch. Karouzos, "Chronikon," *ArchEph*, 1969, pp. 59–79; P. C. Bol, *Die Skulpturen des Schiffsfundes von Antikythera*, AM 2 (1972); Marathon: K. A. Rhomaios, *Antike Denkmäler* 4 (1929).

powerful bronze of heroic proportions," and as a work "of exceptional significance" whose casting "marks the highest point to which Greek foundry-work attained."[15]

For years a Hellenistic bronze statue of a boy jockey from the same shipwreck has fascinated the public and enjoyed tremendous popularity. In 1957 it was featured in the film *Boy on a Dolphin,* starring Sophia Loren and Alan Ladd. The jockey's badly damaged horse was not restored until 1972 and thus remained almost unknown until then, when it was finally reunited with its rider and placed on display in Athens.[16]

After the excitement over the Artemision shipwreck, the public had to wait thirty years for another major discovery of bronzes, although occasional less spectacular finds were made. In 1926, for instance, a small head found in the Sanctuary of Apollo at Cyrene was identified as a portrait of Arkesilas IV, of the fifth century B.C. (fig. 8.1). And in 1932 workmen cleaning an ancient well in the Athenian Agora found a bronze head, once gilded, of perhaps a Nike or Victory (fig. 7.7). A veiled female head and torso of the late fourth to early third centuries was dragged from the sea near Bodrum in Turkey by sponge fishermen in 1953.[17]

Six years later, in July 1959, workmen digging a sewer line in Piraeus, the port city of Athens, came upon a marble herm and two larger-than-lifesize bronzes, one an Apollo or kouros (fig. 4.19) and the other a woman identified as a Muse.[18] Crowds gathered and archaeologists were called in. Excavation revealed that the statues were buried under a layer of ash and roof tiles, evidently the remains of a warehouse. When more bronze statues were found a week later, police had to be called to control the excited crowds. An Athena, an Artemis, and a bronze tragic mask were uncovered, as well as various other large works in bronze and in marble. Found stacked without their bases, the statues had evidently been brought to Piraeus

15. Lullies/Hirmer, p. 75; S. Rossiter, *Greece: Blue Guide* (London, 1977), p. 149; Ch. Karousou, "The Find from the Sea off Artemision," *JHS* 49 (1929): 142; S. Casson, *The Technique of Early Greek Sculpture* (Oxford, 1933), p. 165.

16. Jockey: Athens, National Museum no. 15177; H 0.84 m.; L of horse (excluding modern tail) 2.50 m. See V. G. Kallipolites, "Anasingkrotesis tou chalkou hippou tou Artemisiou," *AAA* 5 (1972): 419–26.

17. Izmir Museum of Archaeology no. 3544. See G. E. Bean, "A Masterpiece from the Sea: A Greek Classical Bronze of Outstanding Beauty and the First Importance Found by Turkish Sponge-fishers in the Aegean," *Illustrated London News*, November 7, 1953, pp. 747–49; B. S. Ridgway, "The Lady from the Sea: A Greek Bronze in Turkey," *AJA* 71 (1967): 329–34.

18. The "Muse" is now usually identified as Artemis.

from elsewhere, perhaps Delos,[19] in the first century B.C., and may have been awaiting delivery to Rome when the warehouse in which they were stored was destroyed by fire.

All of the new finds were removed to the Piraeus Museum, where local officials immediately converged to inspect the spectacular discovery. Clearly these were Greek originals: the goddesses were assigned to the fourth century B.C., the period when Kephisodotos, Praxiteles, and Skopas were at work; and the Apollo was dated to the latter part of the sixth century, with references to such artists as Antenor and Kanachos.[20] The bronzes were taken to the National Museum in Athens for restoration, and they remained on view there until their return to the Piraeus Museum in the early 1980s. Although the Piraeus bronzes are frequently illustrated and appear often in handbooks on Greek art, they have not yet been fully published.

In 1961 a small statue of a striding god (fig. 4.16) was found by workers digging a foundation for a house in Ugento, a town in the heel of Italy's boot. Like the Livadhostro Poseidon, the statue came with a bronze base. The small bronze would have been at eye level when it was set on a Doric column capital. The work is no doubt a product of Taranto, in southeastern Italy. This attibution does much to explain the high lead content of its alloy, as lead in significant quantity is characteristic of bronze from Greece's western colonies but not from the Greek mainland.

A young nude victor of the late fourth or early third century was found in 1964 by fishermen in what an Italian judge later ruled to be international waters in the northern Adriatic Sea. The find spot was evidently near the resort of Fano, just north of Ancona. The statue was acquired in 1977 by the J. Paul Getty Museum from "Artemis," an international art dealership.[21]

The Straits of Messina yielded important finds in 1969. A fisherman discovered an ancient shipwreck at a depth of about 35 meters, and he and some companions systematically looted it. When eventually they were apprehended, pottery and fragments of two or three bronze statues of males were recovered, including a head. While police circulated a reconstructed drawing of the second head, a salvage excavation of the shipwreck

19. Rolley, *BG*, p. 23.

20. For an account of the discovery and first attributions, see M. Paraskevaidis, *Ein wiederentdeckter Kunstraub der Antike?*, Lebendiges Altertum 17 (1966).

21. The lower legs and feet are missing. See B. Rostron, "Smuggled!" *Saturday Review*, March 31, 1979, pp. 25–30; J. Frel, *The Getty Bronze*, rev. ed. (Malibu, 1982).

was undertaken. The bronzes, restored in Rome, are now in the National Museum of Reggio Calabria. The head that was recovered (fig. 8.2), dating to the latter part of the fifth century B.C., represents an individual with thinning hair and a long thick beard.[22]

A find again attracted worldwide attention in 1972 and sparked the national pride of both Italians and Greeks. In August of that year a Roman chemist, scuba diving off the coast at Riace Marina, in the neighborhood of Reggio di Calabria, saw an arm sticking out of the sandy bottom. It belonged to one of two statues that evidently had been jettisoned or lost from an ancient ship during a storm. The statues lay about 300 meters from the beach at a depth of eight meters. The local populace gathered to watch the raising of the statues from the sea and at first resisted their removal: they wanted the statues to be set up right there. The larger-than-lifesize statues (figs. 8.3, 8.4), each weighing a thousand pounds, represent standing nude bearded warriors, one of whom had been wearing a helmet, the other a fillet and perhaps also a helmet. Each originally carried a shield on the raised left arm. Both have inlaid eyes and copper eyelashes, lips, and nipples. The teeth of one statue still retain their silver plate.[23]

The two statues remained in Reggio di Calabria until 1975, when they were removed to the Archaeological Museum in Florence for conservation; later they were displayed there.[24] Between January and June 1981, 600,000 people saw the statues in Florence. Then the bronzes were sent to Rome, where they were displayed in the Quirinal Palace. In two weeks they were seen by 300,000 people. The warriors were then returned to the National Museum of Reggio Calabria. When they were put on display in August of that year, the *New York Times* reported, "the crowds were far too large for the little museum. Those who could not get in stormed the closed iron gates outside the neo-classical structure. 'I bronzi! I bronzi!' they chanted. Museum officials had to summon the police to disperse them. They threatened to return and take the museum apart, piece by piece. . . . [The statues] are presences of extraordinary power. . . . The crowds move as if magnetized by a super-

22. For an account of the discovery, see D. I. Owen, "Excavating a Classical Shipwreck," *Archaeology* 24 (1971): 118–29.

23. For an account of the discovery, see, e.g., *Frankfurter Allgemeine Zeitung*, October 31, 1972, p. 28.

24. The Florence exhibit is described in A. T. Baker, "Ancient Gifts from the Sea," *Time*, January 26, 1981.

natural force . . . [with] cries of admiration, . . . expressions of awe, and even of terror."[25]

So far, these are the major discoveries of Greek bronzes dating from the sixth century through the late Classical period. The most recent finds tend to be the most fully published, whereas those bronzes that have been known for some time are often overlooked or are mentioned only in a stylistic context, and are still seldom distinguished from marble sculptures, even though works in the two materials were clearly considered separately during antiquity.

When we consider Greek bronze statuary in the light of both genre and medium, investigating the evidence for appearance, function, and the techniques by which statues were produced, we shall be able to comprehend the true nature of bronze statuary and restore to it the distinction it enjoyed throughout the Greek period. We shall also begin to understand the affinities between bronzes and works in other media, and the interest of many ancient artists in working in more than one medium.

25. D. L. Shirey, "Italy Celebrates Two Greek Bronzes," *New York Times,* October 10, 1981.

2	CASTING

The Greeks considered the working of metals to be within the domain of Hephaistos, god of fire and patron of craftsmen. The son of Hera, he was, according to some accounts, thrown down from Mount Olympos when she saw that he had a misshapen foot.[1] In retaliation, Hephaistos made a golden throne for his mother, designing it so that she could not arise once she had sat down. It was only by the efforts of Dionysos that the lame god was eventually lured back to Mount Olympos, where he freed his mother.

The return of the drunken Hephaistos to Mount Olympos, either afoot or astride a mule, is a popular subject in vase paintings of the sixth and fifth centuries B.C. On a kylix by Douris we see Dionysos leading Hephaistos, who is so unsteady that Dionysos grasps his wrist to steady him as well as to hurry him along (fig. 2.1). Hephaistos wears a metalworker's skullcap, a tunic, and a short mantle, and carries a mallet slung over his right shoulder. His lameness is not indicated, only the faltering step of one who has drunk too much. Dionysos, the instigator of the debauch, carries a drinking horn. His followers have joined the two gods in an unruly procession. At their head marches a satyr with exaggerated stride, playing a double flute. He is followed by a satyr who strains under the weight of a krater filled with drink but still manages to carry his drinking horn. Next comes a dancing maenad playing castanets. The haphazard procession ends with a satyr walking close beside Hephaistos, assisting him by carrying a hammer and bellows, tools of the god's trade.[2]

The golden throne was only one of the marvelous metal

1. Hesiod, *Theogony* 927–29; *Iliad* 18.395–97. His lameness is described in Hesiod, *Works and Days* 71 and *Theogony* 571, 945.
2. For representations of the god, see F. Brommer, *Hephaistos: Der Schmiedegott in der antiken Kunst* (Mainz, 1978). Variations in representations of the return of Hephaistos are reviewed by M. Halm-Tisserant, "La Représentation du retour d'Héphaïstos dans l'Olympe," *Antike Kunst* 29 (1986): 8–22.

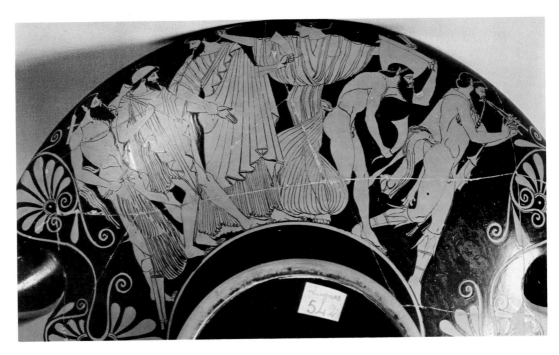

2.1 Kylix by Douris, ca. 470. Paris, Cabinet des Médailles no. 542. Courtesy of Bibliothèque Nationale, Paris.

objects that Hephaistos wrought. He also made such wonders as an invisible net in which he trapped his wife, Aphrodite, in the embrace of her lover, Ares; a glorious set of armor for Achilles; and a winged golden cup that nightly bore the sleeping Helios across the sea to his chariot.[3] Hephaistos worked either on Mount Olympos, where he had made for himself a bronze house, or beneath the earth, where he was assisted by golden handmaidens, whom he had made.[4] Among his other achievements was the production of Pandora, a theoretical model for women, not from metal but from clay and water, materials with which every bronze sculptor was familiar.[5]

Hephaistos is always depicted as a mature, bearded man. He may wear a short tunic and a cap and carry a mallet or pincers. He appears in many contexts. On the north frieze of the Siphnian Treasury at Delphi we see him inflating his bellows, making the draft that he will need to heat the metal that he will use, molten, in the battle of the gods against the giants (fig. 2.2). Here Hephaistos is long-haired as well as bearded, and his tunic is short and tight. His biceps bulge below his short sleeves as he

3. Armor: Homer, *Iliad* 18.390–616; Hesiod, *Shield* 120–25, 215–20, 240–45, 295–300, 315–20. Net: *Odyssey* 8.266–365. Cup: Mimnermos, fragment 10.

4. Mount Olympos: *Iliad* 18.371. Beneath the earth: Hesiod, *Theogony* 866. Golden handmaidens: *Iliad* 18.417–21.

5. Hesiod, *Works and Days* 61.

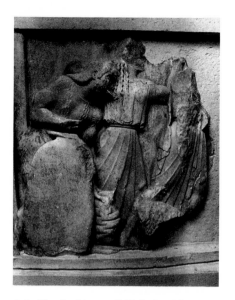

2.2 North frieze of Siphnian Treasury, Delphi, before 525 B.C. Courtesy of Ecole Française d'Archéologie, Athens.

bends forward, straining with the effort to pump air into the bellows. One bellows skin is swollen with air, the other deflated.

During the Archaic period Hephaistos is often represented as assisting Zeus at the birth of Athena. On one characteristic example, a lip cup by the Phrynos Painter, Zeus sits on his throne, flailing his arms in pain and agitation as he clutches his thunderbolt in one hand (fig. 2.3).[6] Hephaistos draws back his mallet after knocking a hole in Zeus's head to remedy a headache. He has started to step away but looks back over his shoulder, raising his free hand to gesture toward his handiwork: a small but fully grown and fully armed Athena is just emerging from behind Zeus's head. This scene is a popular one, and a more elaborate version of it was later carved for the east pediment of the Parthenon in Athens.

Hephaistos and Athena sit amicably side by side on the east frieze of the Parthenon. As patrons of the crafts, the two were apparently worshiped together in a temple not far to the north of the Akropolis. The Hephaisteion, as it is called, completed in the last quarter of the fifth century B.C., overlooked the craftsmen's quarter of the city of Athens.[7]

The word *chalkos* was used by the ancient Greeks to mean copper or bronze or simply metal. Tin, known as *kassiteros,* was mixed with copper to form bronze. A *chalkourgos* was strictly a worker in copper or bronze, or a founder or caster of bronze. *Chalkeus* was the appropriate title for a smith or for any artisan who hammered metal, whether bronze or iron.[8] The forge or smithy was *chalkeion* or *chalkeōn,* and *chalkeuein* was the art of the smith.

Sources of copper were widespread, including Cyprus, Spain, Tuscany, Anatolia, and sites throughout the Near East. Homer refers to Sidon as *polychalkos,* or rich in copper.[9] As tin was far less plentiful than copper, it was always the more expensive of the two metals. Tin was found in England, Spain, and Brittany, as well as Anatolia, Iran, and possibly also Tuscany.[10] It should be remembered, however, that once a

6. See Beazley, *ABV,* 169, 3; Boardman, *ABFV,* pp. 59–60.
7. For a dissenting opinion on the identification of this temple as the Hephaisteion, see E. B. Harrison, "Alkamenes' Sculptures for the Hephaisteion," pt. 1, "The Cult Statues," *AJA* 81 (1977): 137–78.
8. Bronzeworker: *Odyssey* 3.433. Ironworker: *Odyssey* 9.392.
9. *Odyssey* 15.425.
10. See Diodoros 5.22 and 5.38; also *NH* 7.198. For further citations, see J. D. Muhly, "Copper and Tin," *Transactions of the Connecticut Academy of Arts and Sciences* 43 (1973) and suppl. 46 (1976). See also A. D. Franklin et al., eds., *The Search for Ancient Tin* (Washington, D.C., 1978); and J. D. Muhly, "Sources of Tin and the Beginnings of Bronze Metallurgy," *AJA* 89 (1985): 275–91.

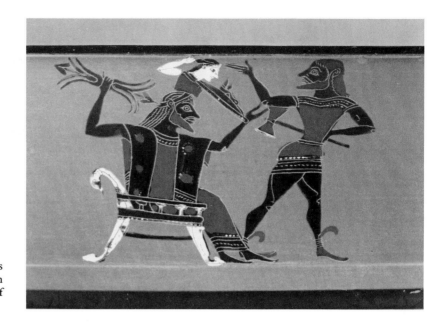

2.3. Detail of lip cup by the Phrynos Painter, 560–530 B.C. London, British Museum B 424. Courtesy of Trustees of the British Museum.

source of alluvial tin had been exhausted, no trace would be left for archaeologists to locate.[11] Pliny's information on copper, tin, and bronze is derived from a variety of sources. In his *Natural History* (7.197) he says: "Aristotle believes that Lydos the Scythian taught how to melt down and work copper, but Theophrastos believes that it was Delas the Phrygian; some attribute the production of copper/bronze to the Chalybes and others attribute it to the Cyclopes."

Copper melts at 1,083°C. Alone it is not particularly good for casting, because it absorbs gases, becomes porous, and then contracts as it cools.[12] Bronze is much more cohesive than copper and was used in Greece for hammered and cast figures from the Geometric period onward. The addition of tin, with its low melting point of 232°C, produces an alloy with a lower melting point than that of copper: with 5 percent tin the melting point is reduced to 1,050°; with 10 percent tin, to 1,005°; and with 15 percent tin, to 960°. Tin also checks the absorption of gases during the casting process, producing an alloy that is stronger and harder than pure copper—particularly advantageous when

11. C. Rolley, "Bronzes grecs et orientaux: Influences et apprentissages," *BCH* 107 (1983): 113.

12. Lifesize Egyptian copper statues of the sixth-dynasty ruler Pepy I and his son (ca. 2300 B.C.) combine sheet-metal body and limbs riveted to a wooden core and cast face, hands, and feet, which are very porous. See G. Maspero, *Manual of Egyptian Archaeology*, trans. A. S. Johns (New York, 1914), p. 342. A. Lucas, *Ancient Egyptian Materials and Industries*, 4th ed., rev. J. R. Harris (London, 1962), p. 214, cites an analysis by C. H. Desch recording 98.2% copper.

the bronze is to be hammered. The addition of lead, with a melting point of 327°C, yields softer and more malleable bronze and simplifies cold-working.

We do not know how precisely the Greeks calculated the compositions of their alloys.[13] However, an unusual inscription found in Eleusis in 1893 and dated to the last third of the fourth century B.C. cites a decree that actually gives specifications for the manufacture of bronze poloi and empolia to be used for the columns of the Philonian Stoa, to be set up on the front of the Telesterion. The copper specified was to be from Marion in northwestern Cyprus, and the bronze alloy was to be composed of eleven parts copper and one part tin, or 91.67 percent copper and 8.33 percent tin.[14] Analyses indicate that Greek statuary bronze frequently had a similar ratio of copper to tin. The problems with analyses are enumerated by E. R. Caley: only random analyses have been made; sample size is often not reported; a single sample taken from a statue may provide results that are valid only for that part of the statue; elements present in small quantities may not be measured; and information may not be provided as to the condition of the piece tested.[15]

13. Greek Geometric bronzes from Olympia, now in Berlin, have been found to contain more than 90% copper. See W.-D. Heilmeyer, *Frühe Olympische Bronzefiguren, OF* 12 (1979): 276–77.

14. *IG* II², no. 1675, ll. 17–18, cited in A. Orlandos, *Les Matériaux de construction et la technique architecturale des anciens Grecs* (Paris, 1966), p. 102. See also G. E. Mylonas, *Eleusis and the Eleusinian Mysteries* (Princeton, 1961), p. 133; G. J. Varoufakis, "Materials Testing in Classical Greece," *Journal of the Historical Metallurgy Society* 9 (1975): 57–63.

15. E. R. Caley, "Chemical Composition of Greek and Roman Statuary Bronzes," in *Art and Technology*, pp. 37–38. Analyses of Archaic and Classical Greek statuary bronze are still rare, but a list of those that are currently available to me is nonetheless of some value: (*a*) Piraeus Apollo (fig. 4.19): Cu 87%, Sn 10%. From M. Leoni, "Observations on Ancient Bronze Casting," in *The Horses of San Marco*, ed. G. Perocco, trans. J. and V. Wilton-Ely (London, 1979), p. 181. It is interesting to note that two of the other Piraeus bronzes, the Athena and one Artemis (it is not specified which one), are said to be 1% lead. (*b*) Ugento god (fig. 4.16): statue, Cu 86.78%, Sn 8.47%, Pb 3.58%; base, Cu 73.98%, Sn 4.68%, Pb 19.58%. From Degrassi, p. 135. (*c*) Selinus Youth (fig. 6.7): Cu 86–91.5%, Sn 8–10%, Pb 0.5–2%. From Leoni, "Observations," p. 181. For slightly different figures, see Degrassi, p. 137n559. (*d*) Riace statue A (fig. 8.3): Cu ca. 83.6–91.8%, Sn 16.4–8.2%. (*e*) Riace statue B (fig. 8.4): Cu ca.73.9–90.1%, Sn 26.1–9.9%. The arms, however, contain 9.8–14.5% lead. (*f*) Chatsworth head (fig. 7.1): Cu 87.5%, Sn 10.4%, Pb .02%, plus trace elements. Curl from Chatsworth head: Cu 90.5%, Sn 9.35%, Pb 0.90%, plus trace elements. Leg in Louvre: Cu 91.5%, Sn 8.9%, Pb 0.57%, plus trace elements. See P. T. Craddock, "The Composition of the Copper Alloys Used by the Greek, Etruscan, and Roman Civilisations," pt. 2, "The Archaic, Classical, and Hellenistic Greeks," *JAS*, 1977, p. 114. Craddock suggests that the leg may be from the same statue as the Chatsworth head because

The few analyses of Greek bronzes which have been done seem to indicate that lead was not commonly added to the bronze alloy until later periods, although it was regularly used in Etruria, southern Italy, and Sicily.[16] Any attempt to draw conclusions before more analyses are available would be premature at best. Interesting questions, however, can be raised. Does a high-lead alloy suggest a later date of production or a specific place of production? Does high-lead content in the bronze base for a statue from southern Italy suggest that alloys were chosen for definite purposes?

Techniques An examination of ancient casting procedures is a necessary preliminary to a thorough understanding of Greek bronze statuary. The lost-wax method of bronze casting, in its direct and indirect forms, was used for both large- and small-scale work. These techniques have persisted until the present, and the methods in use today probably differ in no significant way from those of the fifth century B.C. Many ancient references to the process survive, but no complete descriptions.[17] The earliest modern description of lost-wax casting was written by Theophilus in the early twelfth century.[18] But the most famous

all three pieces contain gold, an unusual trace element. This alloy is discussed in Craddock, "Gold in Antique Copper Alloys," *Gold Bulletin* 15 (1982): 69–72. (*g*) Agora head (fig. 7.7): Sn 8%, from an unpublished analysis by P. T. Craddock cited in Oddy et al., "The Gilding of Bronze Statues in the Greek and Roman World," in *Horses of San Marco*, pp. 182 and 186n11. (*h*) Pieces of Archaic and Classical Greek bronze statues. From Craddock, "Composition of Copper Alloys," p. 114 and table. Leg from Cyprus: Cu 90.5%, Sn 8.6%, Pb 0.08%, plus trace elements. Lock of hair from Calymnos: Cu 90.5%, Sn 8.7%, Pb 0.12%, Fe 0.17%, plus trace elements. Lock of hair from Corfu: Cu 88.5%, Sn 10.4%, Pb trace, Fe 0.13%, plus trace elements. Lock of hair from Corfu: Cu 87%, Sn 11.4%, plus trace elements. Lock of hair from Ephesos: Cu 87.5%, Sn 9.3%, Pb 2.6%, Fe 0.11%, plus trace elements.

16. The Ugento god and the Selinus Youth are two examples (see n. 15*b* and *c*). And, for the sake of comparison, the alloy of the probably much later Piombino Apollo is 8–10% lead (B. S. Ridgway, "The Bronze Apollo from Piombino in the Louvre," *Antike Plastik* 7 [1967]: 43–75) and that of the Mars from Todi is up to 12% lead (F. Roncalli, *Il "Marte" di Todi, Memorie: Atti della Accademia nazionale dei Lincei, Classe di scienze morali, storiche e filologiche* 11.2 [Rome, 1973]: 44).

17. For summaries of the ancient literary testimonia, see H. Blümner, *Technologie und Terminologie der Gewerbe und Künste bei Griechen und Römern*, vol. 4 (1887; rpt. Hildesheim, 1969), pt. 14, "Die Metallarbeit," pp. 1–378; and G. Zimmer, "Schriftquellen zum antiken Bronzeguss," in *Archäologische Bronzen*, pp. 38–49.

18. See Theophilos, *Schedula diversarum artium*, ed. A. Ilg (1874; rpt. Osnabruck, 1970), bk. 3. See also *On Diverse Arts: The Treatise of Theophilus*, trans. J. G. Hawthorne and C. S. Smith (Chicago, 1963), bk. 3.

early description of the modern direct lost-wax process is given by Benvenuto Cellini in his discourse on the casting in one piece of his colossal Perseus.[19] Cellini's feat was surpassed, in plan at least, by Leonardo da Vinci, who proposed to make, in a single casting, an equestrian statue of Francesco Sforza which would stand over twenty-three feet high.[20]

As elements of the direct and indirect methods of lost-wax casting are often combined, they may be seen as variations on a single technique. Variations in the ancient process reflect not different dates of production but simply different artists or workshops and the requirements of the particular piece being cast. Such variations were in use in Greece by the seventh century B.C. for works conceived as small in scale. They were applied to the production of large bronzes from the time they were first cast, in the sixth century B.C.

A bronze statue of the sixth and fifth centuries B.C., whether it was cast by a direct or an indirect process or by a combination of the two, was a unique work. A mold could have been made from a finished statue to produce an exact duplicate, but all available evidence indicates that this process did not come into use until later periods. A statue was not even precisely reproduced from its original model, as we shall see when we examine the modifications that artists made to their basic models. Furthermore, workshops were temporary installations, established for the production of specific bronzes, and then closed down. Thus, when we look at the evidence from ancient foundries, we must recognize that we are reconstructing an industry that was based on the idiosyncracies of individual artists and on the requirements of specific commissions. Representative evidence of the lost-wax process as it was practiced in the sixth and fifth centuries B.C. is catalogued in the Appendix.

The Direct Process

In the direct method of lost-wax casting, a core was constructed out of clay, apparently over an armature. This core was made slightly smaller than the final model was to be, and can be envisioned as a rough version of the intended result. A beeswax model was formed over the dried core and was worked in some detail, with tools or by hand, depending on the effect desired and the consistency or malleability of the wax used. The final

19. See *The Treatises of Benvenuto Cellini on Goldsmithing and Sculpture*, trans. C. R. Ashbee (1888; rpt. New York, 1967), pp. 114–24; also *The Autobiography of Benvenuto Cellini*, trans. G. Bull (Harmondsworth, 1956), pp. 341–47.

20. See M. V. Brugnoli, "Il Cavallo," in *The Unknown Leonardo*, ed. L. Reti (New York, 1974), pp. 86–109.

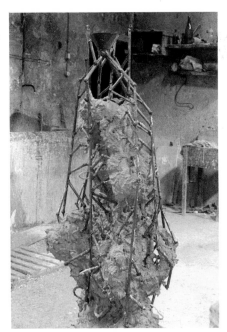

2.4 Complete wax gate system, consisting of funnel, gates, and vents (beside funnel), before addition of clay investment mold. Courtesy of Alison Frantz.

casting in bronze would replace and therefore duplicate the appearance of this model. Small-scale direct hollow castings made in one piece were common during the Archaic and Classical periods.[21] A larger figure entailed greater risk, and artists minimized this risk by casting such works in several pieces, so that damage to one piece during the casting process would not destroy the whole work.

Next, a gate system was attached to the wax, consisting of a funnel through which the molten bronze was poured, gates to regulate its flow, and vents for the escape of gases (fig. 2.4). Today gates and vents are made of wax rods; this was probably the practice during antiquity as well. Vents were usually thinner than gates, and may have been made by dipping string into wax. The funnel, too, was probably first made of wax.

Chaplets (pins) made of iron or bronze were stuck through the wax into the core at several points, their outer ends left exposed to be covered by the clay mold, called the investment mold (fig. 2.5). Thus when the wax was melted, the core was held in position inside the mold. In the case of a core that was entirely enclosed by the mold, or of one designed so that only a very small opening was left through the mold, the venting system must have penetrated the core at some point in order to allow gases to escape from within it.[22] With a piece casting, the artist could avoid this problem by leaving the core exposed.

The wax model with its gate system was finally coated with a refractory clay investment mold applied in two or more layers, the innermost of which had to be fine and liquid to ensure that all parts were completely coated (fig. 2.6). A bubble that dried in the clay would create a lump on the bronze, which the artist would have to conceal by cold-working. Today artists normally apply this layer either by brushing or by dipping and agitating.

The outer layer of the investment mold was composed of coarser clay with a quantity of rough sandy inclusions or temper, which prevented cracking and reduced shrinkage during drying and baking (fig. 2.7).[23] The lip of the wax funnel and the

21. It has recently been observed that some early bronze statuettes were produced from a wax that was pieced together from sections, made either by hand or in clay molds taken from an existing model: U. Gehrig, "Frühe griechische Bronzegusstechniken," *AA* 94 (1979): 547–58.

22. Today a hollow metal tube is stuck through the wax into the core. To prevent the core from filling with bronze, the tube is connected to the exterior by a wax rod or vent that is not part of the venting system.

23. The maximum thickness of any mold fragment from the Agora group mentioned below is 0.062 m.

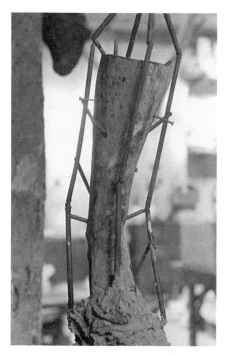

2.5 Wax gate system attached to wax model. Heads of chaplets piercing through the wax model to the core are being covered as the investment mold is added. Courtesy of Alison Frantz.

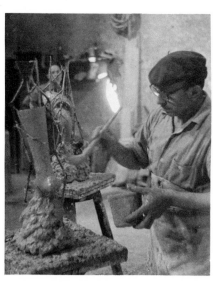

2.6 Inner layer of clay investment mold, consisting of fine wet clay, is brushed onto the wax model and gate system. Courtesy of Alison Frantz.

tops of the vents were left exposed on the exterior of the clay mold. Next the mold was inverted and placed on a base, perhaps constructed of bricks, inside a casting pit that had been dug in the ground (fig. 2.8). If the mold was too large to invert, one of the gates at its base could be extended through the investment to allow the wax to burn out, but the resulting hole would have to be plugged before the bronze was poured.

A fire was then built on the platform around the mold. All of the wax and all traces of moisture had to be burned out of the mold, because any wax left inside would generate gases when it came in contact with the molten metal and would blow holes in the bronze or even cause the mold to explode. When the mold had been heated and the wax burned out, the core was held in place by the chaplets alone; the gates, vents, and funnel were now simply a framework of hollow channels left to contain the molten metal and expel the gases. Today the oven heats slowly for thirty or more hours, depending on the number and size of the molds being baked (fig. 2.9). For about one-third of this time, the oven is at red heat (500–650°C). When the wax volatilizes and its flame billows out of the mold, the clay mold has been baked. The oven is turned off and the molds are allowed to cool very slowly, as a rapid change of temperature would cause them to crack. The many cracks on the inner surfaces of ancient mold fragments result from exposure to extreme heat and rapid cooling, and no doubt reflect inadequate temperature control.

Next the molds were packed firmly in sand in the pit (fig. 2.10). The amount of space to be packed could be reduced by partitions in the pit.

In order to determine how much bronze to melt for the casting, a foundry worker could have weighed all of the wax that was to be used for a piece, as is done today, and calculated approximately ten units of metal per unit of wax. The bronze was heated in a shaft furnace or in a crucible furnace. Bellows were used to raise the temperature of the metal to 1,000 or 1,100°C, depending on the composition of the alloy.[24] Then the molten bronze was poured from a crucible or directly from the adjacent furnace into the funnel (fig. 2.11).

24. Theophilos, *Schedula diversarum artium*, chap. 85, recommends that the copper, with its high melting point, be melted first, before the addition of tin, with its lower melting point. Craddock comments ("Composition of Copper Alloys," p. 113) that if the temperature is then brought back to that of the molten copper, the bronze will have been heated far enough above its melting point to ensure an adequate margin for cooling without danger of solidifying too soon during the pour.

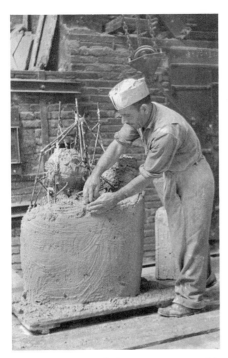

2.7 Outer layer of clay investment mold, coarser and drier than the inner layer, is built up over the model and gate system. Courtesy of Alison Frantz.

Finally, the clay mold was cooled, the sand packing was removed, and the investment mold was broken away from the casting. The hotter the bronze, the harder it is, and so a short cooling period, no more than a couple of hours, was no doubt as desirable during antiquity as it is today. The clay core could be left in place, or parts of it removed if the casting had openings that allowed access to the inside. The investment mold could not be reused. If the bronze had miscast, the model, whose form was contained now only on the inner surface of the broken mold, was irrevocably lost at the same time.

The Indirect Process

The indirect method of lost-wax casting has many of the same steps as the direct method and was easily used in conjunction with it. Extra steps were required in the indirect process, but they were well worth the effort, for the original model could be preserved and used again to produce a second set of molds from which to work if the first attempt at casting failed.

Indirect lost-wax casting involved first the construction of a full-size model from any material in which the artist chose to work. Clay was probably most often used, as it is easily worked and inexpensive; but wax, wood, or stone could also be used.

A clay master mold was taken from the model in separate but joining pieces. This working mold was dried but not baked, for it would not be used to receive the molten bronze. The master mold was then reassembled in groups of manageable size. A nude figure might be divided into relatively few parts, such as head, arms, trunk, and legs, but a draped statue could easily be cast in many pieces, because it would be very easy to conceal joins within folds.[25] Each of the master mold assemblages was then lined with a layer of beeswax, which could be poured in, brushed on, or applied in slabs to the mold. The usual method of coring seems to have been to pour fine liquid clay that would adhere closely to the inside of the hollow wax model. Simple iron armatures that have been found in ancient indirect castings were apparently inserted to stabilize the poured clay core.

25. A female torso from Bodrum, perhaps dating to the early third century B.C., was cast in at least a dozen pieces. See B. S. Ridgway, "The Lady from the Sea: A Greek Bronze in Turkey," *AJA* 71 (1967): 329–34. A lifesize figure cast by the direct process alone might also have been produced in several sections, but as the sections were built onto the original model and cast directly from it, the process would have been so cumbersome and risky that it is not likely to have been used. The Greeks were acquainted with both the indirect and the direct processes well before they began to produce large-scale statuary; see chap. 3, below.

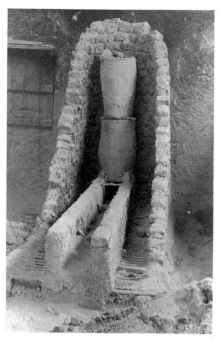

2.8 Molds are stacked, and the oven for baking the clay and burning out the wax is constructed around them. Courtesy of Alison Frantz.

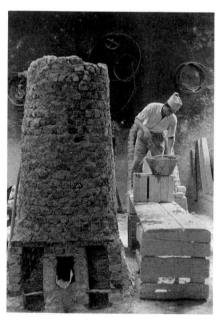

2.9 The completed baking oven, with two channels for fuel and one for wax escaping from the molds. Courtesy of Alison Frantz.

The master molds were then removed and the beeswax model was reworked. This might be an extensive process, involving both the tooling and engraving of surface details, such as ears and eyebrows, and the addition of more wax for such features as locks of hair and beard. Irregularities in the thickness of the walls of some ancient bronzes tell us that additions were made to the wax model. Because of the way the wax was first applied to the master molds, the indirect method left a distinctive inner bronze surface, reproducing the inner surface of the wax: it may be as smooth as the wax, exactly duplicating drips, brushmarks, or seams between adjoining slabs of wax. The interior of a direct casting, in contrast, should bear only the impression of the clay core on the underside of the wax.

When the wax model was ready for casting, the process was the same as in the direct method. A wax gate system was attached to the wax model and metal chaplets were inserted (figs. 2.4, 2.5). The final clay investment was built up in two, rarely three, fine to coarser layers around the cored wax (figs. 2.6, 2.7).

After the casting, the investment mold was broken away from the bronze and discarded. Presumably the master mold remained available for reuse in case of a failed casting. As it was a simplified version of the finished model, however, the final details would have had to be added to a new model if the master molds were reused. The statue was now subjected to cold-working and chasing. The chaplets and the gate system, now of bronze like the statue itself, were removed, as was the blackened casting skin of the bronze, which might have bits of mold adhering to it, as well as fine irregular ridges where the bronze penetrated cracks in the mold. After such imperfections were filed down and patched, the pieces of the work were joined, the details engraved, and the eyes and other inlays inserted. Joints and patches were concealed or polished smooth.

A statue with many projecting parts called for procedures different from those needed to produce a more self-contained image. Surely it would have been preferable to produce loosely falling locks of hair, for example, by modeling them individually in wax, casting them solid, and then attaching them to their statue. The locks of hair would thus be direct castings, whereas the statue itself might be an indirect casting. Or the model for the head of a statue might be so rough as to provide only the proper scale and general contours of the head. Molds would be taken from it, lined with wax, and then cored. If, however, the wax was then so worked over and added to that the head was radically changed, the casting might more accurately be

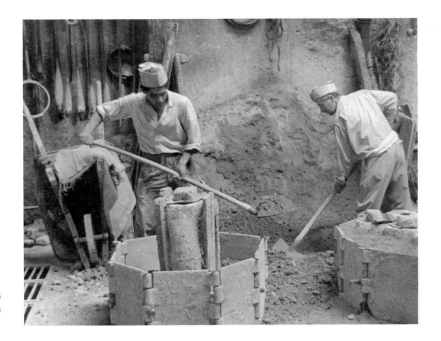

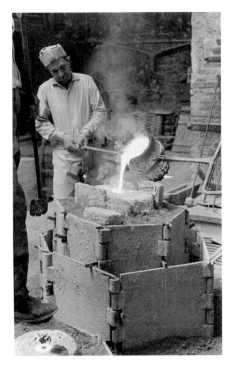

2.10 Hinged metal containers serve as casting pits; inside, molds are packed in sand. Courtesy of Alison Frantz.

2.11 Bronze is poured from the crucible into the mold cavity. Courtesy of Alison Frantz.

described as representing the direct process. For if it miscast, the details that had been added—nose, curls, ears, whatever— would be lost. The master molds would only roughly reflect the head. They could be used as before to set the general contours and scale of the piece from the basic model, but the working of the wax would have to be repeated before a fresh casting could be made.

The details of baking, packing, and casting were the same in both the direct and the indirect methods (figs. 2.8–2.11). The advantage of using the indirect process for as much of a statue as possible became apparent in the baking, when the wax was melted out of the mold. If the direct process alone was used, this step resulted in the destruction of the artist's model, whereas in the indirect process the master molds retained the impression of the original model and could be used again. The use of the direct process alone allowed for only one attempt at casting from one model, whereas the indirect process permitted any number of beginnings to be made from a single model by the use of master molds. This possibility opened up other opportunities. For example, a series of bronzes could be based on a single original model but have individually added details, with the result that all would closely resemble one another: only the elaboration of the basic model would need to be created before the casting.

All of the trash from a casting—bricks from the dismantled

furnace, scraps of metal, broken molds—was discarded, often in the casting pit itself, which had fulfilled its function and would now be closed. From the debris found in casting pits, as well as from the bronzes themselves, a picture is today emerging of the processes used in ancient foundries.

Technical Studies

In view of the great popularity of ancient sculpture from the early Renaissance onward, it is surprising that it was not until the late nineteenth century that scholars took a serious interest in bronze statues as a distinct category and began to investigate how they were made. The most detailed early description of ancient Greek metalworking techniques, with thorough citations of ancient sources, was written by Hugo Blümner.[26] He assumed, as did others, that some form of the lost-wax (*cireperdue*) process was employed throughout antiquity. But in 1901 L. Lewin hinted at impending controversy when he wrote that the use of the lost-wax process should perhaps not be taken for granted, and related the practice of casting in packed earth mentioned in the Bible to the use of sand.[27] The passage he cited, however, can be read simply as a reference to the practice of digging pits for casting below ground level.[28]

In 1921 Albert Neuberger, in interpreting an Egyptian painting that showed a bronze door being cast, referred specifically to an ancient process of sandbox casting after a wooden model.[29] There is abundant evidence, however, that wax was a familiar material in Egypt, and that its many uses there included the lost-wax process, which was common from at least as early as the third millennium B.C. for all types of bronze and copper casting.[30]

In 1927 Kurt Kluge, a sculptor and scholar, presented in *Die antike Erzgestaltung* his theory that both sand casting and lost-wax casting had been in use during antiquity.[31] First he

26. Blümner, *Technologie und Terminologie*. See also H. B. Walters, *Catalogue of the Bronzes, Greek, Etruscan, and Roman, in the British Museum* (London, 1899), pp. xiii–liii. Technical studies were published by E. Pernice in 1904, 1908, and 1910: "Untersuchungen zur antiken Toreutik," pts. 1–5, *JöAI* 7 (1904): 154–97, *JöAI* 8 (1905): 51–60, *JöAI* 11 (1908): 212–28, *JöAI* 13 (1910): 102–107.

27. L. Lewin, "Über die Technik in antiken Bronzen," *AA* 16 (1901): 14–16.

28. Probably 3 Kings 7:46: "In the region of the Jordan he cast [the vessels], in the clay ground between Sokkhoth and Seira."

29. Albert Neuberger, *Die Technik des Altertums* (Leipzig, 1921), pp. 56–57.

30. The uses of wax in Egypt are discussed in Lucas, *Ancient Egyptian Materials*.

31. Kluge, *AG* 1:82–90. Vol. 2 of *AG*, by Kluge and K. Lehmann-Hartleben, is titled *Grossbronzen der römischen Kaiserzeit*.

described modern sand piece casting, a process involving the use of an open iron box in two halves, within which a mold of sand firmed up with a binding medium was prepared for the piece to be cast, one half at a time.

Though Kluge emphasized that he had found no evidence for the use of this technique in the production of any ancient work, he proceeded to reconstruct an ancient process by which the artist carved a wooden model, sawed off all projecting parts, took a negative of each half of the figure in sand, suspended a core within this sand mold, baked the core and mold, and poured bronze between them. All of the removed parts were molded separately in sand, cast solid, and attached to the whole. The details, which to Kluge gave a statue its artistic aspect, were the result of cold-working. Kluge illustrated ancient sand casting with a few Roman bronzes, claiming that they had thick walls, that the interior followed the exterior form only very generally, suggesting a roughly fitting core, and that the metal, where it had not been cold-worked, was rough and grainy like sand. Kluge also considered Roman reproductions of Greek bronzes to be sand castings—some simply technical copies, but others enhanced by the high quality of their cold-working.

In an article describing ancient direct and indirect lost-wax casting, Kluge cited no examples from the Greek period, and suggested that the early works were sand castings.[32] He observed that large bronzes of the Archaic period have thick and uneven walls, and again he assumed that sand casting was the cause. Kluge's basic premise was that there were two sources for Greek bronze casting and two trends in its development. *Holzerz*, casting after a wooden model, had, he felt, earlier origins than the wax-based process, and was associated with the sphyrelaton process. He saw *Wachserz*, the lost-wax process, as a distinct tradition that had come from Egypt and was used to produce small and medium-sized Greek bronzes. Lost-wax casting on a large scale developed, Kluge believed, from both processes, but was originally the direct result of artists' having learned that wooden models could be cut up in separate pieces, molded in sand, and then cast. Archaic bronzes, he believed, provided physical proof of his theory.

Kluge based his arguments on his own observations of Greek bronzes in Athens, Delphi, and Istanbul. Assuming that these works were not made in the same way as small wax castings, he assigned them to the sand-casting process. The head of Zeus

32. Kluge, "Gestaltung," pp. 1–30.

from Olympia (fig. 4.15), for example, has thick, uneven, porous walls, features that Kluge believed to be characteristic of sand castings. He argued further that all the projecting parts of the head are separately cast, which he thought would not have been the case with a wax model.[33] In fact, such a work would not have been cast in one piece by the lost-wax method either, and for the same reason that Kluge adduced for sand casting: casting extremely thick walls in such places as the knot of hair at the nape of the neck and locks of hair over the brow entails unacceptable risk. Furthermore, a beard that is strongly under-cut, such as that of the Olympian Zeus, could not have been molded successfully in sand, but Kluge did not suggest that it had been separately cast.

Kluge also mentioned the thick walls of the Archaic head of a warrior in the Athens National Museum (fig. 5.2) and of the body of the Poseidon from Livadhostro (fig. 4.20), although he called the head of that statue a later wax casting. Kluge believed the Delphi Charioteer (fig. 6.6) to be a sand casting, too, but saw the arm and the horses' legs found with the statue as later wax castings from a different statue group. The simple vertical form of the Charioteer suggested to him that the model for the entire lower portion of the statue, from the hips down, was cut from a tree trunk, and he insisted that such a statue would never have been produced from a wax or clay model.[34] Actually, a glance under the Charioteer's hem clearly reveals the join between skirt and lower legs, and that detail has been generally accepted as evidence that the pieces were separately cast.

Kluge's additional suggestion that the model for the bronze Serpent Column from Delphi (fig. 5.6) had been the slender trunk of a spruce tree did not take into account the great effort that it would take to transform the smooth contour of the tree trunk into the rippling coils of the Serpent Column.[35]

The theory that a wooden core was used for sphyrelaton figures—which is likely to have been the case, though the the-ory is supported by neither literary nor physical evidence—led Kluge to compare early casting and early carved stone, both of which he believed were influenced by wood carving.[36] Kluge drew two related conclusions, one based on physical evidence, the other purely conjectural. First, the thick walls of Archaic bronzes proved to him that sand casting had been used. And

33. Ibid., pp. 14–15.
34. Ibid., pp. 16, 20, 24.
35. Ibid., p. 24. The Serpent Column is now in Istanbul.
36. Ibid., pp. 24–25. For sphyrelaton, see below, p. 41.

second, the simple style of the early sculptures suggested that the models for them had been made of wood.

Kluge's belief in the use of a wooden model was at first widely accepted, even though questions were raised about his technical points. His assertion that chisel marks on the head of the Akropolis warrior were made in the wooden model and reproduced in the cast bronze was contested as early as 1933 by Stanley Casson, who observed that these cuttings were made directly in the bronze head so that its helmet would fit. In general, however, Casson accepted the idea of sand casting from a wooden model.[37]

Beeswax in its natural state is as hard as wood, and carving tools are needed to model it. But if it is heated, it can be worked by hand.[38] By the Archaic period, at which time large-scale bronzes were introduced to Greece, the use of a wax model had already been known for centuries and was commonly used in Greece on a small scale. The next logical step was to add a clay core, thereby making a hollow form, and then to continue with the familiar casting process. This method had in fact been used as early as the seventh century B.C.

The wax layer coating the core had to be thick enough so that the tools used to carve it would not pierce through it to the clay core. This concern may account for the thick and uneven walls that Kluge observed in Archaic Greek bronzes, and that actually can be found in Greek bronzes of all periods. In fact, the development of greater plasticity in the style of bronze sculpture may be linked with the use of softer or even molten wax, with the application of thinner and more uniform layers of wax, and with the addition to the basic wax model of separately worked pieces, such as locks of hair.

A. J. B. Wace, Karl Lehmann-Hartleben, and Charles Seltman all followed Kluge in describing developments in the style and techniques of Greek bronze statuary.[39] These three scholars incorporated Kluge's theory of sand casting in their own stylistic discussions, and shed no new light on technical processes. An excellent summary of the existing scholarship was pub-

37. Casson, pp. 154–57.

38. R. Raven-Hart argued convincingly that the carved appearance of some Geometric bronzes results from the carving of the model in hard wax, but then inexplicably followed Kluge on the use of sand casting from wooden models for large bronzes. "The Casting-Technique of Certain Greek Bronzes," *JHS* 78 (1958): 87–91.

39. A. J. B. Wace, *An Approach to Greek Sculpture* (Cambridge, 1935); K. Lehmann-Hartleben, "Drei Entwicklungsphasen griechischer Erzplastik" (1937), now in *Boreas* 4 (1981); C. Seltman, *Approach to Greek Art* (New York, 1948).

lished in 1949 by Dorothy Kent Hill.[40] In 1960 Jean Charbonneaux again summarized Kluge's sand-casting theory, differing with him only slightly on the matter of the wooden model.[41]

Rhys Carpenter expanded on Kluge's theory of a carved wooden model, speculating that it would have been covered with wax to receive the final details, and that an impression of the wax would have been taken in the clay mold, the model withdrawn, and the mold relined with more wax for casting. His theory of a glyptic style in bronze statuary, allied to marble sculpture through the carving of a wooden model, was based on this assumption. Carpenter suggested that Greek bronze sculptors had worked from the wooden model until the time of Lysippos, in the fourth century, when the introduction of the clay model resulted in a more plastic style.[42]

In a 1969 catalogue of large bronzes in Morocco, Christiane Boube-Piccot demonstrated the value of examining individual bronzes thoroughly, but still relied heavily on Kluge for an explanation of casting techniques.[43] Finally, Gisela Richter stated in the following year that lost-wax casting was the method most commonly used, but that "casting from sandbox molds was also practiced to a limited extent" in ancient Greece.[44]

A second and divergent trend of thought about technique has developed in recent years. In 1950 R. J. Forbes stated flatly that "sand casting was not practised in Antiquity, this is an invention of the eighteenth century."[45] Herbert Maryon differed from Forbes only on the question of date, observing that the first written account of sand casting is contained in Vannoccio Biringuccio's *Pirotechnia* of 1540, and consequently moving the use of sand casting back to the fourteenth or the fifteenth century.[46]

40. D. K. Hill, *Catalogue of the Classical Bronze Sculpture in the Walters Art Gallery* (Baltimore, 1949), pp. xii–xix. In 1969 Hill reiterated her belief in the existence of more than one process, one of which she thought was sand casting from a wooden model. See D. K. Hill, "Bronze Working," in *The Muses at Work*, ed. C. Roebuck (Cambridge, Mass., 1969), pp. 63–72.
41. Charbonneaux, *GB*, p. 28.
42. R. Carpenter, *Greek Sculpture* (Chicago, 1960), pp. 69–80. See also R. Carpenter, "Observations on Familiar Statuary in Rome," *Memoirs of the American Academy in Rome* 18 (1941): 74–81.
43. C. Boube-Piccot, *Les Bronzes antiques du Maroc* (Rabat, 1969), pp. 33–50.
44. Richter, *SSG*, p. 115.
45. R. J. Forbes, *Metallurgy in Antiquity* (Leiden, 1950), pp. 133–34.
46. H. Maryon, "Fine Metal-Work," in *A History of Technology*, ed. C. Singer et al., vol. 2 (Oxford, 1956), p. 475. See *The Pirotechnia of Vannoccio Biringuccio*, trans. C. S. Smith and M. T. Gnudi (Cambridge, Mass., 1966): sand casting, bk. 8, chaps. 3–4; lost-wax casting, bk. 6.

In 1955 Ulf Jantzen presented strong evidence for a link between large- and small-scale lost-wax casting techniques. In his study of bronze griffin protomes, he identified a group of monumental heads that appeared to have been cast by the direct lost-wax process.[47] Such protomes have been found in Olympia, Delphi, Athens, and especially Samos, where, according to ancient literary tradition, large-scale bronze casting originated. The hollow-cast protomes range from 0.50 to 0.80 meter in height, and date as early as the middle of the seventh century B.C. Jantzen believed that griffin protomes set the pace for large-scale castings, suggesting that sculpture in the early seventh century consisted almost entirely of sphyrelata, except for two small cast human heads from midcentury, one in Karlsruhe and one in the Louvre, both of which were surely riveted to hammered bodies.[48]

Further evidence for the use of the lost-wax process to make early large bronzes appears in François Chamoux's monograph on the Delphi Charioteer, which was also published in 1955.[49] Here the monument on which Kluge had relied most heavily for evidence of sand casting from a wooden model is decisively shown to be a lost-wax casting.[50] From this point onward, the theory that a form of sand casting had been used to produce the earliest bronze statues in Greece began to lose its advocates.

Technical studies of the physical characteristics of individual bronzes have shown that the lost-wax method was the only casting process used in Greece during the Archaic and Classical periods, and in fact throughout antiquity. More and more scholars are concerned not just with style and identification but also with state of preservation, conservation of the bronze, and analysis of the alloy. When possible, a study of the interior may be undertaken or X-ray photos taken to illuminate details of the process by which a bronze was cast. Careful attention is also paid to the number of pieces in which a statue was cast and the manner in which those pieces were joined. In addition, studies are no longer limited to recognizable portions of antique bronze statues, but now include fragmentary bronzes and the debris from bronze casting workshops. Now, one hundred years after the publication of Hugo Blümner's pioneering work on ancient bronzeworking, which mentions only lost-wax casting, scholars

47. Jantzen, pp. 53–83. Evidence for the use of the indirect lost-wax process in the seventh century B.C. is discussed in chap. 3, below.
48. Jantzen, p. 68.
49. F. Chamoux, *L'Aurige de Delphes*, FdeD 4, no. 5 (1955): 57–66.
50. The evidence is discussed in chap. 6, below.

have at last rejected sand casting as a technique known during antiquity.[51]

The picture that emerges from recent studies of ancient bronzes and bronze workshops is one of a highly sophisticated and flexible technology. Certainly, styles were governed by tradition and by convention, but techniques and even alloys evidently varied according to individual artists, workshops, and regions. Particulars of the installation and specifications of the patron were certainly also considered.

The discovery of a number of bronze statues during recent years has aroused new interest in the medium, in the techniques associated with it, and in the conservation of bronze. A two-volume supplement to the *Bollettino d'Arte*, for example, concentrates on the Riace bronzes—their discovery, restoration, scientific analysis, style, identity, date, and origin—and a volume about the Porticello shipwreck contains a lengthy study of the statuary bronzes.[52]

Scholars are also turning their attention to bronzes discovered earlier, but only recently made accessible for study by virtue of the need for cleaning and conservation. In every case, scientific studies accompany and even overshadow traditional stylistic analysis. The earliest such study that was widely publicized was done on the four horses of San Marco, which were removed from their familiar outdoor setting overlooking the Piazza San Marco in Venice during the 1970s. They were cleaned and studied, and one of them was sent to London and New York as the centerpiece of a major loan exhibition in 1980.[53] Now they are no longer displayed in the open air, but are maintained in a controlled environment.

In the United States, this new scientific interest in familiar bronzes can be traced back even further, to early December

51. Some recent works concerned with ancient bronze technology are W.-D. Heilmeyer, "Giessereibetriebe in Olympia," *AA* 84 (1969): 1–28; *Art and Technology*; Roncalli, *"Marte" di Todi*, pp. 35–56; Mattusch, "Agora," "BFC," and "Corinth"; Bol, *Bronzetechnik* and *Grossplastik*; Perocco, ed., *The Horses of San Marco*; Degrassi; E. Formigli, "Bemerkungen zur technischen Entwicklung des Gussverfahrens griechischer Bronzestatuen," *Boreas* 4 (1981): 15–24; "La tecnica di costruzione delle statue di Riace," in *Due bronzi*, 1:107–45; Rolley, *BG*, pp. 13–32; Schwandner/Zimmer/Zwicker; Zimmer, "Giessereieinrichtungen"; *Berliner Beiträge zur Archäometrie* 9 (1984); *Archäologische Bronzen*; M. Cristofani, *I Bronzi degli Etruschi* (Novara, 1985), pp. 29–53; S. Haynes, *Etruscan Bronzes* (London, 1985), pp. 41–50; K. Gschwantler, *Guss und Form: Bronzen aus der Antikensammlung* (Vienna, 1986).

52. *Due bronzi*; C. J. Eiseman and B. S. Ridgway, *The Porticello Shipwreck: A Mediterranean Merchant Vessel of 415—385 B.C.* (College Station, Tex., 1988).

53. See Perocco, ed., *Horses of San Marco*.

1967, when the *New York Times* informed its readers that the "Met finds its Greek horse a fake."[54] The bronze statuette in question had long been accepted as a Greek original of the Early Classical period. In 1923 Gisela Richter had stated unequivocally that the bronze was "without doubt artistically the most important single object in our classical collection."[55] Joseph Veach Noble, whose reputation had been established with his reconstruction of the techniques used to produce Greek vases,[56] now turned his attention to the Metropolitan's horse. Using X rays, he determined that the horse was not solid, as Richter had thought, but a hollow casting. His additional observations, both technical and stylistic, led him to the conclusion that the bronze had been produced in Paris between 1918 and 1923.[57]

The scholarly world was shocked, and heated debate ensued on both technical and stylistic fronts. The Metropolitan Museum staff launched a thorough scientific investigation of the bronze horse and eventually concluded that it was ancient after all.[58] Perhaps in deference to the museum's earlier stance on the subject, however, the statuette was redated, on stylistic grounds, to the first century B.C. or the first century A.D.[59]

Theft and recovery led to recent studies of two important bronzes. A bronze youth (fig. 6.7) found in 1882 near Selinus in Sicily was stolen in 1962 from the town hall in Castelvetrano, where it had been on display. Recovered in 1968, the figure was sent to Rome for conservation. New technical observations there established the astonishing fact that the statue had actually been lengthened during antiquity.[60] The Kythera head in Berlin (fig. 4.18) was also stolen, recovered, and then cleaned and carefully studied. In a recent volume concerning technical studies of bronzes, the Kythera head is used to illustrate the use of gammaradiography and computertomography to determine

54. *New York Times*, December 7, 1967, p. 1, referring to New York, Metropolitan Museum of Art acc. no. 23.69; H 0.402 m.

55. G. M. A. Richter, "A Greek Bronze Horse," *BMMA* 18 (1923): 89.

56. J. V. Noble, *The Techniques of Painted Attic Pottery* (London, 1966).

57. J. V. Noble, "The Forgery of Our Greek Bronze Horse," *BMMA* 26 (1968): 253–56.

58. D. W. Zimmerman et al., "Thermoluminescence Authenticity Measurements on Core Material from the Bronze Horse of the New York Metropolitan Museum of Art," *Archaeometry* 16 (1974): 19–30; K. C. Leffert et al., "Technical Examination of the Classical Bronze Horse from the Metropolitan Museum of Art," *Journal of the American Institute for Conservation* 21 (1981): 1–42.

59. See, e.g., J. R. Mertens, "Greek Bronzes in the Metropolitan Museum of Art," *Metropolitan Museum of Art Bulletin* 43 (1985): 62–63.

60. A. M. Carruba, "Der Ephebe von Selinunt: Untersuchungen und Betrachtungen anlässlich seiner letzten Restaurierung," *Boreas* 6 (1983): 44–60.

the varying thicknesses of ancient bronzes and materials contained in their cores.[61] Further technical observations about the bronze have since been presented by Wolf-Dieter Heilmeyer.[62]

One particularly promising area of current research is that of bronze statuettes, which, being more easily accessible than large bronzes, tend to be subjected more frequently to scientific analysis. Studies in Berlin have shown that a late-seventh-century statuette of a ram bearer was cast in pieces, and that a kouros from Samos dating to approximately 530 B.C. (fig. 4.2) is a cored hollow casting.[63] This information raises the question of how many more early bronze statuettes once thought to be solid simply because of their weight and size may as a result of radiography prove to be hollow castings.

Indeed, the study of ancient bronzes is a rapidly expanding field. Summaries of work in progress in all areas of ancient bronze studies are contributed regularly by Claude Rolley to the *Revue Archéologique*.[64] International bronze congresses, attended by scholars from Eastern and Western Europe and the United States, are held biennially in Europe. In 1984 the eighth congress, held in Stara Zagora, Bulgaria, concentrated on bronze figures from the Roman Empire and Thrace. In 1986 more than three hundred scholars met in Vienna, and close to two hundred papers were delivered on Greek and Roman statuettes and large bronzes. The 1988 congress, in Freiburg, concentrated on bronzes from the Roman provinces.

61. J. Goebbels et al., "Fortgeschrittene Durchstrahlungstechniken zur Dokumentation antiker Bronzen," in *Archäologische Bronzen,* pp. 126–31.

62. W.-D. Heilmeyer, "Neue Untersuchungen am Kopf von Kythera," in *Akten* of the 9th International Bronze Congress, 1988.

63. U. Gehrig, "Frühe griechische Bronzegusstechniken," *AA* 94 (1979): 547–58.

64. C. Rolley, "Les Bronzes grecs: Recherches récentes," *RevArch*, 1983, pp. 325–36; 1984, pp. 273–88; 1985, pp. 277–96; 1986, pp. 377–97.

3 BEGINNINGS

The Minoans made statuettes of clay, wood, ivory, and metal. They were highly skilled in the use of the lost-wax process and produced fine cast bronze statuettes, some of them hollow.[1] The Mycenaeans made clay figures but not metal ones, as they were not familiar with the casting process. They were clearly impressed by statuettes made of metal, however, for there is evidence that they imported them.[2]

Human figures appear early in Greek art, emerging almost imperceptibly from geometric patterns. In vase painting they seem at first no more important than the abstract ornament with which they are mingled. They are arranged in the same formal terms: equally spaced figures with triangular torsos, wasp waists, stick arms and legs, and nearly identical poses, all neatly lined up within the bands of geometric designs. When a scene is depicted, such as the ceremony of laying out the dead (the *prothesis*), it is as formal and abstract as the surrounding pattern. Figures are silhouetted, torsoes frontal, heads and legs in profile. Stick arms are uniformly raised to the head in a schematized gesture of mourning.

Geometric figures are represented in terms of what is known, not of what is seen. A triangle stands for a torso, a dotted circle a head with an eye in it, and so forth. These devices form readily recognizable signs for the visual world: they are patterns, like the earlier nonfigural devices that were already known and accepted for use in the decoration of a vase. There crossed circles side by side beneath a crosshatched box stand for a two-wheeled wicker chariot; a single-bodied, two-tailed, eight-legged, and two-headed form next to it represents a team

1. E.g., a Minoan statuette of a praying woman with solid torso and hollow skirt, from the sixteenth century B.C., H 0.184 m.: Berlin, Antikenmuseum inv. no. misc. 8092. See U. Gehrig, "Betende Priesterin," in *Antikenmuseum: Staatliche Museen Preussischer Kulturbesitz* (Stuttgart, 1980), p. 18.

2. See S. Hood, *The Arts in Prehistoric Greece* (New York, 1978), pp. 112–14.

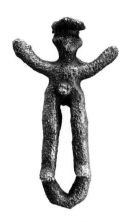

3.1 Bronze statuette, Geometric period. H 0.065 m. Olympia B 4245. Courtesy of Deutsches Archäologisches Institut, Athens, neg. no. OL 4599.

of horses; and an apple core with stick arms and legs is an armed charioteer.

In the eighth century the figure came to be seen as more than pattern; it emerged from its surroundings and assumed greater importance than its setting. Artists introduced more complicated subjects than the *prothesis*, scenes whose symbolism is not readily apparent. And so today one wonders whether a particular battle is represented, or simply a universal scene of combat.

The earliest freestanding figurines of the Greek period are made of baked clay, like their Mycenaean predecessors. They resemble the painted stick figures on Geometric vases, and we can easily see how the clay was rolled, pinched, and gouged into simple forms. Some of the earliest cast bronze statuettes, found at Olympia, look no different.[3] They are very rough, with few particulars beyond the head, the limbs, and the genitals. A characteristic example with raised arms, beaklike face, and heavy ears (fig. 3.1) was cut, rolled, and pinched into shape. It is almost as two-dimensional as if it were painted, and we might get the impression that the wax model was worked on a flat surface and never picked up and assessed from the side. The dished hat or helmet almost looks like a mistake that should have been removed, and the feet are still joined by casting gates. The presence of the gates, however, is not due to carelessness; surely they were intended to be used to attach the figure to the base.

The usual convention for gender differentiation is simply that men have two legs and women wear long skirts. Occasionally women are nude, in which case they tend to have breasts and no genitals.[4] There are few women, however. We usually see men, often armed, and such animals as deer, horses, and oxen. Great numbers of these freestanding statuettes were produced to serve as dedications in sanctuaries, and most of them were no doubt made in nearby workshops.

The human figure, both painted and sculpted, emerged from a small-scale tradition. Geometric bronzes that show many details are delicate figurines with the same linear conventions and simple silhouettes as their counterparts in vase painting. Another statuette from Olympia (fig. 3.2) makes a good comparison with the very simple one seen in figure 3.1, for here the

3. See W.-D. Heilmeyer, *Frühe Olympische Bronzefiguren,* OF 12 (Berlin, 1979).
4. See, e.g., Delphi Museum inv. 7730: H 0.165 m.; eighth century B.C. Probably a decoration for a tripod: Rolley, *Monumenta,* no. 4, p. 1 and pl. 2.

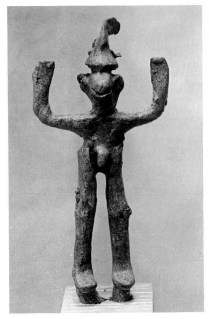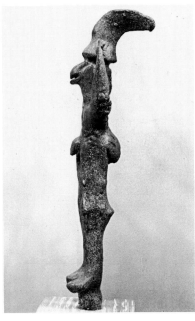

3.2 Bronze statuette, Geometric period. H 0.1 m. Athens, National Archaeological Museum 6249. Courtesy of Deutsches Archäologisches Institut, Athens, neg. nos. NM 5025, 5026.

a *b*

modeler took great pains to define the features. The knees are small angular protrusions from the legs. The arms are raised, the elbows are bent at right angles, and the ends of the two rolls of wax have been flattened to show the hands and bent over at the tips like fingers. The face was squeezed into shape, then the ears were pinched out, and a mouth was cut with a sharp tool, probably a knife. An effort was made to approximate a crested helmet on top of the head. The gates are again preserved, and they have been sunk into the modern base much as was surely the original intent for mounting the figurine.

A number of Geometric statuettes are notable for their exploration of three-dimensional space. They include statuettes of charioteers still standing in their chariots but missing their teams of horses. Typically the charioteer stands frontally, arms extended and surrounded by the box of his chariot. An example from Olympia (fig. 3.3) is exceptional for its extremely detailed workmanship.[5] A network of rolled strips represents the body of an openwork chariot. Inside, the driver leans forward, his legs bent, his arms resting on the bar in front of him, his hands curled to grasp the reins. He is broad-shouldered, with a neck nearly as long as his torso, and curiously flatheaded. Nonethe-

5. See W.-D. Heilmeyer, "Fragment eines Votivbilds: Wagenlenker im Wagenkasten," in *Antikenmuseum*, no. 3, p. 20.

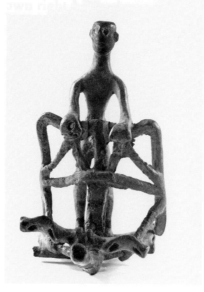
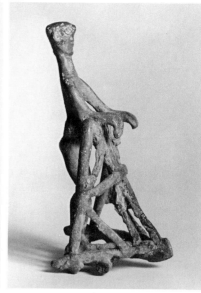

a *b*

3.3 Bronze statuette of charioteer, third quarter of eighth century B.C. H 0.095 m. Berlin, Ol. 9215. Courtesy of Antikenmuseum, Staatliche Museen Preussischer Kulturbesitz, Berlin. Photos by Ingrid Geske-Heiden.

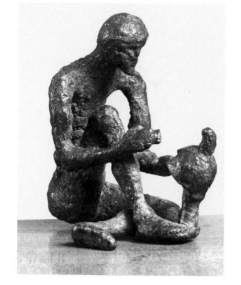

3.4 Bronze statuette of helmet maker, late eighth to early seventh centuries B.C. H 0.052 m. New York, acc. no. 42.11.42. Courtesy of Metropolitan Museum of Art, Fletcher Fund, 1942.

less, the artist, undeterred by working a complex figure in miniature, picked out the line of the jaw, the ears, and the eyes, nose, and mouth.

The combatant and the artisan are other subjects of interest to the Geometric bronzeworker. In figure 3.4 a helmet maker of the late eighth or early seventh century B.C. sits on the ground, the left leg bent under the raised right knee, the right foot and left knee supporting the anvil. A helmet rests on the anvil and the artisan bends over it intently, mallet in hand (only part of the shaft is preserved). The handling of the space in front of this little figure, filled by the knee and anvil and enclosed by the arms, represents an attempt to utilize three-dimensional space.[6]

All of the earliest bronze figures cast in Greece were made by the lost-wax process. It is easy to see how the wax models for the statuettes were worked by hand or with tools before being covered with a clay mold and cast.[7] We have seen evidence that

6. See G. M. A. Richter, "Five Bronzes Recently Acquired by the Metropolitan Museum," *AJA* 48 (1944): 1, figs. 1–4; J. R. Mertens, "Greek Bronzes in the Metropolitan Museum of Art," *Metropolitan Museum of Art Bulletin* 43 (1985): 19.

7. For techniques used, see R. Raven-Hart, "The Casting-Technique of Certain Greek Bronzes," *JHS* 78 (1958): 87–91; and, more recently, Heilmeyer, *Frühe Olympische Bronzefiguren*, pp. 29–53.

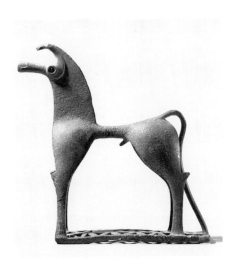

3.5 Bronze statuette of horse, third quarter of eighth century B.C. H 0.16 m. Berlin inv. no. 31317. Courtesy of Antikenmuseum, Staatliche Museen Preussischer Kulturbesitz, Berlin. Photo by Jutta Tietz-Glagow.

the gate system was modeled at the same time, and that the gates could be used as tangs to erect the figurines after casting. This practice continued in later periods. Or the entire base of the figurine might be cast with it, as in the case of a Geometric horse in Berlin (fig. 3.5). The horse's form was partly modeled and smoothed by hand, though its precise angular outline and the flat inner surfaces of the legs bespeak the use of a tool. So do the sharp knees and hocks and the openwork pattern of triangles cut through the base. The tiny but deep circular indentations for the nose and eyes could have been accomplished only with a punch. Both nostrils and eyes were then inlaid with iron.[8]

Among the imports to Greece during the Orientalizing period of the eighth and seventh centuries were new types of bronzes and new techniques by which to make them. As objects were brought from the east, so artists traveled back and forth, learning new styles and techniques.

Eastern innovations are particularly noticeable among the finds from the cosmopolitan sanctuaries of Samos, Argos, Delphi, and Olympia. The Geometric tripod cauldron was replaced by a round cauldron that rested on a conical stand or on a rod tripod.[9] The flattened shoulder of such a vessel was adorned with elaborate attachments for ring handles, often in the form of sirens, and with protomes, frequently the long-necked griffin. Bronzes from the Near East contained a significant amount of tin; Greek bronze apparently did not until the middle of the eighth century B.C., when those Greek artists who were imitating Near Eastern objects and motifs also began to follow the lead of Near Eastern bronzeworkers in developing more sophisticated alloys.[10]

The griffin's head is a common decorative attachment or protome for bronze cauldrons. Typically this exotic Eastern creature has a scaly head and neck, tall narrow pricked ears, a topknot, and a wide-open, sharply curved beak with a raised tongue within (fig. 3.6). Spiral curls fall on either side of a long

8. W.-D. Heilmeyer, "Grosses Votivbild: Hengst auf durchbrochener Standplatte," in *Antikenmuseum*, no. 4, p. 22.

9. For the cast legs and ring handles of Geometric tripod cauldrons, see M. Maass, *Die geometrischen Dreifüsse von Olympia*, OF 10 (Berlin, 1978). For Orientalizing cauldrons, see H. V. Herrmann, *Die Kessel der orientalisierenden Zeit*, OF 6 (Berlin, 1966): *Kesselattaschen und Reliefuntersätze*; and OF 11 (Berlin, 1979): *Kesselprotomen und Stabdreifüsse*.

10. For this theory, developed through analyses of bronzes at Delphi and Olympia, see C. Rolley, "Bronzes grecs et orientaux: Influences et apprentissages," *BCH* 107 (1983): 111–32.

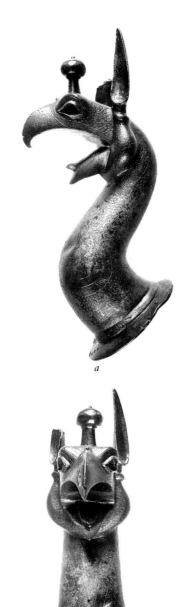

a

b

3.6 Bronze griffin cauldron attachment, late seventh century B.C. H 0.36 m. Olympia B 945. Courtesy of Deutsches Archäologisches Institut, Athens, neg. nos. OL 1312, 1313.

S-curved neck. Stylized wrinkles adorn the lids of wide elegant eyes, left hollow for inlays.

Most of the griffin protomes are small, under 30 centimeters in height. The earliest ones are made of hammered and engraved sheet bronze. Later griffin heads were cast and attached to hammered necks, and finally head and neck were both cast.[11]

Several miscast griffins have been excavated at the Heraion on the island of Samos. All were cast in piece molds that were not sealed tightly enough, with the result that the molten bronze seeped out along the cracks. The profile of one discarded head in Samos, on which at least three piece molds were used, is surrounded unevenly by a wide bronze flange, the result of a poorly joined mold (fig. 3.7).[12] Denys Haynes has demonstrated that as early as the second quarter of the seventh century B.C., a group of Samian hollow griffin protomes were cast in piece molds by the indirect lost-wax process. The artist first made a model, omitting such details as the topknot and ears. Then he took a piece mold from the model and lined it with wax, forming hollow wax models, which he subsequently filled with core material. After removing the mold, he worked over each wax model, added the topknot, ears, and so forth, and finally he invested and cast the griffin.[13] By reusing the mold taken from the original model for subsequent wax models and adding different details to each one, he could have produced a variety of heads for his group, in effect combining the indirect and direct casting methods. The protomes would have been similar in scale and general contours, but not exactly alike.

A colossal griffin protome in New York (fig. 3.8), the work of a highly skilled artist, is another example of the early use of the indirect lost-wax process.[14] The dominant feature of the

11. Jantzen, pp. 53–83.

12. See G. Kopcke, "Heraion von Samos: Die Kampagnen 1961/1965 im Süd-temenos," *AM* 83 (1968): 285, pls. 113.4–5. B 642 in the Vathy Museum (H 0.148 m.) is a failed casting from a four-piece mold; see Jantzen, no. 47, pp. 16, 57–60. See also B 643, ibid., p. 16. For a recent discussion of griffins made in two- and three-piece molds, see U. Gehrig, "Frühe griechische Bronzegusstechniken," *AA* 94 (1979): 552–54.

13. D. E. L. Haynes, "The Technique of the Erbach Griffin-Protomai," *JHS* 101 (1981): 136–38. There is also evidence for the production of three seventh century terra-cotta lions' heads from Crete in a single mold, suggesting that duplication was not unknown. See R. Hampe, *Kretische Löwenschale des siebten Jahrhunderts v. Chr.* (Heidelberg, 1969), pp. 16–17.

14. See Mertens, "Greek Bronzes," no. 9, p. 21; Herrmann, *Kessel der orientalisierenden Zeit*, G106, p. 50. For two very similar griffins, see ibid., G104, pp. 49–50, and G105, p. 50. I am grateful to Joan R. Mertens for allowing me to look at the Metropolitan griffin in 1987 and for sharing with me her extremely helpful ideas about the head.

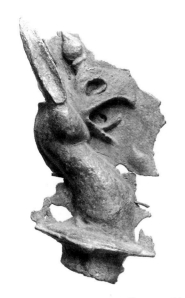

3.7 Miscast bronze griffin cauldron attachment, seventh century B.C. H 0.167 m. Samos, Vathy Museum B 1284. Courtesy of Deutsches Archäologisches Institut, Athens, neg. no. Samos 7262.

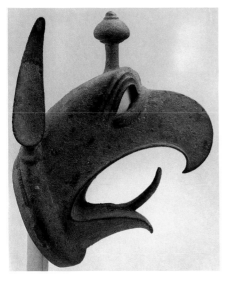

3.8 Head of griffin, seventh century B.C. H 0.258 m. New York, Metropolitan Museum 1972.118.54. Courtesy of Metropolitan Museum of Art, bequest of Walter C. Baker, 1971.

head is the beak, wide open, its downward-curving tips forming a sharp counterpoint to the long upward-darting tongue. A puffy roll of flesh crosses over the beak and droops below the lower rims of wide drooping eyes, whose sharply arched upper rims are emphasized by triple-layered lids.

It is fair to assume that one artist prepared all of the protomes for a single cauldron. To make them of the correct size and shape, he is likely to have begun with a rough model made to the proper scale and proportion. Then he would have molded it and made as many wax models from the molds as he needed protomes for the cauldron. He would then have worked the models in detail before investing and casting.

A careful study of the Metropolitan griffin reveals much about the way the artist prepared his protome for casting. The thinness and regularity of the wax model are picked up in the bronze, which ranges from about 0.001 to 0.004 meter in thickness, with a fairly smooth interior marked by a few rough projections and by a drip mark on the right side of the head. The inside of the lower half of the beak is lumpy, with a small bridge crossing from one side to the other. It is not clear whether this was an addition intended to strengthen the wax, because the bronze here is almost entirely altered by heavy corrosion. Certainly the artist felt a need to strengthen the angular meeting of the upper and lower halves of the beak, and he added a few blobs of wax inside to thicken this edge.

When the wax model was ready to be finished on the outside, the artist stabilized the piece by pouring a clay core. The delicacy and precision of the head indicate that much work was then done on the wax. The smooth concave ears, the ringed topknot, and the curling tongue were added in solid wax. The artist cut the eyes through the wax from the outside, leaving ragged internal edges, and tooled the fine ridges around the beak and eyes. The griffin's scales were impressed in the wax, most of them punched with a semicircular object, but a few in odd corners were drawn in the wax by hand.

The next step was to secure the core within the wax for investment and casting. The open eye cavities made this an easy procedure. During investment, the artist would simply have made sure that the clay of the mold intruded through the eyes and joined the core within the head.[15] The invested wax model was baked, and then the bronze was cast.

15. It is possible that chaplets were also used, but they would surely not have been necessary. Inside, two protrusions may be chaplets, one below the left ear, the other below the left eye.

The major task after casting was to affix the heavy cast head to a neck and to the cauldron, both no doubt of hammered bronze. A finished edge around the back of the head is flattened for attachment. In front of it, a widening bulge ringing the head from the ears downward may have been useful for joining the head to the neck, perhaps with a pliable core of some kind. The bulge is ornamented by a hammered strip only 0.004 meter wide and decorated with a tiny bead-and-reel motif. This strip is nailed over the back of the head behind the ears, at a point that corresponds with the long spiral locks seen on some smaller griffin protomes. An unnecessarily large number of tiny nails was used, and eight are still *in situ*, their oval heads cleverly concealed by placement on the beads of the bead-and-reel strip. These nails may have helped to secure the head to the neck, the bead-and-reel strip being added to conceal them. The cauldron was surely a very large one, and although its size is difficult to reconstruct with any accuracy, it may be useful to recall a cauldron mentioned by Herodotos (4.152). Produced in the late seventh century and dedicated in the Heraion on Samos, it was supported by three bronze kneeling figures that were seven cubits high (ten to twelve feet), and it cost six talents to produce.

Variations on the lost-wax process were evidently brought to Greece along with the idea of the griffin. Once the type of the griffin was known, as well as the technique for casting it, these protomes were made at the Greek sanctuaries where they were subsequently affixed to their cauldrons and dedicated. But protomes did not set an immediate precedent for the production of large castings. During the seventh century there was little demand for truly large-scale bronzes; they did not become popular until the sixth century, and then the initial demand was for works in stone.

Two small bronze human heads may fit into the same category as the griffin protomes, in that they once served as attachments of one form or another. Both are female heads, considered to date from the seventh century B.C.; both are hollow cast and were originally intended to have inset eyes. One of them (fig. 3.9), from the bed of the Alpheios River in Olympia and Daidalic in style, is now in Karlsruhe. It is simple and unadorned, with the exception of a narrow polos bordered with pairs of horizontal lines that were cut into the wax model.[16] The

16. F. Studniczka provides the weight (403 grams) and thickness (0.003 m.) of the head: "Ein frühgriechischer Bronzekopf in Karlsruhe," *Antike Plastik* (Berlin, 1928), pp. 245–53. See also F. Eckstein, ed., *Dädalische Kunst* (Hamburg, 1970), pp. 52–54; Boardman, *GSAP*, p. 14, fig. 37.

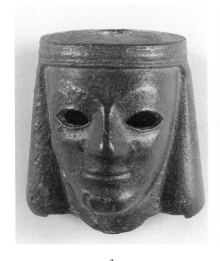

3.9 Bronze female head, seventh century B.C. H 0.085 m. Karlsruhe F 1890. Courtesy of Badisches Landesmuseum, Karlsruhe.

a

b

hair falls in bulbous triangles at the sides of a triangular face and lies flat in back; fine engraved wavy lines mark individual strands. A plain triangular nose, projecting strongly, contrasts with the brows, cheekbones, and lips, which are marked only by gentle swellings. A flat polos truncates the top of the head, just as the hair flattens the back of the head. A clean finished edge at the base of the neck suggests that the head was once attached to a body, made perhaps of a different material, as was done with the heads and necks of early griffin protomes.[17] A round hole in the center of the polos suggests that this head could have belonged to one of the supports for a large bowl or perirrhanterion (water basin). The total height of the figure might have been as much as half a meter.

The other head (fig. 3.10), said to be from Cyprus, is much larger than the Karlsruhe head and is usually dated later in the seventh century.[18] Plastic features, including globular tresses and spiral curls, were worked by hand on the model, and then detailed with stippling. The incised details of the polos and of the moldings on which the head is set were also cut in the wax but no doubt were touched up on the bronze. The delicately feathered eyebrows are engraved, perhaps directly in the bronze. The ears are applied to the hair, as is the case with some early stone korai, but are not so large as we often see them in stone. The angular precision of carving is lacking, and here

17. Bol, *Bronzetechnik*, p. 98.
18. See A. de Ridder, *Bronzes antiques du Louvre*, vol. 1 (Paris, 1913), no. 1, pl. 3; Studniczka, "Frühgriechischer Bronzekopf," pp. 246–48.

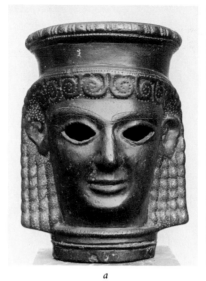
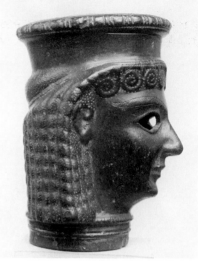

<div style="text-align:center">a b</div>

3.10 Bronze female head, seventh century B.C. H 0.111 m. Paris, Louvre. Courtesy of Musées Nationaux, Paris.

again we get the impression that the artist worked over most of the details of the head in the soft medium of wax. The top of the polos is flat. Holes along the lower unbroken molding suggest that the head was riveted to a hammered bronze body, just as was done with the early cast griffin heads.[19] Here again, the head may have been part of a support for a vessel, but the use of a molding in place of a neck may well have precluded the addition of a body beneath.

An entire figure that probably served as a support was found in Olympia: a small standing woman wearing a belted chiton. She lifts the skirt into a fold with her right hand while with her left hand she clutches her breast. The tiny cylindrical body supports a large round head with inset eyes, straight hair cropped above the shoulders, a fillet, and a large wide ring-shaped support or bolster on the top of the head. A vertical iron rod within the solid-cast figure was surely intended to strengthen the piece.[20]

Large cast bronzes appeared late in Greece, but there was already a large-scale tradition in bronze, and this fact may have contributed to the relatively late development of hollow casting

19. Jantzen, p. 68.

20. Athens, National Museum 6149; H 0.225 m. First half of the sixth century B.C.: Rolley, *Monumenta*, no. 66, p. 7. Early Ionic, perhaps Samian: Furtwängler, *Bronzen*, no. 74, p. 24. Another bronze figure of a woman which may have served as such a support is in the Walters Art Gallery: no. 54.773, H 0.18 m. See Hill, *WAG*, no. 237, pp. 105–6, pl. 47; and Richter, *Korai*, no. 14, p. 31 and figs. 60–62.

for statuary. The early technique known as *sphyrēlaton*, a process of hammering sheet metal, had been used in Egypt during the third millennium B.C. and perhaps was imported to Greece from there.[21]

When Pausanias was in Thebes, he saw a log that he was told had been covered with bronze after it had fallen from heaven along with a thunderbolt into the bridal chamber of Semele. This log was called Dionysos Kadmos. At Amyklai, Pausanias saw an outdoor cult figure of Apollo which he guessed to be as much as thirty cubits (about 45 feet) in height. He said that it was old and made without much skill. "Although it has face, feet, and hands, the rest of it resembles a bronze column. On its head it has a helmet, in its hands a spear and a bow." Elsewhere Pausanias tells of gold sent by King Kroisos of Lydia, intended for Apollo Pythios but used instead to adorn this Apollo.[22]

Pausanias gives his most complete account of a sphyrelaton statue in his description of the figure of Zeus Hypatos (the Highest) in Sparta. "It is not made in one piece. Each part of the statue is hammered separately; then the parts are fitted together with nails to hold them so that they do not come apart. They say that this statue was made by Klearchos of Rhegion, either a pupil of Dipoinos and Skyllis or of Daidalos himself."[23] Pausanias also says that the Zeus Hypatos is the oldest of all bronze statues. However, Klearchos, who is said to have been the teacher of Pythagoras of Rhegion,[24] probably worked in the second half of the sixth century B.C., and, as we shall see, bronze statues were being made in Olympia and in Athens before that time.

Although the sphyrelaton technique directly preceded casting for the production of large bronzes, it was, in a sense, its antithesis. In this process, unheated sheets of metal were hammered

21. Two hammered copper standing statues, the larger one of Pepy I, who reigned during the sixth dynasty (ca. 2400–2250 B.C.), were found at Hierakonpolis and are now in the Egyptian Museum, Cairo (nos. J 33034 and 33035, H 1.78 m. and 0.60 m). See C. Aldred, *Egyptian Art* (New York, 1980), p. 94 and fig. 52. Pepy's hands, face, and feet are said to be cast solid, but the rest of the figure is made of hammered sheets of copper riveted to a wooden core. A. Lucas, *Ancient Egyptian Materials and Industries*, 4th ed. (London, 1962), p. 214, identifies the metal as 98.2% copper, with no tin. See also J. Muhly, *Copper and Tin: The Distribution of Mineral Resources and the Nature of the Metals Trade in the Bronze Age*, Transactions of the Connecticut Academy of Arts and Sciences, vol. 43 (New Haven, 1973), p. 219.
22. Pausanias 9.12.4, 3.19.2–3, 3.10.8.
23. Pausanias 3.17.6.
24. Pausanias 6.4.4.

over a core, whereas in casting, molten metal was poured into a predetermined space between the core and the mold.[25]

There are few extant Greek sphyrelata. The best-known and the earliest surviving examples are three large statuettes that immediately call to mind Pausanias's descriptions of early statues. The one male and two female figures were found in 1935 on the altar of an eighth-century B.C. temple of Apollo at Dreros in Crete.[26] All three figures stand in strictly frontal poses. The right leg of the man (fig. 3.11) is very slightly advanced and the arms are raised. The head is large and the hollow eyes were originally inset. A smooth cap covers the triangular mass of hair, defined with repoussé, which falls symmetrically to the upper back. The backbone is subtly indented. In front, the triangular torso has repoussé collarbone, nipples, and thoracic arch. The thighs are long and tubular, the shins angular, and the calves bulging. The feet, the lower arms, and the hands are missing. The fairly small sheets of metal are joined with bronze nails at the base of the cap, around the ears (missing), and at the jaw, neck, shoulders, both sides of the back, the waist, thighs, knees, and calves.

The two female figures (fig. 3.12), more fully preserved, are remarkably similar to each other. They are rigid and columnar, arms and opened hands adhering to their sides. They wear the flat-topped polos, belted peplos, and epiblema. Again the hollow eyes were once inset, and the repoussé hair, short and straight with bangs, obviates the need for ears. Guilloches and dotted borders running down the front of the peplos, above the hem, and along the edges of the polos are the only other adorn-

25. For sphyrelaton cult statues, see I. B. Romano, "Early Greek Cult Images" (Ph.D. dissertation, University of Pennsylvania, 1980). For an Etruscan sphyrelaton figure, see British Museum Bronze 434, a complete female bust of the late seventh century, H 0.34 m., from the Polledrara Tomb at Vulci. The figure consists of eight sheets of bronze nailed together and two cast pieces—the right hand and a hollow bird that the figure holds. See S. Haynes, "Zwei Archaisch-Etruskische Bildwerke aus dem 'Isis-Grab' von Vulci," *Antike Plastik* 4 (1965): 20–25. Her n. 58a provides analyses of the right hand (Cu 92.0%, Sn 5.3%, Pb 2.5%) and of the bird (Cu 93.2%, Sn 5.3%, Pb 1.2%). More recently, see S. Haynes, *Etruscan Bronzes* (London, 1985), no. 21, pp. 252–53; and M. Cristofani, *I bronzi degli Etruschi* (Novara, 1985), no. 111, pp. 289–90 and color plates p. 217.

26. See P. Lemerle, "Chronique des fouilles," *BCH* 60 (1936): 485; G. M. A. Richter, *Archaic Greek Art* (New York, 1949), pl. 33 (mid-seventh century); Romano, "Early Greek Cult Images," pp. 284–93 (eighth century); J. Boardman, "The Khaniale Tekke Tombs II," *BSA* 62 (1967): 57–61; Boardman, *GSAP*, p. 11 (second half of eighth century). For a discussion of how the figures were pieced together, see P. Cellini, Appendix 2 in J. Papadopoulos, *Xoana e Sphyrelata: Testimonianza delle fonti scritte*, Studia Archaeologica 24 (Rome, 1980), pp. 99–100.

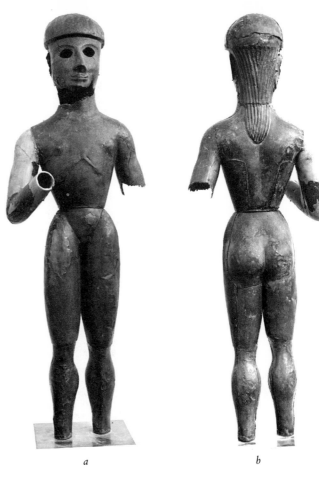

3.11 Hammered bronze male from Dreros, eighth century B.C. Pres. H 0.8 m. Heraklion no. 2445. Courtesy of Alison Frantz.

a

b

3.12 Hammered bronze female from Dreros, eighth century B.C. H ca. 0.4 m. Heraklion no. 2446. Courtesy of Alison Frantz.

a

b

ments. Despite their relative simplicity, the three Dreros figures are generally believed to be cult images.[27]

Among the few other sphyrelata that have been preserved is a figurine of Artemis from Brauron, preserved from head to lower skirt and dating perhaps to the seventh century, as does a female head from Olympia with repoussé ears and a polos decorated with repoussé rosettes.[28] The eyes, eyebrows, and earrings of the Olympia head were inset. A large one-winged goddess, also from Olympia, is just under lifesize.[29] The head, inset eyes, wing, and torso are preserved, and the figure probably dates to the middle of the sixth century B.C.

One other remarkable example of a hammered metal figure is a silver bull from Delphi.[30] The bull was discovered with pieces of chryselephantine statues during the 1939 excavations in the Sacred Way at Delphi. All of the pieces have been dated to the middle of the sixth century B.C.

In Egypt, styles for representing the human form were developed, as formulas, during the third millennium, and thereafter changed relatively little. In fact, Plato made the expansive statement in the fourth century B.C. that the *kala schēmata* of Egyptian art had not changed for 10,000 years.[31] Techniques were learned early too, and the lost-wax process was in use from the third millennium onward. Greeks had been living in Egypt since the middle of the seventh century, when the colony of Naukratis was founded. At that time, Egyptian practices for casting hollow figures in pieces, inlaying them, and insetting the eyes had already withstood the test of time. A particularly fine large example of approximately 700 B.C. is a statuette of the lady Takushit from Bubastis. The body, skirt, and arms are inlaid in silver with "processions of gods and sacred emblems."[32] The eyes, too, were once inlaid. Before patination the statue must have presented a glittering, colorful effect. The simple striding figure, left foot forward, could just as well have

27. For a sense of the decorative detail that might be added to a hammered bronze figure, see E. Kunze, *Archaische Schildbänder*, OF 2 (Berlin, 1950).

28. Brauron Museum no. B.E. 119, H ca. 0.30 m.; Olympia Museum, less than lifesize (see A. Mallwitz, *Olympia und seine Bauten* [Munich, 1972], p. 57 and fig. 59).

29. Olympia Museum B 6500, H 0.535 m. See Rolley, *BG*, figs. 6, 99, 253; and Bol, *Bronzetechnik*, p. 101, fig. 63.

30. Delphi Museum, H 1.46 m. See P. Amandry, "Statue du taureau en argent," *BCH*, suppl. 9 (1977), pp. 273–93.

31. *Laws* 656D–E.

32. Athens, National Museum, unnumbered(?), H ca. 0.69 m.; 22d–25th dynasties. See W. Stevenson Smith, *The Art and Architecture of Ancient Egypt* (Baltimore, 1958), p. 391, fig. 385.

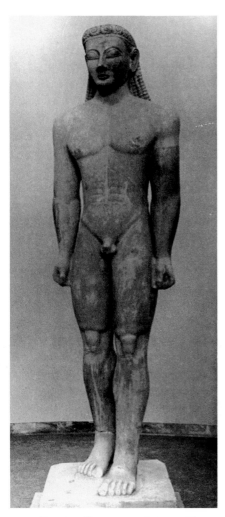

3.13 Sounion Kouros, ca. 600 B.C. H 3.05 m. Athens, National Archaeological Museum no. 2720. Courtesy of Alison Frantz.

been carved in stone, for it in no way takes advantage of the flexibility and light weight of bronze.

The images that the Greeks saw in Egypt influenced their own early large-scale works. Pausanias cites two early *xoana* (wooden statues) that looked Egyptian: the Pythian Apollo at Megara and the first statue of Apollo Lykios at Argos. He also thinks that the image of Herakles at Erythrai looks decidedly Egyptian.[33] And Diodoros of Sicily states from his vantage point in the first century B.C. that "the form of ancient statues in Egypt is like that of statues made by Daidalos among the Greeks."[34] Of course, all "ancient" Egyptian statues, whatever their dates, could be seen by an unschooled eye to resemble one another closely. Furthermore, the sculptural style of works attributed to Daidalos, the legendary Greek artist to whom important early works and discoveries were often attributed, was probably understood as manifested in the kouros type.[35]

Nude and posed frontally, a kouros has one leg extended in front of the other, but both feet are flat on the ground, and hips and shoulders do not shift. The hands of a kouros are sometimes clenched against the thighs, sometimes extended forward from the elbow. The Sounion Kouros (fig. 3.13) is typical.[36] A large blocklike head is adorned with elaborate linear detail, including curls in high relief, volute-like ears, and huge, prominently outlined eyes. The head is fixed on a cylindrical neck above a massive, stiffly frontal body. The sharp anatomical details that decorate the body are also bound by the guiding principle of surface design.

Each side of a stone kouros was carved separately, with little attention given to the problem of creating a three-dimensional form from a four-sided block of marble. The Greek figural style was certainly derived from the Egyptian style, but the differences are plain. The kouros wears no skirt, and the physical features are at first rendered with less interest in anatomical correctness than in surface designs. The kouros is truly freestanding, whereas an Egyptian stone sculpture appears to emerge from the squared block, its limbs still connected to it by stone screens.[37]

An echo of these innovations is preserved in Diodoros, who

33. Pausanias 1.42.5, 2.19.3, 7.5.5.
34. Diodoros 1.97.6.
35. Daidalos is also credited with, e.g., the discovery of carpentry: *NH* 7.198.
36. See Richter, *Kouroi*, no. 2, pp. 42–44.
37. See Boardman, *GSAP,* pp. 18–21.

describes the lifelike statues of Daidalos: "He was the first to give open eyes to statues, to make them standing with the legs apart, and to make the arms stretched out, for which men naturally admired him: artists before Daidalos had produced statues with closed eyes, with the arms hanging down and cleaving to their sides."[38] Pausanias observes that all of the works of Daidalos are "rather odd . . . but inspired."[39] This statement may be arguable, but, as we have seen, the earliest preserved Greek statues can certainly be said to possess the characteristics that Diodoros attributes to Daidalos. Whether or not the kouros as a type can be attributed to the skill and innovative ability of one individual is a question that cannot be answered.

Daidalos is associated with both Athens and Crete.[40] Early kouroi, large and small, mostly stone but some in other materials, have been found on many of the Aegean islands, as well as on the mainland of Greece, particularly in Attika, and at Naukratis in Egypt.[41] In general, these works all fit the description of Diodoros and attest to the expansion of the Greek trade contacts that had begun during the seventh century.

It is Diodoros again who suggests to us where the Greeks learned to cast bronze statues. "Of the ancient sculptors, the most renowned—Telekles and Theodoros, the sons of Rhoikos—visited with [the Egyptians]."[42] These artists are known from several sources, and there is general agreement that they came from the island of Samos, where they were learning how to produce large cast bronzes. Diodoros adds that they made a xoanon of Pythian Apollo using the Egyptian system of proportions, and explains that the Egyptian system did not correspond with visual appearances but was based on a fixed formula.[43] Diodoros then characterizes an Egyptian statue in a few words as a striding figure with its arms fixed rigidly at its sides.

38. Diodoros 4.76.3.
39. Pausanias 2.4.5.
40. Athens: Pausanias 9.3.2, Diodoros 4.76.1ff; Crete: *Iliad* 18.590–93, Diodoros 4.77.4.
41. For kouroi from Naukratis, see Richter, *Kouroi*, nos. 28–30, pp. 57–58. All three are statuettes and are made of alabaster, sandstone, and limestone, respectively—relatively soft materials that are easily workable on a small scale.
42. Diodoros 1.98. Diodoros does not share the opinion of Pausanias (8.14.8, 10.38.6) that Rhoikos was the son of Philaios and Theodoros the son of Telekles.
43. For a discussion of this problem, see B. S. Ridgway, "Greek Kouroi and Egyptian Methods," *AJA* 70 (1966): 68–70; and, earlier, R. Anthes, "Affinity and Difference between Egyptian and Greek Sculpture and Thought in the 7th and 6th Centuries B.C.," *Proceedings of the American Philosophical Society* 107 (1963): 60–67. The interest of Theodoros in proportions is seen not only here but also in his self-portrait with quadriga, desribed below.

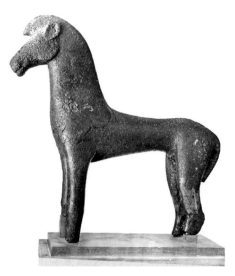

3.14 Bronze horse, seventh century B.C. H 0.455 m., L 0.47 m. Olympia B 1741. Courtesy of Deutsches Archäologisches Institut, Athens, neg. no. 71/496.

After all, Diodoros lived at a time when sculpture in the Greek world had undergone radical changes in the direction of naturalism.

We might wonder why these Samian artists needed to learn a new process. In Greece, protomes and statuettes were being cast hollow by the direct and indirect lost-wax processes during the seventh century, but they were all relatively small in scale. The larger the piece to be cast in one piece, the more uncertain it was that the molten bronze would flow from the gate system into the farthest part of the mold cavity. And the more bronze used, the greater the shrinkage during cooling. Pausanias reports the existence of one solid bronze statue, a figure of Dionysos that stood at Thebes, near the earlier Dionysos Kadmos, and he ascribes this statue to a man named Onasimedes.[44] No further clues are provided as to the floruit of the artist or the size of the bronze. The cost and risks of producing solid-cast statues were probably seen as insurmountable difficulties.

Bronze weighs approximately ten times more than wax, and it is both difficult and dangerous to cast in large quantities; thus it is not surprising that large solid-cast Greek bronzes were fairly uncommon. Two large pieces will serve to illustrate the technical difficulties. A stallion in Olympia (fig. 3.14), dating to the seventh century, is preserved to the remarkable height of 0.455 meter, even though all four legs below the knees and hocks are now missing.[45] The horse's head and neck were cast separately in one piece and then cast onto the body along the slope of the shoulder. The two pieces were joined metallurgically by a process known today as casting on or fusion welding; that is, a mold was built around the place where the two pieces were to be joined, and molten bronze of the same consistency as the pieces of the statuette was poured into the mold.[46] But the bronze that was used for the join is less porous than the bronze

44. Pausanias 9.12.4.

45. The original height was over half a meter. See Heilmeyer, *Frühe Olympische Bronzefiguren*, no. 823, pp. 167–70; C. Rolley, "Bronzes grecs et orientaux," p. 119n22; and Bol, *Bronzetechnik*, p. 28. For smaller horses from Olympia, of late eighth and seventh century date, see J. Schilbach, "Eine Gruppe grosser protoarchaischer Pferdestatuetten aus Olympia," *AM* 99 (1984): 5–15, pls. 1–4.

46. A small hollow-cast Geometric bird (H 0.145 m.), in the Norbert Schimmel Collection, New York, was repaired metallurgically. For a description of the process, see H. Lechtman and A. Steinberg, "Bronze Joining: A Study in Ancient Technology," in *Art and Technology*, pp. 14–22; and *Master Bronzes*, no. 25, pp. 41–42. A lengthy treatment of the subject of casting on can be found in H. Drescher, *Der Überfangguss* (Mainz, 1958).

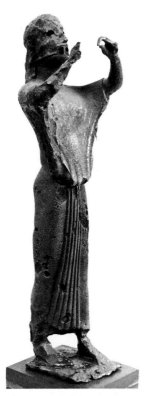

3.15 Bronze statuette of flutist, third quarter of sixth century B.C. H 0.42 m. Athens, National Archaeological Museum 16513. Courtesy of National Archaeological Museum.

used for the rest of the horse, and the irregular overlap of the join is clearly visible.

The wax original for the horse was probably modeled mostly by hand, with a tool used to mark the mouth, to define the jaw and ears, and no doubt also to model in areas that were too small for the artist's hands to reach easily. The horse has a small head with a large ear and a roached mane, which is differentiated from the strong vertical neck only at the forelock. The body is long and slender, but the legs are heavy and cursorily modeled. The right flank, hindquarters, and thigh are deeply pocked, the result of air pockets in the molten bronze. The air pockets may have occurred because of the unusually large amount of bronze that the artist had to melt at one time to produce a work of this size.

A statuette of a long-haired flutist from the Heraion of Samos (fig. 3.15) is, like the Olympia horse, unusually large for a solid bronze.[47] It can be dated to the third quarter of the sixth century B.C. The flutist, wearing a long, belted chiton with a large overfold in front emphasized by six heavy pleats between the legs, stands with his left leg advanced. The shoulders are thrust back and the hands are raised to hold the double flute that once was attached to the head. The separately made flute, now lost, was fixed in two holes at the mouth. Narrow ridges across both cheeks represent straps holding the flute in place.

The flutist was cast together with a rectangular base, which may have served as the funnel to admit the molten bronze to the mold. The relatively large quantity of bronze that had to be poured may have released gases that were not adequately vented out of the mold. The gases remained as bubbles, which were reproduced in the badly pitted surface of the statuette. Larger bubbles of this kind could have caused the clay mold to explode. Further, the right arm and hand may well have been left incomplete as they are today because bronze began to solidify before it flowed all the way into the extremities of the mold. The risks of solid casting are only too evident here, and we can understand why the project was rarely attempted.[48]

Sphyrelaton was a far safer process to use for making bronzes of any significant size, and the three figures from Dreros (figs. 3.11, 3.12) exemplify the accepted method. Nonetheless, their

47. Touloupa/Kallipolitis, no. 18, p. 22. For a bibliography, see *Greek Art of the Aegean Islands* (New York, 1979), no. 147, p. 182.

48. The surface appearance is probably also due in part to the fact that the statuette was cleaned by electrolysis: S. Karouzou, *National Archaeological Museum Collection of Sculpture: A Catalogue* (Athens, 1974), p. 51.

stiff columnar frontality suggests why an artist would have attempted to cast a large piece like the Olympia horse or the Samos flutist. The risks were great but the finished casting, even when imperfect, has the freedom that is possible only with an original modeled by hand. The flutist's outspread arms, his gracefully arched back, the solid curves of buttocks and thighs, and the billowing chiton would probably have been impossible to hammer from sheet metal. The same is true of the horse, with four long legs, an elongated body, a fine head, and thick roached mane. To work in sphyrelaton did not present so great a risk, but the stylistic possibilities inherent in casting a figure far outweighed the risk of that technique.[49]

The flutist was made on Samos, during the third quarter of the sixth century. Samos was the home of Rhoikos and Theodoros, two remarkably versatile artists who are usually mentioned as a pair in the literary testimonia. Together Rhoikos and Theodoros are said to have built the Heraion on Samos and to have written a book about that building;[50] these accounts place the pair in the sixth century B.C.

Theodoros, a pupil of a man named Nikosthenes, is reported to have made a structure called the Skias, perhaps a pavilion, at Sparta; a huge silver krater that Kroisos of Lydia sent to Delphi; and a gold signet ring set with an emerald for Polykrates, tyrant of Samos.[51] He is also reputed to have produced a self-portrait with a file in one hand and a tiny quadriga in the other, and a fly whose wings could cover the quadriga.[52] His interest in scale is apparent, and the visual impression given by a lifesize or even a somewhat smaller statue holding a tiny quadriga would be that of a colossus. But the idea of a fly whose wings could cover the quadriga also suggests the artist's sense of humor and his consummate skill. The versatility of Theodoros is further attested by Pliny's ascription to him of the invention of the carpenter's square, the level, the lathe, and the key or lever (*clavis*).[53] Rhoikos was evidently less versatile than

49. A statuette of a nude standing youth of about the same height and date as the Samos flutist is a thick hollow casting: Delphi Museum, inv. no. 1663, H 0.4 m. It has been dated to approximately 530–520 B.C. See Rolley, *Monumenta*, no. 69. See below, chap. 4.

50. See *NH* 34.83 and 34.90; Vitruvius 7, Pref. 12.

51. Teacher: *NH* 35.146; pavilion: Pausanias 3.12.10; krater: Herodotos 3.41 (Athenaeus, *The Deipnosophists* 12.514–15, suggests that this krater was gold, not silver); ring: Herodotos 3.41.

52. *NH* 34.83.

53. *NH* 7.198.

Theodoros, because he is mentioned for having made only the Samian Heraion and a bronze figure of Night in Ephesos.[54]

Diodoros refers to a xoanon or wooden statue that Telekles and Theodoros made in two equal halves that joined perfectly, even though Telekles carved his half in Samos and Theodoros made his in Ephesos.[55] Diodoros explains that they worked according to the Egyptian system, whereby the proportions of a figure's parts are determined by a formula. He remarks that this statue looked rather Egyptian, with its hands at its sides and its striding pose. The bronze statues that Rhoikos and Theodoros made were not hammered but cast, and Pausanias and others mention repeatedly that Rhoikos and Theodoros were the first men to melt bronze and to cast statues.[56] Pausanias evidently found the subject of bronze casting as complex as have many others since his time: in one passage he misstates, saying that Theodoros discovered the melting of iron (*sidēros*), not bronze, and the molding of statues from it.[57]

In a passage dealing with the origins of clay modeling, Pliny states that this art was first introduced by Rhoikos and Theodoros on Samos.[58] However, Pliny dates the two artists long before the expulsion of the Bacchiadai from Corinth (581–580 B.C.), and consequently also long before the reign of Polykrates, with which period they are otherwise associated. Here, as elsewhere, Pliny's sources may not have provided accurate information. After all, modeling and molding in clay are closely allied to modeling in wax, and both are part of the production process for bronze statuary.

What all of the literary passages do not tell us is how statues were actually cast: they suggest only that Rhoikos and Theodoros imported the idea from Egypt and then developed and perhaps refined it. That none of their works is preserved is, of course, not surprising, but the high quality of the early statuettes from Samos may reveal their influence, and the techniques used to produce those statuettes may reflect lessons learned in Egypt. We can also get a sense of the rapid spread of new materials and techniques during the sixth century when we look at the archaeological evidence from the Greek mainland.

54. Heraion: Herodotos 3.60; Night: Pausanias 10.38.6.
55. Diodoros 1.98.
56. Pausanias 8.14.8, 9.41.1, 10.38.6. In view of their reported Egyptian visit (Diodoros 1.98), it is interesting to note that hollow-cast Egyptian statuettes have been found in Samos. See U. Jantzen, *Agyptische und orientalische Bronzen aus dem Heraion von Samos*, Samos 8 (Bonn, 1972), pp. 7, 92–93.
57. Pausanias 3.12.10.
58. *NH* 35.152.

DEVELOPMENTS

4

Greek sculptors of the sixth and fifth centuries explored the range of possible stances, poses, and gestures of the three-dimensional human figure. We see the development of large-scale human figures, the establishment of stylistic conventions, and experimentation with new techniques. Bronze was of primary importance in this development. It differed radically from marble in capabilities as well as appearance. The freedom enjoyed by the bronze artist was in direct contrast to the restriction imposed on a sculptor by the medium of stone. A bronze sculptor making his model in clay and wax was not faced with the same finality as a sculptor carving a work in marble. And yet there is no sign that the artist realized the opportunities offered by the medium in the earliest large-scale bronzes. They have none of the lively postures of the early bronze statuettes, and we may wonder why an artist of the sixth century would choose to produce a large-scale bronze if not to exploit the features peculiar to that medium, features that distinguished it from marble.

The early lure of bronze may have been its very newness, its high price, and the sophisticated skills required to work it. Growing familiarity with bronze and with the techniques of producing it led slowly to its use in ever more varied forms and its consequent rise in popularity during the first half of the fifth century, and then to its ascendancy over stone as the preferred medium for large-scale sculpture.

Occasionally we come across early hollow-cast statuettes, and further investigation will no doubt bring to light many more. Two small eighth-century birds, for example, have been identified as being hollow.[1] And there is ample evidence for hollow castings on a small scale, mostly griffin protomes from

1. Birds: Delphi Museum, inv. 6038, H 0.138 m.: Rolley, *Monumenta*, no. 24, p. 3, and FdeD 5, no. 146; Schimmel Collection: H 0.145. See *Master Bronzes*, no. 25, pp. 41–42, and *Ancient Art: The Norbert Schimmel Collection*, ed. O. W. Muscarella (Mainz, 1974), no. 10.

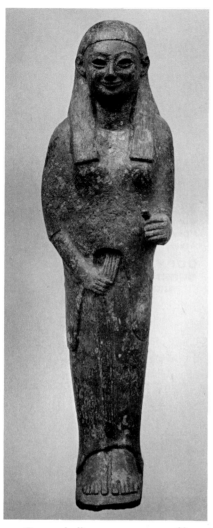

4.1 Bronze hollow-cast statuette of kore, middle of sixth century B.C. H 0.27 m. Samos, Vathy Museum B 1441. Courtesy of Deutsches Archäologisches Institut, Athens, neg. no. Samos 5835.

the seventh century, but also a few statuettes from the seventh and sixth centuries.[2] One of these statuettes is a kore of the middle of the sixth century (fig. 4.1).[3] Long straight hair falls in solid masses to either side of the face, its descent interrupted only by the projecting ears. The face is round, with pudgy cheeks, a thin mouth curved upward, and large oval eyes, hollow without their original insets. The left hand is raised, hand clenched and thumb up. The smooth contours of the chiton and short mantle are interrupted only by a bunch of pleats that are grasped in the right hand in the manner of the figures of the Samian Geneleos dedication.[4] But here only the pleats that are actually clutched are at all plastic, the rest of the folds consisting of scratched incisions in the bronze which are so shallow that they are barely noticeable. The hem arcs over large feet, which are so flat that we can imagine the block of wax being cut down to reveal them. The inset eyes are a feature that we commonly associate with griffin protomes, not usually with statuettes. A remarkably similar statuette from Olympia also has inset eyes, suggesting that there was some interest in exploring the possibilities of combining bronze with other materials.[5]

In 1981 two bronze kouroi of the mid–sixth century were excavated at the Heraion on Samos, both of them hollow castings.[6] Another kouros from Samos (fig. 4.2), now in Berlin, is hollow-cast with an iron armature, but the lower arms and legs are solid.[7] Dating to about 530 B.C., the slender elegant youth

2. A seventh-century horse at Olympia is hollow: B 10344; pres. H 0.24 m., pres. L 0.24 m.; first half of the century: J. Schilbach, "Eine Gruppe grosser protoarchaischer Pferdestatuetten aus Olympia," *AM* 99 (1984): 5–15, pls. 1–4.

3. See U. Gehrig, "Zum Samischen Opferträger in der Antikenabteilung," *JbBerlMus* 17 (1975): 48; *Greek Art of the Aegean Islands* (New York, 1979), no. 151, pp. 186–88.

4. For a reconstruction of the Geneleos group, see Boardman, *GSAP*, fig. 91.

5. Athens, National Museum no. 6149, H 0.225 m. See Rolley, *Monumenta*, no. 66, p. 7. For a much earlier bronze statuette with hollow eyes, see the Mantiklos Apollo, Boston, Museum of Fine Arts, Francis Bartlett Collection, 03.997: M. Comstock and C. Vermeule, *Greek, Etruscan, and Roman Bronzes in the Museum of Fine Arts, Boston* (Greenwich, Conn., 1971), no. 15, pp. 16–17; Boardman, *GSAP*, p. 10 and fig. 10.

6. Vathy Museum: kouros B 2252, preserved to lower thighs, H 0.18 m.; kouros B 2251, head only preserved, H 0.061 m., probably draped. See H. Kyrieleis, "Zwei Samische Bronze-kuroi," *AM* 99 (1984): 105–111, pls. 17, 18.

7. Berlin: see Rolley, *Monumenta*, no. 67, p. 7, pl. 22; Gehrig, "Zum Samischen Opferträger," pp. 45–50 (and p. 48n10 for reference to another hollow casting, Berlin 32118); Gehrig, "Frühe griechische Bronzegusstechniken," *AA* 94 (1979): 554–58. It is also possible that iron chaplets were used to stabilize the core. Three early Archaic hollow-cast statuettes have been recognized among the finds from the Kabeirion near Thebes: B. Schmaltz, *Metalfiguren aus dem Kabirenheiligtum bei Theben*, Das Kabirenheiligtum bei Theben, vol. 6 (Berlin, 1980), nos.

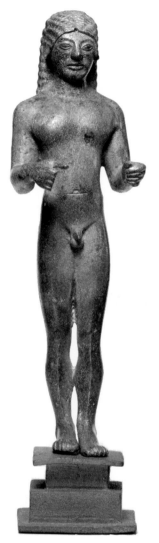

4.2 Bronze hollow-cast statuette of kouros from Samos, third quarter of sixth century B.C. H 0.28 m. Berlin, inv. 31098; and Samos, Vathy Museum B 392 (base). Courtesy of Antikenmuseum, Staatliche Museen Preussischer Kulturbesitz, Berlin. Photo by Uta Jung.

has smoothly rendered musculature and wavy, ridged hair falling nearly to the waist. The deeply incised lines indicating the navel, fingers, and eyelids were, like the wavy hair, cut in the wax model. The raised arms, one hand clenched, the other open, surely held an offering. The arms are not cleanly detached from the body at the biceps, nor are the legs at the thighs.

A bronze kouros in Delphi of similar date and somewhat larger than the Berlin statuette is also a hollow casting.[8] The figure is muscular and almost stocky. The incomplete arms were originally extended forward at the elbows. The youth is sandaled, necklaced, and diademed. His long hair falls past the shoulders, where it divides as if the ends were knotted. A lock follows the contour of each cheek and outlines each shoulder; pairs of locks fall neatly to each nipple. This kouros is so similar to the Berlin statuette that it is easy to argue that it was a Samian dedication.[9]

It is of course tempting to imagine that the earliest hollow-cast bronze statues were made on the island of Samos, where the great artists Rhoikos and Theodoros were supposed to have lived. The earliest preserved works that can be considered large-scale, however, come from Olympia and Athens. The work in Olympia consists of the legs and right hand of a bronze kouros (fig. 4.3) found in three pieces in widely separate locations. The figure, no more than a large statuette, originally standing between 0.4 and 0.5 meter in height, has been dated to either 600 B.C. or some fifty years later.[10] The legs are massive, with muscular thighs, prominently ridged shins, and two deep curving incisions for the kneecaps. The left leg is advanced in the characteristic kouros pose, and the right hand, thumb forward, is clenched against the upper thigh. Like many early bronze statuettes of kouroi, this slightly larger figure could be described as a metal version of the marble sculptures of the day. The large thumb, incised oval knees, and pronounced shins

128 and 131 (iron armatures), pp. 44–45; no. 187, p. 55; and pp. 117n193 (hollow-cast statuettes from elsewhere), 133n259 (hollow-cast birds), 133n260 (a hollow-cast fibula).

8. Delphi Museum, inv. 1663; H 0.40 m.; 530–520 B.C.: P. Perdrizet, *Monuments figurés,* FdeD 5 (Paris, 1908), p. 35; Rolley, *Monumenta,* no. 69, p. 7, with bibliography.

9. Lakonia has also been mentioned: Rolley, *BG,* p. 102.

10. Bol cites as parallels two smaller bronze statuettes in Samos (Richter, *Kouroi,* nos. 22 and 23, pp. 55–56—Sounion group), and suggests that this figure was a Samian import of about 600: *Grossplastik,* no. 1, pp. 7–8. Gehrig dates the piece to the mid–sixth century on the basis of the rendering of the knee: "Zum Samischen Opferträger," p. 48n10.

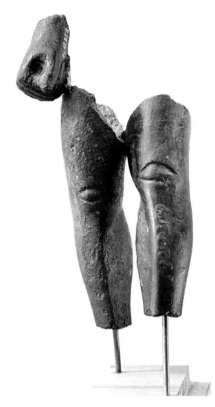

4.3 Bronze legs, first half of sixth century B.C. Max. pres. H 0.155 m. Olympia B 1661, Br. 2702, Br. 12358. Courtesy of Deutsches Archäologisches Institut, Athens, neg. no. 72/3546.

have parallels in the Sounion and Orchomenos-Thera groups, which suggest a date in about the first quarter of the sixth century.[11]

The lower legs are solid but the hand and thighs are hollow. The irregular thickness of the walls may be attributed to slippage of the core during production.[12] It is impossible to tell now whether the work was cast in one or more pieces because no finished edges are preserved, but its substantial size indicates an early interest in casting works larger than the ordinary statuette. The fact that the figure was cast hollow also reflects the exigencies of the medium. A smaller kouros could be cast solid or hollow, but at this scale, the cost and risks of casting were such that hollow casting was preferable.[13]

A great deal of evidence is preserved for a bronze kouros or Apollo that was more than twice the size of the Olympia kouros. Not the statue but the clay investment mold in which it was cast in the middle of the sixth century (fig. 4.4) was excavated in 1936, in a pit on the west side of the Athenian Agora. The mold for the statue's feet, legs, buttocks, hands, lower arms, and lower torso has been mended to a height of 0.75 meter, and we can see that the finished bronze would have stood just over a meter tall, more than half lifesize (fig. 4.5).[14] The statue was of the common kouros type, with the usual rigid stance, arms pressed against the body, fists clenched at the thighs, left foot advanced but, like the right one, placed flat on the ground. A piece of the mold for the statue's face was also found (fig. 4.6). It preserves, in the negative, the tip of the nose, delicate lifted nostrils, part of the mouth, and a clean-shaven chin. A plaster cast taken from the mold returns the face to the positive, and we see a pronounced triangular depression at the corner of a smoothly curved mouth, which invites comparison with a marble head in Athens dated between 575 and 550 B.C.[15]

11. For the knees and shins, see especially the bronze statuette from the Heraion of Samos (H 0.2 m.) cited by Bol (*Grossplastik,* pp. 7–8: Richter, *Kouroi,* no. 23). However, similarly cut but vertical kneecaps can be seen on a statuette of somewhat later date: Leningrad, Hermitage B.616; H 0.13 m.: Richter, *Kouroi,* no. 54, pp. 71–72, figs. 193–95—Orchomenos-Thera group.

12. Bol, *Grossplastik,* p. 7.

13. Parts of two bovine eyes from a lifesize hollow casting are also preserved in Olympia: B 2150 and Br. 7224 (Bol, *Grossplastik,* no. 2, pp. 8 and 102: early Archaic).

14. See Mattusch, "Agora," pp. 346–47; Mattusch, "Molds for an Archaic Bronze Statue from the Athenian Agora," *Archaeology* 30 (1977): 326–32.

15. Akropolis Museum no. 617; Richter, *Kouroi,* no. 65, pp. 81–82, fig. 219: Tenea-Volomandra group.

4.4 Mold for bronze statue of kouros, ca. 550 B.C. Max. pres. H 0.75 m. Athenian Agora S 741. Courtesy of American School of Classical Studies at Athens: Agora Excavations.

In a nearby dump in the same stratigraphic context, parts of a mold for a second head were found (fig. 4.7). This discovery was at first somewhat mystifying, as the second mold is made of the same clay and on the same scale as the first one. Perhaps a second attempt was made to cast the head for the statue after the first proved a failure. We shall return to this question.

A good portion of the mold for the second head is preserved, and the nose, mouth, clean-shaven cheeks, eyes, ears, and hair can all be distinguished. Again with the aid of modern plaster casts (fig. 4.8) we can look at the positive of this relatively well-preserved mold and arrive at a clear sense of the appearance of the bronze statue.

The second head differs stylistically from the first one. In both molds the delicate nostrils project slightly upward, but the mouth of the second head is slimmer, the lips joining more naturalistically at the corners. The mouth resembles the one of the well-known kouros from Melos and two from the Ptoan Sanctuary, all of which can be dated between 555 and 540.[16]

The small ear of the second head is at the level of the nose. It has a broad, roughly modeled helix, a slight indication of the tragus, and a broad smooth lobe. On the left ear we can just distinguish a crude antitragus. The eye has a well-marked loop or canthus at the inner corner, and the upper lid curves significantly more than the lower lid over the solid, undetailed eye. The cheekbone is high, with a gentle curve, and the hair is massive but undetailed, with only a wavy border marked along the temple. On the right side of the head the hair forms a heavy straight mass behind the ear; originally it no doubt fell at least to the shoulder. Any locks, waves, or curls must have been cold-worked in the bronze.

It is surprising to realize that the styles of both of these heads and of the statue follow the same stylistic conventions as contemporary works in stone. Did not the use of bronze suggest new ways of handling certain stylistic passages? The answer must be that the artist was not prepared to experiment. He was constrained by tradition, a very useful thing for an artist who was working in a medium that was still relatively unfamiliar at this scale. And so, like the Olympia artist, this Athenian sculptor allowed himself to be guided by the stylistic tradition of

16. Melian kouros: Athens, National Archaeological Museum no. 1558; Richter, *Kouroi*, no. 86, pp. 96–97, fig. 278: Melos group. Ptoan kouroi: Athens, National Archaeological Museum nos. 10 and 16; Richter, *Kouroi*, no. 95, p. 100, fig. 309, and no. 101, p. 102, fig. 322: Melos group.

4.5 Reconstructed drawing of kouros cast from Agora molds. The shaded areas are preserved in the molds. Courtesy of American School of Classical Studies at Athens: Agora Excavations. Drawing by John Travlos.

stone sculpture. Bronze would have allowed far greater freedom of movement, but the artist did not break the convention of his day.

Most of the mold fragments, as well as other casting debris, were discovered in what was quickly identified as a casting pit, dug into the bedrock near the small Temple of Apollo Patroos (fig. 4.9). The rectangular pit measures 1.70 meters in length. At a depth of 0.25 meter, there is a smooth level floor 0.90 meter long. The rest of the pit descends to an oval floor at a depth of 0.85 meter. In fact, the oval base of the mold, measuring 0.20 by 0.36 meter, would have fitted neatly into the oval end of the pit, which measures about 0.30 by 0.50 meter (fig. 4.10). We can assume that this large mold was packed here for casting in an upright position. Evidence of burning throughout the casting pit indicates that, as might be expected, the large mold was also baked here before the bronze was poured into it.

The casting pit is not deep enough to have contained the mold for the entire statue, and no bricks were found with which the pit walls might have been built up to an appropriate height. Furthermore, the casting of a statue of this size in one piece would have required the melting and pouring of a dangerously large amount of bronze in a single operation. Our conclusion must be that the mold was constructed, baked, and cast in more than one piece. A separate mold for the head of the Agora bronze would have greatly facilitated the casting of the statue, as a smaller pit would have been needed and the amount of molten bronze to be melted at one time would have been reduced. Furthermore, if the first head miscast, as it evidently

4.6 Mold for lower part of face of kouros made from Agora molds, with plaster cast at right. Max. pres. dim. 0.07 m. Athenian Agora S 741. Courtesy of American School of Classical Studies at Athens: Agora Excavations.

4.7 Mold fragments for second kouros head. Max. pres. dim. 0.144 m. Athenian Agora S 797. Courtesy of American School of Classical Studies at Athens: Agora Excavations.

4.8 Plaster casts of molds for second kouros head. Courtesy of American School of Classical Studies at Athens: Agora Excavations.

did, it would have been far simpler to cast a replacement head than to recast the whole statue. And this is what was apparently done here. The casting pit itself was not cleaned out and reused, but the second head was cast in the shallow pit nearby where its mold was found. Indeed, we shall see that it was common practice later in the Archaic period, and in the Classical period as well, to cast at least the head of a statue separately, but to cast a great deal of the rest of the figure in one piece.

The Agora molds in this group were constructed of three layers of clay, ranging in thickness from about 0.006 meter in the innermost layer to 0.016 meter in the exterior layer. The two burned inner layers are made of fine clay smoothly applied and then scored with a narrow spatulate instrument to improve the adhesion with the next layer. The unblackened outer layer of clay consists of coarser clay; all of the layers are baked very hard.[17]

Two funnels used to channel the bronze into the mold were 0.150 and 0.160 meter in diameter, and two gates were 0.010 and 0.024 meter in diameter.[18] A look at the inner mold surface reveals traces of bronze still remaining where it once flowed into cracks and other imperfections. Small rectangular holes in each hand and in each heel of the large mold once contained metal chaplets that held the core in place during casting. There is thus no doubt that the statue cast in this mold was hollow.

Unfortunately, the evidence provided by the mold and the gate system does not allow us to reconstruct with any certainty the exact procedure by which the small statue was cast. A cored wax model for most of the statue, with chaplets in place, was invested with a clay mold and lowered into the deeper part of the casting pit. At the same time, at least one smaller mold for the head may have been placed in the shallow end of the pit. Then the molds were baked and the wax was burned out.

A metallurgical furnace, either a shaft furnace or a crucible furnace, would have been constructed immediately adjacent to the casting pit.[19] Here the bronze would have been melted and then poured from filled crucibles into the mold cavity. Finally, the molds were broken up, the pieces of the statue were joined, and the surface of the bronze was finished. A replacement for

17. See also Appendix, "Molds," no. 1, "Chaplets," no. 4, "Bellows," no. 6.
18. Funnels: Agora B 1536 (Mattusch, "Agora," A1, p. 346) and 1534; gates: Agora B 1537 (ibid., A2, p. 346) and 1535.
19. For a reconstructed drawing of a shaft furnace beside this pit, see Mattusch, *Bronzeworkers in the Athenian Agora*, Athenian Agora Picture Book 20 (Princeton, 1982), fig. 26, p. 12.

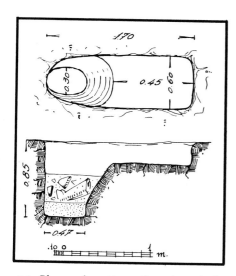

4.9 Plan and section of casting pit in Athenian Agora, ca. 550 B.C. Courtesy of American School of Classical Studies at Athens: Agora Excavations.

the first, flawed head would have been cast soon after the first casting was completed.

After the statue had been completed, the furnace was dismantled and all of the debris was discarded, including mold fragments, congealed bronze drips, and the like. Most of the trash went into the casting pit, which, because it had been dug specifically for this project, would not be reused. Other leftovers were dumped nearby, including the mold for the second head, parts of the gate system, bricks from the furnace, and the clay coverings for bellows nozzles.[20]

There are many unanswered questions about the Agora kouros. We cannot now ascertain, for example, whether it was made by the direct or indirect lost-wax process. A founder who used the direct lost-wax process to cast a cored figure of this size in one piece would have been faced with a difficult and risky operation. And if he made a piece casting by the direct method, he would have had to prepare the model in pieces or cut up the finished model, thereby greatly complicating production.[21]

The indirect lost-wax process is well suited for piece casting, however, because it simplifies the finishing of a model and the preparation of the waxes for casting. The artist would have produced a complete model, taken molds from it, lined the molds with wax to produce a wax model, and then inserted a clay core. He would then have removed the master molds and finished the surface of the wax model by modeling, carving, and perhaps adding certain features, such as long curls, which would have been difficult to take a master mold from but easy to add before the final investment. In the end, the wax model would have differed significantly from the original model as transmitted to the wax through the master molds. Chaplets would then have been inserted through the wax to the core, the wax invested, and the whole packed in its pit for baking and casting. By this process, the original model would have been saved, but the finishing of the wax, including the addition of projecting parts, and then the investment and the casting would have been carried out just as in the direct lost-wax process.

A hollow-cast statue of half lifesize was a new development in the mid–sixth century B.C. and represented a major technical achievement, even without experiments in style. Such a statue

20. See Mattusch, "Agora," pp. 345–46.
21. Bol, *Bronzetechnik*, p. 125, argues in favor of the direct process, saying that the molds for two heads show that an entirely new model had to be made after the first casting failed.

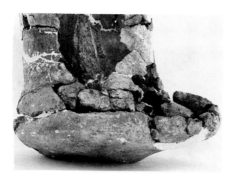

4.10 Detail of base of mold for bronze statue of kouros, ca. 550 B.C. Athenian Agora S 741. Courtesy of American School of Classical Studies at Athens: Agora Excavations.

was certainly far more expensive to produce than a marble sculpture, both because of the cost of the metal and because of the requirements in the workshop. The bronze statue made in the Athenian Agora must have been a work of some importance.

The date of the casting pit's use, in the middle of the sixth century, corresponds to the construction date of the small apsidal temple nearby, which was dedicated to Apollo Patroos. Here Apollo was worshiped as the father of Ion, the legendary founder of the Ionian race, to which the Athenians belonged. It is surely no coincidence that the casting pit was dug so near the Apollo temple, and it is likely that the bronze figure was not just a kouros but Apollo himself, and that it was made as the cult statue for that building.[22]

A cult statue that is similar in scale and appearance is illustrated on a red-figure neck amphora of the early fifth century (fig. 4.11).[23] On the vase we see Helen kneeling on a broad two-stepped base, desperately clutching a statue of Apollo which is only about two-thirds her size. Frontal, long-haired, and belted, the little figure stands stiffly with hands pressed against the thighs. The feet are together, further demonstrating its antiquity and emphasizing the contrast between the inanimate statue and the suppliant Helen. The painted statue gives us a clear impression of how the Agora Apollo must have looked when it was standing in the temple during the second half of the sixth century.

When the Persians looted and burned the city of Athens in 480 B.C., the little temple of Apollo Patroos was destroyed and, as we might expect, the bronze Apollo disappeared without a trace. A record of it was unintentionally saved, however, in the broken clay molds that had been dumped when the statue was finished, approximately seventy years before the Persians' attack on the city. From these molds we are able to reconstruct the production and the appearance of the lost Apollo.

The mold from the Athenian Agora is remarkable in that it preserves the form of most of the statue. The few large-scale

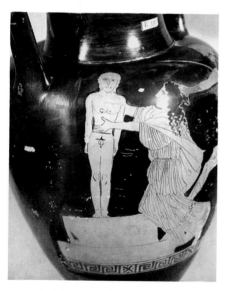

4.11 Red-figure neck amphora, early fifth century B.C. London, British Museum E 336. Courtesy of Trustees of the British Museum.

22. For a reconstruction of the apsidal temple with the statue inside, see Mattusch, *Bronzeworkers,* fig. 31. For a recent discussion of the kouros type and its uses, see A. F. Stewart, "When Is a Kouros Not an Apollo? The Tenea 'Apollo' Revisited," in *Corinthiaca: Studies in Honor of Darrell A. Amyx,* ed. M. A. Del Chiaro and W. R. Biers (Columbia, Mo., 1986), pp. 54–70.

23. See Beazley, *ARV*[2], 1010, 4: the Dwarf Painter; H. B. Walters and E. J. Forsdyke, *CVA,* Great Britain fasc. 7, British Museum fasc. 5 (London, 1930), p. 9, pl. 65.

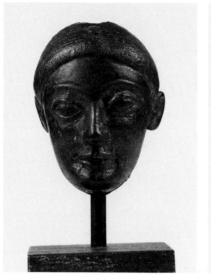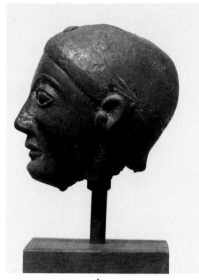

4.12 Bronze head of youth, ca. 550–525 B.C. H 0.069 m. Boston, Museum of Fine Arts 95.74. Courtesy of Museum of Fine Arts, Boston, Perkins Collection.

a *b*

bronzes left from the late sixth and early fifth centuries are usually in more fragmentary condition. Four heads, one in Boston (from Sparta?), the others from Olympia, Kythera, and Athens, belonged to figures of between one-half and one meter in height. One entire statue, from southern Italy, is massive in its proportions but stands only 0.71 meter tall. Only two bronzes are truly lifesize: one is the head of a warrior from the Athenian Akropolis, from a statue of perhaps 1.70 meters in height; and the other is the so-called Piraeus Apollo, 1.91 meters in height, which, some scholars have argued, is not from this period at all.

A small bronze head in Boston (fig. 4.12) probably belonged to a kouros of approximately half a meter in total height, or about the same size as the Olympia figure whose legs are seen in figure 4.3.[24] The face is oval, narrowing sharply toward the chin. The forehead slants gracefully outward, with incised brow lines curving just above an angular brow ridge. The fact that the head was hand-modeled and tooled in hard wax is particularly noticeable in the eyes, which are large simple ovals with angular corners and heavy projecting lids, irregular and somewhat crudely marked. The eyes are cast solid with the

24. This is large for a statuette, but, as we have seen, size was not the only reason for the decision to make a hollow casting. I am grateful to Cornelius C. Vermeule for allowing me to study this head in 1987. For the suggestion that the head is that of a warrior, see E. Homann-Wedeking, "Von spartanischer Art und Kunst," *Antike und Abendland* 7 (1958): 65.

head—a relatively unusual practice for a large bronze, although the same feature can be seen in the Agora mold. The left eye of the Boston head is smaller and higher than the right one, and the left cheekbone is higher and more pronounced. The straight nose ends in a rounded tip, flattened by a broad tool applied to the wax on the left side; the nostrils were poked into the wax with a pointed tool. The lips are straight and thin, the upper one projecting as far as the chin, which is flattened, perhaps by the same blade that was used on the nose. The left ear projects much farther than the shallow right one, its slanting position is more accurate, and its helix, as well as a broad tragus joining a flat lobe, are cursorily rendered.

At first glance, the hair of the Boston head looks like a simple undetailed cap. A closer inspection reveals fairly broad incisions marking a double band or fillet whose strands meet above the ears. After the fillet was incised, the artist engraved dozens of fine parallel lines in the wax to represent a fringe of straight hair held neatly in place by the band. Above the band, the rounded crown of the head is not incised at all, suggesting that the crown was not intended to be visible. Unsightly holes in the crown support this theory: there is one hole at the top center of the head, and two more can be seen toward the back, one of them distinctly pushed into the wax model. A bronze chaplet was also inserted, with no attempt made to conceal its head. It was pushed into the wax right on top of the fillet, also impinging on the engraved hair. The head of the chaplet is rounded, but the chaplet itself is rectangular and is bent back nearly flat against the interior of the head.[25]

The generally smooth and undetailed interior of the Boston head bears witness to the fact that extra wax was added to the outside of the head for the modeling of the protruding eyes, nose, chin, and ears. The head is thickest inside the chin, and the entire face is thicker than the crown, the sides, and the back of the head. This feature and the relatively small size of the piece suggest that the artist used the direct lost-wax process, applying warm wax over a clay core, adding to it as necessary, then inserting one or more chaplets, investing with a clay mold, and casting. The process was the same as for solid casting, with the simple addition of a clay core held in place by chaplets. The uneven coating of wax over the core increased the quantity of bronze that was needed for casting.

The delicately incised border of short straight hair curving

25. L of chaplet 0.011 m.; diam. of head 0.006 m.

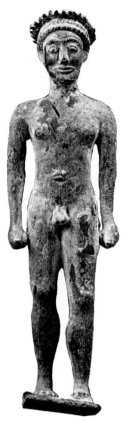

4.13 Bronze statuette, ca. 550–525 B.C. H with plinth 0.178 m. Olympia B 2400. Courtesy of Deutsches Archäologisches Institut, Athens, neg. no. OL 2746.

across the forehead and the nape of the neck of the Boston head is characteristically Lakonian, and in fact the head, though purchased in Athens, is said to have come from Sparta.[26] Compare it with two statuettes of youths, one from Olympia (fig. 4.13), the other from the Amyklaion at Sparta (fig. 4.14).[27] The poses are stiff and frontal, the features roughly articulated. The figurine from Olympia has the hands clenched at the sides, large thumbs to the fore; the one from Sparta has bent arms, the right hand missing, the left hand opened vertically, with all fingers extended. A projecting pin at the wrist was originally attached to an attribute. Like the Boston head, each of these figurines has a fringe of short straight hair and prominent, linear eyes. Each is crowned with a prominent wreath of radiating palm leaves or reeds. It is likely that the Boston head also belonged to a kouros of this type. The double incised band on the head may be the border of a wreath; one or more of the holes in the top of the head may have been used to attach the wreath, which, to judge from the other two statuettes, would have projected for some distance from the head.

Like the two statuettes from Olympia and Sparta, the Boston head has usually been dated to the middle or third quarter of the sixth century B.C., or not long after the Agora molds.[28] Reports of the travels of Archaic artists are not uncommon, and reference has often been made to the connection between Sparta, the place of origin of the Boston head, and Samos, for Theodoros is reported to have been in Sparta to make his Skias, or pavilion.[29] It has even been suggested that Lakonian bronze sculptors

26. Comstock and Vermeule, *Greek, Etruscan, and Roman Bronzes,* no. 25, p. 28; M. Herfort-Koch, *Archaische Bronzeplastik Lakoniens, Boreas,* suppl. 4 (Münster, 1986), no. K85, pp. 26, 43, 105.

27. Olympia statuette: E. Kunze, "Ein Bronzejungling," *Olympia Berichte* 5 (1956): 97–102; Herfort-Koch, *Archaische Bronzeplastik,* K91, p. 107. Amyklaion statuette: Herfort-Koch, K92, pp. 46–47, 56, 107 (missing attribute identified as a kithara); Rolley, *BG,* p. 100, fig. 80. Rolley associates the wreath with a Lakonian festival in honor of Apollo or Hyakinthos. For a discussion of the wreath, see Kunze, "Bronzejungling," p. 98; A. Furtwängler, "Bronzekopf aus Sparta," in *Kleine Schriften,* vol. 2 (Munich, 1913), pp. 429–33; Herfort-Koch, pp. 45–47. An extreme and rather comical example of the foliate wreath can be seen on a statuette of a kouros carrying a cock, Athens, National Archaeological Museum no. 13056, illustrated in S. Karouzou, *National Museum* (Athens, 1977), p. 104.

28. G. M. A. Richter, *Archaic Greek Art* (New York, 1949), p. 88; Boardman, *GSAP,* p. 76, fig. 122; Herfort-Koch, *Archaische Bronzeplastik,* p. 105. For a much earlier date, of approximately 600 B.C., see G. Kaulen, *Daidalika: Werkstätten griechischer Kleinplastik des 7. Jahrhunderts v. Chr.* (Munich, 1967), pp. 64–69.

29. Pausanias 3.12.10.

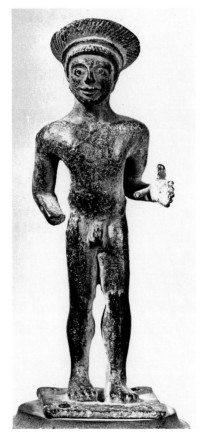

4.14 Bronze statuette, ca. 550–525 B.C. H 0.12 m. Athens, National Archaeological Museum Br. 7547. Courtesy of Deutsches Archäologisches Institut, Athens, neg. no. N.M. 3994.

learned their skill from Samian artists.[30] However, we have no other evidence that proficiency in bronzeworking occurred in Sparta as a direct result of contact with Samos.

The strong chin, fine nose and mouth, cast eyes, heavy and imprecise ears, and thick solid mass of hair are not unique to the Boston head. The same features can be seen in the Agora mold, and the later Piraeus Apollo also had solid-cast eyes. These are an unexpected feature in the more familiar context of bronze statuary with colorful inlays. Artists who shunned inlays may have been adhering to the stylistic conventions of stone sculpture; other artists, working in the tradition of small bronzes, had chosen to inset eyes from as early as the Geometric period onward.[31]

A bronze bearded head from Olympia (fig. 4.15), in places over 0.01 meter thick, is such an irregular casting that it may have been produced by a relatively pure version of the direct lost-wax process.[32] A rectangular iron rod surrounded by clay core material was found in the head and was identified by Adolf Furtwängler as a dowel to attach the head to the rest of the statue.[33] But it has now been suggested that the iron rod was part of an armature.[34] The casting was evidently considered a successful one, even though it is very porous, for there are no visible patches covering flaws.[35]

Although only the head and part of the neck are preserved, part of a finished edge high on the back of the neck and at a slight diagonal along the sides of the neck shows that the head

30. See, e.g., M. Collignon, *Histoire de la sculpture grecque*, vol. 1 (Paris, 1892), p. 228.

31. See, e.g., an eighth-century warrior, Delphi inv. 3649: Rolley, *Museum of Delphi: Bronzes* (Athens, n.d.), fig. 2, p. 7; the Mantiklos Apollo of ca. 700 B.C., Boston, Museum of Fine Arts, Bartlett Collection, 03.997: Comstock and Vermeule, *Greek, Etruscan, and Roman Bronzes*, no. 15, p. 17; a warrior from Olympia of about 650 B.C., Olympia Museum B 1701: Boardman, *GSAP*, p. 16, fig. 46; a kouros from the Heraion on Samos, Vathy Museum: Richter, *Kouroi*, no. 23, p. 56, figs. 120–22 (Sounion group); and a kouros from Magna Graecia(?) in the Louvre, no. 116: A. de Ridder, *Musée du Louvre: Les Bronzes antiques* (Paris, 1913), fig. 6.

32. See Furtwängler, *Bronzen*, no. 1, pp. 9–10; Bol, *Grossplastik*, no. 3, pp. 10–12, 102.

33. Furtwängler, *Bronzen*, p. 9. See also W.-D. Heilmeyer, "Giessereibetriebe in Olympia," *JdI* 84 (1969): 15n78.

34. Bol, *Grossplastik*, p. 102.

35. Kluge was convinced that the Olympia Zeus was cast from a wooden model molded in sand, and argued that all the projecting parts, including the knot of hair at the back, the brow, locks, and hair band, were separately cast and attached by hard soldering: "Gestaltung," pp. 14–15.

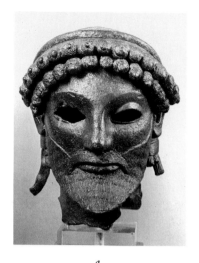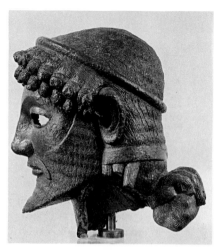

4.15 Bronze head of Zeus from Olympia, late sixth to early fifth centuries B.C. H 0.17 m. Athens, National Archaeological Museum 6440. Courtesy of Deutsches Archäologisches Institut, Athens, neg. nos. 72/330, 72/363.

a *b*

and neck were cast in one piece, separate from the body. The statue would have stood about one meter in height. The modeling of the neck suggests only that the pose was a frontal one, but it is tempting to posit an upright striding god with weapon raised to strike, of the type known from the Ugento god (fig. 4.16), and from numerous statuettes of the later Archaic period.

The entire mass of hair is engraved with fine parallel strands that start behind the spiral curls, rise over the top of the head, and descend down the back. The hairstyle is dominated by two decorative rows of highly plastic spiral locks across the forehead. Behind them a tubular fillet encircles the crown of the head. A wide flat band loosely binds the long hair just below the exposed ears. Three engraved wavy locks emerging from beneath this band on either side are broken, but were once brought forward over the shoulders. In fact, pieces of three separate tresses with the same kind of incision probably belong with the head.[36] The rest of the hair is gathered into a tight knot by a second wide flat band at the nape of the neck.[37] Five separate locks are brought over this band and hang decoratively on top of the knot of hair. These locks, the knot of hair, the three locks on either side of the head, and the double row of

36. Olympia, Br. 1955, 1999, and 2016: Bol, *Grossplastik*, no. 3a, p. 102, pl. 2.
37. For a discussion of this hairstyle, defined as a "chignon," and for citation of other examples, see B. S. Ridgway, "The Bronze Apollo from Piombino in the Louvre," *Antike Plastik* 7 (1967): 55–57.

brow locks were all separately cast and attached with bronze hard solder.[38]

The beard, more finely engraved than the hair, makes a sharp diagonal below the cheekbones and falls to a point; the line of the jaw is angular, with little depth beneath the chin. The beard itself is shallow and lacks volume. An equally flat engraved moustache forms a double arc above thin, horizontal lips and curves down to rounded points, concealing the corners of the mouth. The contours of the face are as flat and plain as the beard. The nose descends almost on the same line as the forehead. Curving, undetailed brows make a sharp angle with the forehead. The eyes are long and narrow, slanting upward toward the outer corner. Their insets are lost and the rim of the right eye is damaged. The only really plastic forms are the strongly projecting ears, which make a striking contrast to the simplified linear handling of the other details of the head. Both tragus and antitragus are smoothly modeled, but the right ear is far more carefully modeled than the left.

The Olympia head wears a fillet, suggesting that a deity is represented. An identification of Zeus is universally accepted, and a date has been proposed in the last quarter of the sixth or the very early fifth century B.C.[39] The simplicity, linearity, and unsophisticated technique of the Olympia Zeus seem to allow a date no later than 500 B.C., possibly somewhat earlier. The stylistic provenance is problematic. Did the artist come to Olympia from elsewhere? Or is the Zeus the product of a local workshop, influenced by the many styles that were represented in Olympia by the end of the sixth century?

A close parallel for the hairstyle of the Olympia Zeus can be seen on another mature deity, one that has also been identified as Zeus (fig. 4.16). A complete statue, only 0.71 meter tall, was discovered in 1961 by workers digging the foundation for a house in Ugento, a small town in the province of Lecce. The top of the statue's base, consisting of a Doric capital made of local stone and decorated with carved rosettes, is also preserved. A column has been restored and probably correctly elevates the statue, surely a votive offering, to a height of just above eye level.[40] The statue has most recently been attributed

38. Furtwängler, *Bronzen*, p. 9; Bol, *Grossplastik*, p. 102.
39. See Bol, *Grossplastik*, p. 12, for a summary. G. M. A. Richter, *Archaic Greek Art* (New York, 1949), p. 191, calls this head an excellent example of an early-fifth-century work.
40. See Degrassi.

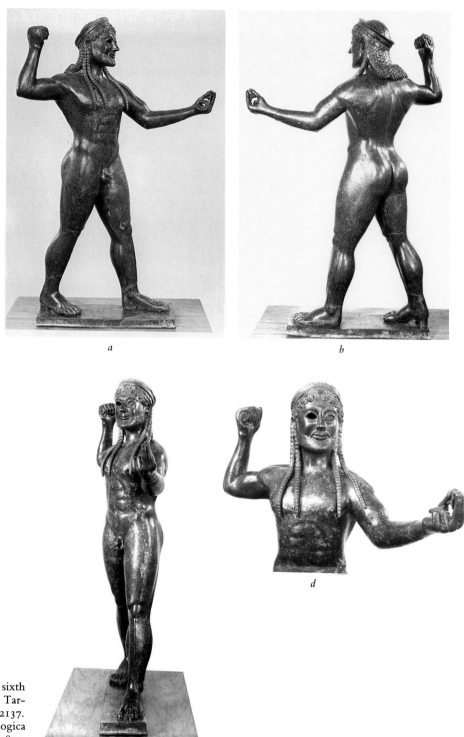

4.16 Bronze god from Ugento, late sixth to early fifth centuries B.C. H 0.71 m. Taranto, National Museum no. 12137. Courtesy of Soprintendenza Archeologica della Puglia, neg. nos. A 1831, 1832, 1834, 1838.

a

b

c

d

to a Tarantine workshop and dated to 530 B.C., but other dates assigned to the work range from 520 to 510–500 to the early fifth century B.C.[41]

Carefully rendered details mark the Ugento statue as a work of high quality. The god is in a striding pose, left leg advanced. The right arm is raised as if to strike, the left extended forward, and both once held attributes, which are only partly preserved.

A large oval head accounts for nearly one-sixth of the statue's total height. Two rows of elaborate spiral curls lying across the broad forehead are backed by a diadem decorated with rosettes and a prominent stylized foliated wreath.[42] Above the wreath a straight part marks the top of the head; wavy locks begin behind two rows of waves and angle slightly outward on either side of the part. Below the wreath in back, the lines of the loose locks continue until they are caught up at shoulder level by a single fillet, forming a broad knot of hair with eight neatly aligned overlapping ends. In addition, two long wavy locks fall gracefully forward over each shoulder and lie splayed across bulging pectorals and deltoids.

The short beard, incised to show vertical sections of curls, arcs well below the pronounced cheekbones and defines a strong, well-rounded chin. A moustache curves down to touch the beard, and the lips, broad at the corners, curve tautly upward. The small elongated ears are more schematized than naturalistic, with tragus and long lobes but no antitragus. A long delicate nose angles out from the line of the forehead. The eyes are large and oval, the left one retaining a bronze casing that once held the inset eye. Projecting brows, surrounded by incised lines, curve smoothly above the eyes.[43]

A powerful, rather long neck joins the head to a short, triangular torso. The broad upper torso is turned stiffly back on the right side by the raised arm, giving the initial impression that the god is holding his breath. Broad, massive pectorals surmount three transverse divisions above the navel, and on the

41. 530: Degrassi, pp. 99–106; 520: Rolley, *BG*, p. 34; 510–500: W. Herrmann, "Archäologische Grabungen und Funde im Bereich der Superintendenzen von Apulien, Lucanien, Calabrien und Salerno von 1956 bis 1965," *AA* 81 (1966): 293, 296 (Herrmann also suggests that the bronze is a product of the Lakonian school); early fifth century: R. Holloway, *Influences and Styles in the Late Archaic and Early Classical Greek Sculpture of Sicily and Magna Graecia* (Louvain, 1975), p. 10. Attributions are summarized in C. Rolley, "Les Bronzes grecs: Recherches récentes," pt. 5, "Ecoles et styles archaïques," *RevArch*, 1986, pp. 389–91.

42. Similar spiral curls, in a single row, can be seen on a terra-cotta votive head in Taranto: National Museum no. IV 4004; H 0.239 m.; Langlotz/Hirmer, p. 260, fig. 29.

43. The brows are inset: Bol, *Grossplastik*, p. 90.

right side of the body below the nipple five parallel diagonal grooves mark the ribs through the taut flesh. From behind we can see that the right shoulderblade is raised and more prominent than the left. The arms are short and simplified, the right one raised with the elbow bent at an acute angle. Clasped in the fist is part of a thick object, circular in section, which has been identified convincingly as the remains of a thunderbolt.[44] The left hand, extended forward with the palm up, once held something between the thumb and two forefingers, perhaps a bird or a flower or a piece of fruit.[45] Late Archaic vase painters, such as the Andokides Painter, frequently illustrate such an attribute, which is, however, otherwise unattested in large-scale sculpture.

To complicate matters further, a once-gilded bunch of grapes made of a tin–lead alloy was found with the statue. It has been suggested that the grapes may have referred to Zeus in his association with vegetation, and that they may have rested, with other bunches of grapes, atop the stone base where holes, perhaps for their attachment, are preserved.[46]

The god's buttocks, legs, and feet are stocky. The left foot bears the weight, and the right one is raised at the heel, as if in stride.[47] Nonetheless, the figure's stance is vertical, the weight balanced directly over the legs, which gives the gesture a certain rigidity and makes the statue a purely formal representation of the idea of the attacker.

A statuette of Zeus in Munich (fig. 4.17), grasping a thunderbolt in the left hand and a rolled object, perhaps another thunderbolt, in the right, provides a close parallel to the Ugento god. Here, too, the arms are extended more formally than threateningly. The legs are spread but both feet remain flat on the base, the body firmly balanced over them. The strong line of the diagonal right leg continues upward through the swelling forms of the torso, giving an impression of forward impetus. The god's torso is taut and does not twist so markedly as that of the Ugento god, for the right arm is merely raised as if cocked, not drawn back. As a result, the profile view is less effective than the more frontal angles.

Certain details of the two striding gods are similar. On both

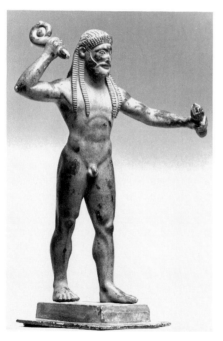

4.17 Bronze statuette of Zeus, ca. 530–520 B.C. Total H 0.186 m. Munich, Antikensammlungen Br. 4339. Courtesy of Staatliche Antikensammlungen und Glyptothek, Munich.

44. Degrassi, pp. 31–32, 152.

45. Degrassi, p. 32, argues that the attribute was an eagle. A flower or fruit is held by a bronze female figurine, perhaps a maenad, in Taranto, National Museum 4780: Degrassi, p. 95 and pl. 55a.

46. Degrassi, pp. 7–10, 27–30, 34, 112; figs. 2, 10; pls. 26, 28. For the alloy of the grapes, see below.

47. The low circular support under the heel is modern.

bronzes, for example, the pubes are unadorned, being simple concave curves coming to a central point. This line is incised on the Munich Zeus, raised on the Ugento god. The Munich Zeus has neat rows of tight curls ringing the forehead, rolling back over a plain fillet, rather than a diadem. Two long locks hang symmetrically over each shoulder, falling to just below the nipples, the same point as on the Ugento god. But the familiar, sharply delineated hair hangs loosely behind, gathered lightly with a broad band at shoulder level, and not looped up, as on the Ugento god. The beard is short, as on the Ugento god, but smooth, overlapped by a more generous and elegant moustache. The Munich statuette is dated between 530 and 520 B.C. and assigned to Corinth,[48] although Taras, very near Ugento, may be an equally strong possibility.

The evidence for the base of the Ugento god is substantial enough to give us some insight into the intended viewpoint for the statue. The statue was attached by lead dowels to a narrow rectangular bronze base. This base was set in turn into a shallow rectangular cutting in the center of the decorated stone capital, which originally crowned a column.[49] Nevio Degrassi has reconstructed a height for the capital and column of approximately 1.6 meters. Such a base would have put the figure at a height at which it could have been seen equally well from a distance and from close by. From a distance, the profile view of the figure was surely intended, for it has a simple but powerful silhouette. The pose and gesture are common ones for statuettes during the late Archaic and early Classical periods, and the profile view is often intended. We see it on coins, a type used especially for representations of Zeus and Poseidon, always in profile.[50] An interesting variation can be seen on a Campanian vase of the fourth century B.C., where a diminutive profile figure of Zeus on a tall column is shown from behind, the thunderbolt drawn far back over the right shoulder, and the left arm, an eagle perched on the wrist, extended in the foreground.[51]

48. Michael Maass, *Griechische und Römische Bronzewerke der Antikensammlungen* (Munich, 1979), pp. 17–19. See also Günter Kopcke, "Eine Bronzestatuette des Zeus in der Münchner Glyptothek," *Münchner Jahrbuch der bildenden Kunst* 27 (1976): 7–28: northeast Peloponnesos.

49. Degrassi, pls. 19–21.

50. For variations on this common pose, see Ch. Karouzos, "Ho Poseidon tou Artemisiou," *Deltion* 13 (1930–31): 55–67.

51. Berlin, Staatliche Museen 3167 V.I., H 0.60 m. See A. D. Trendall, *The Red-Figured Vases of Lucania, Campania, and Sicily* (Oxford, 1967), vol. I, pt. 2, no. 785, p. 338 and pl. 131.2; Campanian, Ixion group, later fourth century B.C.

A look from above at the positioning of the Ugento god on the capital reveals that the figure is not directly aligned with its bronze base but is turned to the right, as would be expected from the position of the right arm, drawn back to strike. At the same time, the gesture is static or self-contained, with no convincing forward movement indicated. Instead, the spread but bent arms are balanced formally above the diagonals of the firmly planted legs.[52]

If we assume that the front of the statue base faced a path, we can reconstruct three logical viewpoints for the statue. From a distance, viewers saw the figure in profile, and probably noted simply the bent arms framing an erect head, the massive, slightly parted legs, and the attributes. Nearby, viewers would have progressed to the right front of the statue, where they would be confronted by the three-quarter view. Here they would have had the clearest view of the details of head, hair, and beard, and would have gotten a sense of the foreshortening in the extended torso, while inspecting the attributes at closer range. Last of all, as they passed in front of the base, viewers could have read the dedicatory inscription.

Technical study has revealed that the hands and feet of the Ugento god are solid-cast and that the rest of the statue is filled with clay and contains a simple iron armature like the one found in the Piraeus Apollo. Joins between parts have not yet been identified with certainty, but it has been surmised that the hands, feet, and head, the long shoulder locks, the diadem and wreath, and the attributes were all separately cast.[53] It would of course have been possible, particularly since the statue is less than half lifesize, for it to have been cast in one principal piece, with the later addition of the shoulder locks and the attributes. In this case, the statue could be a simple direct casting, modeled in wax over a core with an armature.

Although very few alloys of Archaic bronzes are so far known, analyses of the Ugento god have produced results suggesting a high degree of sophistication among the bronze sculptors of sixth-century southern Italy. The statue consists of 86.78 percent copper, 8.47 percent tin, and 3.5 percent lead, plus various impurities. The alloy of the bronze base contains a significantly larger amount of lead: 73.98 percent copper, 4.68

52. See Degrassi, pl. 11b. Degrassi (p. 42) prefers to call the figure an epiphany of the victorious god rather than an attacking god.

53. Degrassi, pp. 138, 142. Degrassi's suggestion (p. 147) that head and hands may be indirect castings is not so far supported by the evidence. He does not comment on the thickness of the bronze or the character of the insides of the walls.

percent tin, 19.58 percent lead, plus impurities. The intention was clearly to ensure that the base was heavy enough to stabilize the statue. The bunch of grapes found with the statue is made of a totally different alloy, consisting of 90.76 percent lead, 6.09 percent tin, and 2.06 percent silver. With this evidence, we see that even at an early date an artist working in bronze was perfectly capable of calculating alloys to satisfy particular requirements. So far as we know now, artists working in mainland Greece during the Archaic and Classical periods did not deliberately add lead to the alloy, but the practice was common in Etruscan and western Greek workshops.[54]

Pliny suggests that alloys varied from place to place. He reports that Corinthian bronze, first produced by chance when Corinth was burned in 146 B.C., could be white (with silver in the alloy) or yellow (with gold in the alloy), or could contain equal proportions of all the metals. Delian bronze, he says, was first used for the feet and framing of dining couches, and later for statues of gods and men. Finally, Aeginetan bronze is famous, he has heard, not because the metal was mined on the island but because of the alloying done in workshops there, and was used by Myron, in rivalry with Polykleitos, who used Delian bronze. Pliny is less concerned with chronology than with natural history, and thus with medium, which leads him to mention the places known for the alloying of types of bronze.[55]

A bronze head and neck in Berlin (fig. 4.18) belonged to a statue, probably of kouros type, which stood about a meter in height. Said to be from Kythera, the head was acquired in Athens in 1873, stolen in 1975, recovered in 1982, and restored in 1984.[56]

54. Degrassi, pp. 27, 135–37. It now seems certain that the inclusion of lead in the alloy does not show an ancient bronze to be of Roman date, as was at one time believed; see, e.g., Charbonneaux, *GB*, p. 22; and E. R. Caley, *Analysis of Ancient Metals* (New York, 1964), p. 117. Instead, the presence of lead seems to be indicative of an Italian provenance.

55. *NH* 34.6–10. Elsewhere Pliny discusses copper from Cyprus (with lead, a purple color is produced in the alloy) and bronze from Campania (with lead, it is good for utensils) and Gaul. He also describes, in universal terms, the appropriate alloy for statues, consisting of copper ore, a third part of scrap bronze, and either $12\frac{1}{2}$ pounds of silver-lead to every 100 pounds of molten metal or one-tenth part of black lead and one-twentieth of silver-lead (which makes the metal look like the Greek bronze in color). Finally, pot bronze contains 3 to 4 pounds of silver-lead for every 100 pounds of copper (*NH* 34.95–98).

56. See K. A. Neugebauer, *Katalog der Statuarischen Bronzen im Antiquarium,* vol. 1, *Die Minoischen und Archaisch Griechischen Bronzen* (Berlin, 1931), no. 195, pp. 94–96; and Ridgway, "Bronze Apollo," pp. 55n80, 57. W.-D. Heilmeyer has published a technical note that includes information about the head: "Neue Unter-

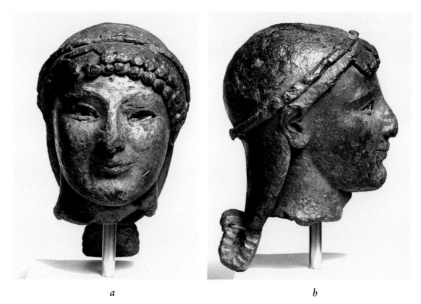

a *b*

4.18 Bronze head of youth, late sixth to early fifth centuries B.C. H 0.193 m. Berlin, Inv. Misc. 6324. Courtesy of Antikenmuseum, Staatliche Museen Preussischer Kulturbesitz, Berlin.

Often cited but rarely illustrated, the Kythera head is a thick casting, its original edge preserved for a short distance across the nape of the neck. A core remains inside the head, consisting of a coarse inner layer and a fine outer layer of clay, the latter bearing the rough outline of the bronze. The badly damaged surface of the work has obscured the extremely fine engraved strands of hair that radiate from the crown of the head. A rectangular hole in the crown may once have held a meniskos.[57]

Because of its feminine appearance, the Kythera head was once identified as female,[58] but it has since been described as that of a man. He wears the same hairstyle as the Olympia Zeus, without the locks that fall forward over the shoulders. The treatment of the hair must originally have presented a striking textural contrast. Two rows of separately cast spiral curls, flattened and almost doughy in appearance, are arranged across a rounded forehead. Some curls are missing at the right temple,

suchungen am Jüngling von Salamis im Antikenmuseum Berlin," in *Archäologische Bronzen*, pp. 137–38. Elsewhere in the same volume the head is cited as an illustration of current radiological techniques used in the study of ancient bronzes: J. Goebbels et al., "Fortgeschrittene Durchstrahlungstechniken zur Dokumentation antiken Bronzen," pp. 126–31. Heilmeyer, who kindly allowed me to look at the newly conserved head in 1985, is preparing a further study of the work.

57. This suggestion was made to me by Gerhard Zimmer.

58. A. von Sallet, "Beiträge zur antiken Münz- und Alterthumskunde: Aphrodite von Kythera," *Zeitschrift für Numismatik* 9 (1882): 142–43; H. Brunn, F. Bruckmann, P. Arndt, and G. Lippold, *Denkmäler griechischer und römischer Skulptur in historischer Anordnung* (Munich, 1888–1895), no. 222; H. Brunn, "Marmorköpfchen aus Meligu," *AM* 7 (1882): 118.

revealing that they were cast separately and attached in groups to the head. A tubular fillet following the same line as the curls was also separately cast and added after the fine strands of hair were incised. A narrow copper tubular tie gathers the long hair into a wavy knot, which originally lay on the statue's upper back.[59] There were once overlying curls, and a large irregular patch is visible on the knot.

The face is smooth and rounded, giving the impression of robust, chubby youth. The chin is strong, the line of the clean-shaven jaw plastic, and the mouth curves tautly upward in a smile. The nose was probably once straight, and the fleshy cheekbones are defined by indentations reaching diagonally outward from the nose. Narrow, thick-lidded eyes once set into hollows gouged in the core still contain some of the white glass paste that once held the pupils.[60] Copper eyebrows arc in a high smooth curve from the nose.

The round face, the delineation of the broad cheekbones, and the strong chin resemble the features of the Ptoon 20 Kouros and the Strangford Apollo.[61] The narrow, heavy-lidded eyes and the curving mouth are close to those of a marble head in New York.[62] Dates assigned to the Kythera head range nearly as widely as those of Richter's entire Ptoon 20 group, 520–485 B.C.;[63] the heavy lids may point to the later date. The hairstyle, though fairly common in bronze, does not appear in freestanding stone sculpture. The individual shoulder locks, however, which are not represented on the Kythera head, are carved occasionally on stone kouroi and appear commonly on korai of all periods and of many origins. The island of Kythera is close to Lakonia, and the production of the head has been assigned to a workshop in the Peloponnesos or Lakonia, or to Sparta, with Ionian influence.[64]

59. A. Furtwängler, *Bronzen*, p. 9, observes that the knot was cast separately, as on the Olympia Zeus. Computer tomography now reveals that the thick knot is cored: see Heilmeyer, "Neue Untersuchungen," fig. 9, p. 137.

60. Heilmeyer, "Neue Untersuchungen," p. 138.

61. Ptoon 20 Kouros: Athens, National Museum no. 20; Richter, *Kouroi*, no. 155, p. 134, figs. 450–57. Strangford Apollo: London, British Museum no. B 475; Richter, *Kouroi*, no. 159, p. 128, figs. 461–63: late sixth century.

62. Metropolitan no. 19.192.11: origin uncertain; Richter, *Kouroi*, no. 172, pp. 141–42, figs. 505–6.

63. 520: Ridgway, "Bronze Apollo," p. 57n96. Late sixth century: E. Buschor, *Frühgriechische Jünglinge* (Munich, 1950), p. 94. 500–490 B.C.: Neugebauer, *Katalog,* p. 95.

64. Peloponnesos: H. Brunn, "Archaischer Bronzekopf im Berliner Museum," *AZ*, 1876, p. 28, and *Kleine Schriften*, vol. 2 (Berlin and Leipzig, 1905), pp. 141–52. Lakonia: Herrmann, "Archäologische Grabungen und Funde," p. 296. Sparta, with Ionian influence: Buschor, *Frühgriechische Jünglinge,* p. 94.

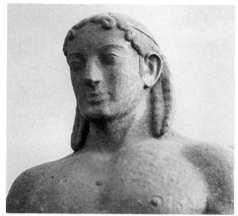

b

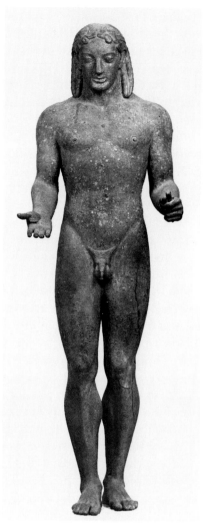

a

4.19 Piraeus Apollo, late sixth to early fifth centuries B.C. Piraeus Museum. H 1.91 m. (*a*) Courtesy of Ministry of Culture, Athens; (*b*) photo by Carol C. Mattusch.

According to the literary testimonia, bronze was frequently used to make cult statues during the Archaic period.[65] The monumental scale of a bronze kouros found in Piraeus in 1959 (fig. 4.19) suggests that Apollo is represented.[66] Traces of the

65. For all materials used and for citation of evidence, see I. B. Romano, "Early Greek Cult Images" (Ph.D. dissertation, University of Pennsylvania, 1980), pp. 351–81.

66. See Richter, *Kouroi*, no. 159 bis, pp. 136–37; E. Vanderpool, "News Letter from Greece," *AJA* 64 (1960): 265–67; and "Discovered in a Sewer at Piraeus: Remarkable Works of Art," *Illustrated London News*, 29 August 1959, pp. 130–31. In 1975 P. Kalligas kindly allowed me to look at the material saved from the interior of the statue.

attributes that he once held support this identification. It is generally agreed that the attributes were a bow, once gripped in the left hand, and a patera, held on the right palm.[67] We see the same type of Apollo illustrated on a fragment of an Apulian vase. There, inside a temple, stands an oversize gilded bronze statue of Apollo. He has a bow in the left hand and a phiale or patera in the right.[68]

It has been suggested that the Piraeus Apollo and the other statues found with it were brought as a group from a sanctuary on Delos to Piraeus in 88 B.C., and were in storage there when the port city was destroyed by Sulla two years later.[69] On the basis of style, the production of the Piraeus Apollo is usually set at approximately 520 B.C. or slightly later.[70] The long massive hair, reminiscent of that of the Agora Apollo, falls onto the upper back in separate strands, simple beaded tresses ending in points. Neither the length of the hair nor the simple marking of the locks is unusual in the context of marble kouroi, but the total lack of detailing above the plain flat fillet is generally uncharacteristic of works in marble. On a kouros from Athens,

67. See Robertson, *HGA*, p. 182.

68. Amsterdam, Allard Pierson Museum 2579; G. Schneider-Herrmann, "Kultstatue im Tempel auf italischen Vasenbildern," *BABesch* 47 (1972): 31 and fig. 1*a*.

69. G. Dontas, "La Grande Artémis du Pirée: Une Oeuvre d'Euphranor," *Antike Kunst* 25 (1982): 32–33.

70. During cleaning, about eight small fragments of pottery were found stuck in the core of the Piraeus Apollo. Unfortunately, the sherds can be only very roughly identified: two are black-glazed, one very fine and the other coarser and thicker; one is a piece of cooking ware and the others are unidentifiable coarse-ware. In a paper delivered at the 1975 annual meeting of the College Art Association, C. Houser reported that E. Vanderpool had tentatively dated the sherds between 540 and 520 B.C. Vanderpool reiterated that opinion in conversation.

G. Dontas sees the sherds as being of indefinite date; he gives the statue a date of 480–470 and calls it Attic, with a combination of Archaic and Early Classical traits borrowed from a mid-sixth-century model of the northeastern Peloponnesos: "Ho Chalkinos Apollon tou Peiraia," *Archaische und Klassische Griechische Plastik,* ed. H. Kyrieleis (Mainz, 1986), pp. 181–92. See also B. Holtzmann, "Colloque international sur la sculpture grecque archaique et classique, Athènes, 22–25 avril 1985," *RevArch,* 1985, p. 308. Robertson, *HGA,* pp. 182–83, favors an early date; Richter, *Kouroi,* no. 159 bis, pp. 136–37: ca. 520; Boardman, *GSAP,* pp. 81, 85, fig. 150: 530–520.

Whether the statue is Archaistic rather than Archaic is a question that has occasionally been raised, despite stylistic and technical evidence to the contrary. The other works found with this statue are, after all, later, being dated usually to the fourth, third, and first centuries B.C. All were stored together in a warehouse that was destroyed during the first century B.C. See A. Perkins, "The Piraeus Kouros," abstract in *AJA* 72 (1968): 170. N. M. Kontoleon details stylistic problems that he sees with the Piraeus Apollo: "Zur archaischen Bronzestatue aus dem Piräus," *Opus Nobile: Festschrift Ulf Jantzen* (Wiesbaden, 1969), pp. 91–98.

however, and on one from the Ptoan Sanctuary in Boiotia, the crown of the head above the fillet is also plain, continuing in a broad section of hair below the fillet on the back of the head.[71] A short smooth spiral lock curls over the Piraeus figure's fillet on either side of the forehead and joins an undecorated plastic mass of hair at the temple.[72] Finally, a narrow flat lock, incised vertically after casting, falls in front of each ear like a sideburn.[73]

The eyes were cast with the head, as was also the case with two other works—the bronze from the Agora mold and the Boston head. Beneath delicately arched ridged brows the Piraeus Apollo has horizontal eyes, the upper lid curving above the iris. Both iris and pupil are incised, a feature that is occasionally found on marble works, where paint was used to point up the details.[74] The large plastic ears are naturalistic, with both tragus and antitragus shown. The ears are rendered as if they are being pushed out by the bulging mass of thick hair pulled behind them.

The body of the Piraeus Apollo is modeled in accordance with the principles for marble sculptures of kouroi produced at the beginning of the last quarter of the sixth century B.C. Smooth rounded shoulderblades protrude behind high, broad pectoral muscles. From the side, the spinal column can be seen to make an S-curve down the back. The nipples are incised. The rectus abdominus, marked by a central vertical depression, is modeled with two transverse divisions above the waist. The hips are horizontal and the pubes curve simply upward.

Both feet rest flat on the ground, and, unexpectedly, the right foot instead of the left one is advanced. There are other examples of this practice, however, including Kittylos of the pair

71. Athens kouros: Paris, Louvre MNC 748; Richter, *Kouroi*, no. 66, p. 82 (Tenea-Volomandra group, 575–550 B.C.). Ptoan kouros: Athens, National Museum no. 16; Richter, *Kouroi*, no. 101, p. 102 (Melos group, 555–540 B.C.).

72. Compare the kouros from the Ptoan Sanctuary, Athens, National Archaeological Museum no. 10: Richter, *Kouroi*, no. 95, p. 100, figs. 306–11 (Melos group, 555–540 B.C.), which also has undifferentiated scalloped hair over the temples.

73. A marble kouros from the Ptoan Sanctuary has the same detail: Athens, National Archaeological Museum no. 16; Richter, *Kouroi*, no. 101, p. 102, figs. 322–23.

74. Similarly incised iris and pupil can be seen on a marble kouros in Florence: Richter, *Kouroi*, no. 70, pp. 83–84, figs. 239–44, Tenea-Volomandra group, 575–550; on the limestone head of Hera in Olympia: Richter, *Korai*, no. 36, p. 38, figs. 118–21, ca. 600 B.C.; and on a sphinx from the Themistoklean Wall in Athens, of the second quarter of the sixth century: Boardman, *GSAP*, fig. 226, and Richter, *Gravestones*, figs. 38–39.

Dermys and Kittylos, a marble kouros in Agrigento, the Kritios Boy from Athens, and the Selinus Youth.[75] When statues of Apollo are represented in vase painting, they may have either the left or the right foot advanced, or both feet may be together.[76]

The simple frontal stance of the Piraeus Apollo is to be expected in a sixth-century work, but the marked inclination of the head in conjunction with the freely extended arms invites a certain contact with the viewer, an unusual feature for the kouros type. Throughout the Archaic period this freedom of movement is associated more with bronze statuettes than with marble sculptures of kouroi, and in this respect the artist of the Piraeus Apollo may have been influenced by small works in bronze and by the stylistic opportunities afforded by the ease of modeling instead of carving a work.

When the Piraeus Apollo was discovered, the left leg was broken off. Museum technicians inserted long wires into the break, some with mirrors attached, and managed to remove much of the clay core and an iron armature. The armature, consisting of straight iron rods, square in section, was distributed in five separate pieces throughout the statue. One heavy rod about 0.02 meter thick ran vertically from neck to groin; two similar rods were found inside the legs; and two smaller ones were inside the arms. None of the iron rods was connected to another, as is true of later bronzes, such as the Delphi Charioteer (fig. 6.6) and the Riace bronzes (figs. 8.3, 8.4). One museum technician said that during cleaning it was possible to see that there were no joins in the statue between the legs and torso, and that they were cast together in one piece. As we have seen, this was also the case for the statue from the

75. Kittylos: Athens, National Archaeological Museum no. 56; Richter, *Kouroi*, no. 11, pp. 48–49, figs. 76–77; Sounion group, 615–590 B.C. Agrigento kouros: Museo Civico; Richter, *Kouroi*, no. 182, pp. 145–46, figs. 547–49; Ptoon 20 group, 520–485 B.C. Kritios Boy: Akropolis Museum no. 698; Richter, *Kouroi*, no. 190, p. 149, figs. 564–69; Transitional group, 485–460 B.C. Selinus Youth: Palermo Museum; see fig. 6.7.

76. Left foot: Apulian red-figure fragment from Taranto, ca. 380 B.C.: Amsterdam, Allard Pierson Museum 2579; Schneider-Herrmann, "Kultstatue." Right foot: Attic red-figure bell krater from Nola, third quarter of fifth century, in Frankfurt: Beazley, *ARV²*, 1683, 1113–16, 31 bis; Romano, "Early Greek Cult Images," p. 457. Both feet together: Attic red-figure Nolan amphora from Capua, beginning of fifth century B.C.: British Museum E 336 (fig. 4.11, and n. 23 above); and a Lucanian red-figure bell krater, ca. 430 B.C.: Collection P. Ludwig, Antikenmuseum, Basel: K. Schauenburg, "Zu Götterstatuen auf unteritalienischen Vasen," *AA*, 1977, pp. 285–86, fig. 10; A. D. Trendall, *Early South Italian Vase-Painting* (Mainz, 1974), no. 27, p. 28.

Agora mold, but that was a much smaller figure; the quantity of bronze needed to cast the legs and body of the Piraeus Apollo would have been tremendous.

The arms of the Piraeus Apollo are said to have been cast separately from just below the shoulders, since, during cleaning, horizontal drips marking joins were seen on the insides of both upper arms. Air space between the insides of the upper arms and the torso supports the argument that the arms are not part of the same casting as the torso, but were separately cast and cut at an angle to fit the body.[77] The hands, part of the same casting, are solid bronze.[78]

The sandy clay core for the Piraeus Apollo was applied in a series of thin layers.[79] The clay is fairly rough, porous, and reddened around the armature, with shell inclusions. The layers that lie closer to the exterior consist of finer and more consolidated material. Where the clay originally lay directly next to the bronze it is fine and powdery, with a consistency similar to that of slip. Here and there it is burned.

The layers of clay closely follow the contours of the bronze. Where the outer layers of the core are preserved, they have the same forms as, for example, the rib cage and one shoulder. And the smooth and dense core repeats the smooth interior walls of the bronze. The walls are thick, ranging from approximately 0.006 to 0.010 meter.

At least six iron chaplets, square in section and about 0.002 meter thick, can be identified among the core fragments from the statue.[80] On the exterior of the statue, other chaplets can be located at raised brown corroded spots. Three lie along the center of the torso: one on the sternum, a second on the linea alba above the navel, and the third just above the pubes. A chaplet is also placed low on the outside of each deltoid, close above the point where the arms are joined to the statue. The arms have corresponding chaplets midway along the inside of either forearm and on the outer forearms below the elbow. One last chaplet, on the right calf, may have been paralleled by a corresponding one on the left calf.

According to the museum technicians, the head of the Piraeus

77. A small arm exhibited in Athens with the Archaic bronzes from the Akropolis (Athens, National Archaeological Museum no. 14816) has a similar large flat surface on the inside of the upper arm where it was originally joined to its body.

78. Robertson, *HGA*, p. 182.

79. See Appendix, "Core," no. 3.

80. See Appendix, "Chaplets," no. 1.

Apollo, like the arms, was cast separately. Large horizontal drippings of bronze around the inside of the base of the neck were explained as having resulted from a metallurgical join between neck and body. Evidently the join was effected right across the curls, which in fact look unusually rough across the back of the head. The technicians asserted that in front the join was low on the neck, and not hidden beneath the chin. Both the head of Zeus from Olympia (fig. 4.15) and the bearded head from the Athenian Akropolis (fig. 5.2) are divided in the same way, that is, high in the back and then lower and at a slight diagonal across the neck. The join at mid-neck must have been common practice, or at least well enough known for a vase painter to represent it on the incomplete statue of an athlete illustrated on the Berlin Foundry Cup (fig. 5.7).

The Piraeus Apollo, made in pieces, is probably an indirect casting. The fine core, which follows so closely the exterior form of the statue, and the disjointed armature both suggest the use of this process. The body and legs were cast together, as was the case with the statue from the Agora mold, and the head was cast separately. The two differ, however, in that the arms and pubes of the Piraeus Apollo were also separately cast and metallurgically joined to the body. The bottoms of the feet are open, including the undersides of the big toe, with flat ridges around the edges, and were filled with heavy lead tangs to stabilize the statue on its base.

In 1897 a bronze statue (fig. 4.20) was found in Livadhostro Bay off the north shore of the Corinthian Gulf, not far from Plataia.[81] Along the front and right edges of the rectangular bronze plinth, facing outward, an inscription in the Boiotian dialect reads "Sacred to Poseidon."[82] The plinth, with four feet for attachment in a larger stone base, is short, no longer than the combined length of both feet, but broad enough for the feet to be placed quite far apart. Thus the Poseidon has a frontal stance, one that is hardly more animated than that of a kouros. In contrast to this statue, the Ugento god (fig. 4.16) has a long

81. I am grateful to E. Touloupa for allowing me to look at the statue in the laboratory of the National Archaeological Museum in Athens before the present restoration work was done.

82. A fragmentary stone base from Taranto in the shape of a capital has a bronze plinth similarly inscribed on two adjacent edges, but facing inward (Boston, Museum of Fine Arts, Pierce Fund, 01.8214). The base has been dated between 500 and 490 B.C.: Comstock and Vermeule, *Greek, Etruscan, and Roman Bronzes*, no. 39, p. 39, with bibliography. See also D. K. Hill, "Bronze Working: Sculpture and Other Objects," in *The Muses at Work*, ed. C. Roebuck (Cambridge, Mass., 1969), figs. 6 and 7, p. 79.

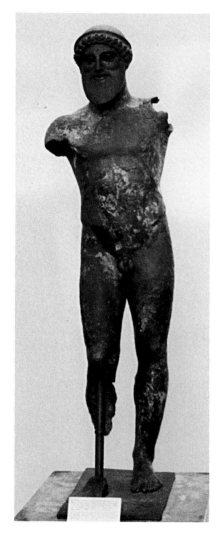
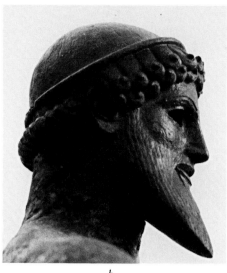

b

a

4.20 Livadhostro Poseidon, ca. 480 B.C. H 1.18 m. Athens, National Archaeological Museum no. 11761. Photos by Carol C. Mattusch.

narrow plinth, with the left foot well ahead of the right one, but the right foot positioned almost in line with the left, so that a direct frontal view is unsatisfactory, as it obscures the inner outlines of the legs and appears to give the god a precarious stance.[83] The position of the Livadhostro Poseidon also differs from that of the normal striding god and kouros types in that the right foot is in advance of the left, just as is the case with the Piraeus Apollo.

Both arms of the Livadhostro Poseidon are missing and the statue is heavily restored. The positions of the shoulders, how-

83. Degrassi, pl. 3a.

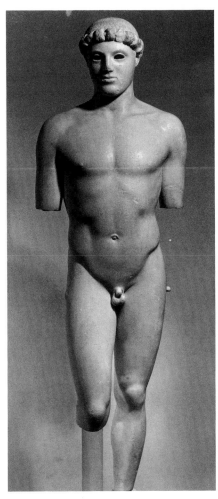

4.21 Kritios Boy, ca. 480 B.C. Pres. H 1.17 m. Athens, Akropolis Museum no. 698. Courtesy of Alison Frantz.

ever, indicate that the right arm was once extended forward, whereas the left was raised and drawn back to carry a weapon, probably a trident, in an attitude of striking.[84] The complexity of the pose is a sign of the Transitional date. The left shoulder is raised, and the gesture pulls the muscular torso slightly to the left. The right shoulder is advanced. The weight is planted firmly on the left foot and the left hip projects slightly. The right foot is set forward and the right hip correspondingly drops.

Several comparisons can be made between this statue and the marble Kritios Boy of about 480 B.C. (fig. 4.21). The Kritios Boy stands in the same position, but on more slender legs. He has the same slight deviation from the vertical, but his upper arms are at his sides, as is to be expected of a marble statue of the kouros type. The heads of both statues are turned almost imperceptibly to the right. Because of the Livadhostro Poseidon's poor surface condition, it is difficult to compare the musculature with the polished fluidity of the Kritios Boy. However, it is possible to see that the nipples of the Poseidon were once inlaid, an indication of the artist's interest in a variegated surface.

The head of the Livadhostro Poseidon, approximately one-seventh of the height the statue, appears to be slightly more stylized than the body. The full, spadelike beard was fully detailed in the wax: it is incised with groups of delicate wavy lines, interspersed at regular intervals by a deeper wavy channel. This neatly combed pattern is repeated in a neat ornamental tongue within the beard and in the curving moustache that frames the gently curving inlaid copper mouth. The upper line of the beard arcs just beneath the cheekbones. The long oval eyes and the low brows that follow the same curve were once inlaid; the lips and left brow retain reddish copper inlays.[85]

84. We might expect the positions of the arms to be reversed for an active pose. D. Philios suggests that the god was not striding but standing, resting one end of a trident on the plinth and holding a dolphin in his outstretched right hand: "Chalkoun Agalma Poseidonos ek Boiotias," *ArchEph* (1899), cols. 65–67. A red-figure amphora in Würzburg (L 502) may provide a parallel: it shows a rapidly striding Poseidon holding a fish forward in his left hand and a trident in his lowered right one: E. Simon in *Werke der Antike im Martin-von-Wagner-Museum der Universität Würzburg*, ed. G. Beckel et al. (Mainz, 1983), no. 42 pp. 98, 182–83; Beazley *ARV*², 195. This type, known from later sources but with the arms reversed, is also illustrated on Roman coins of Kenchreai: Imhoof-Blumer, pl. D LXI-LXII.

85. For reference to the inlaid brows, see Landwehr, *AGB*, p. 45, and Bol, *Grossplastik*, p. 90.

The noticeably plastic ears, the most naturalistic feature of the head, are half hidden beneath a double row of heavy spiral locks descending from a tubular diadem to a line low across the forehead. The hair radiates from the crown of the head and is incised, like the beard, with groups of fine wavy lines divided by regularly spaced deeper lines. The hair is rolled up along the nape of the neck, heavy ropelike locks with fine incision continuing the motif of the carefully separated spiral locks over the forehead.

The Livadhostro Poseidon is usually dated to approximately 480 B.C.[86] The beard, moustache, and mouth bear strong similarities to those features on the Akropolis Warrior (fig. 5.2), just as the body resembles that of the Kritios Boy. Workshop attributions include Aegina, Sikyon, and, somewhat more reasonably, Boiotia.[87]

Until the late 1970s, when the Livadhostro Poseidon was restored and placed on display, technical observations were fairly easy to make because the ill-preserved pieces of the statue were supported on a modern metal framework, which left the interior easily visible. K. Kluge, who had looked inside, suggested that the body was cast in sand after a wooden model, but that the head was a later lost-wax casting.[88] K. Lehmann-Hartleben expanded on Kluge's theory by arguing that the head, with its earlier style but later technique, represents an effort on the part of a mid-fifth-century artist to restore the sense of the lost original work.[89]

My own more recent investigations clearly indicate that the head and body of the statue do indeed join, and that the whole work was cast by the lost-wax process. Because of the statue's fragmentary condition, it is not possible to ascertain the number of pieces in which it was cast. It is safe to assume, however, that the arms were made in the same way as those of the Piraeus Apollo, that is, that they were cast separately from the point below the shoulders where they broke from the statue. And a close look at each foot reveals a seam that crosses the widest part just behind the toes. In other words, the front of the foot

86. Ridgway, "Bronze Apollo," p. 51n53; Robertson, *HGA*, p. 183.

87. Aegina: Philios, "Chalkoun Agalma Poseidonos," col. 72. Sikyon: Charbonneaux, *GB*, p. 95; E. Langlotz, *Frühgriechische Bildhauerschulen* (Nuremberg, 1927), pp. 32, 41–43, 100. Boiotia: G. Lippold, *Die Griechische Plastik: Handbuch der Archäologie* (Munich, 1950), p. 113.

88. Kluge, "Gestaltung," p. 16.

89. K. Lehmann-Hartleben, "Drei Entwicklungsphasen griechischer Erzplastik" (1937), *Boreas* 4 (1981): pp. 2–3n10.

was cast separately from the rest, perhaps to facilitate the process of attaching the statue to the bronze plinth. The same characteristic has been observed on various other bronzes of slightly later date, including the Selinus Youth (fig. 6.7) and the Riace bronzes (figs. 8.3, 8.4). As to the cold-working of the statue, the poor preservation of the surface prevents careful scrutiny of the details. However, a single deep patch hole can be identified on the right pectoral, measuring approximately 0.015 by 0.030 meter.

The walls of the bronze are thin and of uniform thickness throughout, following the exterior contours of the statue. The inner surface is fairly smooth and regular, a characteristic of an indirect lost-wax casting, which this statue must be.[90] Once again, we surely have evidence here for the early use of this technique.

To sum up, the earliest large cast bronzes that we have from Greece exhibit technical features that will also be found in the bronzes of later periods. They are hollow, cast in large pieces, the body being cast as one, and the head, arms, and legs cast separately. An armature of nonjoining rods may be found inside, as well as remaining core material. Eyes may be cast or inset, and eyelids and nipples may be inlaid. For attachment to their bases, statues may have the bottoms of the feet open, or the feet may be cast in two pieces.

Stylistically, bronze artists of the sixth century were content to follow the lead of stone sculptors. The statues that they cast could have been carved in stone, even though bronze has a far greater tensile strength than stone. But the use of a new medium evidently presented so many challenges that artists did not experiment with the new and freer poses that were now possible. Nor is there likely to have been a demand for innovative types of statues. It seems that the challenges sought by artists were not stylistic, as we might expect, but technical. In fact, Rhoikos and Theodoros are known not only for being the first men to cast large statues in bronze but, as we have seen, for their work in other media, an ability characteristic of a number of artists during the Archaic and Classical periods.

As we have seen, hollow casting was not a new idea in Greece during the sixth century B.C. But the scale of cast bronzes was beginning to increase. And the widespread interest in producing lifesize or larger figures, developed in stone, was surely an incentive for artists working in bronze. Perhaps it was the

90. Mattusch, "BFC," p. 438.

genius of Rhoikos and Theodoros that made large-scale casting possible, with the introduction to Greece of a way to cast large statues, no doubt in more than one piece.[91] Once this accomplishment was mastered, it was possible to make bronzes that equaled marble sculptures in scale.

In fact, as we have seen, the earliest bronze statues closely resemble stone sculpture. Throughout the latter half of the sixth century, types were limited to simple standing, striding, or seated figures. At the same time, the artists who made solid bronze statuettes enjoyed far greater freedom in the representation of movement and in the use of space than did their colleagues who worked on a large scale. The work of most makers of statuettes was, of course, as simple as modeling and carving a figure in wax, and production expenses were limited. Moreover, their patrons were numerous. Vase painters, who worked only with line and consequently did not have to worry about volume, went even further than the makers of statuettes, experimenting with a wide range of poses and gestures, and with the illusion of three-dimensionality. Perhaps bronze sculptors did not at first realize that they could produce large freestanding figures that, because of the medium, differed altogether from the marble types they were imitating stylistically.

The naturally gleaming surface of bronze could be exploited for visual effects. Making his model in clay and wax, the artist also had more latitude for effecting changes while his work was in progress. This was a process of building up, not, as with stone, of breaking down. Mistakes could be corrected by the simple addition of more of the modeling medium. In fact, we can see in the early large bronzes that the artist worked the wax by hand-molding. The ear of the Boston head (fig. 4.12), for example, could have been carved to look as precise and delicate as the ear of a contemporary marble kouros, but it was not: the roughly worked ear is clear evidence for its having been modeled by hand in wax.

The physical characteristics of bronze as a medium were also at first ignored. The stiff frontality of the Olympia legs (fig. 4.3) is remarkably like what we see in contemporary stone kouroi. Bronze weighs far less than stone, however, and an artist did not have to fear that excess weight would defeat a pose he wished to create. A bronze statue can be made to assume any

91. Bol, *Grossplastik*, p. 9, suggests that Theodoros may have been famous for discovering a way to join pieces of a bronze statue, and uses as evidence the wooden statue of Pythian Apollo, which Diodoros says (1.98) that Theodoros and Telekles made in two pieces.

posture without breaking, whereas an extended stone arm may break away from its body if it is not supported. Nonetheless, stone remained the dominant medium for sculpture during the sixth century, and bronze artists followed the lead of stone sculptors for another century, ignoring the flexibility and the strength that characterize their medium. To be sure, the new techniques of working in clay and wax to produce a large hollow bronze statue quickly became popular, but no major changes in style occurred, for artists simply borrowed from the familiar conventions of stone sculpture.

5 CHALLENGES

The flexibility of methods for working bronze was surely an important attraction for the Archaic artist, and we must assume that the bronze sculptors of the sixth century B.C. were aware of the capabilities of their medium and of its advantages over stone. After all, they produced the models for their statues by working in clay and wax, materials in which mistakes can be corrected by the addition of more of the medium. The artists could carve the wax model, as we have seen, with linear details, as in the eyes of the Boston head and the kneecaps of the Olympia legs. Or artists could work the clay and wax by hand, smoothing and rounding such features as the cheeks and spiral curls of the Kythera head. In contrast, artists working in stone carved a block that would itself be the finished work. Mistakes could not be mended, and a nose cut too small had to remain as it was.

Bronze sculptors did not at first exploit bronze to produce new types of freestanding sculpture, which could be totally different from what was possible in stone. The statue from the Agora molds, the Piraeus Apollo, and other early bronze statues with rigid poses look like stone sculpture because the latter set the stylistic precedent for sculpture in bronze. As for bronze statuettes, types were based on functions that were entirely different from those of large-scale sculptures in stone. And it was to these large works that sculptors turned for inspiration as they began to examine the possibilities of using bronze on a large scale. Early bronze artists simply followed the already established stylistic conventions of the stone sculptor.

A larger-than-lifesize marble kore made by Antenor and dedicated by Nearchos on the Athenian Akropolis during the last quarter of the sixth century (fig. 5.1) illustrates the point.[1] The figure is massive, the ample proportions barely toned down by elaborate surface decoration. The left hand grips the skirt of the

1. See Richter, *Korai*, no. 110, pp. 69–70, figs. 336–40.

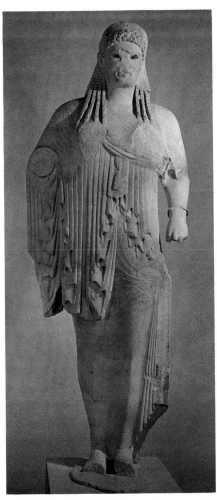

5.1 Antenor's Kore, last quarter of sixth century B.C. H including plinth 2.155 m. Athens, Akropolis Museum no. 681. Courtesy of Alison Frantz.

chiton, thereby creating an excuse for a linear scheme of repeating catenary folds across the front of the legs. In back, these folds become tight diagonals. The side fold below the hand is sharp and clear. A short himation has heavy vertical pleats that descend to strong hollowed zigzags along a rising and falling hemline. Four locks of long hair splay neatly forward across each shoulder, and a triple row of spiral locks over the kore's forehead is crowned by a diadem. Holes in the diadem suggest that bronze ornaments, perhaps rosettes, were originally attached to it. Earrings were also added. The eyes were separately inset and were no doubt framed by a set of bronze lashes.[2] Finally, painted decoration was lavishly applied to the diadem and the chiton. The colors used can only be imagined, but they probably included black and white, red, blue, yellow, and green.[3] The effect of the whole statue must have been striking, with the brightly painted surface and the gleaming bronze attachments highlighting the massiveness of the broad-shouldered kore. Antenor's familiarity with other media, and especially with the working of bronze, is immediately apparent.

Antenor was surely one of the most famous artists of the late Archaic period. He is mentioned frequently in the literary testimonia, but the work with which he is most notably linked is not a marble kore but a bronze group of the Tyrannicides, who killed Hipparchos in 514 B.C. Pliny tells us that this was the first work erected to commemorate heroes, and he dates the group: "The Athenians were, I believe, introducing a new custom when they set up statues at the public expense in honor of Harmodios and Aristogeiton, who killed the tyrants. This occurred during the same year as the one in which the kings were driven from Rome."[4]

In telling the story of Harmodios and Aristogeiton and their heroic act, Thucydides explains that the youthful Harmodios, lover of Aristogeiton, had twice turned down the advances of Hipparchos, who in turn insulted the youth's sister.[5] Hippias, the older brother of Hipparchos, was the one who held the power. When the political conspiracy to kill Hippias went awry, Harmodios and Aristogeiton, spurred on by their personal feelings, took the opportunity to kill Hipparchos instead.

2. Richter, *Korai*, p. 70, calls the eyes "purple glass, and set in a metal case." Boardman, *GSAP*, no. 141, p. 124, identifies them as "rock crystal set in lead."
3. See Richter, *Korai*, pp. viii, 69.
4. *NH* 34.17.
5. Thucydides 6.53–59.

They were both killed, and for a short time the Athenians suffered greater oppression than before. The Tyrannicides were revered nonetheless, and after the fall of the tyranny in 510, Antenor made bronze statues of them which were erected in the Athenian Agora. Carried off to Persia by the army of Xerxes which invaded and destroyed Athens in 480 B.C., Antenor's statues were later returned to the city by Alexander the Great or by one of his successors. They were reerected beside a second pair that had been made by Kritios and Nesiotes only three years after the Persians' destruction of Athens.[6]

Antenor's Tyrannicides were especially important for being the first work set up in the Athenian Agora to commemorate a heroic political act. Unfortunately, we are not certain about the appearance of his Tyrannicides. Groups were by no means unusual. The so-called portraits of Kleobis and Biton, of about 600 B.C., are so stiffly alike that they cannot be distinguished from each other and clearly belong in the category of kouroi, not in that of portraits.[7] Similarly, the bronze Apollo at Didyma by Kanachos and the wooden one like it in Thebes were probably of the usual kouros type, even though the bronze one technically became a group sculpture by the addition of a bronze stag. The names inscribed on the statues served to identify them. Antenor's Kore still falls firmly within the Archaic tradition, and we can assume that another work by Antenor, albeit one in bronze, was similar in style to what we see in the kore. His bronze group sculpture may have been no more than two figures standing side by side. There were Archaic conventions for distinguishing youth from maturity, however, and the older Aristogeiton was probably bearded in conformity with the accepted formula.

Antenor is the only Archaic artist who is known to have worked in bronze and by whom an original is today recognized. That the original is marble simply reinforces the point that artists of the sixth century often worked in more than one medium. The marble kore gives us a good idea of the style of his bronze Tyrannicides, for we have seen that Archaic bronze artists followed the conventions that had already been developed for freestanding stone sculpture. The marble kore also shows us that Antenor could produce colossal works, which we know to have been an Archaic predilection. His Tyrannicides

6. *NH* 34.70; Pausanias 1.8.5.
7. Richter, *Kouroi*, nos. 12A-B, pp. 49–50, figs. 78–81: Sounion group, 615–590 B.C.

were famous because of who they were, not because this was a sculptural group of innovative style or composition. More will be said about the Tyrannicides in chapter 6.

Many of the Archaic artists that we know by name are reputed to have produced groups, from simple chariots (Glaukias and Onatas) and two-figure groups (Hegias: Castor and Pollux) to large groups (Kallon: a chorus). Some of these works evidently included elaborate arrangements and poses, which might have been derived from contemporary pedimental groupings, such as those at Aegina. It is interesting to note that Onatas of Aegina produced two big groups, one representing Trojan heroes, the other foot soldiers, horsemen, a king, heroes, and a dolphin.

We know of many early bronze sculptors, some of them only from inscribed statue bases. Diopeithes, for example, is known from four bases in Athens dated between 500 and 480, three of which carried bronzes, the fourth a work in marble.[8] And the lost works of Gorgias can be dated with some assurance in the last quarter of the sixth century, on the basis of the letter forms used on his several statue bases.[9] Three or four bases from the Athenian Akropolis inscribed with his name held marble statues; two others supported bronze horses, probably with riders.[10] The horses were once attached to bronze plinths that were inserted into the marble bases. As this method was developed in Samos, it is possible that Gorgias studied with a Samian master or even in a Samian workshop.[11]

Pausanias tells us that the island of Aegina had its own *ergastērion*—that is, a workshop or perhaps even a school—which he observed to be different from that of Athens and evidently somewhat inferior to it. He adds a few puzzling details about the style: the shape of the he-goats on the island of Sardinia is similar to that of the wild ram modeled by artists on Aegina, except that their breasts are shaggier; of three ebony statues of Apollo at Megara, two of them are like Egyptian xoana, but the third resembles Aeginetan works; a black stone image of Artemis on the road to Antikyra is also of Aeginetan workmanship.[12]

8. Raubitschek, *Dedications*, nos. 106, 107, 279, 52.
9. Ibid., p. 502.
10. Ibid., no. 77, pp. 82–83; no. 147, pp. 163–65.
11. Ibid., p. 503. There is no evidence to support Pliny's statement that a Spartan artist named Gorgias worked during the 87th Olympiad (432—429 B.C.): *NH* 34.49.
12. Pausanias 7.5.5, 5.25.13, 10.17.12, 1.42.5, 10.36.5.

The Aeginetan style, then, was clearly recognizable, and not just for Pausanias, as he remarks when he describes an ebony statue of Artemis on the road from Tegea into Lakonia: "The manner of workmanship is called by the Greeks Aeginetan."[13] We can see that this well-known style of the Aeginetan artists was not at all limited to bronzes, but was recognizable in works made of wood and of stone. Furthermore, the Aeginetan style need not have arisen from work in bronze, but should be understood as a local style that could be recognized in works made of virtually any medium.

The workshops of Aegina produced an alloy of bronze that was so famous that some artists from elsewhere chose to use it. Pliny assigns some importance to the Aeginetan alloy of bronze, but ranks it behind Corinthian and Delian bronze. He tells us that Myron preferred it, and that Kanachos used the Aeginetan alloy for his Apollo Philesios at Didyma, evidently recognizing Aeginetan bronze by its appearance. He never mentions its color, however, and he may only have guessed that a bronze ox in the Forum Boarium was made of Aeginetan bronze because he knew that it came from Aegina and was probably familiar with that island's sculptural style. Pliny also knows that Aeginetan bronze was used especially for the production of the upper parts of candelabra.[14]

The marble pedimental figures on the temple of Aphaia at Aegina were richly embellished with bronze attachments, including bows, arrows, quivers, quiver straps, belts, helmet decorations, and locks of hair. The gorgon on Athena's aegis on the west pediment was bronze, but on the latest of the east pediments, Athena's aegis was adorned with marble snakes that were only attached with bronze. A huge ivory eye from the cella of the temple, with a bronze pupil, may have belonged to the cult statue.[15] Presumably the bronze additions were made of the Aeginetan alloy. The practice of accenting sculpture with bronze was by no means limited to Aegina.

As we have seen, the Aeginetan style was once recognizable in any medium. Of works today thought to be in the Aeginetan style, the only widely accepted attribution is that of the pedi-

13. Pausanias 8.53.11.

14. *NH* 34.8, 10–11, 75.

15. The eye, measuring ca. 0.085 m. across, would have been about the right size for a standing figure of approximately 3.50 m. in height or a seated one of perhaps two-thirds that size. For calculations of size based on eyelashes, see chap. 7, below.

mental sculptures from the Temple of Aphaia.[16] The artists were perhaps experimenting and may have been influenced by other media, whether bronze statuary or vase painting. The argument that the freedom of pose of these Parian marble figures, the sophistication of the composition, and the use of bronze attachments are derived from contemporary Aeginetan works in bronze is pure conjecture.[17] The whole question of Aeginetan style should be reassessed in the light of what is now known of Greek bronze techniques. It is perhaps time to discard the familiar but clearly untenable notion, based simply on literary sources, that bronze techniques affected the style of works in other media. It was rather the other way around for a long time, bronze sculptors relying upon stone precedents until demands of the market freed them from the earlier tradition.

Vase painters had the freedom allowed by working only with lines and in two dimensions: they were concerned not with support but simply with stylistic matters. Pedimental sculptors had the security afforded by the backdrop of the tympanum wall.[18] But sculptors of fully three-dimensional works in a flexible medium were guided by the types of freestanding sculpture that had been developed for stone. So far as we know, the freestanding figures of the Archaic period were limited to fairly simple forms—standing, striding, riding, and a few reclining males, standing females, and simple seated figures. Bronze artists, having discovered the technical possibilities of their medium, did not simultaneously free themselves from the traditions and physical limitations imposed by the use of stone. If indeed Aeginetan bronze artists were at first in the vanguard, they had a short-lived triumph, for their prosperous island was defeated by Athens in 456 B.C. and depopulated in 431, at which time Attic colonists were installed.[19]

The bronze head of a bearded warrior (fig. 5.2) was found in 1886 near the Propylaia on the Athenian Akropolis. The imposing individual was originally helmeted, for the hair, which lies

16. M. Robertson states unequivocally that the task of distinguishing schools and individual styles, "though often attempted, seems to me on the existing evidence impossible" (*HGA*, p. 97).

17. Carpenter, *GS*, pp. 115–16; also J. Charbonneaux, *La Sculpture grecque archaique* (Paris, 1939), p. 72; and M. Collignon, *Histoire de la sculpture grecque* (Paris, 1892), 1:280–301. F. Studniczka argues that the technique of hollow-casting was brought from Samos to Athens and the Peloponnese by way of Aegina: "Archaische Bronzestatue des Fürsten Sciarra," *RM* 2 (1887): 90–109.

18. See Robertson, *HGA*, p. 167.

19. Thucydides 1.105, 2.27.

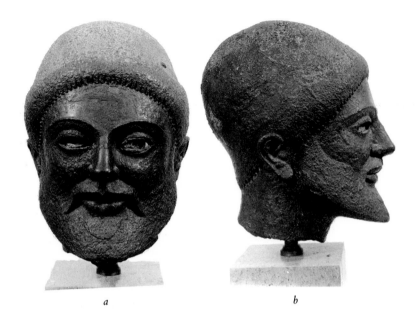

5.2 Akropolis Warrior, early fifth century B.C. H 0.29 m. Athens, National Archaeological Museum no. 6446. Courtesy of National Archaeological Museum.

a *b*

thick across the forehead, was left flat and undetailed on the rest of the head to receive the helmet. Stanley Casson suggests that gouges on the left side of the head represent an attempt after casting to reduce the size of the head further, so that the helmet would fit.[20] The casting is a very thick one, measured once at 0.01 meter.[21] The edge at the base of the neck is broken and does not represent the original edge of the casting. A deep patch hole about 0.013 meter long remains at the break on the left side of the neck.

The Akropolis Warrior's head is set squarely on the neck, suggesting that the figure was frontal. If standing, the warrior was about 1.7 meters high, or approximately lifesize. The head has often been compared with the heads of the later east pediment from Aegina. The full, rounded beard comes to an angular, almost sharp edge when seen from the side. The finely incised hairs of the beard, resembling those of the dying warrior on the later east pediment at Aegina (fig. 5.3),[22] are mostly

20. Casson, p. 157.
21. Studniczka, "Archaische Bronzestatue," p. 95. Kluge identified the head as a sand casting from a wooden model: "Gestaltung," pp. 16, 28. I have not had an opportunity to examine the inside of the head.
22. See D. Ohly, *Die Aegineten*, vol. 1, *Die Ostgiebelgruppe* (Munich, 1976), pp. 107–8.

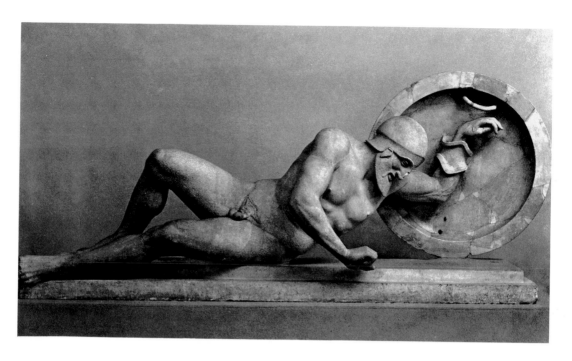

5.3 Dying warrior from Aegina. L 1.785 m. Courtesy of Staatliche Antikensammlungen und Glyptothek, Munich.

obliterated by encrustation on the surface of the bronze. The full, precisely modeled lips are accentuated by a stylized tongue pattern in the beard and by a moustache with long ends that curve gracefully onto the beard. A head of a warrior from the earlier east pediment at Aegina (fig. 5.4a) is remarkably close in these details, as in the slightly projecting cheekbones, defined by the smooth curves of the upper edge of the beard.[23]

The strongly outlined eyes of the Akropolis Warrior still retain some of the white paste into which the pupils were once set. Broad upper eyelids and smoothly arcing brows can be seen here, as in the Aegina heads from the earlier east pediment (fig. 5.4), though these brows form ridges. The hair of the Akropolis Warrior is a swelling smooth mass, with traces of the same fine incision that was used for the beard. Across the forehead a tight row of tiny flamelike curls makes a crisp sawtooth pattern from one naturalistic ear to the other. The original effect can be reconstructed from the Aegina head seen in figure 5.4b, where a double row of similar but heavier waves is also capped by a helmet.

We do not know whether the Akropolis Warrior was a legendary hero or a votive offering. The style, with its sharp lines and

23. The beard was painted rather than incised. See S. Karouzou, *National Archaeological Museum: Collection of Sculpture* (Athens, 1968; rpt. 1974), p. 22.

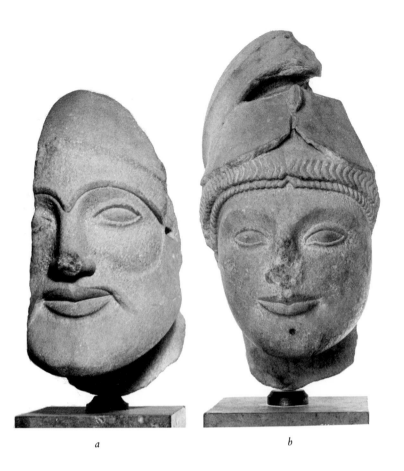

5.4 Heads of warriors from Aegina. H (*a*) 0.23 m.; H (*b*) 0.28 m. Athens, National Archaeological Museum nos. 1938 (*a*), 1933 (*b*). Courtesy of National Archaeological Museum.

a

b

angular profile, is so close to that of the Aegina warriors that we can assume that the artist was from Aegina, which is, after all, very close to Athens. The date, too, may correspond with that of the heads from the earlier east pediment at Aegina, but similarities exist with heads on the later east pediment as well. Thus the Akropolis head belongs somewhere between 500 and 480 B.C.

A second bronze head from the Athenian Akropolis, that of a youth (fig. 5.5), was found in 1866 while foundations were being dug for the Akropolis Museum.[24] The head is a thick casting, the surface deeply pocked by corrosion. Long hair is rolled around a fillet in front and knotted at the nape of the neck. Deeply incised strands of unparted hair radiate from the crown of the head. The hair is divided low in the center of the forehead

24. See A. de Ridder, *Catalogue des bronzes trouvés sur l'Acropole d'Athènes* (Paris, 1896), no. 767, p. 288. There may be no connection between this head and the objects that were buried after the Persians' destruction of the Akropolis in 480 B.C.: W.-H. Schuchhardt, *Geschichte der griechischen Kunst* (Stuttgart, 1971), p. 280; Houser also raises the question: p. 42.

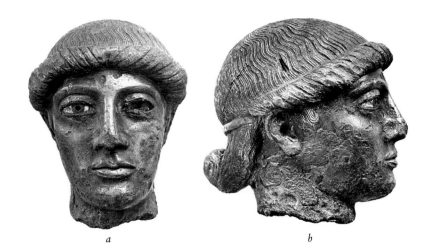

5.5 Akropolis Youth, ca. 470 B.C. H 0.13 m. Athens, National Archaeological Museum no. 6590. Courtesy of Deutsches Archäologisches Institut, Athens, neg. nos. N.M. 4947, 4948.

a *b*

and swept diagonally back to either side around the fillet. Just in front of the naturalistic ears, small tufts of hair are incised on the taut smooth cheeks. The rolled hair ends behind the ears and the fillet reappears, slightly indenting the hair. Lips and brows are inlaid with copper,[25] and the white and iris of the right eye retain their inlay. A groove above each lid emphasizes the broad, horizontal eyes.[26]

The head of the Akropolis Youth has the same taut contours, strong chin, and symmetrical features as the well-known Kritios Boy (fig. 4.21). The arrangement of the finely incised hair, parted only where it rolls over the fillet, is also similar, although the Kritios Boy lacks the knot behind. The Akropolis Youth probably also belonged to a figure derived from the kouros type, and its original height of probably 0.9 meter was just slightly less than that of the Kritios Boy. The strong chin, soft full lips, long straight nose, and heavy eyelids of the bronze head betoken the emerging early Classical style. The best date for the Akropolis Youth is probably around 470 B.C., as has frequently been suggested.[27] As for the provenance, if not Athens, a workshop in the northeastern Peloponnese has been postulated, specifically Argos.[28]

25. Ridder, *Catalogue,* p. 290.

26. Similar treatment of the hair and eyes can be seen on a terra-cotta head in the Ashmolean Museum, Oxford, dated to the second quarter of the fifth century B.C. See Boardman/Dörig/Fuchs, fig. 183.

27. See, for example, Touloupa/Kallipolitis, no. 22, p. 23. But Boardman prefers 460: *GSCP,* fig. 10.

28. Northeastern Peloponnese: Rolley, *BG,* no. 239, p. 232. Argos: Boardman/Dörig/Fuchs, p. 281.

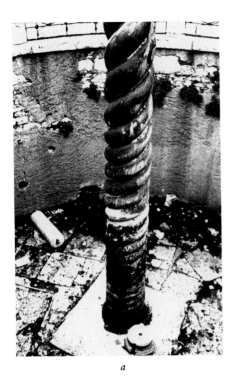

b

a

5.6 (*a*) Serpent Column from Delphi, 479
B.C., in Istanbul. Pres. H 5.35 m. Photo by
Carol C. Mattusch. (*b*) Upper jaw of ser-
pent from Serpent Column. L 0.338 m.
Istanbul, Archaeological Museum inv. no.
18. Courtesy Hirmer Fotoarchiv, Munich.

Herodotos mentions one bronze at Delphi which has sur-
vived until today (fig. 5.6). He describes a golden tripod bal-
anced on a three-headed bronze snake which was made for
Apollo with a tithe of the spoils from the Greek victory at
Plataia.[29] Herodotos does not give any more information, but
Thucydides quotes an inscription that specifically credits
Pausanias of Sparta with the dedication, which was, he says,
placed on the tripod but was quickly removed by the Spar-
tans.[30] Elsewhere, Pausanias notes that the Phokaians later
removed the golden tripod but left the bronze Serpent Col-
umn.[31] The column itself is no longer in Delphi, but was
removed to Constantinople in the fourth century A.D.

Most of the Serpent Column is preserved, to a height of 5.35
meters, with a maximum diameter of just over 0.60 meter.
Brunilde Ridgway has made a convincing reconstruction of the
original monument, suggesting that the tripod cauldron rested
on the coils and that the three serpents' heads reared up around

29. Herodotos 9.81. See W. Gauer, *Weihgeschenke aus den Perserkriegen, IstMitt,*
suppl., 2, 1968, pp. 75–96.
30. Thucydides 1.132.
31. Pausanias 10.13.9.

it like protomes.[32] The column now consists of only the tightly coiled body or bodies of the serpents. A vertical inscription on the coils naming the Greek cities that fought at Plataia has not been easily discernible in recent years.

No joins are visible on the Serpent Column, and it was once thought that it had been cast in a single piece.[33] It would have required an extraordinarily large casting pit, however, not to mention a vast quantity of molten bronze. And so it is far more likely that the column was cast in sections and that the joins were concealed among the coils of the three snakes. This would have been relatively easy to do, and was surely within the capabilities of artists working at Delphi, where only a few years later the Charioteer (fig. 6.6) was produced in seven pieces, its simple mechanical joins masterfully hidden.

The upper jaw of one serpent's head from the column is preserved (fig. 5.6*b*), and we can see that the viewer was supposed to be impressed by a long row of jagged, menacing teeth in a gaping jaw.[34] Round cavities for the eyes, gouged in the wax, originally held inlays, which no doubt added to the snake's fearsome appearance. Heavy arched eyelids are defined by three parallel arcs, which were cut deeply into the wax model. The nostrils were also hollowed out of the wax, and did not cut all the way through it. The walls of the bronze head range from 0.001 to 0.015 meter in thickness and are said to be smooth on the inside.[35]

Bronze statuettes would eventually provide the stylistic direction for large works in bronze, but solid casting, commonly used for small works, would not be the method. As we have seen, hollow casting was known by the seventh century and was used for protomes and also for some statuettes, such as both kouroi and korai from Samos (fig. 4.2).[36] The molds might be pieced together, as in the case of a miscast griffin protome from Samos (fig. 3.7), or perhaps even the wax model was pieced together.[37] The piecing of a full-size bronze statue, once the parts were cast, was known during the sixth century

32. B. S. Ridgway, "The Plataian Tripod and the Serpentine Column," *AJA* 81 (1977): 374–79.
33. Kluge, "Gestaltung," pp. 2–3; and thereafter, W. C. West III, "Greek Public Monuments of the Persian Wars" (Ph.D. dissertation, University of North Carolina, Chapel Hill, 1966), p. 79.
34. See Rolley, *BG*, p. 32.
35. P. Devambez, *Grands Bronzes du musée de Stamboul* (Paris, 1937), pp. 10–11.
36. See Gehrig, "Frühe Griechische Bronzegusstechniken," *AA* 94 (1979): 554–58 and figs. 10–13.
37. Ibid., p. 554, fig. 9 (piecing molds); pp. 547–52, figs. 1–6 (piecing model).

B.C., and the practice was followed for works as large as the Piraeus Apollo (fig. 4.19).

Why, then, does the Piraeus Apollo look so much like a stone sculpture? For one thing, because it was cast in only a few pieces. A large bronze cast in this way had to be fairly self-contained in order to minimize the size of the casting pit. The head, the genitals, and the arms of the Piraeus Apollo would have been cast separately, but the pit had to accommodate the body and legs of the statue as well as its heavy, bulky clay investment. The casting pit would have had to be approximately two meters deep and one meter across. Other problems encountered with a piece as large as the Piraeus Apollo were the large quantity of bronze used at one time, the size of the furnace needed to melt the bronze, and the importance of expediting the pour so that the molten metal would not solidify before the mold was completely filled.

Bronze has a far greater tensile strength than stone, and for this reason a bronze figure of any size can be given an active pose, arms and legs bent, raised, or fully extended, with no fear that the limbs will break off.[38] The only real constraint is the size of the casting pit. The Ugento god (fig. 4.16) already gives us an idea of the possibilities. The pose of the attacking god is not an unusual one in bronze, but in the Archaic period it is not represented at all in stone: the raised right arm could not have supported its own weight or that of the thunderbolt clasped in the fist. A stone arm or leg that is extended needs support, or it can easily break off.

Besides the opportunities afforded by the strength of bronze and its versatility as far as modeling is concerned, its naturally gleaming surface was an added attraction. It was possible to distinguish alloys by color. Pliny mentions white, yellow, and liver-colored alloys, and could evidently also recognize other alloys by their color.[39] He was not alone, for Cicero implies, in what is surely a sarcastic comment, that this was not so difficult a task as some people might suggest: "It is clear [Verres] that you alone appreciate Corinthian vases, you appreciate the composition of that bronze."[40] The original luster was at one time

38. For a general discussion of the uses of bronze in Greek sculpture and for a comparison of bronze and stone figures, see B. S. Ridgway, "Stone and Metal in Greek Sculpture," *Archaeology* 19 (1966): 31–42.

39. *NH* 34.8–12.

40. Cicero, *Verres* 2.4.98. See E. Pernice, "Untersuchungen zur antiken Toreutik," pt. 5, "Natürliche und künstliche Patina im Altertum," *JÖAI* 13 (1910): 102–7. For more recent discussion of Corinthian bronzes, see E. G. Pemberton,

protected, Pliny tells us, by a coating of bitumen: "In former times, they used to coat statues with bitumen" and "We have said that it [bitumen] was also used to coat copper and/or bronze and to cover statues."[41] Furthermore, the gleaming surface of a nude bronze statue gave an appropriate illusion of the suntanned body of the male deity or athlete.[42] It was primarily for such subjects that bronze would be exploited in the coming decades.

As we have seen, however, during the sixth century the bronze sculptor was strongly influenced by the traditions of stone, the older, dominant medium for sculpture. The polished surface of a bronze statue may have been the initial appeal of the medium, but among the earlier bronze statues that are preserved the texturing of the surface was almost entirely overlooked. The hair of the Boston head (fig. 4.12) is engraved very finely, almost imperceptibly, and that of the Piraeus Apollo (fig. 4.19) not at all. The sharp textural contrast that is possible between smooth and engraved bronze is explored more fully on the Ugento god (fig. 4.16), with its highly decorative detail. But the richly textured surfaces and great plasticity possible with deep carving of the wax model and engraving of the finished bronze are not fully exploited until the fifth century. As we shall see, the Artemision god (fig. 6.10) and the Riace bronzes (fig. 8.3, 8.4) demonstrate the striking contrasts that can be created between textured and smooth surfaces. Inlaid stone eyes, copper nipples, lips, and eyebrows, and even silver teeth were also used to vary the smooth polished surface of a statue and to create the illusion of nature.

The Archaic artist who chose to work in bronze was governed by convention: by the format of the cult or votive statue; by the stance of the kouros or of the striding god; and by the very restrictions of another medium, stone. The introduction of athletic statuary in the third quarter of the sixth century provided new opportunities for sculptors, and thus a new impetus for their art. "The first athletes who had statues dedicated at Olympia," Pausanias tells us, "were Praxidamas of Aegina, victorious in boxing in the 59th Olympiad [544 B.C.], and Rhexibios the Opuntian, a pankratiast who won in the 61st Olym-

"The Attribution of Corinthian Bronzes," *Hesperia* 50 (1981): 101–11; P. T. Craddock, "Gold in Antique Copper Alloys," *Gold Bulletin* 15 (1982): 69–72; and J. Murphy-O'Connor, "Corinthian Bronze," *Revue Biblique* 90 (1983): 80–93.

41. *NH* 34.15, 35.182.

42. See, e.g., a discussion between visitors to Delphi about the fresh or brilliant appearance of a group of bronze statues: Plutarch, *De Pythiae oraculis* 395B.

piad [536 B.C.]. These statues stand not far from the pillar of Oinomaos and are made of wood: the one of Rhexibios is made of fig; that of the Aeginetan is of cypress, and his statue is less worn than the other."[43]

Thus began the tradition of erecting statues of victors in atheletic contests. The first such statues were made of wood and were certainly formulaic, but the tradition would soon be established in bronze. The style for the new type of figure would involve the naturalistic representation of young athletes, many engaged in their sports, all intended to be admired for their physical prowess. As might be expected, this type was to affect all other types of Greek statuary.

Pliny tells us that "at Olympia, . . . it was the custom to dedicate statues of all who had won a victory; the statues of those who had won there three times were modeled as actual resemblances of the winners; they are called likenesses."[44] With this emphasis on the physical appearance of the victors, a whole new range of types, stances, and gestures was called for. And so that these poses could more easily be modeled, the statues of victors soon came to be made not of wood but of bronze. When Pausanias later described these statues, it was his habit to mention the material only if a statue departed from the norm by being made of wood or marble.

Pausanias introduces his description of the dedications in the sanctuary at Olympia by distinguishing between votive offerings and athletic statuary. "From here on, my narrative will proceed to a description of the statues and of the votive offerings. But I think that it would be unacceptable to mix the descriptions of them. For whereas on the Athenian Akropolis the statues and everything else are votive offerings, in the Altis some things are dedicated in honor of the gods, and the statues are among the things given to the victors in the games."[45] Athletic statuary is not just a new type, then; it also has a new function. Pausanias sees athletic statues specifically as commemorative works rather than as offerings to the gods. In this respect, they clearly depart from the traditional uses of statuary.[46]

43. Pausanias 6.18.7.
44. *NH* 34.16.
45. Pausanias 5.21.1.
46. This passage is discussed in J. G. Frazer, *Pausanias's Description of Greece* (New York, 1965), 3:623–24. The question of dedication versus commemorative monument is also raised by a statuette of a runner dedicated in Olympia ca. 480–470 B.C. and inscribed on the right thigh, "I belong to Zeus": Olympia Museum B

Bronze statuettes are the major source of evidence for the early development of Greek athletic statuary. Many statuettes of victors are preserved from many sites, ranging in date from the latter part of the Archaic period onward. The type was broadened to include all kinds of athletes—competing, training, victorious, and making offerings. To judge from the abundant literary sources and from the preserved statue bases, such works were made in all sizes, but the 250 or more mentioned by Pausanias at Olympia were apparently all large-scale. And with the introduction of these new and active types, the old techniques for producing large works were no longer satisfactory: they would have to change. A small casting pit like the one used to produce the statue from the Agora molds could not accommodate a lifesize statue of, say, a runner, nor would it be feasible to dig a casting pit that would. But during the latter part of the Archaic period, technical refinements were made, adjustments that dealt with the emerging problems and risks. The new methods quickly became familiar to artists and founders throughout the Greek world.

When one looks at the Olympia legs (fig. 4.3), at the Boston head (fig. 4.12), and at other large statuettes cast hollow and probably in no more than one or two pieces, they seem to have been conceived almost as colossal statuettes. The need to cast still larger works, which many patrons certainly requested for statues of victorious athletes, was probably also a major motivating factor in the development of piece casting. The old process was simply too unwieldy and too risky to be worth pursuing.[47] The statue made from the Agora molds (fig. 4.5) and the Piraeus Apollo (fig. 4.19) are among the earliest large bronzes known to us which were cast in more than one piece, albeit large pieces.

An Attic red-figure kylix in Berlin (figs. 5.7, A.30) provides remarkable insight into the contrast between the new styles and the old and unparalleled information about the techniques used by sculptors in the early fifth century. Found in Vulci, the kylix

26; H 0.102 m.; see R. Hampe and U. Jantzen, "Bericht über die Ausgrabungen in Olympia: Die Grabung im Frühjahr 1937," *JdI* 52 (1937): 77–82, 182. As Frazer suggests, the function of athletic statues probably changed somewhat from one period to another. See fig. 5.12.

47. As late as the sixteenth century, Cellini cast in one piece his eleven-foot Perseus, by his own account a colossus, for no other reason than to demonstrate his technical virtuosity. See *The Autobiography of Benvenuto Cellini*, trans. G. Bull (Baltimore, 1956).

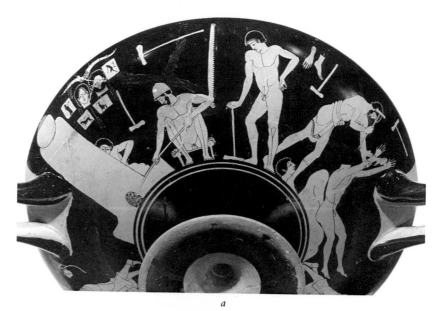

a

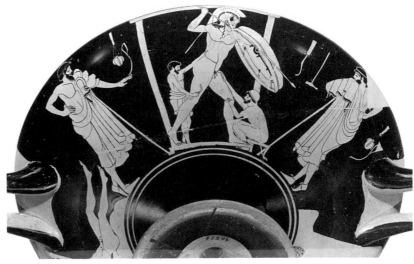

5.7 Berlin Foundry Cup, 490–480 B.C. Berlin, F 2294. Courtesy of Antikenmuseum, Staatliche Museen Preussischer Kulturbesitz, Berlin. Photos by Ingrid Geske.

b

is the name piece of the Foundry Painter and is dated to the late Archaic period, perhaps between 490 and 480 B.C.[48]

Of the two bronze statues represented on the vase, one is a striding warrior about twice the size of the two founders who are working on it (fig. 5.7b). The well-muscled, long-haired warrior, wearing only a helmet, raises his right hand, drawing

48. See Beazley, *ARV²*, 400, 1; *CVA*, Berlin 2, pp. 25–26; Ziomecki, no. 8, pp. 148–49; Zimmer, *Werkstattbilder*, pp. 8–16, pls. 1–5, fig. 2.

back a spear into striking position. The broad torso is turned so that the chest faces directly outward. From the waist down, however, the figure is in profile, as is the head. The right arm twists abruptly from a front to a back view at the bent elbow; the left arm is concealed by a large circular shield. A somewhat rigid forward motion is shown, the left leg flexed with the foot flat on the base, the right leg straight back on a diagonal, with the toes of that foot pushing off from the base as if in stride. The figure's youth is indicated by the clean-shaven face and the long hair. A single wavy tress spilling over the right shoulder onto the breast is reminiscent of the scheme used on such bronzes as the Ugento god (fig. 4.16) and the head of Zeus from Olympia (fig. 4.15).

The Foundry Painter has clearly tried to represent a stiff and "archaic" figure. A glance at the humans represented on the vase reveals a wide range of poses and a certain freedom in the representation of torsion and of three-dimensionality. For vase painters, after all, the late Archaic period was an experimental phase, in which the painted line was increasingly used to achieve the illusion of space and of realistic action within that space. And yet the statue shown here is of the same traditional Archaic type as the Ugento god. The attributes identify him as a warrior, and a close parallel can be drawn with a bronze statuette from Dodona, which, like the Ugento god and the Livadhostro Poseidon (fig. 4.20), is still attached to a bronze base.[49] As we should expect, the Foundry Painter's colossal warrior is evidently attached to a low-footed bronze base of the kind commonly used to attach statuettes to their stone bases.

The smaller statue painted on the other side of the kylix (fig. 5.7a) is strikingly different. It has been set on a mound of earth for assembly, and the completed head, ready for attachment, rests on the ground as a workman joins the right hand to the arm. The finished statue will be lifesize and will represent a slender, short-haired nude youth, arms stretched upward, legs slightly bent, feet extended. The body is shown in profile but slightly turned to the right, revealing a partial three-quarter view of the chest. This is an athlete in action, perhaps a runner or a jumper, represented in a graceful, naturalistic pose.[50] His

49. Berlin, Antikenmuseum Br. 7470. For other comparisons and other possible identifications, see Mattusch, "BFC," pp. 443–44, fig. 7.

50. See ibid., pp. 442–43, figs. 5–6, for suggestions as to the type of athlete represented. See also E. B. Harrison, "Early Classical Sculpture: The Bold Style," in *Greek Art: Archaic into Classical*, ed. C. G. Boulter, Cincinnati Classical Studies 5 (Leiden, 1985), pp. 40–41, for a discussion of the statue types depicted here.

pose is as free as that of any of the humans represented on the vase. Apparently the Foundry Painter wished to contrast two distinct types of bronze statue, one bound by Archaic formalism, the other demonstrating the relatively new naturalism that was to be characteristic of athletic statuary. His warrior is rigid in its traditional pose, whereas the freer pose of his athlete shows an awareness of the opportunities presented by bronze. It is this freedom that presages the directions to be taken by sculptors during the fifth century.

The Foundry Painter's technical references are so detailed that it is safe to assume he was familiar with foundry practice. A tall cylindrical furnace at the far left of figure 5.7a is being stoked by a bearded workman seated on a stool and wearing only a skullcap. A youth seated behind the furnace is working the bellows, and a second nude youth, resting on his long-handled mallet, watches the operation. A workman at the right, his mantle hitched up and rolled around his waist, hammers vigorously to join the hand of the athletic statue to the arm. Directly behind the furnace hang votives,[51] and elsewhere in the background are four hammers, a saw, and a pair of feet. The head of the statue, resting on the floor, is meant to have been cast separately, like the hand that the workman is attaching, and no doubt like other parts of the statue, whose joins have already been effected and concealed. The clearly visible evidence for piece casting on the Berlin Foundry Cup supports the more obscure evidence of, for example, the finished edge along the neck of the Olympia Zeus (fig. 4.15) and the reports of joins visible on the interior of the Piraeus Apollo (fig. 4.19).

Much later, in the second century B.C., Philo of Byzantion describes the same process: "First the craftsmen model the . . . statues, and then, after cutting them up into their natural parts, they cast [them], and in the end they put the pieces together and stand the statue up."[52] Philo does not describe how the modeling, melting, casting, and joining are actually accomplished, nor does he even make clear what it was that the sculptors cut up, the model or the mold. He implies that the original model is made of a soft, hand-workable material, that it is cut up or sectioned so as to yield manageable pieces for casting, and that the completed bronze pieces are assembled.

Pliny adds to the confusion by remarking, "Some say that clay modeling was first introduced in Samos by Rhoikos and

51. See Mattusch, "BFC," p. 436n13.
52. Philo of Byzantion, *De septem miraculis* 4.

Theodoros."[53] Does he mean clay modeling for bronze statuary? After all, the two artists are most often associated with that art. And if they are to be credited with introducing to Greece the method of piece casting for statuary, then surely they made the original model for such a work out of clay. If we assume that both Philo and Pliny are referring to indirect lost-wax casting, then their comments are readily interpreted.

Indirect lost-wax casting, as summarized by Philo and demonstrated much earlier by the Foundry Painter, is very well suited to the production of large bronzes. As we have seen, the sculptor first makes a model in an easily workable material such as clay. Piece molds taken from the model are used to make wax impressions, which are cored, invested, and cast. Then the statue is assembled. There is no danger of destroying the artist's model during casting: the models, like those for feet hanging on the wall on the Foundry Cup, can always be molded and cast again.[54] The pieces are not necessarily large, to judge from the Foundry Painter's depiction of the separate head and hand, so that most casting pits did not need to accommodate large, heavy pieces.

Quintilian, writing about oratory in the first century A.D., twice refers to the familiar process of piece casting. "Whoever claims that these commonplaces do not pertain to the orator does not believe that a statue is begun when its parts are being cast." Later he continues, "In fact, although all of the parts have been cast, it is not a statue until it is put together."[55] It has been suggested that the purpose of the tall furnace on the Foundry Cup (fig. 5.7a) is to melt the bronze needed to hard-solder the pieces of the statue together.[56]

On the basis of Pliny's comment that Lysistratos, the brother of Lysippos, developed a method for taking plaster casts from a human model, the introduction of indirect lost wax casting was at one time dated to the fourth century B.C.[57] As the feet hanging in the background on the Foundry Cup must be models, however, the process must have been in use by the early fifth

53. *NH* 35.152.
54. The feet appear to be models for the athletic statue just in front of them. See Mattusch, "BFC," pp. 439–40.
55. *Inst. orat.*, 2.1.12, 7.1.2.
56. E.-L. Schwandner and G. Zimmer, "Zum Problem der Öfen griechischer Bronzegiesser," *AA* 98 (1983): 61–70. For previous bibliography on the subject and for other representations of similar furnaces, see Mattusch, "BFC," pp. 436 and 435n5; Mattusch, "Agora," pp. 378–79.
57. *NH* 35.153. See, for example, G. M. A. Richter, *Ancient Italy* (Ann Arbor, 1955), pp. 112–16; and Hill, *WAG*, pp. xviii-xix.

century. That the process was depicted by a vase painter suggests further that it was not an experimental one, but one with which the public was already familiar. After all, there is evidence for the use of indirect lost-wax casting as early as the seventh century B.C.

There was even a precedent in clay for the indirect lost wax process. During the late eighth and seventh centuries, a technique was introduced whereby a terra-cotta statuette could be produced from a mold or matrix. First a clay figure or patrix was modeled; then a hollow mold or matrix was taken from the patrix; that mold could be used to make numerous copies of the original. By the sixth century, this process was used for mass production of statuettes.[58] Terra-cottas were inexpensive and were therefore widely distributed. By the early fifth century a similar indirect process was developed for the production of bronze statues, for in fact they too were based on clay originals. But here the point was not to make multiple copies of a single original. Instead, the preservation of the original protected an artist against the loss of the model during the long and risky casting process. The two molds for the head of the Agora bronze statue are testimony to the value of the indirect process, for in that case the artist had to prepare a second head for his statue (fig. 4.7), apparently to replace a failed direct casting. The additional time and expense must have significantly reduced the artist's profit from the commission.

The piecing together of the athletic statue on the Berlin Foundry Cup is complemented by the scene on the other side (fig. 5.7b), where two workmen smooth the surface of the colossal warrior with strigil rasps. The statue appears to stand in a scaffold or in the doorway of the foundry;[59] on the walls hang two oil jars, two strigils, a strigil rasp, and a hammer.

Two large, well-dressed bearded men watch the activity, one on either side of the scene.[60] Their colossal proportions, matching those of the statue, may be intended to stress their status or to place them on a different plane from the actual foundry activities. Or it may simply be a way of filling up the space on the kylix, and thus purely a compositional consideration. The same convention is followed on another vase by the Foundry Painter, where a well-dressed seated onlooker fills the space available on the cup: if he were standing, he would be larger

58. See E. Rohde, *Griechische Terrakotten* (Tübingen, 1968), pp. 10–11n10.
59. Scaffold: Zimmer, *Werkstattbilder*, p. 8; door: Mattusch, "BFC," p. 440.
60. Mattusch, "BFC," pp. 440–41.

than a second onlooker, than a centrally placed and actively involved stone sculptor, and than Athena herself, all of whom are shown standing.[61] The explanation here appears to be that the artist saw no need to imitate natural proportions, but preferred to arrange his figures in such a way that they filled the space on the exterior of the cup.

On the cup in Berlin, the Foundry Painter shows us the interior of a busy foundry, where four mature men and two young assistants are at work piecing one statue and polishing another. We are explicitly shown that the indirect lost-wax process is known, and that two markedly different sculptural types can be produced in a single workshop.

If it is true, as the Foundry Painter tells us, that two radically different styles of statue coexisted, the dating of works on the basis of style automatically becomes far more difficult than it was thought to be. The Foundry Painter represents one traditional Archaic type, a massive figure of a rigid striding warrior. The athlete on the other side of the vase demonstrates that the taste for colossi is by no means exclusive of other types and styles. Following the requirements of athletic statuary, this slender youth is lifesize, and represents an interest in naturalism and in freedom of movement.

The Foundry Painter is very much attuned to early-fifth-century trends in painting, and his concerns reflect those of his contemporaries. The human figures that he paints stand and sit, are seen from the front, from the side, and in three-quarter views from front and back. Torsion and three-dimensionality, a wide range of poses, and the use of drapery to define the bodily shapes beneath are characteristic of his figures.

The Foundry Painter suggests to us that these new directions were also being undertaken in bronze statuary. With the advent of athletic statuary, of which he gives us an example in his unfinished statue, the self-contained, blocklike figure was being transformed into one that was plastic, active, and naturalistic. Statues would now truly come to occupy the space around them, space in which they had in the past simply stood. Piece casting made it possible to create such works. That technique, apparently the innovation in Greece of Rhoikos and Theodoros, was widely known by the early fifth century. This technique and the new type, that of athletic statuary, gave bronze the

61. Munich, Antikensammlungen no. 2650. See Beazley, *ARV*[2] 401, 2; Boardman, *ARFVAP*, p. 137, fig. 264; Ziomecki, no. 34, p. 155; Zimmer, *Werkstattbilder*, pp. 6, 40, fig. 1.

impetus to become the most popular medium for freestanding sculpture in the fifth century.

Pliny in the first century A.D. and Pausanias in the second are our two most important sources of information about Greek sculptors and their works, and we depend on these two authors heavily. Pliny implies that he is being modest when he tells us that the thirty-six books of his *Natural History* contain twenty thousand important facts that he has acquired from one hundred major authors and about two thousand volumes.[62] In view of the breadth of Pliny's interests in the field of natural history, it is not surprising that his account of the great Classical sculptors and their works is somewhat disjointed and uneven. It is based, after all, on secondhand and often random information. Pliny's account purports to be chronological, but errors in date are frequent.[63] He mentions artists as they come to mind, or as one reminds him of another, or, most likely, as he has come across his notes on a particular individual. In general, Pliny remarks about unusual sculptures or about ones that were made by famous artists, and then often recounts an anecdote about the artist or briefly comments on what he has been told about the style or craft of that artist. Some of the works he has seen himself, because they have been brought to Rome; about others he has only heard. Usually Pliny's primary concern in his book on bronzes is simply with the names of the artists or with the subjects of their works.

Pausanias has the great advantage over Pliny of having traveled extensively in Greece. His account is ordered according to the progress of his travels. Here too, of course, are the stories he has been told, the historical, legendary, and sociological digressions that add immeasurably to his own observations. We are fortunate that Pausanias is intensely interested in documenting monuments, most of all sculpture, and that he often mentions the medium of which a work is made. If we sometimes despair of his brevity, we can be sure of Pausanias's honesty and accuracy.[64]

In the first century A.D., Pliny's sources inform him that three thousand statues still exist on Rhodes, and he believes that there are just as many at Delphi, Athens, and Olympia. He is

62. *NH*, Pref. 17.

63. See, e.g., his muddled dates for the great Greek artists of the fifth and fourth centuries B.C.: *NH* 34.49–50.

64. These qualities are discussed in C. Habicht, *Pausanias' Guide to Ancient Greece* (Berkeley, 1985).

also able to name nearly thirty bronze sculptors who worked during the fifth century B.C.[65]

While traveling in Greece during the second century A.D., Pausanias thinks worthy of mention a dozen or more bronze statues in Delphi, more than sixty in Athens, and forty bronzes in the Sanctuary of Zeus at Olympia, as well as hundreds of statues of Olympic victors, probably also of bronze but not specifically identified as such. He implies that there are many more than those he has chosen to cite, and gives the reasons behind his selections: "I shall mention only those [sculptors] who had some reputation and those whose statues happened to have been better made than others."[66] Pausanias is concerned primarily with the earlier statues at Olympia, works by famous artists or works about which he has something in particular to say.

The value of Pausanias, Pliny, and other ancient authors is great, and their information is not matched by the physical evidence, for, as we have seen, very few large-scale bronzes have survived. They could be remelted with ease, and bronze has always been expensive. Furthermore, it was used in many periods for weapons and ammunition. Unfortunately, the bronze statues preserved today are isolated examples, and all too often we think of them as objects without contexts. Their installation and their setting, whether religious or civil, and even their appearances have had to be reconstructed from other sources, from their bases, or from such secondary evidence as vase paintings, literary testimonia, and bronze statuettes.[67] Inscribed statue bases serve to identify some of the works that Pausanias omits, for instance, and a total of five hundred statues of victors in the Altis has been suggested.[68] With the addition of bronze votive offerings and other monuments, more than a thousand bronze statues may be supposed to have been standing in the Altis when Pausanias visited Olympia in the second century A.D.,[69] if not the three thousand that Pliny believed were there in the previous century.

Of the fewer than thirty bronze statues preserved from the

65. *NH* 34.36.
66. Pausanias 6.1.2.
67. The reconstruction of the appearance of a statue from its base is discussed in Raubitschek, *Dedications*, and M. Jacob-Felsch, *Die Entwicklung griechischer Statuenbasen und die Aufstellung der Statuen* (Waldsassen, 1969).
68. W. W. Hyde, *Olympic Victor Monuments and Greek Athletic Art* (Washington, D.C., 1921), p. 361.
69. Bol, *Grossplastik*, p. 1.

Archaic and Classical periods, only eleven retain the lower extremities, and of those only two are attached to their original bronze plinths. Typically plinths are rectangles with low feet that were once inserted into stone bases, in the same way that bronze statuettes were mounted. In the case of the Ugento god (fig. 4.16), the base was a Doric capital mounted on a column, which has been reconstructed to bring the small bronze god to a height just above eye level.[70] The larger Livadhostro Poseidon (fig. 4.20), on the other hand, would surely have stood on a lower stone base, so that the viewer could read the dedicatory inscription on the bronze plinth.[71]

Other large Archaic bronzes do not have bronze plinths still attached to them, but we can assume that these plinths too were rectangular, like most Archaic bases for statuettes, and that the figures were doweled to them. The plinths could in turn have been set into stone bases with low feet. This arrangement would have kept the statues from being easily dislodged. Heights can be assumed to have put the statues at approximately eye level. Viewpoints were then dependent on the settings of statues, but it can be argued that they were intended to be seen from the front (kouroi), the side, or three-quarter angles (striding gods), depending on the type of statue.

Pausanias recounts two incidents in which statues moved or were moved, both having to do with Theagenes of Thasos, a renowned athlete who lived in the first half of the fifth century B.C. "They say that when he was nine years old, going home from school, he was so impressed by a bronze statue of one of the gods in the agora that he hoisted it onto one of his shoulders and carried it back [with him]." The point of the story is surely that a statue was far too heavy for a person of normal strength to lift or even to dislodge from its base, but that Theagenes was strong enough to lift it even as a boy. In fact, a lifesize statue can easily weigh as much as half a ton. The legendary physical abilities of Theagenes are further attested by the report that he won 1,400 victories in boxing, running, and the pankration. After Theagenes died, a bronze statue commemorating him was attacked nightly by a former enemy. Finally, as if in retribution, the statue fell on the vandal and killed him.[72]

When a bronze plinth was not used, statues were normally attached to their marble bases by lead run into holes in the

70. See Degrassi, pl. 20a.
71. For a summary of the evidence provided by the feet of bronze statues regarding attachment to bases, see Bol, *Grossplastik*, pp. 85–87.
72. Pausanias 6.11.2, 5–6.

bottoms of the feet and into corresponding holes in the base. Examples can be cited of two holes in each foot being matched by two holes in the stone,[73] and of the bottoms of the feet being left entirely open to receive the lead (the Piraeus Apollo, fig. 4.19). Statue bases from Olympia dating from the first half of the fifth century as well as Athenian bases inscribed with the names of earlier Aeginetan artists had similar socket attachments, suggesting that the technique was introduced for cast bronzes by approximately 500 B.C.[74]

"The reason for erecting statues of men on columns was to raise them above other mortals," says Pliny.[75] Use of the column base for bronzes is not unusual. The unfluted column with a capital is attested not only by the well-preserved Ugento god (fig. 4.16) but also by a base in Athens from as early as 500 B.C., formerly with a bronze plinth, and by one dating from before the middle of the fifth century, which had a doweled statue.[76]

Low rectangular bases were also used for bronze statues during the late Archaic and early Classical periods, as were circular bases, large bases consisting of two or more blocks of stone, and pillars crowned with moldings or capitals.[77]

Statuettes provide us with numerous insights into the questions of how larger figures were mounted and oriented on their bases. For one thing, their bases raised them to the appropriate height for viewing. One statuette has been found *in situ*, with various other gifts, on an offering table in a sanctuary of Artemis at Kalapodi in Phokis (figs. 5.8, 5.9). Identified as Apollo, the figurine was sunk in lead in a depression in one corner of a stone offering table, facing the altar in front of the table.[78] From the lead, poured to mid-calf, emerges a figurine of kouros type, left leg advanced, arms free of the body and slightly bent. The short hair, encircled with a wreath, does not cover the ears, which, like the large eyes, the nose, and the mouth, are roughly marked. Both hands once held attributes, the one in the right hand cast with the figurine, the other separate. Beside the statuette lay a female mask made of terra-cotta.

73. Bol, *Grossplastik*, p. 85: the Artemision god (fig. 6.10 below).
74. Ibid., pp. 85–87; Raubitschek, "Statuenbasen," pp. 132–81.
75. *NH* 34.27.
76. Raubitschek, *Dedications*, no. 40, p. 43; no. 47, p. 49.
77. Ibid.: low rectangular bases, nos. 77–146; circular bases, p. 62 and no. 160, p. 177 (signed by Kritios and Nesiotes); large bases, no. 172, p. 62 (Bronze Athena on the Akropolis), and nos. 168, 171, 173, and 174, p. 62 (bases for four-horse chariots); pillars, pp. 211–12.
78. See R. C. Felsch, "Apollo und Artemis: Kalapodi Bericht, 1973–1977," *AA* (1980): 90–94. The Kalapodi statuette has been dated to 500 (Thomas, *Athletenstatuetten*, p. 128) or to 480–450 B.C. (Rolley, *BG*, p. 24).

5.8 View of offering table during excavation at Kalapodi. Photo courtesy of and copyright by R. C. S. Felsch.

The Kalapodi figurine is a unique find and its placement is surprising: we normally expect to see a statuette standing as an isolated ornament on a column or pillar base.

Statuettes of the Archaic period are generally meant to be seen in one of two ways. A god or hero striding forward as if balancing on his narrow base is usually best viewed in profile. An offering bearer or a kouros stands squarely on his base and was certainly meant to be viewed from the front. The viewpoint for a figure was sometimes established not simply by pose and gesture, however, but also by its placement on the base. The feet were not always positioned squarely, as can be seen from an inspection of inscribed statue bases. A low rectangular base from the Athenian Akropolis of the beginning of the fifth century, for example, had its bronze statue set in such a way that if one stood in front of the base—that is, facing the inscription—one would have seen the statue in three-quarter view.[79] Statuettes might also be attached to their plinths at an angle, though not many are.[80]

79. See Raubitschek, *Dedications*, no. 150, p. 166. Raubitschek suggests the interesting possibility that the name of the artist might be restored as Euthymides, the name of a vase painter who was concerned with problems of space and three-dimensionality.

80. See H. G. Niemeyer, "Attische Bronzestatuetten der spätarchaischen und frühklassischen Zeit," *Antike Plastik* 3 (1964): 15; I. K. Konstantinou, *Rhythmoi: Kineseon kai Loxai Staseis eis tēn archaioteran elleniken plastiken* (Athens, 1957).

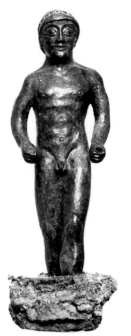

5.9 Bronze statuette from Kalapodi, fixed in lead. Early fifth century B.C. H with base 0.106 m. Courtesy of Deutsches Archäologisches Institut, Athens, neg. no. 78/728.

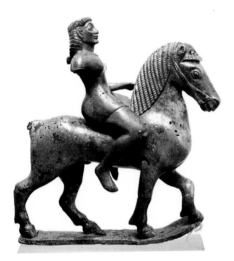

5.10 Bronze statuette of horseman from Dodona, ca. 575–550 B.C. H 0.11 m. (horse), 0.095 m. (rider). Athens, National Archaeological Museum no. 16547, Karapanos 27. Courtesy of Deutsches Archäologisches Institut, Athens, neg. no. 73/1086.

The Ugento god (fig. 4.16) and the Livadhostro Poseidon (fig. 4.20) are large-scale variations on a simple approach to alignment. Both statues are set lengthwise on their plinths. The plinth beneath the Ugento god is just wide enough for his feet. Enough is left of the Doric capital that held the statue to permit us to see that the plinth was aligned with the four sides of the square capital. Although the feet of the god are limited by the proportions of the plinth, the figure itself turns away from this rigid configuration. The right arm, raised and drawn back, forces the torso to turn to the right, so that the upper body faces one corner of the capital. The head too turns slightly to the right, but not enough to disturb the forward motion of the striding figure. The Livadhostro Poseidon's plinth is wider, providing room for the dedicatory inscription along its left side. This side would also have provided the better profile view of the figure, for the right foot is advanced, the right arm extended forward, and the left arm raised.

Only a few Geometric bronze statuettes deviate from the conventional pattern. One example of a truly three-dimensional figure is the Metropolitan helmet maker of the late eighth to early seventh centuries (fig. 3.4). In another remarkable group of the late eighth century, a hunter and his dog battle a beast that holds a small animal in its mouth.[81] The Samian flutist of the later sixth century (fig. 3.15), in contrast, is placed squarely on his base. Even an Athena Promachos of 460 to 450 adheres to the earlier convention: like the Ugento god, she raises her spear and points it directly forward, her movement confined by the placement of her feet on a narrow plinth.[82] A horseman from Dodona attached to a narrow base (fig. 5.10) can be seen satisfactorily only in profile. Both horse and rider face straight ahead, and the horse, though appearing especially stocky and broad in the chest and hindquarters, has his hooves so closely aligned that he seems to teeter on his narrow base. Another point must be considered, however: the rider may have belonged on a second horse from Dodona, now in the Louvre, and the figures may have formed a group representing the Dioskouroi.[83] If this was the case, despite their two-dimensionality, their association on a single stone base would have lent a certain spatial relationship to the pair.

81. Swiss private collection; H 0.102 m.; illustrated in Rolley, *BG*, fig. 35.

82. Athens, National Archaeological Museum no. 6447; H 0.30 m. Touloupa/Kallipolitis, no. 14 and p. 21: 450 B.C.

83. For this theory, see Touloupa/Kallipolitis, no. 6, pp. 16–17. For the horse in the Louvre, see Charbonneaux, *GB*, pl. XIX.1: H 0.097 m.

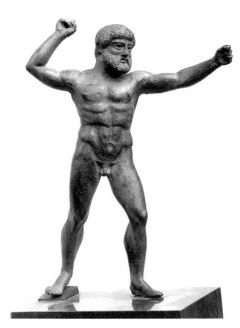

5.11 Bronze statuette of Herakles(?) from Mantinea, ca. 460 B.C. H 0.13 m. Paris, Louvre Br. 4171. Courtesy of Musées Nationaux, Paris.

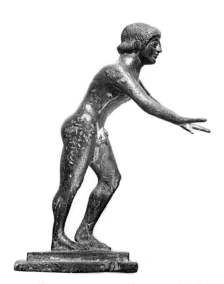

5.12 Bronze statuette of runner, first half of fifth century B.C. H 0.102 m. Olympia B 26. Courtesy of Deutsches Archäologisches Institut, Athens, neg. no. OL 811.

The convention of fixing the figure squarely on its base was not satisfactory for all types of figures. Even the type of the striding attacking figure was not always attached to a long narrow base. The statuette in Munich (fig. 4.17) shows Zeus standing on a broad base, left foot advanced and right arm raised to strike, but facing forward and easier to see from the front than in profile, like the Ugento god (fig. 4.16). The Munich Zeus is aligned squarely with the plinth. The artist has given him a broader base, however, and thus has suggested a somewhat unusual viewpoint for an old type. Another variation on the type can be seen in a statuette from Mantinea of about 460 B.C. (fig. 5.11). The figure, perhaps Herakles, has the forward leg in profile and the trailing leg turned frontally, emphasizing and continuing the near frontality of the twisted torso, in contrast with the leading leg.[84] The same is true of a Zeus from Dodona in Athens.[85]

Athletic statuettes still attached to their plinths reveal an even greater freedom of pose and variety of stance, but again probably through necessity rather than through an interest in experimentation. The introduction of athletic statuary in the latter part of the sixth century surely presented new problems of individualization, for not every athlete could be represented simply as a standing filleted victor. The very number of dedications at any one site probably precluded that approach. And so we frequently see the victor in his role as a runner, jumper, diskos thrower, spear thrower, ball player, rider, or whatever he was. For the pose of a spear thrower, there was of course an established type in the attacking god, who was, however, bearded, mature, and armed with weapons different from the attributes of the youthful athletes who had now to be represented.

Runners at the start are aligned with their bases, for the action itself proceeds in a straight line. The legs are positioned closer together than those of attacking gods, with the center of balance inclined forward, and both arms are extended, palms down, in front of the figure. A small bronze runner in Olympia (fig. 5.12) with raised head and alert expression, dating within the first half of the fifth century, is a fine example of this group.[86] A

84. See Rolley, *BG*, p. 89 and fig. 67, p. 90.

85. Athens, National Archaeological Museum 16546; H 0.127 m.; ca. 460 B.C. See S. Karouzou, *National Museum: Illustrated Guide to the Museum* (Athens, 1977), p. 99.

86. See Thomas, *Athletenstatuetten*, pls. III.1, IV.1, V.1, p. 40. Inscribed on the right thigh: "I belong to Zeus." See n. 46 above.

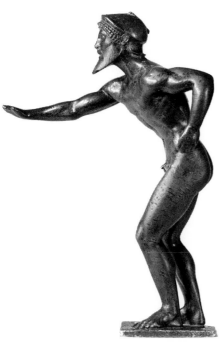

5.13 Bronze statuette of armed runner, beginning of fifth century B.C. H 0.164 m. Tübingen, inv. no. 1. Courtesy of Archäologisches Institut, Universität Tübingen. Photo by R. Balluff.

delicately muscled runner in Tübingen (fig. 5.13), once armed, is a variation on the same theme.[87] Both feet rest on the ground, the left just ahead of the right, as if the runner is about to raise it and spring into action. The runner has tensed for the start, knees bent, the well-muscled torso inclined forward. At the same time, the chest is turned convincingly toward us by the cocked left arm, on which he presumably wore a round shield. The right arm is stretched forward, palm down, and the bearded face is raised expectantly.

A statuette of a figure that once wielded a heavy long-handled instrument (fig. 5.14) is an excellent example of three-dimensionality in the early Classical period. A bearded nude, perhaps Hephaistos, stands firmly on the left foot, with the right foot back and balanced on the toes.[88] Both arms are raised above the head in the act of swinging an ax or a mallet, now gone, and the torso, taut with the effort, turns to the right, in the direction of the swing. The bearded head is inclined to the right with the force of the action. Inlaid eyes once added to the effect of a vigorous, lifelike figure. The statuette has lost its original plinth, and it is therefore impossible to tell how it was mounted; but its three-dimensionality was dependent on its pivoting pose, not on its mount.

Other pivoting figures are found primarily among the statuettes of diskoboloi, but they are relatively rare. Examples date primarily to the early Classical period and include a statuette of a short-haired filleted youth raising the diskos high in front of him (fig. 5.15a).[89] He steps forward onto his right foot, clasps the upper edge of the diskos with the spread fingers of his right hand, and steadies the diskos against the flat palm of his left

87. See Rolley, *BG*, pls. 76–77. It has been suggested that the Tübingen statuette represents an armed dancer: see U. Hausmann, ed., *Der Tübinger Waffenläufer* (Tübingen, 1977). For similar figures, see the interior of a cup in Leiden (Rijksmuseum van Oudheden PC 89), illustrated in *Tübingen Waffenläufer*, pl. 31.2, and an armed runner on a Nolan amphora in Paris (Louvre G 214; Beazley, *ARV²*, 203, 96: Berlin Painter). The left hand of the latter figure, in the same position as that of the Tübingen runner, grasps the shield strap. This figure wears greaves, however, and the Tübigen figure does not.

88. See G. M. A. Richter, *Catalogue of Greek and Roman Antiquities in the Dumbarton Oaks Collection* (Cambridge, Mass., 1956), pp. 25–26. For an alternative identification of the figure, see E. Langlotz, "Epimetheus," *Die Antike* 6 (1930): 1–14; and C. Picard, "Lycurgue L'Édone menaçant une 'Nourrice' de Dionysos," *MonPiot* 45 (1951): 15–31. For a bibliography, see F. Brommer, *Hephaistos: Der Schmiedegott in der antiken Kunst* (Mainz, 1978), p. 215: "fraglich oder unwahrscheinlich."

89. See Thomas, *Athletenstatuetten*, pl. XVII.1–2.

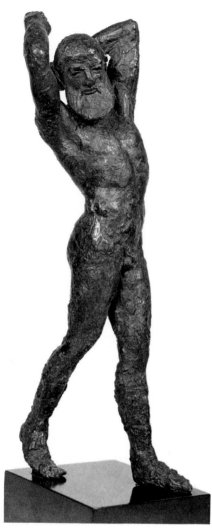

5.14 Bronze statuette of Hephaistos(?), early Classical. H 0.215 m. Washington, D.C., Dumbarton Oaks acc. no. 36.61. Byzantine Visual Resources, © 1987, Dumbarton Oaks, Washington, D.C.

hand. From the right side his face is hidden, but the indentation of his curving spinal column is clearly visible.

In the few instances where a preserved plinth is attached out of square with a statuette, the arrangement was apparently not dictated by the nature of the activity. A bronze statuette of a kouros from Samos (fig. 4.2), for instance, is turned slightly to the left on a stepped base.[90] One may wonder whether the absolutely frontal figure was attached in this way by design or by mistake. It was surely by design that a diskobolos in Athens (fig. 5.15b) was placed diagonally across its small squared plinth.[91] The action is at the point just beyond that of the diskobolos seen in figure 5.15a. The right arm, now partly missing, has lowered the diskos to hurl, and the youth steps back firmly on his left foot while pivoting on his right foot, now missing but once also planted solidly on the ground. The left arm is raised and bent at shoulder level, emphasizing the twist of the body to the right.

The diagonal placement of this diskobolos across its plinth reinforces our need for multiple and continuing viewpoints. A figure aligned with its base, in contrast, suggests only two vantage points: the front and the side. Even though a figure is often turned with the head or body at an angle to the strictly frontal or profile view, the alignment with the base visually fixes and stabilizes the whole.[92]

Groups afforded opportunities but were not necessarily exploited. We have several examples of both large- and small-scale groups of figures set on a single base. Perhaps the best known is the dedication from the Sanctuary of Hera on Samos, dating to the mid–sixth century B.C. Four marble statues stood, a fifth sat, and a sixth reclined, all in a row on a long narrow stepped base signed by the artist Geneleos.[93] The stone plinths of the figures were secured in the base by lead. Other groups are cited in literary testimonia and occasionally attested in inscriptions on bases from the Athenian Akropolis. These bases are usually for groups of bronze statuettes, such as a rectangular base with two rectangular sockets and one irregular socket, which Antony Raubitschek suggests contained two figures turning toward a third, central one.[94]

90. See U. Gehrig, "Zum samischen Opferträger in der Antikenabteilung," *JbBerlMus* (1975), pp. 49–50 and fig. 2.

91. See Rolley, *BG*, fig. 87, p. 106.

92. See H. G. Niemeyer, "Attische Bronzestatuetten der spätarchaischen und frühklassischen Zeit," *Antike Plastik* 3 (1964): 14–15.

93. See Boardman, *GSAP*, fig. 91.

94. See Raubitschek, *Dedications*, no. 81, pp. 86–87. See also nos. 79, pp. 84–85,

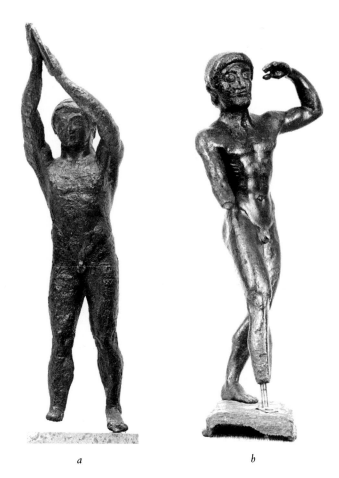

a *b*

5.15 Bronze statuettes of diskoboloi, early Classical. H (*a*), 0.19 m., (*b*) 0.20 m. Athens, National Archaeological Museum nos. 7412 (*a*); 6615, 6930 (*b*). Courtesy of National Archaeological Museum.

At Delphi two nude athletes of about 460 B.C. stand on a single plinth (fig. 5.16).[95] The one on the left holds *halteres* in the left hand and raises the right hand to grasp what may be a wreath. The figure on the right, perhaps the trainer,[96] gestures toward the other. Both figures have long hair, rolled at the nape of the neck. Rods inserted into the legs of the two statuettes

and 83, pp. 88–89. See also the Dodona Dioskouroi, fig. 5.10. An exception to the rule for groups of bronzes on one base is a circular base in Athens which held two marble statues: Raubitschek, *Dedications*, no. 162, pp. 179–80. For further discussion of bases for groups, see F. Eckstein, *Anathemata: Studien zu den Weihgeschenken strengen Stils im Heiligtum von Olympia* (Berlin, 1969).

95. For various theories of date and of origin, see Rolley, *BG*, p. 107: Attic, 460–450; Thomas, *Athletenstatuetten*, pp. 93–95: Peloponnesian, 460–456; Charbonneaux, *GB*, pl. XXII.2: Peloponnesian, mid–fifth century; E. Will, "Groupe de bronze du vême siècle trouvé à Delphes," *BCH* 70 (1946): 642: Attic, 480–460.

96. Thomas, *Athletenstatuetten*, p. 93. The surface condition of the two figurines is poor, and the one on the right is not so well preserved as the one on the left—a fact that weakens Thomas's argument (pp. 93–94) that the figure on the right is intended to be the more youthful of the pair. Rolley identifies this figure as an athlete saluting the victor: *BG*, p. 107, and *Monumenta*, no. 45, p. 5.

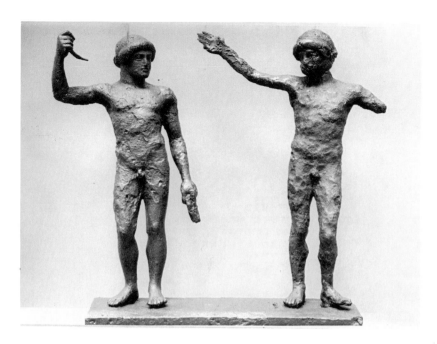

5.16 Two bronze statuettes of atheletes on one base, ca. 460 B.C. H 0.16 m. Delphi no. 7722. Courtesy of Ecole Française d'Archéologie, Athens.

attach them to the rectangular plinth, which in turn has eight tabs on the bottom edges to be set into a larger base.

The two bronzes stand side by side, but our eyes are not drawn to the visual confinement of the plinth. In fact, the higher this group was raised above the ground, the less notice-able would the plinth have been and the more strongly the figures would have stood out against the stone base. The figure to the left bends the right leg, the one to the right the left leg. They look toward each other at an angle, a compositional de-vice that opens the group so that it appears to include space beyond itself. The torsion of the athletes' bodies and the exten-sion of their arms effectively relate the two figures to each other; the base itself would have been of no significance. This sophisticated handling of a group contrasts markedly with the static character of the much earlier Geneleos dedication, where the strongly defined base is the major unifying feature of the monumental group.

The concept of the sculpted group is a problem that was also being addressed on a large scale during the first half of the fifth century. One of the most famous groups was Antenor's Tyran-nicides, the first public commemorative monument to be set up in the city of Athens, late in the sixth century. The Tyrannicides made by Kritios and Nesiotes in the early fifth century to replace this group were certainly very different from those conceived by Antenor. More will be said about this group in chapter 6.

6 VARIATIONS

Pliny tells us that the custom of erecting commemorative statues at public expense was established in Athens with the production of the statues of Harmodios and Aristogeiton.[1] We know that Antenor made this group and that they were cast in bronze.[2] Antenor was, in fact, the first artist who had ever been hired by the city of Athens to produce commemorative statues. The importance of this commission, the first of its kind, cannot be overemphasized. It attracted much public attention and it probably cost a good deal of money. Pliny explains that this monument set a precedent for public statuary everywhere. "Thereafter, the practice was taken up by the whole world as a most natural desire for fame, and statues began to be erected to ornament the fora of all cities, and to propagate the memory of men; the bases of these statues were inscribed with their honors, to be read for all eternity, instead of being read only on their tombs."[3]

Hollow casting on a large scale was well established by the early fifth century. The use of bronze for such an important monument as the Tyrannicides testifies to the popularity of the medium and ensured its continuing use for public statuary, despite the expense. The more often artists used bronze, the more likely they were to experiment in order to discover the full potential of the medium.

In 480 B.C. Antenor's bronze figures were carried off to Persia, but three years later a replacement group representing the famous pair was installed.[4] The short time that elapsed between the looting by Xerxes and the placement of a second group of

1. *NH* 34.17.
2. See especially Valerius Maximus 2.10, ext. 1; *NH* 34.69–70; Pausanias 1.8.5; Arrian, *Anabasis of Alexander* 3.16.7–8 and 7.19.2. For a discussion of the sources, see Brunnsaker, pp. 33–45.
3. *NH* 34.17.
4. The date is established by the Marmor Parium, a stele recording the names of Parian magistrates, whose dates can be matched with Athenian chronology. Marmor Parium, Epoch. 1.54.70–71 = Overbeck no. 458.

119

the two heroes attests to the honor in which they were held by the Athenians. There is no doubt that the second group was, like the first one, cast in bronze.

Because of the renown of Antenor's Tyrannicides, they were eventually returned to Athens from Susa, probably in the late fourth or early third century B.C., by Antiochos, or by Seleukos, or maybe even by Alexander the Great himself.[5] Several hundred years later, Pausanias saw the two groups of Tyrannicides standing side by side near the Temple of Ares in the Agora. "Not far off stand statues of Harmodios and Aristogeiton, who slew Hipparchos. The occasion for this deed and the way in which it was accomplished have been told by others; of the statues, some were the work of Kritios, but Antenor made the old ones."[6]

Pausanias names only one artist for the later pair, but Lucian says that Kritios and Nesiotes worked together on the commission.[7] In addition, six statue bases signed by both Kritios and Nesiotes and dating shortly after 477 have been found on the Athenian Akropolis,[8] and it seems reasonable to assume that the two artists also worked together to create the Tyrannicides.

It was not at all unusual for artists to collaborate. The potter and painter of a vase were frequently two individuals; both an architect and a builder might be involved in a construction project; a single sculptural monument, usually a group, might also be the work of two people. A bronze chariot dedicated by Hieron in Olympia, for example, was primarily the work of Onatas of Aegina, but a racehorse on each side of it ridden by a boy was the work of Kalamis (of Athens?); and Dionysios of Argos and Simon of Aegina each made a horse and charioteer for a monument that Phormis dedicated in Olympia during the first part of the fifth century B.C.[9] As we have seen, the very introduction of large-scale bronze casting is attributed to two men, Rhoikos and Theodoros, who no doubt shared a single workshop.

Did Kritios and Nesiotes each make one of the Tyrannicides? If so, they did not always collaborate in this way, for at least

5. Antiochos: Pausanias 1.8.5; Seleukos: Valerius Maximus 2.10, ext. 1; Alexander: *NH* 34.70; Arrian, *Anabasis* 3.16.7–8. Brunnsaker, p. 45, dates their return between 330 and 281 B.C.

6. Pausanias 1.8.5. For other sources referring to the placement of the statues, see Brunnsaker, pp. 33–45.

7. Lucian, *Philopseudes* 18.

8. Raubitschek, *Dedications*, nos. 120–23, pp. 124–32; nos. 160–61, pp. 177–79; and pp. 513–17.

9. Pausanias 6.12.1, 5.27.2.

three of the statue bases that are signed by them support not groups but individual figures.[10] Certainly the two artists shared a workshop. It is tempting to suggest that the roles of Kritios and Nesiotes may have been quite different, one of them being the sculptor and the other the founder.[11] If so, and if they used the lost-wax casting process, this division of labor would have been entirely appropriate. The two would have collaborated, with the sculptor working on the wax models and the founder molding and casting them. Had they used the pure form of the direct lost-wax casting process, the artistic and technical processes would have been intricately entwined, the sculptor's model being formed in wax over the core and then simply surrounded with a mold and cast. In this case, Kritios and Nesiotes would have had to work side by side throughout the process of making a single statue. If they used only the indirect lost-wax process, however, the division of labor would have been simpler, with the sculptor preparing the model and the founder molding from it and casting the bronze. No doubt a combination of both lost-wax processes was usually used, but the details that we see represented on the Berlin Foundry Cup point to the indirect process. The two well-dressed onlookers in figure 5.7b have been identified as collaborators overseeing activities in their workshop.[12]

Antenor's Tyrannicides, as chapter 5 suggested, were probably truer to Archaic conventions than to the physical appearances of the two individuals. No evidence of their appearance survives, unless we agree with the suggestion that the group by Kritios and Nesiotes was a copy of Antenor's work.[13] By the time the second group of Tyrannicides was erected, Harmodios and Aristogeiton had been dead for thirty-seven years. Their appearances were probably reconstructed from the stories about them, which recounted that one of the two was a youth, the other a mature man.

10. Raubitschek, *Dedications*, nos. 120, 121, 160.

11. Brunnsaker, pp. 138–42, argues that although Kritios and Nesiotes may have shared in some aspects of the casting process, they are probably not to be identified categorically as sculptor and founder. But E. Homann-Wedeking disagrees: "Torsen," *AM* 60/61 (1935–36): 212–14.

12. These two men have previously been identified as Rhoikos and Theodoros by M. Collignon, *Histoire de la sculpture grecque*, vol. 1 (Paris, 1892), p. 157; and as Kritios and Nesiotes by C. Seltman, *Approach to Greek Art* (New York, 1948), p. 60, and by J. D. Beazley, "Un realista greco," *Adunanze straordinarie per il conferimento dei premi della Fondazione A. Feltrinelli*, vol. 1, fasc. 3 (Rome, 1966), p. 54. For further discussion of their identity and for a bibliography, see Mattusch, "BFC," pp. 441–42.

13. Raubitschek, *Dedications*, p. 483.

6.1 The Tyrannicides as Athena's shield device, on a Panathenaic amphora, ca. 400 B.C. London, British Museum B 605. Courtesy of Trustees of the British Museum.

The second group is recalled in Roman copies and in many other representations of the renowned group—on coins, on a lamp, and in vase paintings, reliefs, and plaster casts.[14] Copies made before 330 B.C.—before Antenor's works were returned to Athens, that is—must represent the Tyrannicides by Kritios and Nesiotes. Usually they show two figures placed back to back on a single base.

On a Panathenaic amphora of about 400 B.C. we see the Tyrannicides used as Athena's shield device. (fig. 6.1). Aristogeiton is drawn slightly ahead of Harmodios, perhaps in the interest of the two-dimensional composition, not because the heroes were placed this way in the original sculpture. Both figures step forward onto a bent leg, the other leg straight and extending back on a strong diagonal.[15] The bearded Aristogeiton stretches one arm nearly straight ahead, a cloak draped over it, a scabbard in his hand. The other arm is drawn back beside his hip; in his hand he grips a sword. The youthful Harmodios raises his forward arm above his head, sword in hand. The other arm trails down behind, repeating the line of the leg. His scabbard hangs at his side. The gestures of both figures are variations on the familiar Archaic type of the striding attacking god, warrior, or hero. The gestures are carefully harmonized so that the weapons do not overlap.

In the most complete of the full-size Roman copies of this famous group (fig. 6.2), in Naples, each figure stands on a separate base, no doubt an emendation by the Roman copyist. Aristogeiton's head is missing, but a cast of a head once in the Vatican, now in the Conservatori Museum, has been substituted.[16] The arms of Harmodios are also restored; he once wore a scabbard secured by a strap that crossed from right shoulder to left hip.

In 1954, in excavations at Baiae on the coast of the Bay of Naples, Mario Napoli discovered ancient plaster casts and plaster molds that had been taken from statuary. These remarkable pieces had been dumped in a cellar room of the Sosandra Baths during the first half of the first century A.D. As many as thirteen of the plaster casts may have been made from the bronze Tyrannicides, and eight certainly have been.[17] Fragments assigned to

14. For Kritios and Nesiotes and their works, see Boardman, *GSCP*, pp. 24–25, figs. 3–9; Ridgway, *SS*, pp. 79–83, 90–91; and Richter, *SSG*, pp. 154–56 and figs. 602–15.

15. See Beazley, *ABV* 411, 4.

16. Rome, Conservatori, inv. 906. See Landwehr, *AGB*, pls. 5, 7.

17. Landwehr, *Meisterwerke*, pp. 24–26, nos. 7–19; and Landwehr, *AGB*, pp. 27–47. For further comments about the casts, see E. G. Pemberton, review of

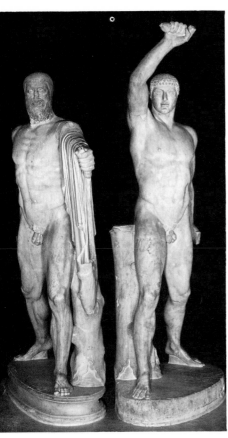

6.2 Roman copy of the Tyrannicides. Naples, Museo Nazionale inv. 6009, 6010. Courtesy of Soprintendenza Archeologica delle Province di Napoli e Caserta.

Harmodios include the left upper arm and the right upper arm and shoulder. Partial casts from Aristogeiton include the right upper arm and elbow, part of the mantle from over the left arm, the back of the right calf, the front of the left foot with some of the toes, and possibly part of the right hand, as well as a large portion of the right side of the face and beard (fig. 6.3). It has been suggested that the casts were taken from the statues in the earlier group by Antenor, which was dedicated in about 490 B.C. and was probably more famous than the substituted group by Kritios and Nesiotes, particularly after the original work was returned from Susa.[18]

The reason that the fragmentary plaster casts in Baiae can be assigned to the Tyrannicides at all is that they correspond closely to details on the well-known Roman copies of those works in Naples and Rome, which were no doubt based on casts such as these. The Baiae cast of the head of Aristogeiton provides us with a closer glimpse of an original bronze statue than does a Roman marble copy, even though the plaster differs from the lost bronze in color and texture. The cast, preserving more than half of the right side of Aristogeiton's face, shows a long beard with thick separated locks, the surface of the original having been roughened with finely incised strands of hair. The curve of the long moustache against the beard is reminiscent of the bearded Akropolis Warrior (fig. 5.2) and of the Livadhostro Poseidon (fig. 4.20), though Aristogeiton's moustache and beard of Aristogeiton are rendered with much more plasticity than those of the earlier works. The full mouth is somber and slightly open. The nostrils are delicate, and the bridge of the nose makes a fine, barely curving line. In contrast to the shallow swell of the cheekbone, the eyelids are heavy and strongly marked. The lower one protrudes sharply, marked by a deep groove beneath; the upper one is accentuated by a sharp groove

Landwehr, *Meisterwerke*, in *AJA* 87 (1983): 420–21, and B. S. Ridgway, *Roman Copies of Greek Sculpture: The Problem of the Originals* (Ann Arbor, 1984), pp. 32, 35n7, 67, and 77n12. Earlier remarks were made by W.-H. Schuchhardt, "Archäologische Gesellschaft zu Berlin, 1973/74: Antike Abgüsse antiker Statuen," *AA* 89 (1974): 631–35, and by G. M. A. Richter, "An Aristogeiton from Baiae," *AJA* 74 (1970): 296–97. For the technique used for taking plaster casts, see Landwehr, *Meisterwerke*, p. 16; Landwehr, *AGB*, pp. 12–25; and Richter, *Portraits*, pp. 31–34. A similar find was made at Nea Paphos in Cyprus, where a workshop dating to the end of the Hellenistic period yielded plaster molds that were probably used for the production of copies. See K. Nicolaou, "Archaeological News from Cyprus, 1970," *AJA* 76 (1972): 315–16; also *Annual Report of the Director of the Department of Antiquities for the Year 1970* (Nicosia, 1971), p. 19.

18. Landwehr, *Meisterwerke*, p. 16, and *AGB*, pp. 43–47. See also W.-H. Schuchhardt and C. Landwehr, "Statuenkopien der Tyrannenmörder-Gruppe," *JdI* 101 (1986): 85–126.

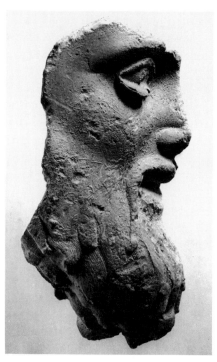

6.3 Roman plaster cast of the head of Aristogeiton, first century A.D. H 0.216 m. Baiae, Antiquarium inv. no. 174.479. Courtesy of Deutsches Archäologisches Institut, Rome, neg. no. 78.1858.

above it which curves outward beneath a fleshy brow ridge. The unusual thickening of the lids probably occurred because the bronze lashes had been coated with wax to preserve them while the plaster mold of the face was being taken.

The Baiae cast and the Conservatori copy of Aristogeiton's head bear such remarkable similarities to each other that there is no question that they came from the same original. The rendering of the thick locks of hair in the long beard differs only in that the incision on the marble copy is not so delicate and a fringe has been added below the lips. Moustache and lips are alike, as are the heavy eyelids, although in the marble copy a second groove is added to show that the upper lid overlaps the lower at the outer corner. The Conservatori head is missing the nose and the surface of the heavy brow ridge. The short haircut and the beard have widely spaced incised strands, not the fine incision picked up from the bronze in the wet plaster of the Baiae head.

The plaster casts from Baiae provide insight into the production of Roman copies.[19] At the same time, like the earlier Agora molds for the Apollo, it provides an accurate glimpse of one of the most famous bronzes that adorned the city of Athens in the fifth century B.C. For with the Tyrannicides, the Athenians essentially initiated the tradition of portraiture and provided the precedent for public commemorative statuary to the present day.

There are at least three possible answers to the question of why the Roman copies of the Tyrannicides are all of the same sculptural group. Perhaps the later group duplicated the earlier one. Or perhaps copies of the earlier group were made but for some reason have not survived, though at least five copies of the later Aristogeiton and four of the later Harmodios can be enumerated. By the time the original group was returned to Athens, the later group of Kritios and Nesiotes had become emblematic of the city. And perhaps the Roman copyists chose the later group because it was the more familiar one and because it seemed to be a more accurate portrait of the heroes. For the earlier Tyrannicides may well have echoed the style of Antenor's kore (fig. 5.1) and been simply a pair of kouroi standing side by side, or alternatively, a kouros standing perhaps

19. Lucian, *Zeus tragoidos* 33, comments more pointedly on this Roman practice: "It is your brother, Hermes of the Agora, the one by the Stoa Poikile; he is all covered over with pitch on account of being molded upon every day by the statue makers." The term "statue makers" should be understood to designate craftsmen who took plaster molds from the Hermes to be used in the production of full-size copies.

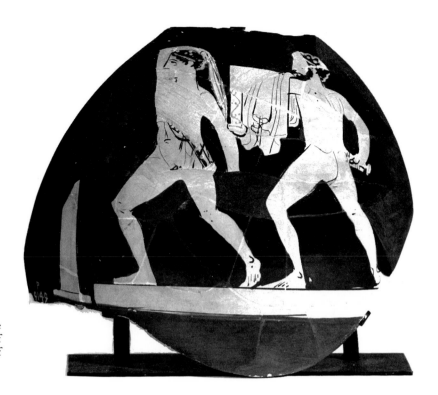

6.4 The Tyrannicides on a red-figure oinochoe, ca. 400 B.C. Boston, Museum of Fine Arts 98.936. Courtesy of Museum of Fine Arts, Boston, H. L. Pierce Fund.

incongruously beside the altogether different Archaic type of the mature attacking god or hero.

This is as close as we can get to the appearance of the original statues. Excavations in the Athenian Agora, however, uncovered a small piece of the inscribed base on which they once stood, near the spot where the assassination took place.[20] The fifth-century illustrations of the Tyrannicides in other media reflect their political importance. The Roman copies of the group indicate the importance of the sculpted pair beyond the city of Athens and after the period of their production.

But what of other contemporary versions of the famous group? On a red-figure oinochoe in Boston (fig. 6.4) the statues of the two heroes on their base are aligned in dramatic silhouette.[21] Harmodios, in the lead, has begun to strike: he moves left, his feet wide apart and his right arm flung back over

20. Brunnsaker, pp. 84–98, discusses the base in detail. See also H. A. Thompson and R. E. Wycherley, *The Agora of Athens*, Athenian Agora 14 (Princeton, 1972), pp. 155–60, for the base, its inscription, and its original location.

21. See Brunnsaker, pp. 105–6, and, for other reproductions of the group, pp. 99–107.

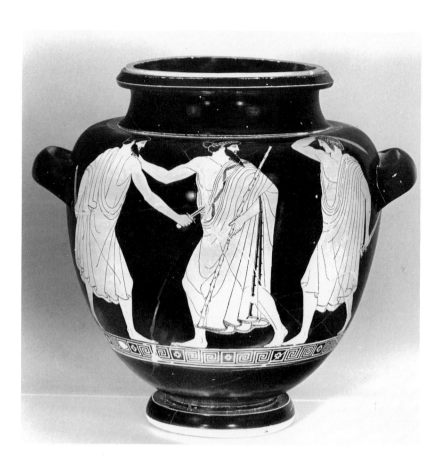

6.5 The Tyrannicides on a red-figure stamnos, 470s B.C. Würzburg, L 515. Courtesy of Martin von Wagner Museum der Universität Würzburg. Photo by K. Oehrlein.

his shoulder, his sword poised ominously behind his head. Aristogeiton is at the right, shown from behind. He stands still, his legs far apart, his sword held low and partially hidden behind his waist. His draped left arm is extended forward and his hand apparently once held aloft his empty scabbard.

Not all of the artists who produced versions of the pair in other media attempted to recreate the famous statues. One particularly fine example, painted on a red-figure stamnos in Würzburg (fig. 6.5), shows again, as did the Berlin Foundry Cup, the stylistic differences between early-fifth-century painting and sculpture.[22] Here we see a truly narrative version of the assassination in a composition that explores spatial relationships and three-dimensionality. Both assassins are clothed, unlike

22. See Beazley, *ARV²*, 256, 5: Copenhagen Painter, 470s B.C. See also G. Beckel et al., *Werke der Antike im Martin-von-Wagner-Museum der Universität Würzburg* (Mainz, 1983), no. 44, fig. p. 103: 475–450 B.C.; Boardman, *ARFVAP*, pp. 113–14, fig. 199; Brunnsaker, p. 108.

those in the sculpture. In the center Hipparchos flees, looking fearfully over his shoulder at his pursuer, Harmodios, who raises his short sword above his head. Hipparchos holds a long knotty staff in his left hand and extends his right hand ahead of him as if he is desperately attempting to break into a run. But Aristogeiton thwarts his move to escape, coming at him from the front and plunging a sword into his ribs. We see Harmodios from the front, moving to the left; Aristogeiton from the back, moving to the right; and Hipparchos in the center, lunging to the left, torso frontal, head turned back to the right, hopelessly trapped between his determined attackers.

Other than the Tyrannicides, we know of few works by Kritios and Nesiotes. Their names appear together on six bases for bronze statues found on the Athenian Akropolis, all of which are inscribed in the same hand. The cuttings on the tops of four of the bases suggest the poses of the statues: one was a hoplitodromos, apparently standing;[23] one a figure in motion with the left foot forward; one a man sitting on or standing beside a horse; and the last a figure standing with his feet close together. The name Nesiotes appears alone on one other statue base.[24] Pausanias calls Kritios an Athenian,[25] and from the available evidence, we can assume that Nesiotes was one also. Certainly the bases reflect the popularity of these two artists in the city of Athens.

Polyzalos, tyrant of Gela during the 470s, dedicated a lifesize chariot group at Delphi in honor of his chariot's Pythian victory in either 478 or 474 B.C. The chariot group stood until it was destroyed in some catastrophe and then buried.[26] What was left of it was discovered in 1895: the left and right hind legs of a horse, a left rear hoof, a horse's tail, a spoke, yoke, withers pads, reins and other harness fragments, the arm of a youth,

23. Pausanias saw this statue but named only Kritios as the artist: 1.23.9. For the various bases, see Raubitschek, *Dedications*, nos. 120, 121, 122, 123, 160, 161.
24. Raubitschek, *Dedications*, no. 84, pp. 91, 436; Brunnsaker, p. 136.
25. Pausanias 6.3.5.
26. The traditional explanation is that the chariot group, like other monuments at Delphi, was destroyed by the earthquake and subsequent landslides of 373 B.C. Thereafter a large retaining wall, the Ischegaon, was constructed to the north of the temple platform and the temple of Apollo was rebuilt. The badly damaged chariot group, then a century old, was no longer deemed worth restoring, and its remains were dumped in the fill behind the Ischegaon: *BCH* 20 (1896), p. 691n2. G. Roux has questioned this interpretation of the evidence on the basis of his reading of the excavation notebooks, and suggests that the statue may have been destroyed and buried in later times, perhaps during the Roman period. See J. Pouilloux and G. Roux, *Enigmes à Delphes* (Paris, 1963), pp. 10–12.

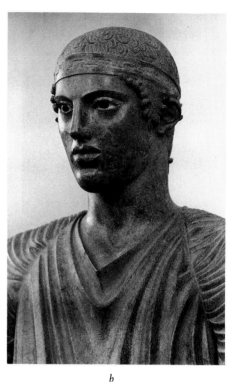

b

a

6.6 The Delphi Charioteer, ca. 474 B.C. H
1.8 m. Delphi, nos. 3484, 3540. Courtesy
of Ecole Française d'Archéologie, Athens.

and all of the charioteer except for the left arm (fig. 6.6).[27] The
inscribed base found with the statue identifies the dedication as
that of Polyzalos and fixes the date of the bronze to approx-
imately 474 B.C.[28]

The Delphi Charioteer is one of the most famous Greek
bronze statues that is today preserved. The Charioteer and the
Serpent Column (fig. 5.6) are the only two large Greek bronzes
that are securely dated. The Charioteer has been of great impor-
tance in establishing the characteristics of the early Classical
style, and it is the only large-scale bronze original that can be
identified without question as a victor's monument. Pliny
describes the tradition of erecting such statuary: "It was not
usual to model likenesses of men unless for some reason or
other they deserved lasting honor, first for a victory in the

27. See F. Chamoux, *L'Aurige de Delphes*, FdeD 4, no. 5 (Paris, 1955), pp. 39–
49.
28. Delphi Museum, inv. 3517. Chamoux (ibid., pp. 27–29) says that the
inscription was recut later in the fifth century to eliminate the information that
Polyzalos had been the ruler of Gela, perhaps by his elder brother Hieron in anger
after Polyzalos's death ca. 470 B.C. or slightly later.

sacred contests, especially at Olympia, where it was the custom to dedicate statues of all who were victorious; and if they won there three times, their statues were modeled in their own likeness; these are called *iconicas*."[29] Although Pliny here mentions Olympia, the most famous of the athletic centers, the dedication of statues in honor of athletic victors was a widespread practice in Greece.

Polyzalos, who was about sixty years old in 474 B.C., surely did not drive his own chariot to victory, and we should not look for his likeness in the statue of the youthful Charioteer. Perhaps we should not look for a portrait of any individual in the bronze statue, for it would have distracted from the purpose of the statue as a dedication to the god made by Polyzalos of Gela.[30]

As only the Charioteer is preserved, we are constrained to analyze it as a single work, not as part of a group or as a figure partially concealed within a chariot. The carefully poised figure is balanced directly over both feet, raising and extending the right hand to hold the horses' reins. From seams along the tops of the shoulders the chiton falls in tight regular gathers, interrupted by crossed straps drawn tightly under the arms and across the shoulderblades. Below the straps the gathers broaden, following loosely the V-shaped neckline of the chiton in front, then blousing gently as the material overlaps the belt. The same arrangement is repeated on the back, where the broadening folds define the spinal column.

Below a high wide waistband, the folds of the chiton are uninterrupted in their descent, creating deep regular vertical shadows. The only suggestion of the volume of the body beneath the chiton is a slight irregularity of the hemline, which drops to just above the ankles. Although the undulating folds above the waist are full of motion, those below the belt are absolutely still, articulating the perfect quiet of the Charioteer's erect pose. They have often been described as giving a columnar quality to the statue.[31] It is a momentary stance, probably representing the instant of attentive calm when the charioteer has halted his excited horses before the judges.

29. *NH* 34.16–17.

30. That the owner of a team was not necessarily the charioteer can be seen in, for example, Pindar's *Pythian* 5. It has been suggested that a statue of Polyzalos may have been placed beside that of the Charioteer: P. Griffo and L. von Matt, *Gela: The Ancient Greeks in Sicily* (Greenwich, Conn., n.d.), p. 154.

31. K. Kluge, "Gestaltung," p. 24, went so far as to suggest that a wooden model for the lower part of the body was carved from a tree trunk, a method that he also suggested for the Serpent Column (fig. 5.6).

The delicately balanced feet, the immobile stance, and the remote expression on the athlete's face emphasize the quiet moment. But other details allude to the wild action of the race just past. The veins bulge on the tops of the feet, which were, of course, hidden from view within the chariot. This realistic detail tempts one to think that the Charioteer was conceived as a distinct piece, apart from the chariot. Praxiteles is said to have made a charioteer for Kalamis, who was less skilled at making human figures than at making horses.[32] The Charioteer's raised right forearm shows the muscles lightly tensed to steady the horses. The short hair is engraved in tightly layered radiating ringlets plastered against the crown of the head, as if damp with sweat, and a fillet encircles the Charioteer's brow. The fillet is inlaid with a silver meander and crosses between copper bands.[33]

The head is rather small, approximately 11 percent of the height of the whole figure. Perhaps the elongated body was intended to compensate for the part of the figure that was concealed within the chariot; otherwise the figure might not have seemed to dominate the excited horses. The face, turning to the right on a tense, heavy neck and framed by projecting curls at the sides, is smooth and beardless, with remarkably regular, generalized features. This is certainly not intended to be a portrait of a specific individual: it should be seen more broadly as a youthful, victorious charioteer. Long flat cheeks descend to a strong chin. The lips are full and sober and slightly parted, revealing teeth that appear to be silver.[34] A straight nose divides the face, and from it curve fine, regular inlaid brows.[35] The wide eyes are fully preserved: rimmed with inset bronze lashes, they are inlaid with white paste set with chestnut-colored irises and black onyx pupils.[36] Their intensity is surprising only because we are used to seeing bronzes that no longer have the eyes.

Although the bronze statue now has a green patina, the surface is otherwise beautifully preserved, and it is easy to imagine the effect of the fixed dark inlaid eyes in the gleaming, reflective

32. *NH* 34.71.
33. See Chamoux, *L'Aurige de Delphes,* p. 52.
34. See T. Homolle, "L'Aurige de Delphes," *MonPiot* 4 (1897): 195n4; and C. Houser, "Silver Teeth: Documentation and Significance," abstract, *AJA* 91 (1987): 300–301. Bol, *Grossplastik,* p. 91, identifies the teeth as a lead bar. As for the lips, according to P. de la Coste-Messelière, they were cast and inset: *Delphes* (Paris, 1943), p. 327.
35. See Bol, *Grossplastik,* p. 90.
36. See Chamoux, *L'Aurige de Delphes,* p. 53.

surface of the new bronze statue. No emotion registers here, and the blank, seemingly unfocused gaze repeats the lack of characterization in the other facial features and gives the Charioteer a certain remoteness, or what might be defined as the inner concentration of an athlete.

A major dedication by an important individual, the Charioteer is certainly a work of high quality. Where it was made and by whom are questions that remain unanswered. Scholars have often been tempted, however, to assign the bronze to an artist or, with slightly more reserve, to a workshop. François Chamoux has identified the statue as Attic, saying that it may be from the workshop of Kritios; Roland Hampe suggests Sotades of Thespiai in Boiotia; José Dörig sees Aeginetan characteristics in the statue; and Percy Gardner suggests the Athenian artist Kalamis.[37] A southern Italian or Sicilian artist has also been proposed, as Polyzalos, who dedicated the chariot group, was a Sicilian, and Pythagoras of Rhegion has been named.[38] It is of course altogether possible that the artist who made the chariot group is not mentioned in the literary testimonia.

The technique by which the Charioteer was produced has been studied frequently since the discovery of the statue. It was found in three pieces: the head and torso, the portion of the statue from the belt to the feet, and the right arm and hand holding three reins. The left arm is still missing. Before the statue was reassembled and filled with plaster for permanent display, physical details, inside and out, were observed and recorded. In 1896 Théodore Homolle concluded that two holes in the plate set in under the skirt of the statue were for the insertion of the separately cast lower legs and feet, and counted seven separately cast pieces of the statue: the two feet, the two arms, the skirt, the torso, and the head. Homolle described the core of the statue as hard, black, baked material that could be reduced to powder by hammering; and he saw an armature inside the lower part.[39]

Homolle's observations were disregarded for over fifty years, during which period many scholars subscribed to a radically

37. Ibid., pp. 77–82; R. Hampe, *Der Wagenlenker von Delphi*, Denkmäler griechischen und römischen Skulptur (Munich, 1941), pp. 22–23; Boardman/Dörig/Fuchs, p. 278; P. Gardner, *New Chapters in Greek Art* (Oxford, 1926), p. 195.

38. Eastern Sicilian: V. Poulsen, "Der strenge Stil," *Acta Archaeologica* 8 (1937): 104–5; Sicilian or southern Italian: Lullies/Hirmer, pp. 71–72; Pythagoras of Rhegion: De la Coste-Messelière, *Delphes*, p. 327.

39. T. Homolle, "Statue de bronze découverte à Delphes," *CRAI* 24 (1896): 369.

different theory proposed by Kurt Kluge in 1929. Kluge suggested that the Charioteer's feet and skirt had been cast in one piece and the torso in another, both from wooden models. He argued that the wooden models were impressed in sand to form the molds. Then a core and armature were suspended within each mold, and bronze was poured into the space between core and mold. But he believed that the undercutting on the head necessitated its being cast in a number of separate pieces: face and neck, cranium, fillet, ears, and locks of hair. Kluge based his theory on two physical features: the interior contours of the bronze follow only roughly the exterior lines, and the interior is not undercut. He asserted that the bronze of the statue is too thick to be a lost-wax casting. However, the single surviving arm from the statue of a youth and the horses' hind legs and tail are, he said, lost-wax castings, and therefore must have come from another, later monument.[40]

Stanley Casson agreed with Kluge's theory that the Charioteer's drapery had been sand-cast after a wooden model, as its style suggested, but added his own variant: he said that the head, arms, and feet had been made by the lost-wax process.[41] Casson either misread or overlooked Kluge's statement that the Charioteer's feet had been cast together with the skirt from a wooden model. And he failed to mention Kluge's point that various parts of the head had been separately cast. Charles Seltman took further liberties with Kluge's theory when he remarked that the formal, poetic character of the Charioteer is due to the process of carving a wooden model.[42] Roland Hampe differed slightly with Kluge, suggesting that the statue had been cast in six pieces: head and neck, neck to waist, the lower part, both feet, the right arm, and the left arm.[43] He did not say then by what process he thought the Charioteer had been cast, but in a later review of Chamoux's monograph about the statue, Hampe emphatically supported Kluge's theory about wooden models.[44]

In a monograph on the Charioteer written in 1955, Chamoux proposed that the entire statue had been made by the lost-wax

40. Kluge, "Gestaltung," pp. 16–20.
41. Casson, p. 157.
42. C. Seltman, *Approach to Greek Art* (New York, 1948), p. 58: "This wooden statue was taken to pieces at the waist, neck and elbows, and each member was first cast separately in bronze, then fitted into place by the founders, and finally chased all over, probably under the eye of the artist himself."
43. R. Hampe, *Wagenlenker von Delphi,* nos. 786–90.
44. Hampe, review of Chamoux, *L'Aurige de Delphes,* in *Gnomon* 32 (1960): 60–73.

process, basing his argument on his own careful examination of the work. In so doing, he reverted in part to Homolle's conclusions. Chamoux, like Homolle before him, noticed an irregular suture attaching the feet beneath the skirt, which disproved Kluge's theory that feet and skirt were cast in one piece. This feature is still clearly visible today. Chamoux also observed that the head is divided into fewer pieces than Kluge had believed it to be: only in two, at the fillet, perhaps to facilitate the insertion of the eyes. Otherwise, Chamoux agreed with Homolle that the arms, the feet, the upper body, and the skirt were separate castings. The joins are all still visible today, except for the ones in the cranium and between head and torso, which Chamoux saw on the interior of the statue.[45]

The statue was slotted, doweled, and soldered together, each join concealed by drapery; neck and arms were set into the sleeves; torso and lower body met beneath a belt; and the feet were set into the plate beneath the hem of the skirt. The ends of the fillet and a number of curls were cast separately.[46] It has been suggested that the letters incised in a fold of the chiton on the right thigh—ĒNI, for *hēniochos,* or charioteer—were used as a guide in the assembly of the statue.[47]

Like Homolle, Chamoux mentioned a gray core and bits of an iron armature inside the statue. His discovery of the same core material in the horses' legs and in the arm from a smaller figure convinced Chamoux that all of the fragments came from the same monument. He argued further that the Charioteer's thick walls are not the result of sand casting but were produced intentionally to provide the weight and stability that the statue needed to withstand the fierce winds of Parnassos.[48] Hampe rejected Chamoux's theory, incorrectly maintaining that if the lost-wax method had been used, traces of the wax would have remained inside the statue.[49] However, Chamoux's argument that the Charioteer was made by the lost-wax process is now widely accepted.

Although the interior of the statue is no longer accessible, earlier scholars' observations about the statue's physical appearance allow a fairly precise reconstruction of the form the process must have taken. Kluge observed that the thickness of the

45. Chamoux, *L'Aurige de Delphes,* p. 59–60.
46. Ibid., p. 60.
47. C. Picard, *Manuel d'archéologie Grecque: La Sculpture,* vol. 1 (Paris, 1935), p. 182n4; E. Bourguet, *Les Ruines de Delphes* (Paris, 1914), p. 228n1.
48. Chamoux, *L'Aurige de Delphes,* pp. 61, 63.
49. Hampe, *Wagenlenker von Delphi,* p. 70.

casting varies considerably from one point to another.[50] Homolle and Chamoux both noticed bits of core and iron armature inside the statue. Bronze nails that Chamoux saw inside the skirt and thought were repairs are probably chaplets that held the core in place during pouring.[51] And there is no doubt that the Charioteer was cast in eight major pieces: the top of the head to the fillet, the rest of the head and the neck, the torso, the skirt, the arms, and the lower legs with the feet. The mechanical joins are all clearly visible today, with the exception of the one concealed by the chiton at the neck.

Thick and uneven bronze walls are characteristic of both sixth- and fifth-century bronzes, and may be found in bronzes cast by either the direct or the indirect process or by a combination of the two. During the application of the wax in the direct process, some portions may need to be built up over the clay core, whereas other areas may follow the core's contours. In the indirect process, a wax layer is applied within the clay master molds and then cored. Evidence of the methods used to apply the wax is often preserved in the form of, for example, brush marks on the interior of the finished bronze. The bronze walls may still be thick and irregular, however, for after removing the master molds, an artist might very well add more wax while modeling the final details of the figure.

It is very difficult to be certain that the Delphi Charioteer was cast specifically by the direct or the indirect process. One further piece of evidence, however, may point to a detail of the direct process. The interior roughness noticed by Kluge[52] suggests that the interior may preserve the negative imprint of the exterior of the clay core with its bubbles, protuberances, and cracks. And it would do so only if the wax had been applied over the core, not if the core had been poured into the already-existing wax model. But why would the Charioteer have been cast by the direct process alone? The equally well-known indirect process was easier and safer, and allowed the artist greater latitude in the creation of his model. Without further evidence, it seems best to conclude that the Charioteer, like other bronzes of the Archaic and Classical periods, was produced by a form of

50. Kluge, "Gestaltung," pp. 16–17. Charbonneaux, *GB*, p. 30, is more specific, stating that the thickness varies from 0.008 to 0.013 m. and that the large folds of the chiton are as much as 0.025 m. thick.

51. Chamoux, *L'Aurige de Delphes,* p. 64.

52. Kluge, "Gestaltung," p. 16. The interior of the statue has not been examined in recent years.

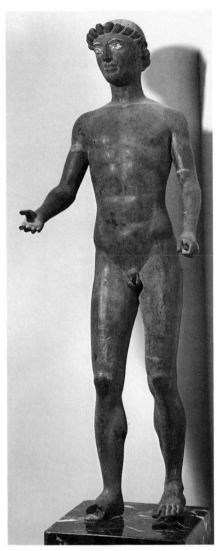

6.7 The Selinus Youth, early Classical. H 0.847 m. Palermo, Museo Nazionale. Courtesy of Hirmer Fotoarchiv, Munich.

the lost-wax process which combined elements of both direct and indirect methods.

Because of the link between the Delphi Charioteer and Sicily, it is of some interest to look next at a work of similar date that was found in Sicily and certainly made there as well. In 1882 a bronze statue of a youth (fig. 6.7) was discovered in the region of Selinus. The unusual fact that the figure was found entombed in a terra-cotta sarcophagus suggests that it may have been buried for safekeeping at some time and then forgotten.[53] The statue was acquired by the city of Castelvetrano,[54] where it was displayed in the city hall until 1962. In that year the Selinus Youth was stolen, and it was not recovered until 1968. By 1975 the statue had been removed to Rome for restoration.[55] Now the statue is in the Archaeological Museum of Palermo.

The Selinus Youth is generally agreed to be of Sicilian origin[56] and is usually dated to the early Classical period.[57] Less than half lifesize, the statue is barely larger than the Ugento god (fig. 4.16). The odd-looking youth has the right foot forward, like the Piraeus Apollo (fig. 4.19), the Kritios Boy (fig. 4.21), and a kouros in Agrigento.[58]

Most scholars agree that the seemingly clumsy style of the Selinus Youth bespeaks local manufacture. The head is fairly small, less than 13.5 percent of the figure's total height. It is set on a long neck that appears to taper downward. The triangular face shows little modeling of the cheekbones. The lips are full

53. E. Langlotz, review of P. Marconi, *L'efebo di Selinunte*, Opere d'arte, vol. 1 (Rome, 1929), in *Gnomon* 6 (1930): 429.

54. P. Marconi, "Palermo—Restauro della statua bronzea d'arte greca detta 'L'Efebo di Selinunte,'" *BdA* 8, ser. 2 (1928–29): 231; Langlotz/Hirmer, p. 273, fig. 81.

55. *Il restauro dell'efebo di Selinunte: Mostra didattica* (Rome, 1979).

56. See V. Poulsen, "Der strenge Stil," *Acta* 8 (1937): 103–4: western Sicilian. On the question of whether the work is a reflection of or reaction against Greek style, see P. Marconi, "L'anticlassico nell'arte di Selinunte," *Dedalo* 11 (1930–31): 395–412, and G. Rizza, "La grande scultura greca nell'Italia meridionale e in Sicilia," *Arte antica e moderna* 12 (1960): 331–50. The figure's features have been compared with those of the figures in the metopes of Temple E at Selinus; e.g., L. Bernabò Brea, *Musées et monuments in Sicile* (Novara, 1960), p. 128.

57. R. Holloway, *Influences and Styles in the Late Archaic and Early Classical Greek Sculpture of Sicily and Magna Graecia*, Publications d'histoire de l'art et d'archéologie de l'Université Catholique de Louvain, 6 (Louvain, 1975), p. 49. 480–460 B.C.: Marconi, *L'efebo di Selinunte*, pp. 8–11; 470 B.C.: Richter, *Kouroi*, no. 192a, p. 157; Langlotz/Hirmer, p. 273; and E. de Miro, *I bronzi figurati della Sicilia greca* (Palermo, 1976), pp. 45–46.

58. Agrigento, Museo Civico; H 1.04 m. See Richter, *Kouroi*, no. 182, pp. 145–46, figs. 547–49.

and the nose angles slightly outward from the line of the brow. The face is dominated by large oval eyes, set more or less horizontally, which retain the inset glass paste of the whites; the copper brows too are inlaid.[59] Little can be seen of the low forehead, which is mostly obscured by a heavy roll of long hair that encircles the head.

The hair adds no mass to the crown; wavy incised strands radiate from the top of the head. At fairly regular intervals a more deeply incised strand denotes a division between locks of hair. These divisions become distinctly separated loops of hair rolled, we assume, around a fillet. Other examples of this hairstyle are worn by the Kritios Boy (fig. 4.21) and the Agrigento kouros, both of which probably date to approximately 480 B.C. An even closer parallel can be found on the head of Aktaion on a metope from the early Classical Temple E at Selinus.[60] Here the hair is also separated into loops; above the ears the fillet is visible. The Selinus Youth bears no traces of the fillet, either at the parting of the locks in front or above the ears. In fact, the ears are set high into the roll, leaving no space for a fillet. In the back the hair is looped up over the roll, the tail end coming to a blunt point. Again it appears to lack its fillet. This and similar hairstyles generally appear in the late Archaic and early Classical periods.[61]

Both feet rested flat on their base, and the distribution of weight is not clearly defined. The torso is long with high, broad pectoral muscles; the rectus abdominis has two transverse divisions and a central vertical depression; and the round raised navel, surrounded by a simple depression, is otherwise marked only by an incised dot. Ernst Langlotz calls the genitals "too childish."[62]

The arms are short, thin, and cursorily modeled, and the shoulders are insubstantial. The arms of the Selinus Youth, like those of the Piraeus Apollo (fig. 4.19), extend forward, right palm upward, four fingers missing. The fingers of the left hand curve together as if to close loosely around an object. It has been suggested that the statue represents a youth pouring an offering from a now-lost patera.[63] Such a figure, with a patera extended

59. See Bol, *AGB*, p. 90.
60. Palermo, Museo Nazionale Archeologico. See Langlotz/Hirmer, pl. 102.
61. Ridgway, *SS*, p. 136. Such hairstyles are discussed in C. M. Galt, "A Bronze Statuette," *AJA* 33 (1929): 47–50.
62. Langlotz/Hirmer, p. 273.
63. Ibid.

in the right hand above an altar and a leafy branch held in the left hand, is represented on coins of Selinus.[64]

From the side the Selinus Youth looks disproportionate, with small, childlike buttocks and a long and slender waist but fairly massive shoulderblades. The spine curves so strongly that the youth appears to be swaybacked.

Before its first restoration, the statue was in six pieces: the trunk and right leg, left leg, right arm, left upper arm, left forearm, and left hand. Four fingers of the right hand and the front part of the right foot were lost. Pirro Marconi reported in 1929 that the statue contained blackish earth mixed with pieces of terra-cotta, presumably the ancient core material. Fragments of iron found within and identified as both slag ("*scorie di ferro*") and pieces of iron from the casting ("*pezzi di ferro di fusione*") deposited in no particular order may be suspected of being instead badly corroded bits of an iron armature. The walls of the bronze were measured at 0.003 to 0.007 meter in thickness, with the bottom of the right foot significantly thicker at 0.012 meter. It was also observed that the back part of the left foot and the hands as far as the wrists are solid.[65]

A hole in the sole of the left foot was identified as a vent for gases to escape during casting, but it is more likely to have been intended for the insertion of a tang to attach the figure to a base. A finished edge at the termination of the right foot had a vertically placed bronze plate with five holes in it and traces of bronze nails in them, said to have been used to attach the separately cast front part of the foot.[66] The observation that the front of the foot was separately cast is a valuable one, for it links the Selinus Youth to other Greek bronzes. The Livadhostro Poseidon (fig. 4.20), the Artemision god (fig. 6.10), and the Riace bronzes (figs. 8.3, 8.4) all have the same feature. Other examples include four front halves of feet from Olympia, three dated to the early Classical period and one to the late Archaic period.[67]

Marconi observed that bronze plates had been used in two places to join the left arm of the Selinus Youth, and concluded that the arm, like the right foot, had been rejoined during antiquity. The high quality of the joins suggested to him that the

64. See L. von Matt, *Das Antike Sizilien* (Würzburg, 1959), pls. 135–37.
65. Marconi, "Palermo," pp. 233–34.
66. Ibid.
67. Early Classical: Olympia K 1050 (Bol, *Grossplastik*, no. 114 and p. 29, pl. 22); Olympia Br. 647 and 5002 (ibid., no. 117 and p. 29, pl. 22); late Archaic: Olympia B 272 (ibid., no. 113, p. 29, pl. 22).

repairs had been made during the Greek period, probably to correct flaws in the original casting. He also saw patches on the arms and on the right thigh, and explained a hole on the inside of the right calf as modern damage by the pick.[68]

After cleaning the statue with soap and water, and with alcohol in a few places, technicians inserted a framework, which they glued to the core.

The Selinus Youth was next studied and cleaned during the 1970s, at which time it was ascertained that the modern glue that had been used in 1928 was cement. It is of far greater interest to note that there is evidence for extensive repairs having been made to the Selinus Youth during antiquity. As for the ancient materials, it was ascertained that the compositions of both the metal and the clay core differ slightly from one part of the Selinus Youth to another. The alloy of the statue is similar to that of the Ugento god in that it contains a little lead, a feature that may be a distinguishing characteristic of works produced in Sicily and Magna Graecia, as it is of Etruscan bronzes.[69] The ancient repairs may indicate that the first attempt at production was unsuccessful and that a second operation was therefore undertaken. The arms and head were reattached, the left arm at a slightly different angle. Furthermore, flaws in the torso and thighs were repaired by a highly unusual initiative, which involved the casting on of bronze strips. As a result, the total height of the statue was increased by approximately 0.05 meter (nearly 6 percent of the present height) and its proportions were altered significantly. The changes also caused the left leg to turn outward, the chest to be turned and lengthened, and the curvature of the back to be increased. It has also been suggested that the stylistic differences between the head and the body signal the work of two artists.[70] But were the stylistic changes intentional or not? The simplest explanation, and probably the most likely, is that the stylistic changes were not planned, but were the result of an attempt to save a faulty casting.

If we were to learn the name of the artist who made the Selinus Youth, we would probably never have heard of him, for he must have been among thousands of local artists who were unknown outside of their own regions. At the same time,

68. Marconi, "Palermo," pp. 235–36.
69. A. M. Carruba, "Der Ephebe von Selinunt: Untersuchungen und Betrachtungen anlässlich seiner letzten Restaurierung," *Boreas* 6 (1983): 46, 56. Carruba found the alloy to be Pb 0.5–2.0%, Cu 86.0–91.5%, Sn 8.0–10.0%.
70. Ibid., pp. 48–57, figs. 5, 11, 12.

we know many Greek sculptors by name alone and have none of their works. Accounts of the famous Greek bronze sculptors are often conflicting, as the sources are generally late, and they rarely tell us anything about an artist's style. Pliny may provide us with a list of works; he and Pausanias are both apt to give brief descriptions of unusual pieces. Probably the most reliable information to be gleaned from these and other ancient literary sources concerns the types of statues that an artist produced, the materials of which they were made, and the sites where they were erected. We learn from the sources that Ageladas, for example, was a very cosmopolitan artist, and that his works were set up in at least five places, his home town of Argos not being mentioned as one of them. In the tradition of Theodoros, Kanachos was technically very versatile: he worked in bronze, wood, and chryselephantine. And Onatas obviously had a broad stylistic range, for he made at least seven totally different types of statues and statue groups.

Ageladas or Hageladas, an Argive artist, made statues of athletes, of gods, and of a Muse, as well as a monument to a military victory which combined bronze horses and captive women.[71] We know nothing of his style, but we get a sense of his versatility from the range of types he produced. His fame is apparent from the fact that his works stood in Olympia, Delphi, Attika, and Achaia.

Pliny dates Hageladas to the 87th Olympiad (432–429 B.C.), but as he names Myron, Phidias, and Polykleitos as his students, we may suspect that this artist actually worked in the early fifth century.[72] A statue of Zeus that Ageladas made for the Messenians living in Naupaktos was later moved to Mount Ithome, where a priest kept the statue in his house.[73] Apparently the figure was small enough to carry. The statue may be represented on coins of Messene: a stiffly striding god is shown, carrying a thunderbolt in one hand and an eagle in the other.[74]

Kanachos of Sikyon, an early-fifth-century contemporary of Ageladas, collaborated with him and Aristokles on a group of three Muses, each of them making one statue.[75] Alone he made a cedar Apollo for Thebes, one like it but made of bronze and with an elaborate stag beside it for Didyma, and a gold-and-

71. Athletes: Pausanias 6.8.6, 6.10.6, 6.14.11. Gods: Pausanias 4.33.2, 7.24.4. Muse: *Anth. Gr.* 2.15.35. Horses and captive women: Pausanias 10.10.6.
72. *NH* 34.49.
73. Pausanias 4.33.2, 7.24.4.
74. See Richter, *SSG*, fig. 599.
75. *Anth. Gr.* 2.15.35.

ivory Aphrodite for Corinth.[76] One passage in Pausanias even hints that this versatile craftsman may have used the indirect lost-wax process. "The statue [of Apollo Ismenios in Thebes] is the same size as the one in Branchidai [Didyma], and the form is no different; whoever has seen one of these statues and has learned who its sculptor was does not need great skill when looking at the other to see that it is a work of Kanachos. They differ in this way: the one in Branchidai is bronze, the Ismenios is cedar."[77] Of course, one of these statues may have been copied by eye from the other, or Pausanias may have seen the two statues, both of the standard Apollo type, and, not remembering them clearly, may have thought or been told that they were identical. But it is certainly possible that, as Pausanias says, the two works really were identical, having a common model, perhaps the wooden version, from which Kanachos could have taken molds to produce the bronze. After all, early Greek bronzes were as rigid in appearance as if they had been carved of stone or wood. This may be why, despite his apparent versatility with materials, Kanachos is criticized by Cicero for his hard, apparently Archaic style. "Who indeed of those who take notice of the minor arts does not perceive that statues by Kanachos are more rigid than they should be to imitate reality?" Cicero continues: "And the statues of Kalamis are hard, but nevertheless they are softer than those of Kanachos. Works by Myron had not yet been brought close enough to reality; however, by that time you would not hesitate to call them beautiful."[78] Quintilian also links Kalamis and Myron, contrasting their sculptures with the harder works by Kallon and Hegesias: "Kalamis made statues that were less rigid, and Myron made ones that were softer than those of the artists mentioned previously."[79]

The versatility of Kalamis recalls that of the famous artists of the Archaic period. He worked in gold and ivory, marble,[80] and, primarily, bronze. At least one of his statues was colossal, an Apollo at Apollonia on the Black Sea.[81] Kalamis may have

76. Cedar Apollo: Pausanias 9.10.2. Bronze Apollo with stag: *NH* 34.75. Bronze Apollo at Didyma: Pausanias 1.16.3, 8.46.3, 9.10.2. Gold-and-ivory Aphrodite: Pausanias 2.10.4.

77. Pausanias 9.10.2.

78. Cicero, *Brutus* 18.70.

79. *Inst. orat.* 12.10.7.

80. A gold-and-ivory statue of Asklepios at Sikyon: Pausanias 2.10.3. A marble statue of Dionysos at Tanagra: Pausanias 9.20.4.

81. Strabo 7.319; Appian, *Illyrian Wars* 30. Pliny describes the statue as being 30 cubits tall (between 43 and 55 feet), and adds that it cost 500 talents: *NH* 34.39.

been a Boiotian, and he was apparently active at about the same time as Myron, during the second quarter of the fifth century.[82] His works could be seen in Athens, Sikyon, Tanagra, Thebes, Delphi, and Olympia.

The subjects of Kalamis ranged widely. He worked primarily in bronze, and made an Apollo Alexikakos (Averter of Evil) which stood in the Athenian Agora, a wingless Nike in Olympia, a Hermes Kriophoros in Tanagra, a cult statue of Zeus Ammon that was dedicated by Pindar (518–438 B.C.) in Thebes, a statue of Hermione, daughter of Menelaos, in Delphi, an Alkmena, and possibly both an Aphrodite and the famous Sosandra that stood on the Athenian Akropolis.[83]

Kalamis was also a sculptor of groups, and we are told that he made a group of bronze praying boys, dedicated at Olympia by the Agrigentines; these figures were set on the wall of the Altis, presumably all in a row. Pausanias says that for the chariot by Onatas that Deinomenes dedicated at Olympia in honor of Hieron's victory in the races of 468 B.C., Kalamis made the horses on either side and the boys riding them.[84] Pliny tells a similar story, about a group for which Kalamis made a chariot with four horses, to which Praxiteles added a charioteer, "lest Kalamis be supposed to have failed at statues of human beings, although being better at making horses. Kalamis himself made other four- and two-horse chariots, always modeled without rival."[85] Pliny adds that Kalamis's statues of humans are not inferior, particularly his famous Alkmena. Little more is known of the art of Kalamis, beyond the record of his popularity during the second quarter of the fifth century.[86]

Of Hegesias much is conjectured but little is known for certain, except that he made a statue of Herakles. Hegias, who may

82. Raubitschek, *Dedications*, p. 506.

83. Apollo: Pausanias 1.3.4. Nike: Pausanias 5.26.6. Hermes: Pausanias 9.22.1. Zeus Ammon: Pausanias 9.16.1. Hermione: Pausanias 10.16.4. Alkmena: *NH* 34.71; the passage may refer to a younger Kalamis. Aphrodite: Raubitschek, *Dedications*, no. 136, pp. 152–53. Sosandra: Lucian, *Imagines* 4. It is in fact possible that there were two artists by this name and that their works have been conflated.

84. Pausanias 5.25.5, 6.12.1.

85. *NH* 34.71. This passage may also refer to a younger artist of the same name; see n. 83.

86. For summaries of attributions to Kalamis and theories as to his style, see Richter, *SSG*, pp. 158–60; Ridgway, *SS*, pp. 87, 89; J. Dörig, "Kalamis-Studien," *JdI* 80 (1965): 138–265; Boardman, *GSCP*, pp. 79–80. Raubitschek, *Dedications*, pp. 505–8, also discusses the question of whether there was a younger Kalamis who lived during the fourth century, and if so, which of the works mentioned in the literary testimonia may be attributed to him instead of to the elder Kalamis. And see Overbeck, nos. 508–32.

be the same person, is said to have made statues of Athena, Pyrrhus, Castor and Pollux, and boys on racehorses (*celetizontes*). Pausanias calls Hegias a contemporary of Ageladas and Onatas; Dio Chrysostom makes him the teacher of Phidias.[87] Two statue bases from the Athenian Akropolis, one a low base with socket attachment, bear the name of Hegias and are dated to the first two decades of the fifth century.[88] Pliny's sources give him a later date, however, and he lists Hegias with Phidias, Alkamenes, and Kritios and Nesiotes in the 83rd Olympiad (448–445 B.C.).[89]

Kallon of Elis made a bronze Hermes that stood at Olympia, as well as an entire bronze chorus, including their trainer and flutist.[90] Pausanias also mentions an artist named Kallon from Aegina, who made a wooden Athena for the akropolis at Troizen and a bronze tripod for the Amyklaion near Sparta.[91] Low rectangular bases for two bronze statues of unknown type by Kallon have been found on the Athenian Akropolis.[92] All of the references may be to a single Kallon, whose work, with that of Hegesias, Quintilian calls *durior*, or rather stiff.[93] This term may refer simply to statues in the Archaic tradition.

Onatas of Aegina, the son of Mikon, was a prolific artist. He had statues in Delphi, Pergamon, and Phigalia and several at Olympia. The earliest one mentioned is his Demeter at Phigalia, which Pausanias places in the generation after the Persian invasion.[94] Two of his works were colossal: his Apollo at Pergamon, which Pausanias says was produced in the second generation after the Persian invasion of Greece; and his Herakles at Olympia, which was ten cubits (five to six meters) high.[95] Other works by Onatas at Olympia included two chariot groups, a statue of Hermes, made with Kalliteles, and a group of Achaean heroes casting lots with Nestor for single combat against the Greeks.[96] His most ambitious work was a group in

87. *NH* 34.78–79; Pausanias 8.42.10; Dio Chrysostom, *Oratoria* 55.1.

88. Raubitschek, "Statuenbasen," p. 138, and *Dedications*, nos. 93–94, pp. 100–102, 504.

89. *NH* 34.49.

90. Hermes: Pausanias 5.27.8. Chorus: Pausanias 5.25.2–4.

91. Wooden Athena: Pausanias 2.32.5. Bronze tripod: Pausanias 3.18.8.

92. Raubitschek, *Dedications*, nos. 85–87, pp. 91–95, 508.

93. *Inst. orat.* 12.10.7.

94. Pausanias 8.42.1–13.

95. Apollo at Pergamon: Pausanias 8.42.7. An inscribed marble statue base from Pergamon is ascribed to Onatas; see M. Fränkel, *Die Inschriften von Pergamon*, vol. 8 (Berlin, 1890), no. 48. Herakles at Olympia: Pausanias 5.25.12.

96. Two chariot groups: Pausanias 8.42.8–10. Hermes: Pausanias 5.27.8. Trojan heroes: Pausanias 5.25.8.

Delphi, on which he collaborated with another artist, perhaps even Ageladas. Foot soldiers and horsemen were represented, and the dead king Opis of the Iapygians; over Opis stood the heroes Taras and Phalanthos and nearby was a dolphin (Phalanthos was reportedly saved from a shipwreck by a dolphin).[97] The style of Onatas is nowhere described, but Pausanias calls his work equal to that done by members of the Attic school: "This Onatas, although his statues belong to the Aeginetan school, I shall place second to none of the successors of Daidalos or of the Attic school."[98]

The closest that we come to preserved works by Onatas is in statue bases, including two pillars for statuettes from the Athenian Akropolis, one of which apparently supported a statuette of a bronze horse.[99] Nonetheless, attempts have been made to assign to Onatas a number of works preserved in Roman copies.[100]

Anaxagoras, another artist from Aegina, made an image of Zeus which stood at Olympia.[101] Commissioned by the Greeks who defeated the Persians at Plataia, it may have been the colossal statue to which Herodotos refers, saying that it stood ten cubits (five to six meters) in height.[102]

The Aeginetan artist Glaukias made a statue of the famous Theagenes, winner of 1,400 athletic victories in the 480s and 470s B.C. The statue, which stood in the Altis at Olympia, weighed enough to fall on a man and kill him.[103] The bronze must have been at least lifesize, in which case it would have weighed about half a ton. Glaukias also made statues of Philon and of Glaukos boxing, as well as a chariot and portrait statue of Gelon of Syracuse.[104] All of these works stood at Olympia.

Myron worked at about the same time as Kalamis, from about 480 to 440 B.C.[105] If Pliny's sources are correct, Myron was a native of Eleutherai on the border of Attika and Boiotia, was a pupil of Hageladas or Ageladas, and used Aeginetan

97. Pausanias 10.13.10.
98. Pausanias 5.25.13.
99. Raubitschek, *Dedications*, no. 236, pp. 272–73, and no. 257, p. 287; pp. 520–22: beginning of the fifth century B.C.
100. For the possibilities, see J. Dörig, *Onatas of Aegina* (Leiden, 1977).
101. Pausanias 5.23.1.
102. Herodotos 9.81.
103. Pausanias 6.11.6, 9.
104. Philon: Pausanias 6.9.9; Glaukos: Pausanias 6.10.1; Gelon: Pausanias 6.9.4.
105. For chronological discussion and attributions, see Richter, *SSG*, pp. 160–66; Ridgway, *SS*, pp. 84–86, 89; Boardman, *GSCP*, p. 80.

bronze.[106] Descriptions of Myron's statues give a clear impression of the radical changes that had occurred in Greek statuary between the late Archaic and the early Classical periods. The changes followed important developments in the sixth century: the introduction of bronze statuary, experimentation with lost-wax processes, a new interest in producing athletic statuary, and the gradual discovery of the variations on the few traditionally accepted types of freestanding sculpture permitted by the use of bronze. The medium had already been tested on a small scale, for Archaic statuettes enjoyed a far greater range of pose and of gesture than did statuary. The archaeological evidence for large-scale sculpture is of course more limited, but it suggests that, apart from the xoanon, only three figural types were produced: the standing male or female, the striding, attacking god or hero, and the stiffly frontal seated figure. The first two types were made in bronze, but we have not yet found evidence that seated figures were also of bronze.

Quintilian, in his outline of Greek sculpture, cites Myron after Kallon, Hegesias, and Kalamis, calling his works softer still than theirs.[107] Cicero states plainly that Myron's works are beautiful.[108]

The skill of Kalamis at modeling horses was rivaled by Myron's superiority at modeling cows, the subject of numerous epigrams in the Greek Anthology. Indeed, the statue for which Myron was the most famous was a bronze cow that was reported to be so lifelike as to have attracted a bull and confused shepherds.[109] All who saw the cow are said to have wondered at its closeness to nature. Some asked whether a real cow had served as the sculptor's model. An epigram attributed to the fifth-century-B.C. elegiac poet Evenus implies that nature, rather than Myron, was responsible for the cow's being so accurately realistic: "Perhaps Myron himself would say this: I did not form this heifer, but of her I modeled the statue."[110]

We read a little too much into the passage if we suggest that Myron actually took molds from a real cow to make his statue. The point must be that Myron's cow was so true to nature that it was hard to imagine its having been made by a man. A second

106. *NH* 34.57–58, 34.10. Pliny's chronology is incorrect. He dates Myron, Polykleitos, Phradmon, Pythagoras, Skopas, and Perellius (?) all in the 90th Olympiad (420–417 B.C.): *NH* 34.49.

107. *Inst. orat.* 12.10.7.

108. Cicero, *Brutus* 18.70.

109. See Overbeck nos. 550–91.

110. *Anth. Gr.* 1.98.11 (no. 718) = Overbeck no. 554.

epigram supports this interpretation: "Myron feigned a cow with his own hands which was not formed in molds, but which turned to bronze through old age."[111] Anakreon must have had only a rudimentary knowledge of lost-wax casting. He knew that molds were used, and perhaps he also knew that the molds were taken from the wax model. His abbreviated notion of the process suggests, however, that he believed that a statue was actually formed in the molds.

Pliny lists many other statues by Myron, including an Apollo, a Herakles, a Perseus with sea monsters, pentathletes at Delphi, pankratiasts, a satyr marveling at the flutes, and an Athena, a cicada, a locust, a dog, and a diskos thrower.[112] Pausanias saw works by Myron on the Athenian Akropolis, on the island of Aegina, on Mount Helikon in Boiotia, and at Olympia.[113] But there were other works as well: a colossal group of Athena, Herakles, and Zeus standing on a single base at the Heraion on Samos; another Herakles, "outstanding, made of bronze"; and, from the shrine of Asklepios in Agrigento, "a most beautiful statue of Apollo, which had inscribed on the thigh in small silver letters the name of Myron."[114] There was also a statue of the runner Ladas known from a poem in the Greek Anthology:

Such as you were living, Ladas, fleeing the swift Thymos,
straining your sinews to the utmost,
so Myron made you in bronze, engraving on every
limb your anticipation of the Pisan crown.

Full of hope he is, breath upon the lips
appears from within the hollow flanks,
the bronze will swiftly leap for the crown, nor will
the base restrain it, oh, swift craft of the spirit.[115]

111. *Anth. Gr.* 228 (no. 716) = Overbeck no. 587.

112. *NH* 34.57–58. Most scholars agree that Myron did not make a cicada or a locust, and that he has been confused with a woman named Myro, in *Palatine Anthology* 7, no. 190.

113. Athens: Perseus and Medusa, 1.23.7. Aegina: a wooden image of Hekate, 2.30.2. Mount Helikon: a standing image of Dionysos, 9.30.1. Olympia: two statues for Lykinos, who entered foals in the horse races and won, 6.2.2; a statue of the pankratiast Timanthes of Kleonai, 6.8.4; one of Philip of Pellana, winner of the boys' boxing match, 6.8.5; and one of Chionis, a Lakedaimonian, 6.13.2.

114. Group on Samos: Strabo 14.637b. Herakles: Cicero, *Verrine* 2.4.3, 5. Apollo: Cicero, *Verrine*, 2.4.43, 93. The silver inscription was probably added during a later period.

115. *Anth. Gr.* 4.185.318 = Overbeck 542. I am grateful to Richard S. Mason for the translation.

To judge from this description, the statue was poised in flight, the exertion of the race plainly expressed in the hard breathing, the strained muscles and sinews. The poet sees the statue as an anticipatory work: the race has not yet been won; Ladas is in the midst of his exertions, and his desire for victory is intense. Thus those who saw the statue, knowing that it commemorated a victory, envisaged the race itself: their knowledge that the runner would soon win expanded the narrative meaning of the bronze statue and made the viewer party to the emotions and exertions of the not yet victorious athlete.

This same sense of engagement with a figure in the midst of action greatly appealed to the ancient authors who describe Myron's bronzes.

> "Are you not speaking of the diskos-thrower," I said, "who bends down in the pose of one making his throw, turning toward the hand that holds the diskos, and slightly bending the other knee, as if to straighten up with the throw?"
> "Not him," he said, "for that diskobolos of whom you speak is one of the works of Myron."[116]

After reading this passage, we can easily recognize the Roman copies of Myron's Diskobolos, such as the one from Castel Porziano in the Terme (fig. 6.8). The stance is remarkably different from the traditional Archaic poses, for the figure has both knees bent, the weight resting firmly on the right foot, the left leg trailing behind. The bent upper body twists to the right, the left hand overlapping the right knee. The head is bent with the effort toward the right arm, which is raised and flung straight backward, diskos in hand.

The silhouette of the athlete can be read as a series of triangles open to the space around the figure, the only fully enclosed one being that formed by the left arm, the body, and the right thigh. Nonetheless, it is clear that the statue was essentially two-dimensional and was intended to be viewed only from the direct front and rear. Efforts to view the diskobolos from other angles are unsatisfactory. Seen head on, the figure appears to have no volume, and the limbs, all presented in a single narrow plane, are visually inseparable.

The original Diskobolos, so well suited to bronze, is marred by translation into marble, even when the copy is of superior quality, such as the one in the Terme. A vertical tree trunk shadows the profile of the bent legs and a short horizontal strut

116. Lucian, *Philopseudes* 18 = Overbeck 544.

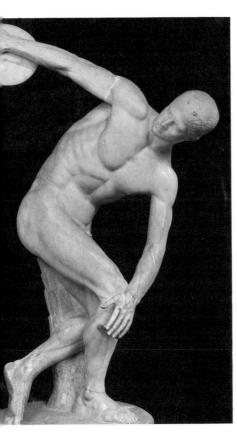

6.8 Roman copy of the Diskobolos by Myron. Rome, Terme Museum no. 126371. Courtesy of Soprintendenza Archeologica di Roma.

once fixed the left hand to the right calf. Far more noticeable is the strut attached to the lower right side of the back. When complete, that strut would have destroyed the rear silhouette of the statue and established a slightly bent but solid line from right knee to right wrist, which would have counteracted or destroyed the intended fluid motion of the Diskobolos.

Despite the struts, the Roman copies of Myron's Diskobolos provide us with a sense of the original statue. There are only two clear viewpoints, one from directly in front, the other from directly behind. The effect of a system of triangles, established by the statue's strong uninterrupted outline, can be seen from either front or back. The figure's lack of depth is apparent when the viewer stands directly in the line of action. From here the athlete looks as precariously balanced as an acrobat on a tight-rope, eschewing the space around it. One limb obscures another and the pose is impossible to read. The simple, linear character of the Diskobolos almost suggests a drawing transferred to sculpture, for the inherent three-dimensionality of the medium is ignored.[117] The sculptor relied on the effect of the statue's outline as seen from two carefully determined viewpoints, front and back, or perhaps only from the front. This fact suggests that the original setting helped to establish these limitations. One might have been prevented from walking around the statue by its placement in a niche or against a wall. Or the statue may have been erected directly beside a pathway, which would have easily prescribed the viewer's movements past the figure.

A statuette of a diskobolos in a somewhat different pose but also dating to the early Classical period (fig. 5.15b) demonstrates the far greater extent to which bronze artists working on a small scale had learned to exploit their medium, in contrast to the sculptors of large bronzes. The statuette balances diagonally over a square base, legs slightly bent and body turned to the right. The left arm is lifted above the shoulder for balance, elbow bent, palm open. The right arm, missing below the elbow, once extended forward, holding the diskos low in front of the body. This athlete, beginning his swing, is a truly three-dimensional figure, one that really uses the space around it; thus it is convincing whether viewed from front, side, or back.

The satyr marveling at the flutes may or may not have belonged in a group with the Athena mentioned next in Pliny's list of statues by Myron.[118] In fact, Pausanias saw such a group

117. This point is discussed in Carpenter, pp. 82–85.
118. The evidence is summarized in Ridgway, *SS*, pp. 84–86.

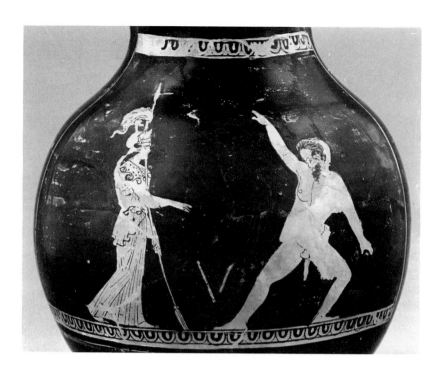

6.9 Marsyas on a red-figure vase, third quarter of fifth century B.C. Berlin, F 2418. Courtesy of Antikenmuseum, Staatliche Museen Preussischer Kulturbesitz, Berlin.

on the Athenian Akropolis, but he does not attribute it to Myron.[119] However, the statues that have been identified as copies of Myron's satyr show the same concern with action in progress as does the Diskobolos.

Reproductions of the satyr, such as the one on a red-figure vase in Berlin (fig. 6.9), and in a Roman copy in the Lateran, show his pose to be an interesting counterpoint to the traditional attacking god or hero of the late Archaic period.[120] He has drawn back from a vertical pose into a stance that can be described only as a momentary one. Instead of striding forward, the satyr steps back, the left knee bent, the right leg straighter. The right arm, following the right leg, is raised; the other arm is pulled back and down. And the gaze of the satyr is directed downward, toward his feet.

The Diskobolos is preparing himself to make a vigorous swing, and Myron shows us the intense physical concentration required of him. We can easily imagine the continuation of this movement. The satyr is also in the midst of an action, but he has drawn back and halted briefly. Here, too, we know the rest

119. Pausanias 1.24.1.

120. Berlin, Antikenmuseum F 2418; Rome, Lateran Collection BS 225: Boardman, *GSCP*, fig. 63.

of the story, but it is more than a contest, for Myron has turned it into a dramatic narrative. He has conveyed intellectual content and has deftly inserted emotional content as well into the satyr's activity.

Quintilian writes in the first century A.D. about stylistic variations in oratory, and recognizes parallels with painting and sculpture:

> We see that dress, expression, and stance are varied. In fact, the very straight body has the least grace; for the face is turned to the front, the arms are hanging down, the feet are joined, and the work is rigid from top to bottom. Bending, or I might say motion, gives [a figure] a sense of action. That is why the hands will not always be arranged in one way, and why there are a thousand forms for the expression. Some figures are running and in rapid motion, others are sitting, and still others reclining; this one is nude, that one draped, and some combine aspects of both. What work is more distorted and artificial than the Diskobolos of Myron? All the same, if someone condemns the work because it is not erect, isn't he failing to understand this art, in which the very novelty and difficulty are especially praiseworthy?[121]

We might think of the type of the striding god as it first appears and of its evolution to Myron's satyr, or of the long-established kouros type and the changes it underwent with the introduction of athletic statuary and the rise in popularity of bronze. Myron's Diskobolos was indeed "distorted" and "elaborate": such poses had become possible with the flexibility of the new medium. Quintilian says that these qualities made the Diskobolos a "novelty," that it had been a "difficult" work to produce. It was certainly remarkably innovative in the context of traditional bronze statuary. But it was not so truly three-dimensional as some statuettes of the Severe period, or as statuary was to become.

The realism of Myron's work is widely acclaimed by Latin authors, and Pliny writes in some detail about his style. "Myron was, it seems, the first to enlarge upon reality, being more prolific [or having more specified proportions: *numeriosor*] in his art than Polykleitos, and being more attentive to symmetry [or to the correspondence of the parts: *symmetria*]. Yet he himself, however careful he was to represent the body, did not portray a sense of the mind, and in the hair and the pubes he did not improve over what had been accomplished in the rough

121. *Inst. orat.* 2.13.8–10.

work of earlier times."[122] The passage is a difficult one to interpret, but it expresses the intense analytical interest of later artists and theorists in the stylistic development of Greek art during the Classical period. Myron's interest in the body was a logical one, as he clearly made great changes in the poses of athletic statuary. Quintilian's criticism of Myron for his lack of concern with the portrayal of the mind does not seem to fit the satyr and the flutes, but is not at all surprising for an artist who specialized in making statues of athletes. Indeed, it was entirely appropriate. After all, Pliny tells us that only after an athlete had won three victories was his statue made to resemble him.[123] Even then, we should not expect likeness to have taken precedence over the rendering of the athlete's prowess.

Stylistically, Myron's Diskobolos can be decribed as a closed composition. It is a figure that is about to unfold; its compressed triangles are understood to be changing as the figure continues with his action. Another statue that we observe in the midst of a motion is the famous bronze god found in 1926 and 1928 in the sea off Cape Artemision in Euboia (fig. 6.10). This statue makes a striking contrast to the Diskobolos for its open pose and full extension of the arms. The system of triangles is again visible, but here they are all open, not closed.

We tend to think of this magnificent bronze statue as an isolated work, but we should really consider it in the context of the sculpture of the early Classical period and the predecessors of that sculpture. This is the familiar type of the striding, attacking god, exemplified earlier by the Ugento god (fig. 4.16) and the Munich Zeus (fig. 4.17). Great changes, however, have been made since the Archaic period in the proportions, the volume, the pose, and the gesture. Composition and outline are still important, but the Artemision god is also a study of anatomical structure and of the complexity of the human form. The arms are slender, fully and gracefully extended to a breadth of 2.1 meters, or slightly more than the total height of the statue. The legs are planted well apart in a stance that somewhat reduces the total possible height of the figure, but the head, about 14 percent of the total height, is still small in proportion to the body.

The god is a massive figure, broad and deep through the chest. Unlike the Diskobolos, he seems not at all compressed

122. *NH* 34.58. The meanings of the terms used in this passage are fully discussed in Pollitt, *Ancient View*, pp. 256–58, 409–15.
123. *NH* 34.16.

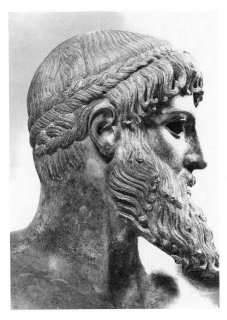

a

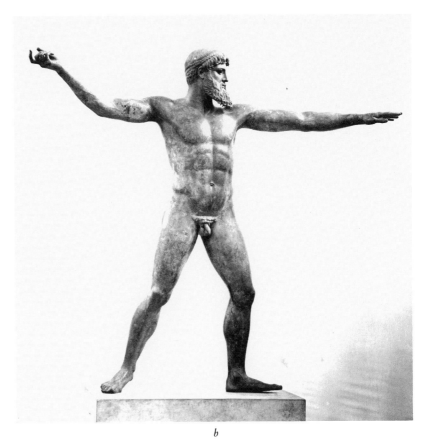

b

6.10 The Artemision god, ca. 460 B.C. H 2.09 m. Athens, National Archaeological Museum no. 15161. Courtesy of (*a*) National Archaeological Museum and (*b*) Deutsches Archäologisches Institut, Athens, neg. no. Hege 850.

when seen from a three-quarter view. But it is in profile that the statue is best viewed, for its outline is surely its most remarkable feature. As with the Diskobolos, a system of triangles is established, but here they have been opened out. The god is raising his right arm and is just beginning to contract it to hurl his weapon, which was once balanced lightly in his palm.

The position of the god's torso is also in the process of changing: following the head, it turns to the left, and we do not see it in a fully frontal position. The left foot is bent somewhat out of its original position, so that the statue's weight is thrown back onto the heel, but the delicate balance is still visible. The god trains his eyes on his mark, setting his aim, but he has not yet thrown his weapon. Thus the highly naturalistic musculature is beginning to flex and the body is beginning to turn for the throw but not yet straining. The raised arms permit us to have a continuous view of the rippling torso. The figure has the potential for violence, is concentrating, poised to throw, but the

action is just beginning, and we are left to contemplate the coming demonstration of strength.[124]

The smoothness of the supple musculature is balanced by the richly textured head with its cap of long hair, braided and bound around the crown, and the long curling beard. Hair and beard are precisely engraved, every hair emphasized, and they provide a deeply shadowed and highly decorative contrast to the rippling flesh beneath. Seen frontally, the face is dominated by the long straight nose, wide eyes marked by gently arcing brows and long, thick, curling bangs. Although the inlays for the eyes are lost, we can easily imagine the original force of the stern imperious gaze. It must have made one uneasy to stand directly beneath the god, in the direct line of incipient attack.

The Artemision god is widely accepted as belonging to the second quarter of the fifth century, close to 460 B.C. The statue has been assigned to Onatas, to Kalamis, and to Myron.[125] Whether it is a cult statue or not has also been discussed.[126] As to the identity, Zeus and Poseidon have both been proposed, but the arguments for the former are at present more convincing.[127] Whoever made the statue and whichever god or hero it may be, it is one of the finest examples of work exemplifying the style of the early Classical period, traditionally known as "Severe" but more aptly described as "Bold."[128]

Because of the early date of discovery and its excellent state of preservation, the physical condition of the Artemision god has been given very little recent attention, and as a result, almost no technical information is available. When the statue was found, however, the arms were detached from the body and the right leg ended just below the knee.[129] Early photographs of the statue show it with the arms broken off across the deltoids just below the shoulders,[130] and it seems reasonable to assume that

124. Ridgway, *SS*, p. 63, discusses anatomical inconsistencies of the statue.
125. Onatas: Lullies/Hirmer, p. 75; BDF, p. 278. Kalamis: Chr. Karouzos, "Ho Poseidon tou Artemisiou," *Deltion* 13 (1930–31): 41–104. Myron: V. Poulsen, *ActaA* 11 (1940): 41–42.
126. Cult statue: Poulsen, "Strenge Stil," p. 140. Not a cult statue: Ridgway, *SS*, p. 62.
127. See R. Wünsche, "Der Gott aus dem Meer," *JdI* 94 (1977): 77–111. For general remarks on the identity of the figure, see also G. Mylonas, "The Bronze Statue from Artemision," *AJA* 48 (1944): 143–60; Robertson, *HGA*, pp. 196–97; Boardman, *GSCP*, p. 53.
128. E. B. Harrison, "Early Classical Sculpture: The Bold Style," in *Greek Art: Archaic into Classical*, ed. C. G. Boulter (Leiden, 1985): 40–65.
129. The left arm was found in 1926, the rest of the statue in 1928. See Chr. Karouzos, "The Find from the Sea off Artemision," *JHS* 49 (1929): 144.
130. Ibid., pl. VII.

they were separated at the same points where they had originally been joined. The restoration of the bronze makes it impossible to ascertain the thickness of its walls or any of the features of the interior, so that technical observations must be confined to the exterior. A fine line crossing the arch of each foot suggests that the fronts of the feet were separately cast, as was the case with a number of other bronze statues, apparently to facilitate doweling the statue to a base.[131]

A single rectangular depression on the front of the left shoulder, measuring about 0.012 by 0.016 meter, once contained a patch. Color was provided by inset eyes, inlaid silver eyebrows, copper nipples,[132] and copper lips.

Tradition prescribed the general form for the Artemision god, but the artist enhanced the type of the striding god so that its origins are nearly unrecognizable. The stance is naturalistic, the gesture forceful, and the gaze lends power to the dynamic effect of the whole. And yet the Artemision god is our only evidence for the exploitation of pose that might be accorded to bronze statues during the fifth century, for no other preserved statues display such freedom of movement.

131. See Selinus Youth (fig. 6.7), Livadhostro Poseidon (fig. 4.20), Riace bronzes (figs. 8.3, 8.4), and Bol, *Grossbronzen*, nos. 113 (B 272: Archaic, pp. 29, 110), 114 (K 1050, pp. 29, 111), and 117 (Br. 647 and 5002, pp. 29, 111).
132. Casson, p. 162.

ELABORATION

When we learn of the range of figures made by the early-fifth-century artists, we may be surprised by the simplicity of the Chatsworth head (fig. 7.1), which was probably made during the period when Kalamis was active. The lifesize head, from Tamassos in Cyprus, once belonged to a standing figure of about 2.1 meters in height, or the same as the Artemision god (fig. 6.10).[1] Because it came from a sanctuary of Apollo, the head has usually been identified as Apollo and dated to the second quarter of the fifth century B.C.[2] And, despite its provincial origin, the head has been attributed more than once to a Greek artist. Adolf Furtwängler, for example, knowing only that the head had been acquired in Smyrna, tentatively assigned it to Pythagoras of Samos.[3]

A broad, square head rests on a stocky neck. The cheeks are smooth and flat, the copper mouth thick but small,[4] and the

1. Robertson, *HGA*, p. 196, thinks that the statue was of the kouros type. For citations of the earliest references to the head, see D. E. L. Haynes, "The Technique of the Chatsworth Head," *RA* (1968), p. 102. A leg in the Louvre with a similar alloy may be from the same statue; see chap. 2, n. 15.

2. E.g., Houser, p. 72. Rolley, *BG*, p. 227, calls the head Cypriot and either of the second half of the fifth century or Classicizing and not before the first century B.C. W.-H. Schuchhardt, "Zum Akrolithkopf von Cirò," *AJA* 66 (1962): 317–18, compares the Chatsworth head with the akrolithic head of Apollo (fig. 7.10) from ancient Crimisa (Cirò), now in Reggio, and calls both heads examples of Hadrianic classicism of the second century A.D. Bol, *Grossplastik*, pp. 21–22, also calls the Chatsworth head a Classicizing work, citing the lack of cold-working on the hair; the inlaid lips, which are made of thin sheet metal instead of being heavy, cast, and inset; and the engraved rather than inset brows. Ridgway, *SS*, pp. 40n85 and 122–23, dates both heads to the Severe period and points out that the Chatsworth head is, after all, likely to be a provincial creation. Robertson, *HGA*, p. 202, agrees. This seems to be the most reasonable conclusion, for not all differences can be traced to different periods of production; they may just as well reflect the idiosyncrasies of different artists, founders, workshops, or regions.

3. A. Furtwängler, *Intermezzi: Kunstgeschichtliche Studien* (Berlin, 1896), pp. 10–13. See also Robertson, *HGA*, pp. 195–96.

4. See P. T. Craddock, "The Composition of the Copper Alloys Used by the Greek, Etruscan, and Roman Civilisations," pt. 2, "The Archaic, Classical, and Hellenistic Greeks," *JAS* 4 (1977): 113.

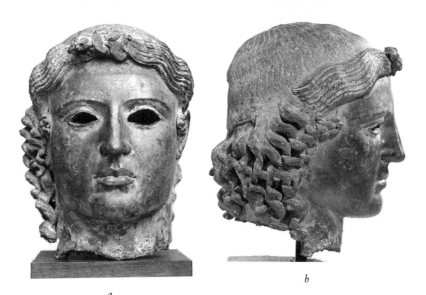

7.1 Chatsworth head, from Cyprus, ca. 460–450 B.C. H 0.314 m. London, British Museum 1958.4-18.1. Courtesy of Trustees of the British Museum.

a

b

nose long and straight. The eyes are wide, the right one retaining the metal casing that was cut to represent lashes. The sockets diminish in size toward the interior, suggesting that the eyes were inset from outside.[5] Long, low, angular brows arc gently above the eyes. Incised strands of wavy hair, sectioned at regular intervals by more deeply incised strands, radiate from the crown. At the level of the ears, corkscrew curls are attached, falling to the back of the neck. One group of curls on the left side is missing, revealing a rounded naturalistic ear. Three small tight ringlets lie in front of each ear. Above them a broad wavy band of deeply incised hair is combed forward from either side and tied in a broad central knot high on the smooth wide forehead.

It is difficult to tell whether the roll of hair across the brow of the Chatsworth head is very deeply undercut or whether it was added separately. If it is part of the head, it is solid, for there is no corresponding indentation on the interior of the bronze. The central knot, however, is cast separately and is fitted into a cutout area in the center of the roll.

The loose curls around the back of the head were modeled separately in five large clumps, cast solid and attached at a level just above the ears. The clump that belonged over the left ear is now missing. The strands of hair on the back of the head are cut back somewhat to accommodate the added curls, which were originally joined metallurgically. All but one group have been reattached in modern times, secured mechanically with rivets.[6]

5. Haynes, "Technique of the Chatsworth Head," p. 112 and fig. 9.
6. Ibid., p. 111.

Behind the left ear and beneath the cut-back in the hair are what appear to be metal drips, evidence of the way the locks of hair were originally cast onto the head. Two groups of tiny ringlets, one in front of each ear, were also cast on.

The Chatsworth head represents a piece casting that is nearly complete. Irregular but finished edges project inward at the base of the neck, indicating that the neck was once joined metallurgically to the body. A couple of small droplets of bronze in the neck are remnants of the hard solder that was used. Two mends can be distinguished on the exterior of the head. On the top of the head, toward the front, is a rectangular patch measuring 0.023 by 0.022 meter. Hair engraved on the patch matches the surrounding strands radiating from the crown. A second partially preserved patch, located on the irregular break at the right side of the neck, is 0.008 meter wide. A large hole in the back of the head, where the bronze is the thinnest, was never mended, and probably occurred when the statue was no longer functional.[7]

The metal in the Chatsworth head contains 87.50 percent copper, 10.40 percent tin, 0.02 percent lead, and traces of various other elements. A curl with rather different ingredients—90.50 percent copper, 9.35 percent tin, 0.90 percent lead, and trace elements—shows the variation that can occur in different parts of a single statue. There is good reason to associate a bronze leg in the Louvre with the head and the curl. The leg, which is also said to be from Tamassos, has similar components in its alloy—91.50 percent copper, 8.90 percent tin, 0.57 percent lead, and trace elements. Paul Craddock notes that samples taken from all three pieces contained traces of gold, an unusual ingredient in bronze.[8]

The interior of the Chatsworth head is accessible, and various scholars who have looked inside have advanced theories as to how the head was made. In fact, more has been written about the technique of this head than about that of most other ancient bronzes, though less has been said of its style, perhaps because

7. See Ibid., fig. 6, p. 105; fig. 8, p. 111; fig. 4, p. 103.
8. Craddock, "Composition," pp. 103–23. Craddock also finds that lead was not deliberately added to Greek statuary bronze until the fourth century B.C., although leaded bronze was normally used for statuettes. He bases his argument on analyses of several hundred assorted small-scale Greek bronzes and approximately twenty-five analyses of bronze statuary. It is interesting to note that Archaic and Classical southern Italian bronzes seem to contain significant amounts of lead, which suggests the possibility of regional preferences for particular alloys. See chap. 2, above.

of its provincial origin. In 1896 Adolf Furtwängler stated for the first time what now seems obvious, that the head had been cast separately from the rest of the statue, and that the projecting ringlets had been cast separately from the head.[9]

In 1938 A. J. B. Wace proposed that the head was a product of Kluge's sandbox process, but that the curls had been cast by the lost-wax method. He also believed that the left ear had been separately cast and that there was no right ear beneath the curls, an error that Martin Robertson noted and corrected. Wace interpreted what is now recognized as a patch to cover a casting flaw on the top of the head as the filling for a hole that had once contained "a rod to hold the core in position." Today we know that a wooden "pattern" or model, associated with the sandbox process, was not used for the production of Greek statuary. Nonetheless, Wace was right to point out that the Chatsworth head had belonged to a statue that had been cast in more than one piece.[10]

In 1956 Herbert Maryon stated that the head had been modeled in wax over a clay core. Then, he thought, a two-piece mold had been taken from one side to the other behind the ears and over the top of the head. After the mold had been removed, the wax would have been scooped out and the mold put back together around the core. Maryon completed his reconstruction by speculating that the core would have been stabilized with chaplets and the bronze poured.[11] This is a somewhat convoluted argument, and it appears that scholars may have been more concerned with disputing previous scholarship than with examining the evidence provided by the bronze itself.

In 1968 D. E. L. Haynes remarked that "neither Wace nor Maryon seems to have given any consideration to the interior of the casting; yet it is here, if anywhere, that a clue might be found." After looking carefully at the head, Haynes logically concluded that it had been cast by the lost-wax process in its indirect form. On the interior of the left side of the head he observed "two parallel seams," which he identified as the marks left by the edges of pieces of wax which were pressed inside the mold and had not completely melted, so that they were

9. Furtwängler, *Intermezzi*, p. 4.

10. A. J. B. Wace, "The Chatsworth Head," *JHS* 58 (1938): 90–95; M. Robertson, "The Chatsworth Head," ibid., p. 255.

11. H. Maryon, "Fine Metal-Work: Metal-Casting," in *A History of Technology*, ed. C. Singer et al. (Oxford, 1956), 2: 476–78.

imprinted in the core material and thus transferred to the inner surface of the bronze.[12]

Haynes's well-prepared arguments and his familiarity with the subject are impressive, but after my own examination of the Chatsworth head, my conclusions differ slightly from his. The "parallel seams" inside the head, for example, may actually be places where cracks in the core filled with wax and were then reproduced in the bronze.

The bronze ranges in thickness from 0.010 to 0.013 meter in the neck, but at the break in the back of the head it is only 0.003 meter thick. In fact, the front of the head is up to 0.01 meter thicker than the back. On the inside of the bronze, the exterior contours are only very roughly discernible, nose and mouth being almost solid. Evidently the original layer of wax over the core was roughly worked without details, and wax was then applied more thickly in front to allow for the modeling of the face. We must assume that many of the final details of the head were added to the cored wax. And so the Chatsworth head is probably not strictly an indirect lost-wax casting, but is instead the product of a combined version of both the indirect and the direct processes.

We may reconstruct the casting process as follows. The original model was a rough one, without the final details. The clay mold that was taken of it was lined with wax. Then the wax was cored and the mold was removed. More modeling could then be done, including the addition of such details as the nose and ears. This process would have allowed the artist many opportunities for working over and changing his sculpture at every step. We can imagine that the same technique was used during the 470s to produce the Delphi Charioteer (fig. 6.6). And there is clear and abundant evidence for the use of this combined lost-wax process in the production of the Riace bronzes (figs. 8.3, 8.4) in the fifth century.

A few other technical details can be observed on the Chatsworth head. High within either side of the neck is a small circular hole that is invisible on the outside. A slightly projecting edge on each hole indicates that both were formed when chaplets were stuck through the wax from the exterior into the core. A third, rectangular hole toward the top of the head may

12. Haynes, "Technique of the Chatsworth Head," pp. 101–12. I am grateful to D. E. L. Haynes for granting me permission on two occasions to study the Chatsworth head, in 1970 and 1973. For excellent views of the interior, see ibid., figs. 1–9.

7.2 Mold, ca. 350–325 B.C. Max. pres. dim. 0.086 m. Athenian Agora B 1475. Courtesy of American School of Classical Studies at Athens: Agora Excavations.

have been made by another chaplet, but the disparity in shape makes the identification questionable.

A close examination of the exterior of the Chatsworth head reveals traces of very fine rasping all over the face and stronger rasp marks on the engraved eyebrows and curls. This rasping appears not to be the result of modern cleaning, for it is fairly uniform over the whole face. In that case, the marks may well be the result of rasping of the wax model to smooth it. Similar marks from the wax model have been transferred quite distinctly to the fine clay of some of the investment molds from the Athenian Agora (fig. 7.2).[13] They too would have been reproduced faintly on the finished bronze but could have been obscured fairly easily by cold-working.

Art critics seem to have followed closely the works of individual sculptors throughout antiquity. During the Roman period, the great Classical sculptors were frequently compared with one another. Cicero, for example, found the works of Myron beautiful, but those of Polykleitos more so, even to the point of perfection.[14] Indeed, a great deal has been written about Polykleitos, who was probably the most influential artist of the Classical period in Greece. Although his works are lost, much is known about them, including the fact that most of his statues were made of bronze. We may wonder, while perusing the literary testimonia, whether Polykleitos's use of bronze allowed him to achieve something that had eluded earlier artists, something that later artists and theoreticians would recognize as his genius.

Plutarch makes a provocative comment about ancient bronze casting when he refers to the work of Polykleitos: "As for the arts, they first model the unformed and shapeless [material], then later they articulate all the details; whence Polykleitos the sculptor said that the work is most difficult when the clay is on the nail."[15] This is a tantalizing sentence because it purports to tell us something about ancient techniques and about an assessment of them by the man who was probably the greatest bronze artist of the fifth century. It is altogether likely that Plutarch is either citing a statement attributed to Polykleitos or paraphrasing a passage from the artist's treatise on sculpture, his *Kanōn*.

13. See Mattusch, "Agora," C14, pp. 352, 355.
14. Cicero, *Brutus* 70.
15. Plutarch, *Quaestiones conviviales* 2.3.2. Plutarch reiterates this comment in abbreviated form in *De profectibus in virtute* 17.86A, using *eis onycha*.

In what respect did Polykleitos find the sculptor's art particularly difficult? The answer rests with the meaning of the phrase "on the nail" (*en onychi*). The word *onyx* can mean a claw, a hoof, or a talon. Rhys Carpenter has suggested that it may mean chaplet and that the passage may refer to the point in the casting process when the wax has been burned out, leaving the core suspended within the mold and the chaplets to withstand the thrust of the molten bronze.[16] Normally, however, *onyx* designates an organic nail, a fingernail, and surely that is its sense here. Even when we agree on this meaning, the passage is obscure, and several interpretations of it have been offered. Perhaps it refers to the working over of the finished model with a fingernail, or to the sticky consistency of the clay encountered by the artist in the process, or even to the fingernails of the clay model.[17]

Dionysios of Halikarnassos uses *eis onycha* to mean "most carefully."[18] And Latin authors use a similar phrase to describe something that is flawless: *ad unguem* actually derives from the practice of testing the smoothness of joints in marble sculpture by running one's fingernail over them.[19]

Two ancient lexicographers define *onychizetai* as *akribologeitai*, "to be exact or precise," and cite Aristophanes as having thus used *onychizetai*.[20] A third defines both *onychizein* and *exonychizein* as *akribologeisthai*.[21] Elsewhere, *exonychizō* has the related meaning of "scrutinize carefully."[22] And even *aponychizōn ta rēmata* is used in the sense of polishing up one's words, although *aponychizō* normally refers to paring one's fingernails.[23]

It seems better to give a broad interpretation to Plutarch's *en onychi* than to have it refer simply to the sculptor's working on

16. Carpenter, p. 72. *Hēlos* is the term commonly used to refer to a manmade nail.

17. Stuart Jones, p. 130; J. J. Pollitt, *The Art of Greece: 1400–31 B.C.* (Englewood Cliffs, N.J., 1965), p. 92n110; Carpenter, p. 72.

18. Dionysios of Halikarnassos, *De Demosthene* 13.944.

19. See Horace, *Satires, Epistles, Ars Poetica*, ed. H. Rushton (Fairclough, N.Y., 1926), pp. 66 (*Satire* 1.5.32), 474 (*Ars Poetica* 294), and 475n; *The Satires of A. Persius Flaccus*, ed. B. L. Gildersleeve (New York, 1875), p. 42 (*Satire* 1.63–66); A. Persi Flacci, *Saturarum Liber*, ed. D. Bo (Turin, 1969), p. 23 (notes on *Satire* 1, l. 65).

20. Photius and Souda Lexicon, s.v. ὀνυχίζεται.

21. *The New Phrynichus*, ed. W. G. Rutherford (London, 1881), p. 350, no. 256.

22. Artemidorus Daldianus, bk. 1, chap. 16; Athenaeus of Naukratis, 3.97d; and Julianus Imperator, *Oratio* 7.216a.

23. Julianus Imperator, *Oratio* 2.77a; e.g., *New Phrynichus*, p. 350, no. 256.

details with his fingernails or specifically to the completion of the nails on the model itself. There is, after all, evidence that the phrase was widely used as a metaphor for exacting or precise work, or to refer to putting the final touches on a project.[24] And so a reasonable interpretation of the passage might be that Polykleitos considered the most difficult part of modeling a figure in clay to be in the execution of the final details.

What does Plutarch find so worthy of note in a statement by a noted bronze sculptor about modeling in clay? Here the answer is easy to find: modeling in clay is the very basis for the artist's work in bronze. The passage must refer to the artist's original model from which molds were taken for casting a bronze statue. If so, the process used to make a statue was a version of indirect lost-wax casting. Reproduction of the model by means of molds, a wax impression, and a final investment ensures that the artist's original model is not lost. In the case of an artist with the stature of Polykleitos, the loss of a model was a disaster to be avoided at all costs, and the precautions taken in the production of a monumental work by a leading artist were surely extensive.

The same was certainly not true of small bronzes, which were much more modest undertakings, both practically and financially. A small bronze athlete in Oxford well exemplifies the kind of lost-wax casting that was used to produce hollow figurines (fig. 7.3). The nude youth from Boiotia originally stood about 0.25 meter tall, but the top of the head is now missing, as are both legs from above the knee, the left arm from above the elbow, and the right hand. Both arms are solid, and a square hole in the bronze above the left elbow may have held a patch. The buttocks are solid, the shoulders nearly so, and the upper legs, though thick-walled, are hollow. Through a large hole in the left upper back, apparently a casting flaw, we can see that the interior of the body and head is smooth and generally follows the exterior contours. Through the hole a single bronze chaplet is visible within the left pectoral.[25] A bulge around the

24. Pollitt's translation of *en onychi* as "in the fine points" is perhaps the best one: *Art of Greece,* p. 92n110. A. F. Stewart takes the passage to refer specifically to the artist's working out of a system of proportions for a statue: "The Canon of Polykleitos: A Question of Evidence," *JHS* 98 (1978): 126.

25. P. Gardner, "Bronzes Recently Acquired for the Ashmolean," *JHS* 30 (1910): 231–32, suggested that the chaplet, which he identified as a pin, might have been associated with sorcery, or maybe with repairs. See also J. Dörig, "Kalamis-Studien," *JdI* 80 (1965): 225; Rolley, *Monumenta,* no. 81, p. 8, and Thomas, *Athletenstatuetten,* pp. 138–39, for other references. I am grateful to Michael Vickers for allowing me to look at the statuette in 1985.

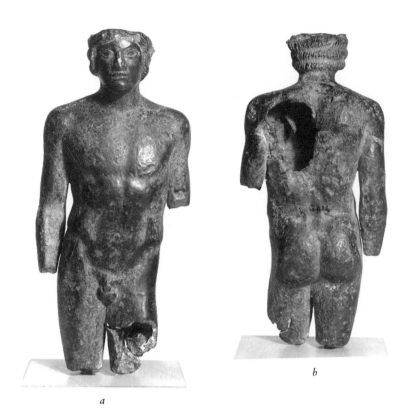

7.3 Bronze statuette from Boiotia, middle of the fifth century B.C. Pres. H 0.16 m. Oxford, G 414. Courtesy of Ashmolean Museum, Oxford.

a

b

pointed angular chaplet is testimony to its having been stuck through the wax into the core of the model. Each hollow part of the statuette would have had a chaplet like this one to stabilize the core. During casting, the chaplets were intended to fuse with the molten bronze; the preserved one did, and cannot be detected on the outside of the pectoral.

The Oxford statuette appears to be a simple direct casting, the wax probably having been worked over a partial clay core, then the chaplet inserted and the piece invested and cast. The large hole in the back, the patch on the left bicep, and the irregular pocked surface of the whole statuette show that this piece is far from perfect. But if the artist deemed the statuette to be usable, he could have saved a good deal of time and effort and no doubt money as well by using the direct process. It is hard to visualize a founder trying to take molds from a model this small to make an indirect casting, for the use of elements of the indirect process is far better suited to the production of large bronzes than to statuettes.

Stylistically, the Oxford statuette echoes the stance that Polykleitos was to exploit most fully in his Doryphoros (fig. 7.4) and describe in his book about the statue. The weight is borne

7.4 Roman copy of Doryphoros by Polykleitos. Naples, Museo Nazionale no. 6011. Courtesy of Hirmer Fotoarchiv, Munich.

on the right leg: the right hip thrusts outward, the right shoulder drops, and the right arm hangs limply beside the hip. The left, free leg is slightly advanced, and the left arm is likely to have been bent at the elbow and extended forward. The head turns almost imperceptibly to the right. It is rather crudely delineated, the eyelids heavy and linear, the short wavy hair represented simply by cursory lines incised across three horizontal rolls. The torso, in contrast, is delicately modeled, and even though the bronze is in poor condition, the surface still produces a rippling gleam as light reflects off the subtly modeled musculature.

Polykleitos was an Argive, and, like Myron, a pupil of Ageladas. He was especially famous for two statues: his Diadoumenos, or fillet binder, for which Pliny reports that the astronomical fee of one hundred talents was once paid; and his Doryphoros, or spear bearer, which, like his treatise on this work, he called his *Kanōn*. Pliny says that Polykleitos was a rival of Myron, both in his choice of Delian over Aeginetan bronze and in the style of statuary that he produced. Myron was certainly attentive to proportion and symmetry, but Polykleitos was the more successful artist of the two. He was considered to have perfected the skill of sculpture and to have illuminated the art of cold-working or engraving (*toreutice*), as Phidias had first revealed it.[26]

Indeed, Polykleitos was the greatest artist of his day. His studio was very large, but his many pupils, including Argios, Asopodoros, Alexis, Aristides, Phryno, Dino, Athenodoros, and Demeas, are scarcely known to us.[27] His own stylistic advances are familiar to us through the literary sources, though they are often hard to interpret, particularly as no original work by Polykleitos is preserved. Of particular critical interest during antiquity was his concern with *symmetria*, as explained in his treatise and exemplified in the Doryphoros. *Symmetria* is usually taken to refer to the precise mathematical proportions of the parts of the statue to one another, proportions that were so perfect that other artists copied them endlessly.[28] Quintilian

26. *NH* 34.55, 10, 58, 56. For a discussion of the meaning of *toreutice*, see Pollitt, *Ancient View*, pp. 106–7n4. For the question of a second, younger artist of the same name, see Ridgway, *FCS*, p. 201. For literary testimonia regarding this individual, see Pollitt, *Art of Greece*, 153, 182.

27. *NH* 34.50, 72.

28. For a discussion of the term as it applies to the work of Polykleitos, with extensive references to the scholarship on the subject, see Pollitt, *Ancient View*, pp. 14–23. See also R. Tobin, "The Canon of Polykleitos," *AJA* 79 (1975): 307–21.

summarizes quite simply the intentions of artists who used the work of Polykleitos as an example in their own efforts: "In fact, the most distinguished sculptors and painters, when they wish to represent the figure as beautifully as possible, . . . choose the Doryphoros, a suitable model for either the military or the palaistra. . . ."[29] In other words, the Doryphoros served as a model for artists making two similar types of figures, so appropriate were its proportions for the standing male in peak physical condition.

Polykleitos made two nude boys playing dice (*astragalizontes*), which were seen as the height of perfection. Pliny tells us that Polykleitos's wounded Amazon, made for the city of Ephesos, was selected as the best of five entries because each of the other contestants—Phidias, Kresilas, Kydon, and Phradmon—voted it second only to his own.[30] Bronze basket carriers by Polykleitos were admired by Cicero in a collection in Sicily: "There were, besides, two bronze statues, not large but of truly exceptional beauty, virginal in appearance and dress, which with raised hands held up their sacred objects, which, like the Athenian virgins, they placed on their heads. They were called the Kanephoroi. But whose work are they? Whose indeed? You counsel correctly—they were said to be by Polykleitos."[31]

Polykleitos made numerous statues of athletes, including an Apoxyomenos or scraper and a spear thrower. At Olympia were his pentathlete Pythokles of Elis, the boy wrestler Xenokles of Mainalos, the boxer Aristion of Epidauros, and three boy boxers, Antipatros of Miletos, Kyniskos of Mantineia, and Thersilochos of Kerkyra.[32] The surviving Roman copies of the Doryphoros and the Diadoumenos, with the free leg trailing behind the weight-bearing leg, probably also reflect the general stance of many of the other athletic statues.[33] Bases of as many

29. *Inst. orat.* 5.12.21. Dionysios of Halikarnassos, also finding a parallel for oratory in the arts, mentions specifically that modelers copy the works of Polykleitos, whereas carvers copy those of Phidias: *De Dinarcho*, 7.

30. *NH* 34.53.

31. Cicero, *In verrem* 2.iv.3.5.

32. Apoxyomenos and spear thrower: *NH* 34.55. Pythokles: Pausanias 6.7.10; for the preserved base of this statue, see Loewy, no. 91, p. 71, and P. E. Arias, *Policleto* (Florence, 1964), no. 52, p. 52, and fig. p. 50. Xenokles: Pausanias 6.9.2; for the preserved base of this statue, see Loewy, no. 90, p. 70; and R. Bianchi-Bandinelli, *Policleto* (Florence, 1938), fig. 10. Aristion: Pausanias 6.13.6; for the preserved base of this statue, see Loewy, no. 92, pp. 71–72; and Bianchi-Bandinelli, fig. 3. Antipatros: Pausanias 6.2.7. Kyniskos: Pausanias 6.4.11; a base associated with this statue is illustrated in Bianchi-Bandinelli, *Policleto*, fig. 1. Thersilochos: Pausanias 6.13.6. For the bases and a survey of the works and style of Polykleitos, see D. Arnold, *Die Polykletnachfolge* (Berlin, 1969).

33. See Richter, *SSG*, figs. 690–97.

as four statues by Polykleitos, all in Olympia, evidently supported figures with similar postures. Pliny remarks that the familiar stance of statues with one weight-bearing leg and one free leg is characteristic of Polykleitos, but adds that Varro calls Polykleitos's statues square and made after a single pattern.[34]

The Roman copy of the Doryphoros in Naples (fig. 7.4), despite a distracting strut from right hip to wrist and the unsightly tree trunk behind the right leg, gives us a surprisingly accurate sense of the original. Supporting evidence comes from among the plaster casts found at Baiae. Fragments of various body parts so closely match the Doryphoros in Naples that they can be presumed to have been molded from the original bronze statue. It was from such plaster casts as these that the Roman sculptor would have worked to produce the Naples statue.[35]

Pliny lists a few other statues by Polykleitos, including a Hermes from Lysimachea, a Herakles, a leader putting on his armor (which, like the Astragalizontes, is in Rome), and a statue of a man named Artemon.[36] Presumably all of these works were made of bronze. Others were not: Pausanias says that Polykleitos made a Zeus Meilichios at Argos and an Apollo, Leto, and Artemis at nearby Mount Lykone of white marble.[37] There is no clue as to the material of his Aphrodite beneath a tripod at Amyklai, financed from the spoils of Aegospotamoi (405 B.C.).[38] As further evidence of his versatility with materials, Polykleitos is often recalled as the artist who made the colossal chryselephantine Hera for the Argive Heraion.[39] The statues in other materials were not so famous as the bronzes, nor is there any indication that they were at all out of the ordinary.

It was for his athletic statues that Polykleitos was famous. The material that he used for them was bronze. Thus he worked in clay and wax, which gave him the freedom he

34. *NH* 34.56. For the Polykleitan style, see P. Zanker, *Klassizistische Statuen* (Mainz, 1974), pp. 3–48; Ridgway, *FCS*, pp. 202–6; Boardman, *GSCP*, pp. 205–6, figs. 184–87. For recent studies of the Kanon, see H. v. Steuben, *Der Kanon des Polyklet: Doryphoros und Amazone* (Tübingen, 1973); Tobin, "Canon of Polykleitos"; and Stewart, "Canon of Polykleitos," pp. 122–31. Monographs about Polykleitos include Arias, *Policleto;* and T. Lorenz, *Polyklet* (Wiesbaden, 1972).

35. Landwehr, *AGB*, no. XIV, p. 177. Stewart, "Canon of Polykleitos," pp. 123–24, finds the style of the plaster fragments "severe and angular," and suggests that the Roman copies were modernized.

36. *NH* 34.55–56.

37. Argos: Pausanias 2.20.1; Mount Lykone: 2.24.5.

38. Pausanias 3.18.8.

39. Pausanias 2.17.4; Plutarch, *Perikles* 2; Lucian, *Somnium* 6; Strabo 8, p. 372. For a recent discussion of this attribution, see Ridgway, *FCS*, p. 201.

needed to develop the stance, gesture, and proportion of each figure. The model was then reproduced in bronze, its great tensile strength supporting any pose that Polykleitos had chosen. Furthermore, the gleaming finished surface brought out all of the subtleties that Polykleitos had imparted to his original model.

The extant criticism suggests that Polykleitos was a rival of Phidias as well as of Myron. Dionysios of Halikarnassos writes that the statues of both Polykleitos and Phidias embodied the qualities of majesty, sublimity, and dignity.[40]

According to the inscription on Phidias's chryselephantine Zeus at Olympia, Phidias was an Athenian, the son of Charmides.[41] During his long career, which lasted from roughly 460 to 430 B.C., he maintained the tradition of the great artists of the Archaic period: he worked in more than one material and he produced some colossal statues.[42] He was also in charge of the Akropolis building program under his friend Perikles. Phidias made the much-touted Athena Lemnia, as well as a boy tying a fillet around his head (*Anadoumenos*) in Olympia, the Eponymous Heroes of the Athenians which stood as a group on a base at Delphi, and the Amazon that won second place (after that of Polykleitos) in the famous contest of the five artists at Ephesos.[43] Pausanias says that Phidias made a cult statue for the Metroon of Athens and a Nemesis at Rhamnous, but Pliny ascribes these two statues to Phidias's pupil Agorakritos.[44] Pliny cites a nude colossus later dedicated by Quintus Lutatius Catulus in Rome, and concludes with the enigmatic statement that Phidias "is deservedly declared to have first revealed the art of sculpture [*toreutice*] and to have explained it."[45]

Quintilian points out that Polykleitos sculpted men better than gods, but that Phidias is "believed to have been more

40. Dionysios of Halikarnassos, *Isocrates* 3. For discussion of these terms in the context of ancient art criticism, see Pollitt, *Ancient View*, pp. 140–41, 201, 234–36.

41. Pausanias 5.10.2.

42. For further details of the life and works of Phidias, see Richter, *SSG*, pp. 167–78; Ridgway, *FCS*, pp. 161–71; Boardman, *GSCP*, pp. 203–4, figs. 180–83.

43. Athena Lemnia: Pausanias 1.28.2; *NH* 34.54; Lucian, *Imagines* 4.6. Anadoumenos: Pausanias 6.4.5. Athenian Eponymous Heroes: Pausanias 10.10.1. Amazon: *NH* 34.53–54.

44. Pausanias 1.3.5 (Athens), 1.33.3 (Rhamnous); *NH* 36.17. For recent consideration of the problem, see V. Petrakos, "Problemata tis Basis tou agalmatos tis Nemeseos," in *Archaische und Klassische Griechische Plastik* (Mainz, 1986), 2:89–108.

45. *NH* 34.56, 54. Elsewhere (*NH* 36.15), Pliny mistakenly states that both painting and bronze statuary are much younger arts than stone carving, having begun with Phidias in the 83rd Olympiad (448–445 B.C.), whereas stone carving originated 332 years earlier.

skilled at making gods than men," and goes on to discuss the skill of Phidias in working ivory, as evidenced by the Zeus at Olympia and the Athena Parthenos.[46] Cicero mentions the same two statues, remarking on Phidias's skill at rendering gods. "Indeed that master, when he made the form of his Zeus or of his Athena, was not contemplating anyone from whom he made an imitation; rather, some exceptional vision of beauty was fixed in his own mind, and, concentrating on it and contemplating it, he directed his art and his hand toward making an imitation of it."[47]

When the material of Phidias's freestanding works is mentioned, it is usually because this aspect of the piece is of particular importance, as with his akrolithic Athena Areia at Plataia, which was a gilded xoanon with marble face, hands, and feet.[48] Chryselephantine, the richest material for cult statues, was a specialty of Phidias. His most famous works in this medium were the Athena Parthenos and the Zeus at Olympia; he also made a chryselephantine Athena at Pellene in Achaia, an Athena in Elis, and an Aphrodite Ourania in Elis.

The Athena Parthenos, the Zeus at Olympia, and the Athena Areia were all colossal statues. Pausanias notes that the Athena Areia was only slightly smaller than Phidias's Bronze Athena on the Akropolis, and elsewhere he declines to reveal the exact measurements of the Olympian Zeus, which he feels would only detract from its imposing appearance.[49] Strabo, however, is enchanted by the idea that if the cult statue of Zeus at Olympia could stand up, it would take the roof off the temple.[50] Pliny reports that the Athena Parthenos was twenty-six cubits high, or between eleven and fifteen meters, and Pausanias reports that the Nike that she held in her hand was about four cubits high, between 1.7 and 2.2 meters.[51]

Phidias managed a large and busy workshop at Olympia for the production of his chryselephantine Zeus.[52] He undoubtedly did the same to produce the Athena Parthenos, in progress for nine years between 447 and 438 B.C., although the circumstances are nowhere mentioned in the literary sources. Phidias's

46. *Inst. orat.* 10.10.8–9. Diodoros also mentions his skill with ivory: 26.1.
47. Cicero, *Orator* 8–9.
48. Pausanias 9.4.1.
49. Athena Areia: 9.4.1. Zeus at Olympia: 5.11.9.
50. Strabo 8.353–54.
51. *NH* 36.18; Pausanias 1.24.7.
52. Pausanias 5.15.1. See A. Mallwitz, *Die Werkstatt des Pheidias in Olympia*, OF 5 (Berlin, 1964); Heilmeyer/Zimmer/Schneider.

role was to design the project and oversee its construction by a staff working under his direction and with his help.

A friend of Perikles, Phidias was certainly not the kind of sculptor disdained by Lucian's Paideia: "a workman, unwashed, unkempt, hands full of calluses."[53] All the same, Phidias's artisanal skills are of great interest to ancient authors. Dionysios of Halikarnassos places Polykleitos among the modelers (*plastai*) and Phidias among the carvers (*glypheis*).[54] Demetrios sees splendor (*megaleion*) and precision (*akribes*) in the work of Phidias.[55] And Pliny names Phidias as the teacher of two other important fifth-century artists who worked in Athens, Alkamenes of Athens and Agorakritos of Paros.[56]

The colossal Bronze Athena by Phidias, though less frequently mentioned in later literature than the Athena Parthenos and the Olympian Zeus, was one of the most visible monuments on the Akropolis of Athens. Pausanias's description of the familiar statue, which he saw in place, may closely reflect its original appearance: "A bronze statue of Athena, a tithe from the Persians who landed at Marathon, is a work by Phidias. But they say that the battle of the Lapiths against the centaurs and the other works on the shield were engraved by Mys, for whom they say that Parrhasios the son of Evenor drew the outlines, as he did for the rest of the works of Mys. The point of the spear of this Athena and the crest of her helmet can be seen by those sailing in from Sounion."[57] Besides attributing the Athena to Phidias, Pausanias has informed us that the statue was financed from the spoils of Marathon. Moreover, Pausanias knows quite a lot about the shield, including its subject matter, the artist, and the engraver. His last remark is particularly interesting. He states that the Athena carried a spear, which must have been held vertically or nearly so for its tip to be visible from a distance. The fact that sailors could see this spear and the crest of the goddess's helmet when they approached the port from the direction of Sounion proves that the statue was large enough not to be completely obscured by the Propylaia or by other buildings and monuments on the southwestern side of the Akropolis. It has been estimated that it stood

53. Lucian, *Somnium* 6–10.
54. Dionysios of Halikarnassos, *De Dinarcho* 7.
55. Demetrios, *De Elocutione* 14.
56. *NH* 36.16–17.
57. Pausanias 1.28.2.

7.5 Bronze statuette of Athena Promachos, from the Athenian Akropolis, middle of the fifth century B.C. H 0.3 m. Athens, National Archaeological Museum no. 6447. Courtesy of Deutsches Archäologisches Institut, Athens, neg. no. N.M. 4742.

fifty or more feet in height.[58] The Bronze Athena must also have been highly polished, so that the gleaming surface, glinting in the sunlight, was easy to see from a distance.

There was a long-standing tradition of colossi, and Phidias made at least five, but the Athena was the only one that he cast in bronze. Other literary sources refer to this Bronze Athena, which a scholiast on Demosthenes eventually calls the Athena Promachos, that is, the Warlike Athena, the name by which the statue is most commonly known today.[59] And yet the Athena was evidently quite unlike the small-scale bronze Athenas of the type that is given the epithet *promachos*. The type commonly recognized as the Athena Promachos is well represented by a statuette from the Athenian Akropolis, of approximately mid-fifth-century date (fig. 7.5).[60] The goddess steps forward with her left foot, extends her shield-bearing left arm in front of her, and raises her right hand high, elbow bent, to hurl a spear. Her attitude is familiar: it is the same as that of the attacking male god or hero, so popular during the late Archaic and early Classical periods.

But the Bronze Athena of the Akropolis fell into an entirely different category, for she stood still. Niketas Choniates may have seen this statue in Constantinople, where it stood until the Christians destroyed it in the early thirteenth century.

The more drunken of the group of people pulled down and broke into many pieces the statue of Athena which stood on a pillar in the forum of Constantine. Standing, it rose to a height of thirty feet, and was clothed in a garment made of the same material as the whole statue. The garment fell over her feet and was folded together in many places. A girdle bound her waist tightly. Over her outstanding breasts she wore an embroidered outer garment, like an aegis, carried over her shoulders, and bearing the head of the Gorgon. Her neck, which was without a tunic and extended to a great length, was a sight for unchallenged pleasure. Her veins stood out distinctly, and her whole body was supple and in places bent around. On her head there was a horsehair crest, which nodded fearfully from above. Her hair was twisted into a knot and bound behind, and that which flowed from her forehead was a feast for the eyes—it was not wholly contained by the helmet, but some of the locks could

58. Robertson, *HGA*, p. 294. W. B. Dinsmoor summarizes the arguments for the other sizes proposed: "Attic Building Accounts IV: The Statue of Athena Promachos," *AJA* 25 (1921): 127–28.

59. *Contra Andration* 13. See also Overbeck, nos. 638–44.

60. Touloupa/Kallipolitis, no. 14, p. 20: 450 B.C.

7.6 Roman coin showing the Bronze Athena on the Akropolis, second century A.D. London, British Museum. Courtesy of Trustees of the British Museum.

be seen. Her left hand held up the folds of her dress, and the other one, outstretched towards the south, supported her head, which was inclined in the same direction, as was her gaze.[61]

Niketas does not agree with the other sources on the positions of the arms; they may have been restored at some time, or perhaps this was not the same statue after all.[62]

Athenian bronze coins of the Antonine period show the Bronze Athena standing out of doors somewhere between the Parthenon and the Erechtheion (fig. 7.6). It is clearly a colossal statue, but the details are impossible to make out on such a small scale. Coins that show only the statue and not its surroundings have a standing helmeted goddess wearing a peplos and the aegis, the head turned to the right. A round shield is worn on the raised left arm; the right arm clasps a spear, its blunt end on the ground close to the figure, its pointed end angled away from the body.[63]

A mid-fifth-century date for the Bronze Athena is supported by remarkable contemporary evidence in the form of inscriptions that document the costs of labor and of materials during the production of the statue. This record by the overseers of the project is inscribed in three columns, each one covering a three-year period. Engraved after the statue was completed, in approximately 455 B.C., the inscription records the materials that were purchased for the project and the wages paid to the employees.[64] Coal (*anthrakes*) and firewood (*chsyla kausima*) for the furnace (*es oikodomian kaminon*) are listed repeatedly. Clay and hair (*ge kai triches*) are also recorded a number of times, if we follow Raubitschek's restoration of the text.[65] The clay must have been used to make the core and mold, and hair was probably mixed with it to reduce shrinkage.[66]

It is somewhat surprising that the word for wax (*keros*) can be restored only once in the text, and that with uncertainty.[67]

61. *Chron. Isaac. Ang. et Alex. F.*, p. 738B, quoted in Stuart Jones, pp. 78–79.

62. See Stuart Jones, p. 80; Richter, *SSG*, p. 169n19, takes the position that this is not the same statue. A Byzantine miniature has also been cited as a possible representation of this statue, but it shows a small figure on top of a tall column. The arms are held not as Niketas describes them but as they appear on Roman coins of Athens. See R. J. H. Jenkins, "The Bronze Athena at Byzantium," *JHS* 47 (1927): 31–33.

63. Imhoof-Blumer, pl. Z, nos. I–II.

64. Raubitschek, *Dedications*, no. 172, pp. 199–200.

65. Raubitschek, "Greek Inscriptions," *Hesperia* 12 (1943): 16.

66. Molds normally retain the impressions of hair, grass, or straw inclusions. See Appendix, "Molds."

67. Raubitschek, *Dedications*, p. 17.

Purchases of copper (*chalkos*) and tin (*kattiteros*), however, are noted several times, and silver (*argyrion*) is mentioned for the decoration of the statue.[68]

Workers were paid by the day, by the prytany (35 to 36 days), and by the job.[69] At the end of each year's account, the total amount spent in that year is recorded, and the amount left over for the following year is noted.

William Bell Dinsmoor estimated that the total cost of the statue was 83 talents.[70] Raubitschek's restoration of the text allows for a partial breakdown of that figure. In one year a total of 78,110 drachmas was available for the project. The price of tin was variable but averaged about $232\frac{1}{3}$ drachmas per talent, whereas copper was only 35 drachmas and one or two obols per talent. And in a whole year, only 26 drachmas were spent on clay and hair.[71]

As might be expected, the total wages paid in a year fluctuated, from around 6,600 drachmas to 10,100 drachmas. The daily wages for four overseers, their secretary, and their servant came to 31 obols at one time during the nine-year construction period—probably one drachma for each overseer, four obols for the secretary, and three obols for the servant.[72] If this was a year in which 6,600 drachmas were assigned to wages, the 31 obols would have amounted to only about a third of the available money, if we make the arbitrary assumption that the same amount of money was paid in wages on each day of the year.

That the inscriptions have nothing to say about the famous artist who made the Bronze Athena is not surprising, for it is unlikely that Phidias was involved full-time in the production process, and he certainly would not have been paid as an employee on the project. Certainly he made the model for the statue, but he may have done little more than that during the nine years of production except perhaps to oversee the admin-

68. B. D. Merritt points out that the proportions of metal used in the alloy may not have been the same as the amounts of metals purchased in one year: "Greek Inscriptions," *Hesperia* 5 (1936): 370–72. Silver may be used in various ways on a Classical bronze statue. An inlaid silver meander ornaments the fillet worn by the Delphi Charioteer (fig. 6.6; see F. Chamoux, *L'Aurige de Delphes*, FdeD 4, no. 5 [Paris, 1955], p. 52), and his teeth too, as we saw in chap. 6, may be of silver. The teeth of Riace statue A (fig. 8.3) are silver. A silver inscription is recorded on the thigh of a statue by Myron (Cicero, *Verrine* 2.iv.43.93), but it may have been a later addition to the work.

69. Merritt, "Greek Inscriptions," p. 375.

70. Dinsmoor, "Attic Building Accounts IV," p. 126.

71. Raubitschek, "Greek Inscriptions," pp. 14–17.

72. Ibid., p. 16.

istrators and crew in the workshop. That the sums of money expended seem so high, the number of employees so large, and the term of the project so long is explained by those who actually saw and described the Bronze Athena.

By the early fifth century, bronze had become the most popular medium for freestanding sculpture, and it was used for this colossus despite the huge expense. As the first statue that sailors could see when they approached the city of Athens, the Bronze Athena would have had considerable public significance. After all, it commemorated the Athenians' victory over the Persians at Marathon, and therefore demonstrated their supremacy over the barbarians. At the same time, it signified the city's wealth and vigor. The statue was not just a monument honoring Athens's patron deity; it was a monument to the city itself, and any traveler sailing in from Sounion would have been expected to recognize it as such.

The head and neck of a bronze female statue 0.8 to 0.9 meter tall, or about half lifesize, was uncovered in Athens in 1932 (fig. 7.7). The piece had been dumped during the late third century B.C. into an unused well on the west side of the Agora. The head and neck are a nearly intact casting, missing only the inlaid eyes and perhaps a topknot.[73] The lower edge of the piece, which has a few small breaks, forms an elongated triangle from the base of the neck down across the shoulderblades and no doubt was originally socketed into drapery, as with the Delphi Charioteer.

The strikingly erect head rests on a long, thick, cylindrical neck, marked in front by two shallow rings of Venus. The oval face, with its rounded chin and smooth cheeks, is accentuated by the fleshy, slightly parted lips and long nose. The large oval eyes have strong, angular rims, but the brows are scarcely marked. The forehead, an asymmetrical triangle, is delineated by a deep irregular groove that follows the hairline.[74] Only the lower halves of the ears are visible: circular depressions in them once held earrings. Delicate tendrils of hair, executed in low relief, escape the heavy cap of hair and frame the ears. The cap

73. See Boardman, *GSCP*, p. 176, fig. 138. The original publication of the bronze is T. L. Shear, "The American Excavations in the Athenian Agora: Second Report," *Hesperia* 2 (1933): 519–28. I am grateful to T. L. Shear, Jr., for allowing me to examine the head.

74. E. B. Harrison notes a general asymmetry of the head, which suggests to her that the head was intended to be viewed on the diagonal and from below: "Alkamenes' Sculptures for the Hephaisteion," pt. 3, "Iconography and Style," *AJA* 81 (1977): 418–19.

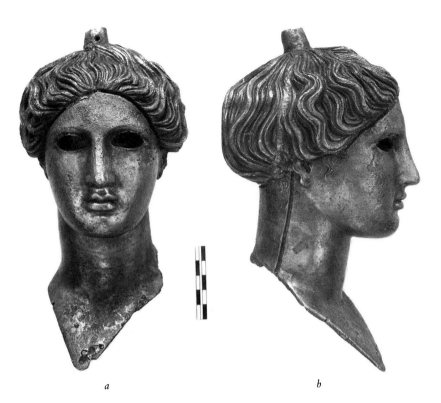

7.7 Bronze female head, ca. 420 B.C. H 0.2 m. Athenian Agora B 30. Courtesy of American School of Classical Studies at Athens: Agora Excavations.

of hair above is far more plastic, with deeply cut, wavy locks swept upward to the center of the head. There a cylindrical knob is probably the base of a ponytail or topknot.[75]

The thickness of the bronze at the neck is approximately 0.004 meter, at the chest between 0.001 and 0.003 meter, and at the rims of the eyes between 0.007 meter (lower lid) and 0.012 meter (upper lid). The interior surface appears to be regular but is obscured by much accretion. On the underside of the chest, fine striations with blurred edges appear to have been made in the wax, not in the metal. Behind each ear a rounded chaplet measuring approximately 0.002 meter in diameter was pushed through the wax from within. Only the holes remain. There are two similar holes in the curls, one on the left side of the head, the other behind the base for the topknot. Part of the interior of the wax was rasped, perhaps to shave it down and make it thinner before the wax was cored and invested. Related to this operation is the letter Ξ incised on the left back of the neck, which may have served as a guide in joining the head to its

75. For a reconstruction of a topknot with spreading locks of hair, in the style known as *lampadion*, see Shear, "American Excavations," pp. 522–25 and figs. 8 and 9. H. A. Thompson envisions a more compact topknot and a wreath, and would attach the topknot by pins: "A Golden Nike from the Athenian Agora," *Harvard Studies in Classical Philology*, suppl. 1 (1940), pp. 183n2 and 184n1.

body.[76] The evidence suggests that the head is an indirect casting. Some of the material remaining within the head is not easy to explain, however, for it appears to be a mixture of beeswax and lime. So far the only suggestion to be offered is that this material may have been used to secure the inlaid eyes within their sockets.[77]

A date of approximately 420 B.C. is widely accepted for the head, though comparable works are difficult to find. There are none in bronze, and those in marble are all too often Roman copies. The best parallels come also from the Athenian Agora. A fifth-century herm in the Agora has the same wide shallow eyes and smooth modeling.[78] A Nike akroterion from the late-fifth-century Stoa of Zeus Eleutherios in the Agora has the same full, slightly parted lips.[79] Another fragmentary head in the Agora has the same ovoid face with wide eyes, long straight nose, full mouth, and chin held high above a strong cylindrical neck.[80] Finally, a second-century-A.D. Roman copy of a late-fifth-century Nike has again the upright head, the smooth oval face, wide eyes, and full mouth.[81]

The appearance of the Agora bronze head immediately attracts attention: grooves encircle the hairline and run up either side of the neck, where they cut right across the delicate locks escaping beside the ears. Gouged out after casting, these grooves are approximately 0.002 meter wide and are as visible as unhealed wounds. Traces of silver and of gold adhere to the open grooves, and a close look reveals a second set of grooves on the sides of the head and the back of the neck, which have been filled in with bronze. Homer Thompson has made the ingenious deduction that this head belonged to one of the so-called Golden Nikai, actually bronze, which were plated with the Athenian gold reserve, apparently in the form of sheet gold on top of sheet silver.[82] The Nikai were twice stripped of their

76. Shear, "American Excavations," pp. 525–26, suggested that this might have been the artist's initial, and names Xenophon as a possibility.

77. M. Farnsworth and I. Simmons, "A Unique Cement from Athens," *Hesperia* 29 (1960): 118–22.

78. Athens, Agora Museum S 2452: T. L. Shear, Jr., "The Athenian Agora: Excavations of 1971," *Hesperia* 42 (1973): 164–65; and Boardman, *GSCP*, p. 177, fig. 142.

79. Athens, Agora Museum S 312: Thompson/Wycherley, pl. 52.

80. Athens, Agora Museum S 1078: E. B. Harrison, "Alkamenes' Sculptures for the Hephaisteion," pt. 1, "The Cult Statues," *AJA* 81 (1977): 169–72, figs. 34–35.

81. Athenian Agora S 2354; *The Athenian Agora: A Guide to the Excavation and Museum*, 3d ed. (Athens, 1976), pp. 199–200 and fig. 103.

82. Thompson, "Golden Nike," pp. 186–94.

gold, once during the financial crisis of 407/6 B.C. (occasioned by the Peloponnesian War) and again in 294 B.C., under the general Lachares, who used the gold to pay his troops. Thereafter the gold was never replaced and the Nikai were either discarded, as this one was, or melted down for the bronze, which could always be reused. Thompson suggests that the two sets of channels in the Agora head, the one filled with bronze and the other retaining traces of gold and silver, reflect the two strippings.

Dorothy Burr Thompson argues that this head could not have belonged to one of the Golden Nikai of Athens because it was plated with both gold and silver, not with gold alone, and was far too small to accommodate the two talents of gold assigned to each Nike. She estimates that the plates that once covered the Agora head were only about 0.008 meter thick.[83] Why the grooves should be 0.002 meter wide but the plating of the whole head only 0.008 meter thick is an unanswered question. Is it possible that a significant amount of the gold assigned to each figure was hammered into the grooves just to use it up quickly, but that the plating over the surface had to be very thin so that it would accurately reproduce the imprint of the bronze figure?

Whether it was a Golden Nike or not, there is no question that the Agora head represents the core or base for a gilded statue. The bronze is fully detailed, and the plate molded over it would have been thin enough to reproduce in the gold the details of the core. The same plating technique, combining gold over silver, can be seen on a later Agora bronze, an equestrian statue perhaps representing Demetrios Poliorketes of Macedon (336–283 B.C.). The largest fragment that is preserved of the statue is a leg, which, like the bronze head, is grooved for attachment of the sheets of precious metal.[84]

The Golden Nikai of Athens appear frequently in inscriptions and in literary testimonia dating from the fifth to the third

83. D. B. Thompson, "The Golden Nikai Reconsidered," *Hesperia* 13 (1944): 178–81. For suggestions as to other interpretations of this figure, see Ridgway, *FCS*, p. 124.

84. See Shear, "Athenian Agora," pp. 165–68, pl. 36. For gilding, see also W. A. Oddy, L. Borrelli Vlad, and N. D. Meeks, "The Gilding of Bronze Statues in the Greek and Roman World," in *The Horses of San Marco*, ed. G. Perocco, trans. J. and V. Wilton-Ely (London, 1979), pp. 182–86; and W. A. Oddy, "Vergoldungen auf prähistorischen und klassischen Bronzen," in *Archäologische Bronzen*, pp. 64–71.

centuries B.C.[85] The paucity of literary evidence, however, suggests that other gilt statues were rare during the sixth, fifth, and fourth centuries. During the first half of the sixth century, Cyrus of Persia is said to have captured from Kroisos of Lydia three gilt bronze statues (*simulacra quaedam aenea inaurata*) representing Artemis, Herakles, and Apollo.[86] And Gorgias of Leontini, the long-lived Sophist (483–376 B.C.), dedicated a gilt statue of himself (*epichrysos de eikōn*) at Delphi.[87] Our only physical evidence for such statues during this entire period comes from the Athenian Agora, in the form of the fifth century bronze head and the early-third-century fragments of the equestrian statue. In both cases, bronze served as the base for plating in silver and gold and the full detail of the bronze would have been picked up in the very thin plating, which could have been easily pressed over the bronze core or mold and then hammered into the grooves to secure it in position.

Artists apparently worked easily in more than one medium, and gilded statues with bronze cores do not represent the only departure that was made from the traditions of stone, wood, and bronze figures. Objects made of gold, ivory, and various kinds of wood were not at all unusual during the Archaic period, to judge from the literary sources. Many of these objects are pieces of furniture, such as the celebrated cedar chest of Kypselos, decorated with figures of cedar, gold, and ivory. Pausanias saw the chest in the Heraion at Olympia and describes it at length.[88] Pausanias notes that the cult statues, a standing Zeus and a seated Hera, are simple works. He also enumerates nineteen early statues kept in the temple, saying that all of them are made of gold and ivory. Next to Zeus and Hera, there are seated statues of the Seasons by Smilis of Aegina. Then Pausanias lists seven gold-and-ivory statues by three Spartan artists, all said to have been pupils of Dipoinis and Skyllis, whose work in various media, including marble, ebony and ivory, and wood, was an appropriately broad background from which to move to gold and ivory.[89] The first statue is a standing Themis, the mother of the Seasons, made by Dory-

85. For the inscriptions, see A. M. Woodward, "The Golden Nikai of Athens," in *ArchEph* (1937), pp. 159–70. For a discussion of the entire question of the Golden Nikai, including the evidence provided by the Agora head, see Thompson, "Golden Nikai Reconsidered," pp. 173–209.

86. Moses of Chorene 2.11.103 = Overbeck 326.

87. Pausanias 10.18.7.

88. Pausanias 5.17.1–19.10.

89. Marble: *NH* 36.9; ebony and ivory: Pausanias 2.22.5; wood: Clement of Alexandria, *Protrepticus* 4.42 = Overbeck 325.

kleidas. His brother Medon made the helmeted Athena carrying a spear and a shield, and the third pupil of Dipoinis and Skyllis, Theokles, the son of Hegylos, made five gold-and-ivory statues of the Hesperides. Pausanias next lists eight more gold-and-ivory statues that appear to him to be very ancient, and says that he does not know the names of the artists. A Demeter and a Persephone sit opposite each other and an Apollo and Artemis stand opposite each other, both pairs obviously conceived as groups. The last four statues represent Leto, Tyche, Dionysos, and a winged Nike. Pausanias does not attempt to date them. The next statues on his list of works housed in the Heraion are later, he says, and none can be dated earlier than the fourth century. But two of these works were also made of gold and ivory: they are statues of Eurydike and Olympias, brought over from the Philippeion.[90]

The Athena that Pausanias mentions as being one of the gold-and-ivory statues in the Heraion had been moved there from the Megarian Treasury, where it had originally been part of a large group depicting the battle between Herakles and Acheloös. In his description of that group, Pausanias refers not to gold-and-ivory statues, but to small figures (*zōdia*) made of cedar inlaid with gold.[91] Visually, then, the distinction between gold-and-ivory and wood inlaid with gold must have been slight. This may also have been the case with regard to technique, for an artist would have had no difficulty in crossing the boundary from one carved material to another.

The gold-and-ivory images that Pausanias saw in the Heraion at Olympia are by no means the only such works to be produced during the Archaic period. Kanachos of Sikyon made for his city a gold-and-ivory cult statue of Aphrodite, wearing a polos and holding a poppy in one hand and an apple in the other. Menaichmos, who lived slightly later than Kallon of Aegina and Kanachos, also made such an image. Representing Artemis Laphria as a huntress, it stood in Kalydon until the emperor Augustus had it taken to Patras.[92]

During their excavations at Delphi in 1939, the French made a remarkable discovery. In front of the Stoa of the Athenians and under the paving of the Sacred Way they uncovered pits containing objects made of gold-and-ivory and of silver, dating

90. Pausanias 5.17.4.
91. Pausanias 6.19.12–14. Here the name of the artist is given not as Medon but as Dontas, probably representing a corruption of the original text.
92. Pausanias 2.10.5, 7.18.9–10.

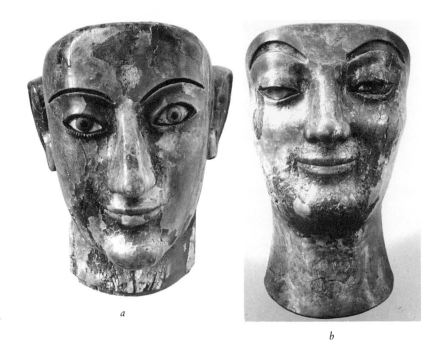

a

b

7.8 Ivory heads of Apollo (*a*) and Leto (*b*), middle of the sixth century B.C. H ca. ²/₃ lifesize. Delphi Museum. Courtesy of Ecole Française d'Archéologie, Athens.

to approximately the middle of the sixth century B.C.[93] The objects had been damaged by fire in the fifth century B.C. and evidently were interred at that time; they are now on display in Delphi. There are ivory reliefs (no doubt furniture inlays), a large silver bull, and fragments of three lifesize gold-and-ivory statues: a seated male, identified as Apollo, and two females, perhaps Artemis and Leto.[94] Two of the heads, those of Apollo and Leto (fig. 7.8), are very well preserved.

The ivory for Apollo's head was pieced together and the eyes, lashes, and eyebrows were inlaid. A cap of gold hair was fitted over the top of the head; separate sheets were attached to represent long locks flowing over the shoulders onto the chest. The portion of Apollo's golden drapery which fell from knees to feet is decorated with repoussé panels containing wild animals and mythical beasts. The ivory face of Artemis is crowned with a diadem of sheet gold. An ivory hand probably held a scepter. Golden earrings, necklaces, bracelets, ornaments from Apollo's throne, and a golden patera are also preserved.

93. P. de la Coste-Messelière, *Delphes* (Paris, 1943), pp. 54, 313; Robertson, *HGA*, pp. 140–41.

94. Gold-and-ivory statues: Boardman, *GSAP*, fig. 127. Delphi Museum: Apollo; Artemis(?), H of head 0.18 m.; Leto(?); silver bull, H 1.46 m., L 2.59 m., parts gilded, originally built over wooden core, attached to silvered copper framework with silver nails. See P. Amandry, "Statue de taureau en argent," *BCH*, suppl. 4 (1977), pp. 273–93.

7.9 Mold for glass drapery from the workshop of Phidias at Olympia, fifth century B.C. Courtesy of Deutsches Archäologisches Institut, Athens, neg. no. OL 4020.

The gold-and-ivory statues at Delphi represent an unparalleled find for any period, as the only extant traces of such works. The literary evidence indicates that such images were not exactly rare during the Archaic period. Of course, it was not until the Classical period that the most famous chryselephantine statues were produced, by such artists as Phidias, Polykleitos, and Alkamenes. And both Phidias and Polykleitos made colossal gold-and-ivory cult images.

Phidias produced the gold-and-ivory Athena Parthenos, a colossal standing figure, as well as the Zeus for the temple at Olympia, a seated figure of comparable size—the one Strabo noted would have gone through the roof of the temple had it been able to stand up.[95] During the excavation of the workshop of Phidias at Olympia, the Germans made an exceptional discovery. They uncovered extensive debris from the production of the gold-and-ivory Zeus, including glass, ivory, obsidian, sheet bronze, lead templates, bone tools, and the bronze head of what must have been a jeweler's hammer. Of particular interest are hundreds of fine clay molds, many of them complete (fig. 7.9). Some are small molds for glass ornaments. Others are much larger but still thin-walled and delicate, the mold surfaces surrounded by wide flat rims. These molds are very different from the investment molds used to cast bronze statuary, and are now thought to have been used to make glass drapery details that lay over gold sheets.[96]

Theokosmos of Megara is said to have produced, with the help of Phidias, a gold-and-ivory Zeus for the Olympieion at Megara. In describing the statue, which was never finished, Pausanias gives us an impression of how it was constructed. The face, he says, was covered with ivory and gold, but the rest of the statue was of clay and gypsum. Behind the temple Pausanias saw half-worked pieces of wood that Theokosmos had intended to adorn with ivory and gold in order to finish the statue.[97] In this instance, evidently the wood served as a core over which the gold might be molded and to which the ivory would be attached.

95. Strabo 8.353–54. For other references to the Athena and to the Zeus, see Overbeck 645–79, 692–743.

96. I am grateful to Brunilde S. Ridgway for passing along this information from a public lecture delivered by A. Mallwitz at Bryn Mawr College in 1984. The molds were at first thought to have been used to impress thin gold sheets for the statue's drapery: E. Kunze, "Olympia: Werkstatt des Pheidias," in *Neue deutsche Ausgrabungen im Mittelmeergebiet und im vorderen Orient* (Berlin, 1959), pp. 280–94; Mallwitz, *Olympia und seine Bauten* (Munich, 1972), pp. 255–66.

97. Pausanias 1.40.4.

The idea of using gold to adorn such statues as the Zeus at Megara and the Zeus at Olympia approaches fairly closely the concept of the gilded statue as we know it from the Athenian Agora. In the case of the Agora head, the bronze base served both as core and as model, and the sheet gold was pressed directly over it into its final shape, then secured in the grooves cut in the bronze. But even the workshop remains from Olympia do not resolve the question about the nature of the core of a gold-and-ivory statue. Normally it would have been less complete than the core of a gilded bronze because of the use of whole ivory sections for the face, hands, and feet and of thin sheet gold for the drapery. Perhaps a wooden base, whether a framework or a solid core, is the best answer.[98]

We have no further evidence for the construction of a gold-and-ivory statue, only descriptions of the finished images. Pausanias mentions several such statues dating to the fifth century. At the Argive Heraion, the chryselephantine Hera by Polykleitos was of great size. Hera held a pomegranate in one hand, a scepter with a cuckoo perched on top of it in the other; the Graces and the Seasons ornamented the crown. Beside this statue stood a gold-and-ivory Hebe by Naukydes. A beardless Asklepios at Sikyon, made by Kalamis, and a Dionysos in Athens, made by Alkamenes, were of unremarkable size.[99]

Pausanias also cites some akrolithic statues, all of which appear to postdate the Archaic period.[100] The bodies were made of wood, with faces, hands, and feet of stone or of white, Pentelic, or Parian marble. He elaborates once by saying that the Athena at Aigeira, a xoanon, was decorated with gold and with colors, and that it had face, hands, and feet of ivory.[101] The cores of akrolithic statues might be concealed by gilt applied to the wood or to the drapery or by the addition of actual drapery to the figure.[102]

Pausanias describes two colossal akrolithic images that were made of gilt wood, a Tyche in Elis and the Athena Areia at Plataia. The latter was funded by the Athenians' share of the spoils won at the battle of Marathon. The Plataians hired Phidias to make this huge gilt wood statue with face, hands, and feet of Pentelic marble; it was barely smaller than the Bronze

98. Ridgway favors a wooden core: *FCS*, pp. 161–62, 167–68.

99. Pausanias 2.17.4–5, 2.10.3, 1.20.3.

100. See I. B. Romano, "Early Greek Cult Images" (Ph.D. dissertation, University of Pennsylvania, 1980), pp. 372, 380n62.

101. Wood and stone: 7.21.10, 8.31.6; wood and white marble: 2.4.1, 6.24.6, 6.25.4; wood and Pentelic marble: 7.23.6, 9.4.1; wood and Parian marble: 8.25.6; Athena at Aigeira: 7.26.4.

102. Gilt wood: 6.25.4, 9.4.1; gilt drapery: 6.24.6; real drapery: 7.23.5.

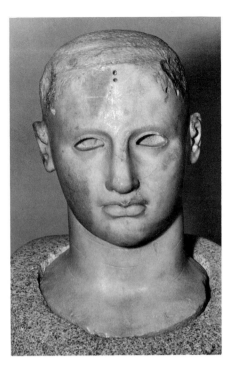

7.10 Head of an akrolithic statue of Apollo(?) from Krimisa, early Classical. H 0.385 m. Reggio Calabria, Museo Nazionale. Courtesy of Hirmer Fotoarchiv, Munich.

Athena that Phidias made afterward for the Akropolis of Athens.[103] And Phidias was of course also hired to make the chryselephantine Athena Parthenos.

The marble head, feet, and left hand of a larger-than-lifesize akrolithic statue (fig. 7.10) were found during the excavations of the temple of Apollo Alaeus at Krimisa, near modern Cirò in Calabria.[104] Presumably part of the cult statue of Apollo, the head is bald, with holes for the attachment of hair of another material. We may imagine a heavy row of bronze curls held at the holes above the forehead and long bronze locks falling over the shoulders from points of attachment directly behind the ears. Lifelike inlays in the eye sockets, rimmed with bronze lashes, would have added color and animation to the now denuded and expressionless Apollo. Below the god's neck the marble spreads and is cut to form a tenon for insertion into the body of the statue. The head is usually, but not always, dated to the early Classical period.[105] A bronze wig found nearby and once thought to belong with the head is now known to be too small to fit.[106]

Although gold-and-ivory statues were made in the sixth century, we first hear of colossal gold-and-ivory statues during the fifth century. During the Archaic period, however—the experimental phase in Greek sculpture—there was a penchant for colossi, and examples can be cited in various other media. The size of the Sounion Kouros (fig. 3.13), at about three meters tall, could almost be called conservative in comparison with other sixth-century works in stone. There are unfinished colossi: a kriophoros on Thasos is 3.50 meters tall; a kouros in a quarry on Naxos measures 5.55 meters; and a draped god in a quarry on Naxos stands 10.50 meters tall. A kouros on Delos, also made of Naxian marble, originally stood about eight meters in height, and one on Samos is more than five meters tall.[107]

103. Pausanias 9.4.1.

104. See P. Orsi, *Templum Apollinis Alaei ad Crimisa Promontorium* (Rome, 1933), pp. 135–70; Langlotz/Hirmer, pp. 284–85.

105. Early Classical: Orsi, *Templum Apollinis Alaei,* pp. 155–70; Ridgway, *SS,* p. 123; Robertson, *HGA,* p. 202. End of fifth century: Langlotz/Hirmer, pp. 284–85. W.-H. Schuchhardt's theory that this and the Chatsworth head are Hadrianic has not won acceptance: "Zum Akrolithkopf von Cirò," *AJA* 66 (1962): 317–18.

106. Ridgway, *SS,* p. 122n19.

107. Sounion Kouros: Athens, National Museum no. 2720. Thasian and Naxian colossi: see C. Bluemel, *Greek Sculptors at Work,* trans. L. Holland, 2d ed. rev. B. Ross (London, 1969), pp. 6–10. Delos: Richter, *Kouroi,* no. 15, pp. 51–53, figs. 87–90. Samos: H. Kyrieleis, "Neue archaische Skulpturen aus dem Heraion von Samos," in *Archaische und Klassische Griechische Plastik,* ed. Kyrieleis (Mainz, 1986), pp. 35–46, pls. 14–22; and Kyrieleis, "Two Archaic Statues from the Heraion of Samos," abstract, *AJA* 91 (1987): 306.

There was also a tradition of large-scale sphyrelata, as we noted earlier. One of the largest such images recorded is the Apollo Amyklaios, which Pausanias estimated at about thirty cubits, that is, between fifteen and sixteen meters.[108] According to Herodotos, the early Samians spent six talents for an offering to Hera—a huge bronze cauldron supported by three kneeling bronze colossi that were seven cubits high, or nearly four meters.[109] Bronze colossi may well have been made as sphyrelata until the technique of casting bronze statues became well known. It is also possible that large castings were introduced when the Greeks had the Persian booty at their disposal. The physical evidence for colossal cast-bronze statues postdates the Archaic period, and their popularity is well attested during the fifth century, as we see by the production of such works as the Serpent Column at Delphi (fig. 5.6), the Bronze Athena on the Akropolis of Athens, the Kerkyraian Bull at Delphi by Theopropos of Aegina, and a similar bull at Olympia.[110]

The bronze statues remaining from any period are few, but bits of them have often survived—locks of hair, fingers and toes, lips, ears, genitals, attributes. Most of these pieces are small, and some may have gone astray on their way to the

108. Pausanias 3.19.1; and see chap. 3, above.

109. Herodotos 4.152. The evidence for Archaic colossi in all media is collected by Panagiotis Karakatsanis, *Studien zur archaischen Kolossalwerken* (Frankfurt, 1986).

110. Kerkyraian Bull: Pausanias 10.9.3–4. Although only the base of this statue is preserved (L 7.3 m., W 2.7 m.), the bull's height can be reconstructed. The height of a mid-fifth-century bronze statuette of a bull is just over half its length. If we assume that these proportions are about average and that the Kerkyraian Bull occupied about three-quarters of its base and was about 5.5 m. long, then it was probably about 3.0 m. tall. For the statuette, see Rolley, *Monumenta*, no. 96, pl. 33 (Cyprus Museum). For a discussion of the base in Delphi and for references to previous publications, see C. Habicht, *Pausanias' Guide to Ancient Greece* (Berkeley, 1985), pp. 75–77. Bull at Olympia: Pausanias 5.27.9.

A colossal greaved leg in the British Museum (Br. 265; H 0.768 m.) originally belonged to a statue over 2.9 m. tall. A long clear drip mark inside the calf testifies to the use of the indirect lost-wax process, and it is tempting to agree with the suggestion of D. E. L. Haynes that the leg is a late Archaic or early Classical Greek original. Two points, however, indicate that the leg must be a much later work. First, its provenance is given as either Anzio in Latium or Potenza in Lucania, which would make Greek production uncertain. Second, fragments of a short chiton and cuirass said to have been worn by the statue would make this a highly unusual piece for the period suggested. See Haynes, "Archäologische Gesellschaft zu Berlin 1961," *AA* 77 (1962): cols. 803–7, figs. 1–2. For the early publication of the leg ("the style very grand"), with reference also to three drapery fragments having a meander border inlaid in silver (a Greek or a Roman feature?) and about ten fragments of armor, see H. B. Walters, *Catalogue of the Bronzes, Greek, Etruscan, and Roman, in the British Museum* (London, 1899), no. 265, p. 33; and H. B. Walters, *Select Bronzes* (London, 1915), pl. XII: mid–fifth century B.C.

furnace for remelting. Such pieces give eloquent testimony to the destruction of statues during later antiquity but provide almost no idea of what the original statues looked like.

Eyelashes are generally ignored as being relatively uninformative pieces. Bronze plates fringed on one edge were hammered, cut, or cast and set into the hollow eye sockets of statues from the outside. These plates held in place the stone-and-ivory eyes that did so much to give a lifelike appearance to bronze statuary.[111] The striking humanity of the Akropolis Youth (fig. 5.5), the Delphi Charioteer (fig. 6.6), and Riace statue A (fig. 8.3) is due in part to the fact that they retain their eyes, a rarity among bronzes preserved today. Long before a statue was considered for destruction and reuse of the metal, the eyelashes are likely to have loosened and fallen out. Many have survived: lashes underfoot were surely too small and too scattered to be worth picking up and saving for future consignment to the crucible.

As we have seen, works in cast bronze, but also in sphyrelaton and in stone, wood, and chryselephantine, were all eligible for inset eyes, but not all Archaic bronze statues had them (the statue from the Agora molds [fig. 4.5], the Boston head [fig. 4.12], and the Piraeus Apollo [fig. 4.19], for example). Bronzes that did have inset eyes were both large and small, both hollow and solid castings.[112] Some stone sculptures, too, had inset eyes (Antenor's Kore, fig. 5.1, and the Kritios Boy, fig. 4.21),[113] while others did not.

When only a lash plate is preserved, it is of course impossible to tell whether it belonged to a work in bronze, in stone, or in

111. See Bol, *Grossplastik*, pp. 93–98, for detailed description of the processes. Bol suggests (p. 93n16) that the idea for inlaid eyes and brows came from Egypt.

112. A few examples of bronze statuettes with inset eyes or inset pupils are: (*a*) the Mantiklos Apollo of ca. 700 B.C., Boston Museum of Fine Arts, Bartlett Collection, 03.997; Richter, *Kouroi*, figs. 9–11; (*b*) a kouros in Samos, Vathy Museum; Richter, *Kouroi*, figs. 120–22, no. 23: Sounion group; (*c*) a seventh-century hoplite from Karditsa, Athens, National Archaeological Museum no. 12831; S. Karouzou, *National Museum* (Athens, 1977), p. 103; (*d*) a seventh-century warrior from Olympia, Olympia B 1701; Boardman, *GSAP*, fig. 46; (*e*) a kouros in Berlin, Staatliche Museen no. 7976; Richter, *Kouroi*, figs. 166–68, no. 45: Orchomenos-Thera group; (*f*) a mid-sixth-century female perirrhanterion(?) support from Olympia, Athens, National Archaeological Museum no. 6149; Charbonneaux et al., *Archaic Greek Art, 620–480 B.C.* (London, 1971), fig. 167.

113. See also (*a*) a female perirrhanterion support, Olympia; Richter, *Korai*, figs. 45–48, no. 8: Nikandre-Auxerre group; (*b*) the Moskophoros from the Athenian Akropolis, Akropolis 624, ca. 560 B.C.; Boardman, *GSAP*, fig. 112 and frontispiece; (*c*) a caryatid head in Delphi; Richter, *Korai*, figs. 270–74, no. 86: Lyons Kore-Ephesos group; (*d*) Akropolis Kore 682; Richter, *Korai*, figs. 362–67, no. 116: Siphnian Treasury, Temple of Apollo group.

some other material. Nonetheless, the sizes of these plates can be used to determine the approximate standing heights of the statues to which they once belonged. Calculations for the late sixth and early fifth centuries can be made in the following way. The width of the eye averages 27 percent of the width of the head on the Olympia Zeus, the Livadhostro Poseidon, the Akropolis Youth, the Akropolis Warrior, and the Piraeus Apollo. On the same works, the width of the head averages 63 percent of the height of the head, exclusive of the beard. The height of the head is just over 14.4 percent or about one-seventh of the total height of the Livadhostro Poseidon and the Piraeus Apollo.[114] Thus an eyelash plate measuring 2 centimeters from end to end could have belonged to a standing figure with a height of approximately 0.84 meter.

The excavations of Konstantinos Karapanos at Dodona in 1875 yielded eyelash plates that are now in the National Archaeological Museum at Athens.[115] The largest of them, about five centimeters from end to end, could have belonged to statues approximately two meters tall, or, like the Piraeus Apollo, slightly larger than lifesize. A dozen smaller lashes, about 2.5 centimeters from end to end, belonged to statues of probably about a meter in height, or slightly less than the original size of the Olympia Zeus (1.2 meter).[116] One other colossal lash plate is about three times lifesize.[117] Six eyelashes from the Olympia excavations, measuring 2.7, 4.9, 6.0, and 7.5 centimeters, once belonged to statues that, if standing, may have been about 1.10, 2.00, 2.50, and 3.15 meters tall.[118]

Some of the largest lash plates can be presumed to date from the Archaic period, when larger-than-lifesize statues were particularly popular. Such Archaic bronzes as the Boston head, the Olympia Zeus, and the Ugento god were of course much less than lifesize, but the Piraeus Apollo is just over lifesize, Antenor's Kore is 2.155 meters in height with the plinth, and the earlier Sounion Kouros (fig. 3.13) is restored to 3.05 meters.

114. The Artemision god and the Riace statues have the same general proportions, but the head of the Delphi Charioteer is only about 11% of the figure's total height, a proportion that would have created the appropriate illusion for a figure partially hidden in a chariot.

115. Karapanos Collection, nos. 113–37.

116. I am grateful to Grant McClanahan for checking the sizes of these eyelashes for me in 1985.

117. Athens, National Archaeological Museum no. 7022.

118. Olympia Br. 427d; 428b, d, f; 429a, b. The Olympia eyelashes are all illustrated in Bol, *Grossplastik*, pp. 135–36, pls. 68–69.

If the Apollo Amyklaios was actually 30 cubits high,[119] or between 15 and 16 meters, it would have required lashes of the extraordinary size of about 40 centimeters. In comparison, the heights of two to three meters estimated for the statues to which the Dodona and Olympia lash plates were once attached seem acceptable, almost modest.

119. Pausanias 3.19.1.

8 POSSIBILITIES

By the fifth century, artists were experimenting with the possibilities of athletic statuary, as in the case of Myron's Diskobolos (fig. 6.8), and they were adding anatomical accuracy to traditional types, as in the case of the Artemision god (fig. 6.10). Furthermore, they were producing individuals and groups engaged in complex activities, and they were beginning to present portraits.

We know the names of many of the artists who worked during the fifth century. Although their works are lost, we have the literary testimonia and some statue bases. As we have seen, sculptors often worked in more than one medium, and an artist might produce statues of a wide range of types and sizes. The variety of statues produced increased vastly, as did the production of some individual artists. Phidias, for instance, directed large workshops in both Athens and Olympia, and we have seen that work on a single statue, such as his Bronze Athena, might go on for as long as nine years.

Pythagoras, a prolific artist, studied with Klearchos of Rhegion.[1] Pliny says that Pythagoras too came from Rhegion, but Diogenes Laertius suggests that there may have been two artists of the same name, the second one being a Samian.[2] Or Pythagoras may have been one of those Samians who emigrated to Zankle in 496 B.C. to avoid Persian domination, and thence to Rhegion.[3] Whatever the case, a number of commissions by Pythagoras are associated with individuals from the western colonies.

Pliny, who was aware of Pythagoras's reputation, tells us that Pythagoras made a statue of a pankratiast which stood at Delphi and was better than Myron's work.[4] At Olympia both

1. Pausanias 6.4.3.
2. *NH* 34.59; Diogenes Laertius 8.46.
3. Herodotos 6.23–25. See A. Linfert, "Pythagoras—Einer oder Zwei?" *AA* 81 (1966): 495–96; Boardman, *GSCP*, p. 79.
4. *NH* 34.59.

Pliny and Pausanias saw other statues of athletes by Pythagoras: Astylos, a runner from Kroton; Leontiskos, a wrestler from Messene; and one or two Libyans.[5] Pythagoras also made a statue of the boxer Euthymos at Olympia; its base is preserved.[6] Athletic statuary was not the only output of Pythagoras: Pliny says that at Olympia he also made a statue of a boy holding a whip and a nude holding apples; and at Syracuse a lame man, Apollo shooting the Python, and a man playing the kythara.[7] His group of seven nude figures and an old man which Pliny saw in Rome may have been the Seven against Thebes, and thus the same group as the Eteokles and Polyneikes mentioned by Tatian.[8] Two other important works by Pythagoras which are referred to as bronzes were a group of Europa and the Bull in Taranto and a Perseus with wings.[9]

A few comments about the style of Pythagoras give a clue as to how his work was compared with that of his predecessors. Pausanias, in speaking of the statue of Leontiskos, calls the artist "a capable sculptor if indeed there ever was one," and later adds that the statue of Euthymos the boxer is well worth seeing.[10] Varro thinks that the group of Europa and the Bull is outstanding.[11] In other words, the works of Pythagoras were still impressive to critics of later centuries. Pliny says that Pythagoras "was the first to model the sinews and veins and to render the hair more carefully."[12] He probably means that Pythagoras attempted to imitate nature in a way that his predecessors had not done. And yet it is difficult to say whether he altered the types that had been established during the Archaic period or strove for greater naturalism while continuing within the traditional framework. Were the Seven against Thebes simply lined up in a row, or did they interact with one another? Perhaps his Europa and the Bull was considered to be outstanding because of the interaction, or perhaps it was simply interesting because

5. Astylos: *NH* 34.59; Pausanias 6.13.1. Leontiskos: Pausanias 6.4.3; *NH* 34.59, where he is incorrectly called an artist. Libyans: *NH* 34.59; Pausanias 6.13.7 (a man in armor); 6.18.1 (a chariot group).

6. Pausanias 6.6.6; *NH* 7.152. Base: Loewy, no. 23. The dates of the victories of Astylos, Leontiskos, the Libyans, and Euthymos range between 488 and 448 B.C.: Richter, *SSG*, pp. 156–57.

7. *NH* 34.59.

8. c. Graec. 54 = Overbeck 501.

9. Varro, *De lingua latina* 5.31 = Overbeck 503; Tatian c. Graec. 53 = Overbeck 502; Cicero, *In verrem* 4.60.135 = Overbeck 504; Dio Chrysostom, *Oratoria* 37.10 = Overbeck 500.

10. Pausanias 6.4.3, 6.6.6.

11. Varro, *De lingua latina* 5.31.

12. *NH* 34.59.

the traditional equestrian group was replaced by a bull and a woman.

Telephanes of Phokaia is known to us only through Pliny, who writes that Telephanes received high praise from artists who wrote treatises about sculpture: as an artist, they ranked him with Polykleitos, Myron, and Pythagoras. Pliny then names the most famous statues by Telephanes—Larisa, Spintharos (a victor in the pentathlon), and an Apollo—and wonders whether his obscurity is due to his remote home or to the fact that he worked for Xerxes and Darius.[13]

According to Quintilian, Polykleitos lacked the ability to represent authority in statues of the gods and maturity in statues of men, a skill in which both Phidias and Alkamenes excelled.[14] That the skills of Alkamenes are linked with those of Phidias is not surprising, for Phidias taught the younger man, also an Athenian, who then acquired a considerable reputation of his own.[15]

Like his master, Alkamenes used more than one material and worked in more than one city. For a victorious pentathlete he made a bronze monument called *encrinomenos*, a title meaning one who is selected for the games.[16] He seems to have specialized in statues of gods. At Mantineia there was a statue of Asklepios, and at Thebes colossal Pentelic marble figures of Athena and Herakles. Between Phaleron and Athens, Pausanias saw an image of Hera by Alkamenes.[17]

The Athenian statues were the most famous. For the sanctuary of Ares in the Athenian Agora, Alkamenes made the statue of Ares. Pausanias believes that Alkamenes made the first triple-bodied statue of Hekate; it stood by the Temple of Nike Apteros and was known as the Hekate on the Tower. The Sanctuary of Dionysos at the foot of the Akropolis held his gold-and-ivory figure of Dionysos.[18] If this work by Alkamenes is indeed the one represented on Athenian coins of Roman date, we can see that Dionysos has a beard and long hair

13. *NH* 34.68.

14. *Inst. orat.* 12.10.1–10.

15. *NH* 34.72, 36.16. In the Souda lexicon, Alkamenes is called a Lemnian: Overbeck 809. Boardman, *GSCP*, pp. 206, 213–14.

16. *NH* 34.72.

17. Pausanias 8.9.1, 9.11.6, 1.1.5. Pausanias also credits Alkamenes with the sculptures on the west pediment of the Temple of Zeus at Olympia (5.10.8), but inasmuch as Alkamenes was active in the late fifth century and the temple was finished in the 450s, this attribution is generally thought to be incorrect.

18. Pausanias 1.8.4, 2.30.2, 1.20.3.

knotted at the nape of the neck. He wears a foliated wreath and his long robe crosses over the left shoulder, leaving the right one bare. In his left hand he holds a scepter that rests on the ground at his feet, and in his right hand he grips what may be a kantharos.[19] The Dionysos is reminiscent of the coin versions of the Olympian Zeus by Phidias.

That Alkamenes's style should be influenced by that of his teacher, Phidias, is to be expected, particularly since both artists worked in Athens and apparently were in close contact. Pliny records a statue of Aphrodite outside the walls of Athens, called Aphrodite in the Gardens, on which Phidias himself put the final touches.[20] To judge from a remark made by Lucian, this was one of the finest statues that Alkamenes ever made. Imagining Panthea, or the ideal female form, Lucian says that if he were to combine various features from works by several famous artists, he would take from the Aphrodite in the Gardens the cheeks and the front of the face, as well as the gracefulness of the wrists and the delicately tapered fingers.[21]

Cicero says that Alkamenes made a noteworthy statue of Hephaistos: "In Athens we praise the statue that Alkamenes made of Hephaistos, which is both standing and clothed, and in which lameness is slightly seen but is not ugly."[22] Whether this was the cult statue for the Hephaisteion is a question that has not yet been resolved.[23] Pausanias says that he saw two statues in this temple, one of Hephaistos and one of Athena, but does not name an artist. There are construction records for two statues, presumably these, dating between 421/20 and 416/15 B.C.[24]. Although we do not learn the name of the artist, the records provide us with several interesting points. Purchases of bronze and tin are mentioned, and of lead for the *anthemon* and for attaching the stones of the statue base. Twelve *krateutai* (lead pigs) are listed; payment to the men who made the *anthemon;* wood and charcoal; and payments to a man who made a table and to another who set up the statues. Wood was also pur-

19. See Richter, *SSG*, figs. 676–77; Imhoof-Blumer, pl. CC I-V and p. 142. Ridgway cites problems with the identification of the statue through Roman copies: *FCS*, p. 174.

20. *NH* 36.16.

21. Lucian, *Imagines* 6.

22. Cicero, *De natura deorum* 1.30. See also Valerius Maximus 8.11.ext. 3 = Overbeck 822.

23. For a summary of the problems concerning the building usually known as the Hephaisteion, see Thompson/Wycherley, pp. 140–49.

24. *IG* I², 370–71.

chased to make a framework for the statues, a scaffolding, and a fence.[25]

In 1936 a bronze foundry was excavated within the precinct wall of the building that is usually identified as the Hephaisteion. The irregular pear-shaped cutting with two large holes inside was linked with the production of the two cult statues, because the pit with its numerous mold fragments can be dated to the late fifth century B.C.[26] Unfortunately, the quality of these fragments is such that they cannot be used to determine what was cast here or to establish any connection with Alkamenes. Only one fragment looks as if it could have been used to cast drapery; many of the others were used to produce rectangular objects, perhaps bronze stelai.[27] The pit itself is not particularly large, surely not large enough to accommodate the many molds that would have been used to cast two statues much larger than lifesize.[28] It remains unclear why a casting pit should have been dug within a temple precinct. It is tempting to suggest that its presence may support the theory that this is the precinct of Hephaistos, the patron god of metalworkers.

The only evidence for Agorakritos having worked in bronze is as follows. In Boiotia, on the way to Koroneia from Alalkomenai, Pausanias saw a sanctuary of Athena Itonia. Inside the temple were bronze statues of Athena Itonia and of Zeus, both made by Agorakritos.[29] This artist, like Alkamenes, was a stu-

25. See R. E. Wycherley, *Literary and Epigraphical Testimonia*, Athenian Agora 3 (Princeton, 1957, 1973), no. 293, p. 101. See also R. P. Austin, "A Note on Temple Equipment," *JHS* 51 (1931): 287–89; and W. Thompson, "The Inscriptions in the Hephaisteion," *Hesperia* 38 (1969): 114–18. For a discussion of the inscription and of the statue of Hephaistos, see E. B. Harrison, "Alkamenes' Sculptures for the Hephaisteion," pt. 1, "The Cult Statues," *AJA* 81 (1977): 137–78. For the statue of Hephaistos see also F. Brommer, *Hephaistos: Der Schmiedegott in der antiken Kunst* (Mainz, 1978), pp. 77–90. At the 1985 open meeting of the American School of Classical Studies at Athens, Fred Cooper argued that the statue base now in the so-called Hephaisteion did not originally belong there.

26. This opinion is stated by W. B. Dinsmoor, "Observations on the Hephaisteion," *Hesperia*, suppl. 5 (1941), p. 109. Subsequently G. P. Stevens commented with a burst of optimism, "When the fragments of the molds . . . are eventually put together, it may be possible to determine the heights of the cult statues more accurately": "Some Remarks upon the Interior of the Hephaisteion," *Hesperia* 19 (1950): 154. The fact that the pit is only 10 m. from the temple has also been cited in support of the argument that it was used to cast the statues of Hephaistos and Athena: Thompson/Wycherley, pp. 189–90.

27. Mattusch, "Agora," B2 (drapery?) and B3 (stele?), pp. 348–49, and pl. 82.

28. L 3.75 m.; W 1.30 m.; max. D ca. 1.15 m. Stevens reconstructs the statue of Hephaistos at ca. 2.45 m. in height: "Some Remarks," p. 154. J. Travlos, *Pictorial Dictionary of Ancient Athens* (New York, 1971), fig. 348, p. 272, seems to accept this size.

29. Pausanias 9.34.1.

dent of Phidias, but Pliny lists him among the sculptors in marble. He says that Agorakritos and Alkamenes competed at Athens in making a statue of Aphrodite, and that the Athenians gave the victory to Alkamenes simply because he was an Athenian; Agorakritos, a Parian, was considered to be a foreigner. Agorakritos, not wanting his statue to stand in Athens, renamed it Nemesis and sold it. And so the statue stood at Rhamnous on the coast of Attika, and Pliny says that Marcus Varro (116–27 B.C.) preferred this work to all other statues.[30]

Agorakritos, with his youthful beauty, was evidently so dear to Phidias that the master allowed his own name to be attached to many of his student's works.[31] Perhaps this explains certain confusion in attribution, for Pliny firmly ascribes the Nemesis to Agorakritos, whereas Pausanias calls the statue the work of Phidias and says that it was made of marble from Paros—the home of Agorakritos.[32] Another discrepancy exists over a statue of the mother of the gods. Pliny is not clear as to whether it stood in Athens or in Rhamnous.[33] If it is the same statue as the one mentioned by Pausanias, it stood in the Metroon in the Athenian Agora and may have been made by Phidias.[34]

Kresilas, who came from Kydonia on Crete, was one of five artists who competed in making statues of wounded Amazons for the Temple of Artemis at Ephesos. The statue produced by Kresilas, who was probably somewhat younger than Polykleitos and Phidias, took third place.[35] Among Kresilas's other statues were a Demeter that stood in Hermione, a spear bearer, and several works in Athens, including an Athena Tritogeneia, a portrait of the Olympian Perikles, and a wounded dying man.[36] The latter statue—Pliny says it gives the viewer an understanding of "how much is left of life"—recalls for us the

30. *NH* 36.17.
31. Ibid.
32. Pausanias 1.33.3. For a discussion of the Nemesis, see Robertson, *HGA*, pp. 351–55nn144–48; Boardman, *GSCP*, pp. 147, 207, fig. 122. For later references to the sculpture, see Overbeck 834–43.
33. *NH* 36.17.
34. .Pausanias 1.3.5.
35. *NH* 34.53. See G. M. A. Richter, "Pliny's Five Amazons," *Archaeology* 12 (1959): 111–15. The type of the wounded Amazon is common in the fifth century. Differences among individual copies are no doubt due to the fact that they are copies of different originals. In fact, one of the five has now been identified as a personification of Ephesos: K. J. Hartswick, "The So-Called 'Ephesos Amazon': A New Identification," *JdI* 101 (1986): 127–36.
36. Demeter: *CIG* no. 1195 = Overbeck 875; spear bearer: *NH* 34.75; Athena Tritogeneia: *Anth. Gr.* 4.142.119 = Overbeck 876; Perikles and dying man: *NH* 34.74. See Boardman, *GSCP*, p. 206.

helmeted dying warrior from the west pediment at Aegina (fig. 5.3), although it was probably cast forty or fifty years later. No doubt it was the same statue as the Diitrephes seen by Pausanias on the Akropolis; the base was found to the west of the Parthenon.[37] Two other bases from statues by Kresilas, one dedicated by Pyres, were found on the Athenian Akropolis, but in neither case can the type of statue be reconstructed.[38]

Pliny calls the Olympian Perikles "worthy of its name" and adds that "the wonderful thing in this art is that it makes famous men even more famous." And so it seems that Kresilas excelled at characterization, whether in showing the pain of a dying man or the lofty appearance of a noted statesman. Roman copies of a fifth-century portrait of Perikles give a sense of this statesman and leader, for in the remote, untroubled expression one sees nobility, dignity, and grace.[39]

Strongylion's works were highly prized during the Roman period. His Amazon with Beautiful Legs was carried around in the retinue of the emperor Nero, and his statue of a youth was known for the love that Brutus of Philippi had for it.[40] Another work mentioned is a bronze Artemis the Savior in Megara, erected in honor of the goddess who had helped the Megarians rout the Persians. And in nearby Pagai, a town that Pausanias says was settled by the Megarians, there was a statue of Artemis exactly like the one in Megara.[41] Pausanias's observation indicates that this was not common practice. His failure to ascribe the copy to Strongylion suggests that the copy was made without the participation of the artist and that it might have been molded from the Artemis in Megara. Whether or not Strongylion was aware of the copy is unfortunately unknown. Coins of both Megara and Pagai showing a running Artemis wearing a short chiton and carrying two torches may represent the two statues.[42]

In reporting that three statues of Muses on Mount Helikon are works of Strongylion, Pausanias adds that the artist is an excellent sculptor of cows and horses, but then he apparently forgets to mention that the so-called Wooden Horse, in bronze,

37. Pausanias 1.23.3. See Raubitschek, *Dedications*, no. 132, pp. 141–44, 510–13.
38. Raubitschek, *Dedications,* nos. 131 and 133, pp. 139–46.
39. See especially Vatican inv. 269 and British Museum cat. 459: Richter, *Portraits,* pp. 173–75 and figs. 136–37; Boardman, *GSCP,* fig. 188.
40. *NH* 34.82; Boardman, *GSCP,* p. 207.
41. Pausanias 1.40.2–3; 1.44.4.
42. See Imhoof-Blumer, pp. 4, 8–9, pl. A.I.

in the Sanctuary of Artemis Brauronia on the Athenian Akropolis was made by Strongylion. He tells us that Epeios made the original Wooden Horse, and observes that the bronze one adheres to the story closely, for Menestheus, Teukros, and the Sons of Theseus are shown peeping out.[43] The statue's inscribed base is preserved. Made of Pentelic marble, it measures 1.74 by 5.08 meters. The inscription, dating to the last quarter of the fifth century, names Chairedemos the son of Evangelos of Koile as the dedicator and Strongylion as the artist.[44] The base would have carried a horse that was between 70 and 80 percent of its length, or about 3.8 meters long from point of shoulder to buttocks. To judge from the proportions of other fifth-century Athenian horses, this one could have stood up to 3.5 meters high at the withers and probably over 4.5 meters to the top of the head.[45] No doubt Strongylion's reputation for making cows and horses was due, at least in part, to this highly visible colossal bronze on the Athenian Akropolis. That Pausanias failed to name him as the artist is probably best explained as an oversight.

Lykios, the son and student of Myron, made for Olympia a large group on a semicircular base. It consisted of Zeus, Thetis, and Hemera in the center, flanked by five pairs of opposing heroes of the Trojan War, all poised for battle. This ambitious work was dedicated by the people of Apollonia, a colony of Kerkyra, after they defeated the people of Abantes.[46] To judge from some of his other works, Lykios was an artist who departed from the traditional types. Pliny records a group of the Argonauts by Lykios, a boy burning incense, and a boy blowing on a dying fire which Pliny says was worthy of the artist's teacher.[47] An inscription from the Athenian Akropolis dating to the 450s B.C. and two copies of it made in the early Imperial period record a monument by Lykios of Eleutherai, the son of Myron, dedicated by three cavalry generals, Lakedaimonios, Xenophon, and Pronapos; the monument consisted of a man leading a horse.[48] One more bronze by Lykios was a boy hold-

43. Pausanias 9.30.1, 1.23.8.
44. Raubitschek, *Dedications*, no. 176, pp. 208–9.
45. This calculation is based on comparisons with horses on the Parthenon frieze (see especially British Museum W III.4, N XLII.132, W XV.28 (illustrated in F. Brommer, *Der Parthenonfries*, vol. 2 [Mainz, 1977], pls. 11, 107, and 43, respectively) and with two horses from a relief base in the National Archaeological Museum at Athens (1464; Robertson, *HGA*, pl. 130d).
46. Pausanias 5.22.2.
47. *NH* 34.79. Presumably these works had all been moved to Rome.
48. Raubitschek, *Dedications*, nos. 135, 135a, 135b, pp. 146–52.

ing a perirrhanterion, standing on the Akropolis, right next to Myron's Perseus.[49]

Dionysios of Halikarnassos refers to the solemnity, the high art, and the dignity of the works of Polykleitos and Phidias, in contrast to the delicacy and loveliness of works by Kalamis and Kallimachos, whose humans were more effectively represented than their gods.[50] Vitruvius tells us that Kallimachos discovered the Corinthian capital and developed that order, and Pausanias describes a golden lamp he made for the statue of Athena in the Erechtheion in Athens. He also mentions a seated image of Hera the Bride at Plataia, but does not specify the material.[51] In his passage on Athens, Pausanias says that though Kallimachos was not one of the greatest artists, he was nonetheless known for his unequaled skill, as he was the first artist to pierce through stones. This skill won him the name *katatēxitechnos,* or one who dissolves his work—in other words, overrefines his art. This term or a variant of it appears elsewhere, and Pliny explains it as referring to someone who always criticizes his work and refines it to excess: thus Kallimachos's group of Lakonian Dancing Women is too much corrected, and the artist's excessive care has stolen all of its grace.[52] The epithet certainly suggests that Kallimachos worked in bronze. And, of course, Pliny cites Kallimachos in his chapter on bronze sculptors.

Pausanias calls Naukydes of Argos a brother of Polykleitos and son of Mothon, and ascribes to each brother a bronze statue of Hekate in Argos.[53] In an inscription of the fourth century B.C., however, Naukydes is called the son of Patrokles, a bronze artist known to Pliny as one of many who made statues of athletes, armed men, hunters, and sacrificers.[54] Pausanias names Patrokles as one of the artists who worked on the votive monument at Delphi commemorating the Spartans' victory over the Athenians in the late fifth century.[55]

Whatever his parentage, Naukydes may have worked closely with Polykleitos the Elder, for he is said to have made the gold-

49. Pausanias 1.23.7.
50. *De Isocrate* 3 = Overbeck 531 and 795. See Boardman, *GSCP,* p. 207.
51. Vitruvius 4.1.8–10; Pausanias 1.26.6, 9.2.7.
52. *NH* 34.92. For other uses, see J. J. Pollitt, *The Art of Greece, 1400–31 B.C.* (Englewood Cliffs, N.J., 1965), p. 86n85, and *Ancient View,* p. 352.
53. Pausanias 2.22.7. Elsewhere (6.6.2) Pausanias says that Naukydes had an Argive pupil named Polykleitos.
54. Loewy, no. 86; *NH* 34.91.
55. Pausanias 10.9.10.

and-ivory Hebe that stood beside the famous Argive Hera.[56] Among his works in bronze were a Hermes, a diskobolos, and a man sacrificing a ram.[57] Naukydes worked in Olympia, where he made several statues of victors, among them the Rhodian boxer Eukles, the wrestler Baukis of Troizen, and the wrestler Cheimon.[58] Naukydes made a second statue of Cheimon in Argos, probably the artist's home city, but that statue had been removed to Rome by the second century A.D. Pausanias thinks the statues of Cheimon were among the most notable works by Naukydes, but does not say why.[59]

Nikeratos, an Athenian artist of the late fifth century, made statues of Asklepios and Hygeia, and a group of Alkibiades and his mother sacrificing by torchlight.[60] And Deinomenes, also an Athenian, made statues of Io and Kallisto which stood on the Akropolis.[61] Pliny credits this artist with a statue of Protesilaos and one of a wrestler named Pythodemos.[62] Theokosmos of Megara made a statue of Hermon for the Spartan victory monument at Delphi.[63] Styppax of Cyprus is remembered not for his style or ability but for an unusual statue: an image of a slave of Perikles cooking entrails and blowing on the fire, his cheeks puffed out with the effort. Even Polygnotos of Thasos is named as an artist who worked in bronze, though he was much more famous for his paintings. No specific statues are mentioned.[64]

The production of the Tyrannicides inaugurated the tradition of portraiture in Greece. The pose of each figure was generally derived from an older conventional type, that of the striding, attacking god or hero. The faces of the two, like their bodies, were no doubt standardized to some extent. A distinction was at least made between youth and maturity, however, and that distinction, augmented by the inscription on the base of a statue, was tantamount to portraiture. In looking at the Tyrannicides, the public could see commemorative statues that provided a dramatic sense of the individuals represented.

Other portraits produced during the fifth century represented

56. Pausanias 2.17.5.
57. *NH* 34.80. Overbeck, in a note to no. 997, suggests that the sacrificer was the statue of Phrixos seen by Pausanias (1.24.2) on the Athenian Akropolis.
58. Eukles: Pausanias 6.6.2; for the base of this statue, see Loewy, no. 86 p. 67. Baukis: Pausanias 6.8.4.
59. Pausanias 6.9.3.
60. *NH* 34.80, 88.
61. Pausanias 1.25.1.
62. *NH* 34.76.
63. Pausanias 10.9.8.
64. *NH* 34.81, 85.

people who had lived long before, such as the statues of Homer and Hesiod dedicated by Mikythos at Olympia about 460 B.C.[65] As these were invented likenesses, however, they raise different questions from those called forth by contemporary portraits.[66]

Panainos, the brother of Phidias, portrayed Athenian and Persian leaders in his painting of the battle of Marathon in the Stoa Poikile in Athens.[67] Phidias himself concentrated on making images of gods rather than of men. He is known for a few bronze portraits, however, such as a youth binding a fillet at Olympia, which Pausanias called a portrait rather than a statue. And among the gods and heroes that Phidias included in his bronze group at Delphi was the Athenian general Miltiades.[68] Miltiades was the only historical figure in the group, and he was probably represented simply as a bearded standing nude. These standardized characteristics were no doubt sufficient to identify him as the commanding general whose role in the Athenian victory over the Persians at Marathon in 490 gave him the honor of being represented alongside the Athenian eponymous heroes. The monument was financed with a tithe of the spoils, and, like the Serpent Column at Delphi, was probably commissioned immediately after the victory.

As we have seen, Kresilas made a portrait of Perikles, and Pliny's suggestion that Kresilas heroized Perikles is consistent with the standardization of the types of gods and heroes in Archaic and Classical sculpture.[69] In fact, statues of mortals could be as standardized as those of gods once a portrait tradition was established. Roman copies of a portrait of Perikles show a bearded, helmeted man with short curly hair and angular features.[70] Only the placid expression may belie the notion that this is a true portrait. Other portraits of individuals who lived during the fifth century have been identified, nearly all of them Roman copies in marble.[71] Surely the original portraits were made of bronze.

Of all the fifth-century bronzes preserved, only one has been widely accepted as a portrait. It is a smaller-than-lifesize head

65. Pausanias 5.26.2; Herodotos 7.170.

66. For a discussion of imaginary portraits, see Richter, *Portraits*, p. 24.

67. Pausanias 5.11.6; Strabo 8.353–54; *NH* 35.57.

68. Pausanias 6.4.5, 10.10.1.

69. *NH* 34.74.

70. See, e.g., British Museum cat. 549, H 0.41 m., and Vatican inv. 269, H of head 0.388 m.; Richter, *Portraits*, pp. 174–75, figs. 136–37.

71. See, e.g., a marble herm of Themistokles: Ostia Museum no. 85, H of head 0.26 m.; A. Linfert, "Die Themistokles-Herme in Ostia," *Antike Plastik* 7 (1967): 87–94; Richter, *Portraits*, p. 211, fig. 173.

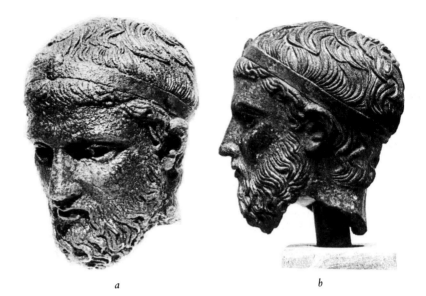

8.1 Head of Arkesilas IV(?), middle of the fifth century B.C. H 0.102 m. Cyrene Museum. Courtesy of Bryn Mawr College. Photos by Elizabeth Harrison.

a　　　　　*b*

that was found in 1926 in the Sanctuary of Apollo at Cyrene, ancient Kyrana (fig. 8.1).[72] Because of the site of the find, the fifth-century style of the head, and its diadem, the work has been identified as Arkesilas IV, the last of the Battiad kings of Cyrene.[73] Arkesilas IV won a victory at Delphi in 462 B.C. with a chariot raced by his brother-in-law Karrhotos. The victory was celebrated by Pindar.[74] As Arkesilas was overthrown in 440, any official portraits of him must have been produced before that date.

The bronze head is hollow-cast, broken diagonally across the neck and more or less along the line of the jaw, the break probably marking the original edge of the casting. The face is that of a mature man; he wears a serious expression. A finely engraved moustache curves into the more deeply incised broad strands of a short, wavy beard. A small mouth, delicate cheekbones, and a gentle brow ridge over a thin, straight nose and wideset oval eyes give a certain severity to the face. Like the beard, the short hair lies close to the head, with broadly sweeping layered curls radiating from the crown. Only above the

72. Original H, if standing, perhaps ca. 0.70 m. See L. Laurenzi, *Ritratti Greci* (Florence, 1942), no. 13, p. 90; Boardman, *GSCP*, p. 176, fig. 141.

73. E.g., L. Beschi, "Antichità cretesi a Venezia," *Annuario*, 1972–73, pp. 501–2; and Richter, *The Portraits of the Greeks* (London, 1965), 1:104–5. Ridgway discusses the problem of the head of a ruler being represented as smaller than lifesize: *FCS*, pp. 179–80.

74. Pindar, *Pythians* 4 and 5.

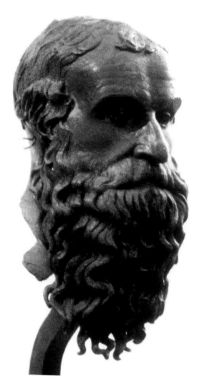

8.2 Porticello head, third quarter of fifth century B.C. H 0.40 m. Reggio Calabria, Museo Nazionale 17096. Courtesy of Alinari/Art Resource, New York.

tight fillet or diadem does the hair bulge slightly away from the head. Short bangs parted in the center lead the eye to an oval projection, incised with a rough cross, at the center of the diadem. The head is usually dated between 450 and 440 B.C.[75]

In 1969 looters were apprehended as they ransacked an ancient shipwreck in the Straits of Messina near the village of Porticello. A salvage excavation was undertaken in 1970 by the University of Pennsylvania Museum. Amphoras and other pottery from the cargo of the ship have been dated to the late fifth or the early fourth century B.C.[76]

Of particular interest are the fragments of lifesize bronze statues which were recovered from the looters, including a portrait head of an old man which has been dated to the latter half of the fifth century (fig. 8.2). The head was not the only bronze in the ship's hold: there were twenty-one other fragments of statues, and it seems that at least three bronzes were being transported, including one draped figure and two nudes. Among the fragments are a left forearm and elbow with drapery, a left hand, a right hip with drapery and the upper leg, a nude male buttock, genitals, two feet and part of one leg, four fragments of flesh, and four drapery fragments.[77] A second head may have been sold before the looters were caught.[78] The nude figures probably represent athletes. If the drapery belongs with the bearded head, then the figure could be a philosopher.

The Porticello head is remarkable for its long unkempt hair, tousled beard, and the suggestion of advanced age in the jutting head, sunken cheeks, and wrinkled brow. A prominent aquiline nose curves over the moustache, and the spare cheeks are sagging from age. Small, sunken, wideset eyes are overpowered

75. 450: G. M. A. Hanfmann, *Classical Sculpture* (Greenwich, Conn., 1967), p. 319; 440: Laurenzi, *Ritratti Greci,* p. 90. See also Chamoux, *Cyrène sous la monarchie des Battiades* (Paris, 1952), pp. 368–73 (calls the head a sand casting); and Richter, *Portraits of the Greeks,* 1.105.

76. C. J. Eiseman, "Amphoras from the Porticello Shipwreck," *International Journal of Nautical Archaeology* 2 (1973): 13–23; C. J. Eiseman, "The Porticello Shipwreck: A Mediterranean Merchant Vessel of 415–385 B.C." (Ph.D. dissertation, University of Pennsylvania, 1979); C. J. Eiseman, "Classical Inkpots," *AJA* 79 (1975): 375; and C. J. Eiseman and B. S. Ridgway, *The Porticello Shipwreck: A Mediterranean Merchant Vessel of 415–385 B.C.* (College Station, Tex., 1987).

77. For a catalogue of the pieces, see E. Paribeni, "Le statue bronzee di Porticello," *BdA* 24 (1984): 1–14. Also B. S. Ridgway, "The Bronzes from the Porticello Wreck," *Archaische und Klassische Griechische Plastik* (Mainz, 1986), 2:59–69.

78. D. I. Owen, "Excavating a Classical Shipwreck," *Archaeology* 24 (1971): 118–29.

by a beetling, furrowed brow that is marked by a central vertical indentation.

The hair is parted on the left and combed from the back forward over a noticeably balding head. Along the sides of the head, heavy flat incised waves fall to an indentation above the ears where a circlet or fillet was originally added. From there, long plastic locks fall in some disarray to the nape of the neck. Thick clusters of shorter curls, equally unkempt, lie over the long-lobed ears. The beard is unusually long, measuring approximately half the total height of the piece. It is also highly plastic, and has irregular corkscrew curls separated by deep furrows. Incised strands add to the impression that the rough beard is slightly matted. A wide bushy moustache descends over the mouth, revealing only a small part of the lower lip and curling at the sides into the beard.

The identification of the Porticello head is difficult. The stark realism of this aging, balding individual with his remarkably long, tousled beard seems very different from the idealized portraiture that has heretofore been assumed to have typified the fifth century, but that has been known only through marble copies. If it is a portrait, the head significantly enlarges our picture of the genre. The individual is of the type of the partially draped philosopher. B. S. Ridgway has suggested a date of 440 to 430 B.C., a provenance of either Magna Graecia or North Africa, and an identification of the head as a centaur, based on comparison of this head with some of the Parthenon metopes.[79] It must be remembered that we have no comparable original fifth-century portraits. The Porticello head may be not a centaur but simply our only preserved example of extreme realism in fifth-century portraiture.

Technically the Porticello head is of great interest. As preserved, it is a separate hollow casting. There is an almost clean break along the join at the neck. But on the right side, a wide rectangular flap apparently broke off the statue along with the head. The head was cast in two pieces, joined at the circlet. Below, the locks of hair falling onto the back of the neck were separately cast and soldered into place. The ends of a few locks have broken away, revealing bronze wires, over which it

79. Ridgway, *FCS*, pp. 120, 180; and Ridgway, "Bronzes from the Porticello Shipwreck," pp. 59–69. Philosopher of ca. 460 B.C.: Rolley, *BG*, p. 40. 450 B.C.: Boardman, *GSCP*, p. 63. Hellenistic philosopher: Paribeni, "Statue bronzee di Porticello," pp. 12–13.

appears that the locks were originally modeled in wax. The right eye retains lids made of sheet copper and an iris of vitreous paste, originally set in ivory.[80]

The interior of the Porticello head is smooth, with no extraneous metal from the fusion welding of the upper part of the skull and with clearly visible bronze chaplets.[81] Within the head there is no sign of the contour of the lower neck or of the chin and mouth, the interior surface preserving instead the imprint of the beard. The nose is marked by a cavity but the ears are not; they must have been added in wax to the wax model of the head.[82]

The other bronze fragments provide further information about the production of the statues. Some pieces are, like the two parts of the head, complete castings: the left hand, the genitals, and the left buttock. And so we can see that the bronzes were cast in numerous separate pieces, a practice that was to become very common, at least for draped figures, during the fourth century and the Hellenistic period. The feet as well were cast in two pieces, divided at the arch, and welded together.[83] The right foot has a carefully worked ledge for the addition of the separately cast third toe, now missing. Part of an armature, consisting of wood encased in metal, is contained within the leg. And the interior surface of the right hip fragment retains the impression of two joined slabs of wax.[84]

All of the Porticello fragments are said to be made of essentially the same alloy, and all were made in the same way, suggesting that they all came from the same workshop. Analysis of numerous samples of the metal revealed an alloy averaging 89.8 percent copper, 9.4 percent tin, and 0.7 percent lead.[85]

The Riace bronzes (figs. 8.3 and 8.4) have been the subjects of extensive research, speculation, and publication since their discovery off the coast of Calabria in 1972. The official publication of the two statues appeared in 1984 in a profusely illustrated

80. P. Fiorentino et al., "Indagini e intervento di conservazione sui reperti bronzei di Porticello," *BdA* 24 (1984): 19–20; Paribeni, "Statue bronzee di Porticello," p. 4.

81. Fiorentino et al., "Indagini e intervento," p. 19 and pls. II, III, IV.

82. For information about the appearance of the interior, I am grateful to B. S. Ridgway, who in January 1986 shared with me her observations about the head. See also Eiseman and Ridgway, *Porticello Shipwreck*.

83. We have seen this done with earlier works, such as the Livadhostro Poseidon and the Selinus Youth.

84. Fiorentino et al., "Indagini e intervento," pl. IV.

85. Ibid., pp. 15–16. The range of readings was Cu 88.5–91.3%, Sn 7.9–11.2%, Pb 0.1–2.9%.

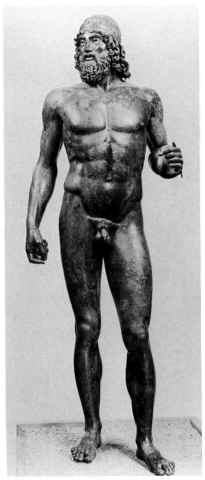

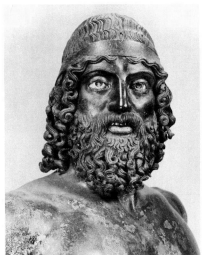

b

8.3 Riace statue *A*. H 1.98 m. Reggio Calabria, Museo Nazionale. Courtesy of Alinari/Art Resource, New York.

a

two-volume supplement to the *Bollettino d'Arte*. This is the most thorough study of its kind to date. The first volume contains accounts of the discovery of the bronzes and of the procedures used in the subsequent excavation of the underwater site; analyses of the bronzes, of their clay cores, and of pottery and wood found with the statues; charts and diagrams of their measurements and varying thicknesses; lengthy descriptions of both statues; photogrammetry of each statue; accounts of the conservation and preparation for exhibition; and a reconstruction of the technique by which the statues were produced. The second volume covers the wide range of current opinions about the identification of the two statues, their dates and provenances, and the artists who made them; a comprehensive bibli-

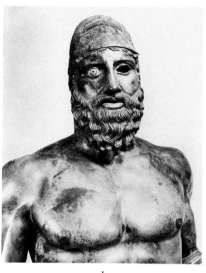

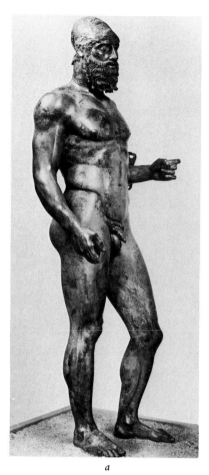

b

a

8.4 Riace statue *B*. H. 1.97 m. Reggio Calabria, Museo Nazionale. Courtesy of Alinari/Art Resource, New York.

ography; and more than one hundred color and black-and-white photographs of the two statues.

At first glance the two Riace bronzes look very much alike. They are almost exactly the same height, and in fact all of their measurements are very close.[86] Both rest their weight primarily on the right foot, with the left leg slightly advanced to balance the body. Both statues retain the shield strap on the raised left arm, and both probably held a spear more or less vertically, following the line of the lowered right arm.[87] In many other

86. For full measurements, see C. Sabbione, "Tavole delle misure," app. II in *Due bronzi*, pp. 221–25. I am grateful to Dr. Sabbione for allowing me to look at these statues while they were undergoing preliminary restoration in the Museo Nazionale of Reggio Calabria in 1973.

87. C. Rolley makes the interesting point that statue *B*'s shield strap is identical to one in Delphi dated to the second half of the fifth century: *BG*, p. 226, fig. 205, and "Delphes? Non!" in *Due bronzi*, p. 328.

respects, however, the two statues differ significantly in appearance.

Statue *A* has a broad, youthful face framed by long massive curls. Incised eyebrows repeat the line of the heavy lids, and copper lashes surround ivory corneas. An alert, attentive expression is enhanced by parted copper lips and silver teeth.[88] The long hair is contained by a broad band encircling the head above the ears and crossing low over the forehead. Originally the head was probably helmeted, but the hair is nonetheless executed in great detail.[89] It radiates from the top of the head as a smooth cap of neatly undulating strands, only to escape below the band as plastic, individually carved curls. Two delicate tendrils escape the band in the center of the forehead and curl neatly across either temple. The ears, though mostly covered by the long curling locks, are worked in full detail. A cascading layered beard repeats on a smaller scale the luxuriant locks of hair. The upper lip is hidden by a thick but neatly combed moustache, which trails decoratively into the beard.

The head is turned to the right and the shoulders and upper back reveal corresponding movement, but these features do not interfere with the basic frontality of the figure. When seen from the side, statue *A* is a massive figure with stiffly vertical posture. The figure appears more slender from the front, and its sinuous outline is repeated by the gentle curve of the well-muscled right arm. The thoracic arch makes a delicate ogival curve. The young man is poised with muscles flexed and veins raised, and the rippling surface of the flesh reflects the light. Copper nipples further highlight the fluid musculature of the chest.

The crown of the head of statue *B* was formed for the sole

88. Soprintendenza Archeologica per la Toscana–Centro di Restauro, "Intervento di restauro sui bronzi provenienti da Riace," in *Due bronzi*, p. 56.

89. It has been suggested that a bronze rod fixed in lead in a hole at the top of the head supported a helmet, and that two other bronze pins served a similar function during another phase of the statue's existence: C. Sabbione, "La statua *A*," in *Due bronzi*, pp. 157–60. The markings on the band and a ledge on the curls emerging from beneath the band around the back of the head support this theory. One possible reconstruction of the helmet is made by A. di Vita, "Due capolavori attici gli oplitodromi-'eroi' di Riace," in *Due bronzi*, p. 269, fig. 20. Alternatively, F. Nicosia has suggested that *A* wore a foliate wreath: lecture delivered at the Center for Advanced Study in the Visual Arts, National Gallery of Art, Washington, D.C., March 16, 1982. The former theory has gained wider acceptance because of the unnatural elongation of the head and the large hole in the crown. For a Chalkidian helmet on *A* and a Corinthian helmet on *B*, see B. Cohen, "Kresilas' Perikles and the Riace Bronzes: New Evidence for Schinocephaly," abstract, *AJA* 90 (1986): 207–8.

purpose of supporting a helmet, and its loss has somewhat marred the statue's appearance. The narrow, elongated head is unfinished, as are the upper parts of the ears. Statue *B*'s hair is short and compact, as is the beard, betokening a more mature individual. The brow is slightly wider than that of statue *A*, and the face is longer and narrower. The eyebrows are incised and the left eye is missing, but the right one has a white calcite cornea; the iris is thought to be of ivory, the pupil of vitreous paste.[90] The beard is a solid mass, separating into individual locks only at the very end. The moustache, not so long as that of statue *A*, hides most of the upper lip, then blends with the longer hair of the beard. The slightly parted copper lips do not reveal any teeth. A row of tiny curls once emerged from beneath the helmet, framing the forehead and parting above the nose. Longer hair at the temples blends into the still longer curls of the beard. At the back of the head short curls emerge from beneath the helmet and arc across the nape, leaving most of the neck bare.

Statue *B*'s head turns almost imperceptibly to the right, but the shoulders seem to turn as powerfully as do those of statue *A*. Statue *B* is frontal, like statue *A*, with the weight firmly planted on the right foot, but the chest, with its copper nipples, curves more markedly than does that of statue *A*. The body also looks leaner and flatter, and the statue is in fact slightly smaller in circumference than statue *A*. The thoracic arch is a broad, smooth curve. The right hip is thrust out more prominently. The lowered right arm juts outward too, in a position that appears almost forced. The left leg is not placed so far forward as that of statue *A*, and the raised left arm is not drawn back and tensed. Lead remains for attaching the attribute, probably a spear, that was once held in the right hand. Statue *B*, a more mature individual than statue *A*, is also less tense and aggressive.

Each statue was cast in one large section, consisting of the torso and legs, and several small sections, including the head, arms, hands, genitals, the front halves of the feet, and the middle toes. Some of statue *A*'s curls were cast separately and added to the finished bronze, as was the top of statue *B*'s head.

Edilberto Formigli has made a detailed study of how the Riace bronzes were produced, and his reconstruction of the

90. A hole in each ear was probably used to attach the helmet: C. Sabbione, "La statua *B*," in *Due bronzi*, pp. 189–90, 192.

process is the most detailed that we have for any Greek bronze. He suggests that master molds were taken from the original model of each statue and lined with wax, which was then filled with a clay core around a simple armature consisting of unconnected iron bars. After the core had dried, the master molds were removed and the finishing details were worked in the wax.[91]

According to Formigli, the original model for the head of statue *A* may have been a very rough one, lacking both the hair and the beard. The cored wax was then used as a model on which to add, also in wax, the deeply undercut hair and beard. Extensively undercut locks, which would have been difficult to mold and cast, were removed, cast solid, and added later to the finished bronze head.[92]

Formigli suggests that the lips of statue *A* were also modeled separately and cast in copper before being reinserted into the wax from outside. The portions of the wax beard and moustache which were to be cast with the head were then added.[93]

Statue *B*, with shorter, more contained hair and beard, had no separately cast locks, but for some reason the top of the head was cast separately and later soldered into place. Its rough surface and the equally rough ears bear testimony to the fact that most of the head would have been concealed by a helmet.

After the wax had been cored and finished, it was invested with a clay mold and cast in an upright position. With the exception of the right arm and left hand of statue *B*, both statues are made of tin-bronze, with only traces of lead in the alloy. But

91. E. Formigli, "La tecnica di costruzione delle statue di Riace," in *Due bronzi*, pp. 107–42. Ultrasonic readings established the varying thickness of the bronze, and thus also the original thickness of the wax. The range for each statue is great, but the average thickness of *A* is 0.0085 m. and of *B* 0.0075 m. The hollow bars were square in section (0.020 by 0.020 m.) and contained a wooden core. Gammagraphy established the original locations of the bars. In *A*, one extended from the right ankle to the neck and another was inside the left leg. *B* contained one rod extending from the right ankle to the chest or neck and a short rod within each leg. (The Piraeus Apollo, fig. 4.19, had a similar armature.) The core material was found to contain hair, added to give the clay the necessary porosity. (See also the fifth-century accounts recording the production of the Bronze Athena by Phidias, chap. 7, above). As it was not necessary to bake the master molds, the clay could be reused. Thus these molds do not survive among the debris from ancient foundries.

92. Ibid., p. 130 and fig. 29, p. 131. These locks are direct castings.

93. Ibid., p. 132. Bol agrees that such a process is possible, but only because the melting point of pure copper is higher than that of bronze; thus the lips would not melt during casting, but needed only to be fixed to the core so as not to shift: *Bronzetechnik*, p. 124. For varieties of inset lips, see Bol, *Grossplastik*, pp. 90–91.

TABLE 1
Average tin content of Riace bronzes (percent)

	Statue A	Statue B
Body	11.3%	9.9%
Left foot	8.2	20.8
Left center toe	13.2	17.3
Right foot	8.2	17.0
Right center toe	13.6	26.1
Head	12.4	13.5
Testicles	14.1	11.2
Penis	16.4	13.7
Left arm	11.5	23.7
Right arm	11.9	0.3
Right hand	15.6	3.2

Data from Soprintendenza Archeologica per la Toscana, Centro di Restauro, "Relazione sulle analisi," in *Due bronzi,* pp. 102–5; E. Formigli, "La tecnica di costruzione delle statue di Riaci," in ibid., pp. 120–22.

the alloy varies from one portion of a statue to another, as Table 1 indicates.[94]

Samples taken from the left arm and hand and from the right forearm and hand of statue *B* show lead content ranging from 9.8 percent to 14.5 percent, leading to the assumption that these are later repairs, perhaps not earlier than the Hellenistic period.[95] As the alloy of the Ugento god also contains lead, however, perhaps the lead content is a regional characteristic and we should seek a southern Italian origin for the Riace statues.

After casting, the molds were broken off the bronzes and discarded, the pieces of the statues were hard-soldered into place,[96] and the surfaces of the bronzes were finished. The eyes, encased in copper plates that were cut along the outer edges to indicate lashes, were inserted from the exterior; statue *A*'s strip of silver teeth and bronze curls were added; and the helmets

94. The fact that the amount of tin in the alloy is greater in samples taken high on the statues than in samples taken lower suggests that the tin was added to the molten metal during the pour to increase its fluidity, and at the same time indicates that the statues were cast upright.

95. Formigli, "Tecnica di costruzione," pp. 104, 127, 140n66. Di Vita, "Due capolavori," p. 256, suggests that the repairs may be late Hellenistic or Roman.

96. A variation on this process, probably intended to ensure a tighter join, can be seen in filled ovoid cuttings at the point of juncture on the left wrist of statue *A*. See Formigli, "Tecnica di costruzione," pp. 124–26, and "Tradizioni ed innovazione nella metallotecnica etrusca," *Atti del XII congresso di studi etruschi: L'Etruria mineraria* (Florence, 1981), pp. 67–68.

were set in place on both statues.[97] No doubt the front half and middle toe of each foot had been separately cast to facilitate attachment of the statues to their bases. At the time of excavation, lead tenons were still fixed as they had been poured into the feet of the two figures. A single tenon projected from the opening in the sole of either foot of statue *A*, and a double tenon projected from each of the similar openings in the feet of statue *B*.

Where the Riace bronzes were made, who made them, and for what purpose are much more controversial questions than those of technique, and are far less likely ever to be answered. The statues have been called Attic, but as we have seen, a southern Italian origin is also a possibility. The statues have been seen as coming from the same workshop and as having been made by the same artist or by different artists. The names of Onatas, Myron, Phidias, the school of Phidias, Polykleitos, and a follower of Polykleitos have all been suggested. Dates given for the statues as a pair range from between 460 and 450 to the middle of the fifth century B.C. to between 100 B.C. and the reign of Hadrian in the second century A.D. When the two statues are given different dates, statue *A* may be placed between 460 and 450 and statue *B* twenty to thirty years later; or statue *A* before Kimon's ostracism in 461 B.C. and statue *B* after his return in 452.[98]

97. Formigli, "Tecnica di costruzione," pp. 133–35.
98. Attic: C. Rolley, "Delphes? Non!" pp. 327–30. Southern Italian: E. Paribeni, "I bronzi di Riace," in *Due bronzi*, pp. 307–12. Same workshop: B. S. Ridgway, "The Riace Bronzes: A Minority Viewpoint," in *Due bronzi*, pp. 313–26; Boardman, *GSCP*, p. 54. By different artists: C. Houser, "The Riace Marina Bronze Statues, Classical or Classicizing?" *Source: Notes in the History of Art* 1 (1982): 5–11; P. E. Arias, "Lettura delle statue bronzee di Riace," in *Due bronzi*, pp. 243–50; G. Dontas, "Considerazioni sui bronzi di Riace: Proposte sui maestri e sulla provenienza delle statue," in *Due bronzi*, pp. 277–96; Rolley, "Delphes? Non!" pp. 327–30. Onatas: Arias, "Lettura." Myron: Dontas, "Considerazioni." Phidias: Dontas, "Considerazioni"; W. Fuchs, "Zu den Grossbronzen von Riace," *Boreas* 4 (1981): 25–28; J. Frel, "Some Observations on Classical Bronzes," *J. Paul Getty Museum Journal* 11 (1983): 117–19. School of Phidias: Arias, "Lettura." Polykleitos: di Vita, "Due capolavori," pp. 251–76. Influence of Polykleitos: Dontas, "Considerazioni." Same date: Boardman, *GSCP*, figs. 38–39 (460–450 B.C.); Ridgway, "Riace Bronzes" (100 B.C. to second century A.D.); A. Giuliano, "I grandi bronzi di Riace: Fidia e la sua officina," in *Due bronzi*, pp. 297–306 and Frel, "Some Observations" (mid–fifth century). Different dates: Rolley, "Delphes? Non!" (*A* = 460 B.C., *B* = 430); di Vita, "Due capolavori" (*A* = Kimonian, *B* = Polykleitan); Arias, "Lettura" (*A* = 460–450 B.C., *B* = 30 years later). For a more extensive summary of the scholarship to date, see J. Marcadé, "Rapports techniques et publications archéologiques: A propos des bronzes de Riace," *RevArch*, 1986, pp. 89–100.

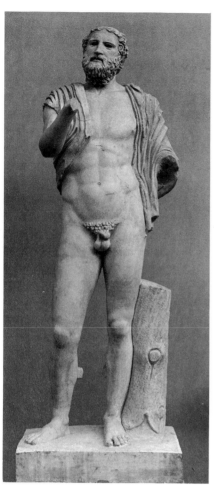

8.5 Roman copy of a statue of Anakreon. H 1.9 m. Copenhagen, I.N. 491. Courtesy of Ny Carlsberg Glyptotek, Copenhagen.

The statues have been identified as heroes, as generals, and as hoplitodromoi.[99] When they are believed to have been produced in the same workshop, they may be thought to have belonged to the same monument.[100] Three possible groups have so far been suggested: the Athenian dedication at Delphi honoring the victory at Marathon and consisting of statues of Athena, Apollo, the general Miltiades, and the eponymous heroes of Athens;[101] the Achaean dedication at Olympia in which Greek heroes stand ready to meet Hektor;[102] and the fifth century group of the Eponymous Heroes in the Athenian Agora.[103] One question that has not been thoroughly addressed is why the two statues are so similar in stance, pose, and measurements. The answer may be linked with the technique by which they were cast, a process we saw first in the seventh-century production of griffin protomes. A rough model was made to the appropriate scale, then the wax made from it was individualized by the addition of surface details. Is it not likely that the Riace statues are similar in general outline and scale because they were both started from the same rough model? This would certainly have been the logical way for an artist or workshop to proceed with a commission for a large group of figures. Whether they were legendary or historical figures, the statues would need to represent particular types, and so would be generalized, not particularized. The lost-wax technique as we have seen it used in Greece was ideally suited to the production of a group of such statues.

A Roman copy of a statue of the poet Anakreon (fig. 8.5) bears a strong superficial resemblance to the Riace statues. The copy is marble and struts have been added, but the cavities for

99. Heroes: Arias, "Lettura"; Dontas, "Considerazioni" (*A* only); Paribeni, "Bronzi di Riace" (*A* only). Generals: Arias, "Lettura"; Paribeni, "Bronzi di Riace" (*B* only). Hoplitodromoi: di Vita, "Due capolavori."

100. Giuliano, "Grandi bronzi di Riace."

101. Pausanias describes the dedication and names Phidias as the artist: 10.10.1. See Fuchs, "Zu den Grossbronzen von Riace," pp. 25–27; Giuliano, "I grandi bronzi di Riace," *Xenia* 2 (1981): 55–62.

102. Pausanias describes the dedication and names Onatas as the artist: 5.25.8. See Arias, "Lettura," pp. 243–50. Determining whether or not the Riace bronzes could actually have been part of a monument seen by Pausanias depends on arriving at a precise date for their shipment from Greece to Italy. E. Harrison favors this designation and summarizes the many stylistic attributions that have so far been presented: "Early Classical Sculpture: The Bold Style," in *Greek Art: Archaic into Classical*, Cincinnati Classical Studies, n.s. 5 (Leiden, 1985), pp. 47–56.

103. See Dontas, "Considerazioni," for discussion of this possibility. For fifth-century references to the monument, see R. E. Wycherley, *Literary and Epigraphical Testimonia*, Athenian Agora 3 (Princeton, 1957, 1973), nos. 229–32, p. 86.

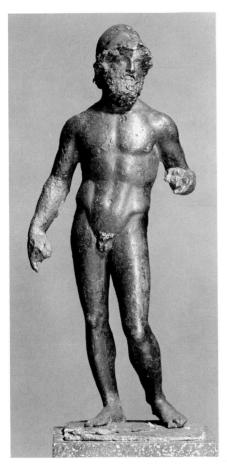

8.6 Bronze statuette of a late-fifth-century-B.C. type. H 0.29 m. Hartford, Wadsworth Atheneum, J. Pierpont Morgan Collection, no. 1917.820. Courtesy of the Wadsworth Atheneum, Hartford.

inset eyes probably bear testimony to the material of the original, which must have been bronze. Although Anakreon lived in the late sixth and early fifth centuries B.C., the style of this and of the other copies suggests that his portrait statue was made as much as fifty years after his death.[104] We can conclude that physical likeness was less important than the remembrance of the poet's wit, his skill at entertaining, and his love of life's pleasures.

The figure of Anakreon is of the same type as the Riace statues, a broad-shouldered, mature, bearded standing man, full of assurance, feet planted fairly far apart. The Riace statues were armed and helmeted, and their firm stance and level gaze bear witness to the weighty responsibilities of their public roles. Anakreon is altogether different. A short cloak is draped casually around his shoulders. His left hip juts informally outward as he rests his right leg, his shoulders swing to his left, and his gaze probably once followed the direction of a pointing forefinger. If we add these details to the cocked head, the jutting jaw, and the tousled beard, we may conclude that Anakreon is not declaiming on a solemn subject and that he is not entirely sober. In the rendering of detail the Anakreon matches the Riace bronzes fairly closely and he is the same type of figure, but the artist combined subtleties of stance, of gesture, of expression, and of attribute to create a wholly different kind of character. In fact, stance and gesture are clearly more important to this portrait than physical resemblance.

A large bronze statuette in Hartford (fig. 8.6) is a close parallel to the type of the Riace statues.[105] The cocked right hip of this sinuous warrior supports a trailing left leg and the head turns to the left. However, the tousled hair, emerging from a pushed-back Corinthian helmet, and the long beard are reminiscent of Riace *A*, and the positions of the arms are strikingly similar to those of both Riace statues. The left one is raised to the horizontal to hold a shield, and the lowered right hand once grasped a long vertical staff or spear, balanced by the extended index finger.

A smaller bronze warrior in Boston (fig. 8.7) is younger and

104. Richter, *Portraits*, pp. 83–86: 440 B.C.

105. Found in the Tiber in Rome, the statuette has been called a Roman imperial copy of a late-fifth-century statue. See E. Bielefeld, "Bronzestatuette des Wadsworth Atheneums in Hartford, Connecticut," *Antike Plastik* I (1962): 39–45, pls. 30–37: Athenian type of later fifth century B.C.; Robinson, *HGA*, p. 336 and pl. 112b.

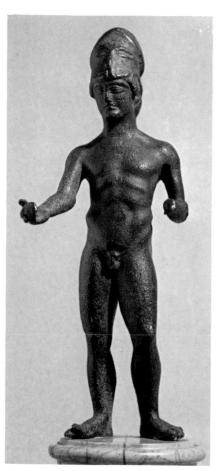

8.7 Bronze statuette, late fifth century B.C. H 0.169 m. Boston, Museum of Fine Arts 01.7507. Courtesy of Museum of Fine Arts, Boston. Purchased by contribution, E. P. Warren Collection, 01.7507.

beardless, but again of the same type as the Riace statues.[106] He stands with his feet rather clumsily splayed, the left leg, knee bent, slightly behind the right, and the right hip almost imperceptibly raised. Both arms are bent and held away from the body; a pin through the left elbow attached a shield, and the right hand is bent around an object, perhaps a weapon, now lost. Like Riace *A*, the small figure turns his head slightly to the right. He wears a high Corinthian helmet, and short neatly combed hair escapes over the nape of his neck.

The Riace bronzes, the Porticello head, and the head of Arkesilas IV(?) have all been identified as portraits by at least some scholars. Whether or not they are, they illustrate various points that can be of use in an attempt to define Greek portraiture of the fifth century. All of the individuals we see represented in Greek portraits were important people. Just as athletic statuary represented the action of the subject and not necessarily his physical features, so portraiture depended on attributes suggesting the events, occupations, or actions by which the subjects were remembered, not their exact or even approximate likenesses. Portraitists also represented the whole figure, not just the head.

Harmodios and Aristogeiton, the first portraits commemorating famous individuals, were figures in action, for their public deed was what endeared them to the Greeks, not their private lives or their precise appearances. As for their looks, we learn little more than that one was young and clean-shaven, the other mature and bearded, and that both were in good physical condition. Their stances and gestures, however, would have been immediately recognizable to fifth century viewers. These were new versions of the action figures known so well during the Archaic period: the striding gods and heroes with their weapons raised in a gesture demonstrating both their power and their readiness to meet the enemy. Such statues were not established in the fifth century as a type for portraits, although they served well in the particular case of Harmodios and Aristogeiton, whose statues could be seen as a cross between the types of gods and athletes. Statues of athletes could, like striding gods, be shown in action. After all, physical action was the sole reason for such statues to be made.

As a rule, men who were represented in sculpture were statesmen, generals, philosophers, poets, playwrights, and the

106. See M. Comstock and C. Vermeule, *Greek Etruscan and Roman Bronzes in the Museum of Fine Arts* (Greenwich, Conn., 1971), no. 41, p. 41: ca. 440 B.C.

like, people who were being commemorated for their ideas and for their very presence. There was no need here to express much movement. The standard type is a standing figure; sometimes he is seated. Gestures and attributes serve as more precise references to the occupation of the individual. The head may be slightly turned, the arms engaged or extended. The simple addition of a helmet, a beard, a cloak, or a lyre gives greater specificity. The portrait statue thus served to identify a famous individual by characterizing him as a type.

9 THE HUMAN FIGURE AND ITS SCULPTORS

A study of the development of cast bronze statuary in the Greek world of the sixth and fifth centuries B.C. is really a study of the development of the male figure in Greek art. Standing, striding, and seated sculptures of this period are often limited to two major viewing points: front and side or front and back. The standing frontal male, first known in the sixth-century kouros and exemplified in bronze by the Olympia legs (fig. 4.3), the Agora molds (figs. 4.4–4.8), and the Piraeus Apollo (fig. 4.19), is later reinterpreted in such statues as the Riace bronzes (figs. 8.3 and 8.4). Here we see that the heads turn, the muscles flex, and the feet bear unequal weight, giving the figures a curving outline. The Delphi Charioteer as we see him now (fig. 6.6), without his chariot, provides another variation on the formula: he is fully clothed, both feet are flat on the ground, and his gesture encloses the space in front of him. Physically and emotionally he concentrates on steadying his horses, and thus in two ways encourages the viewer to take part in his activity.

Statues in motion, such as the striding Ugento god (fig. 4.16) and Myron's coiled Diskobolos (fig. 6.8), are still formulaic. A head may be turned to a three-quarter view but the rest of the figure is still meant to be seen from front or back. To judge from the preserved bronze statues and statue fragments of the fifth century, artists were less concerned with the idea of three-dimensional space than with developing naturalistic representations of anatomical details. The magnificent Artemision god (fig. 6.10), a figure in the midst of action, is still a reflection of an older type, still two-dimensional, but with more emphasis on realistic anatomy and on its visual exploitation through the medium of bronze.

Athletic statuary was introduced in Greece during the third quarter of the sixth century. The first such statues were made of wood, but bronze soon came to be preferred. In the early fifth century, this new genre evidently made a sharp contrast with

the traditional types of figures. The painter of the Berlin Foundry Cup (fig. 5.7) gives us a picture of this contrast in showing us both the familiar stiff striding figure and a remarkably three-dimensional athlete, on his toes and straining forward. Thus we get a sense of the many statues that are now missing. Thousands of athletic statues were placed in sanctuaries throughout the Greek world. Many of these commemorative figures were probably modeled in simple upright positions, perhaps making a gesture of offering: the only association with a particular sport was found in the inscription. But when athletic statues are specially noted in the literary sources, if it is not for anecdotal reasons, it is because they represented a departure from the standard type, probably in their actions. More than half of the bronze artists known to us made at least some athletic statuary, which probably ensured a steady source of income and a technical if not an aesthetic challenge.

Our few preserved large statues make a striking contrast to the many extant bronze statuettes, whose complex movements and marked torsion make them strongly three-dimensional. Differences between the types represented in statuettes and in large-scale bronzes are probably due more to independent stylistic traditions than to differences in methods of production.

There are literary references to about thirty artists who worked in bronze during the sixth and fifth centuries. As we have seen, the literary testimonia are not always reliable, but if we take a broad look at the information they provide, we can make a number of general observations about the activities of the best-known Archaic and Classical bronze artists. Unlike contemporary philosophers, who came mainly from the islands and the colonies, Greek bronze sculptors tended to come from the mainland, from Athens and Attika, Argos, Sikyon, Elis, Megara, Boiotia, and Phokaia; but some also came from the Aegean islands of Samos, Aegina, Crete, and Paros, and a few came from farther afield, from Cyprus, Halikarnassos, and Rhegion. These artists traveled a great deal to carry out commissions and thus were able to establish contacts with other artists, to see their works, and no doubt to discuss methods of production with them. Theodoros started the tradition with a trip from his native Samos to Sparta. Among the later traveling artists, Kalamis is notable for having had works installed in seven cities.

Theodoros of Samos was an architect, a bronze sculptor and founder, a modeler in clay, a woodcarver, a silversmith, and an accomplished jeweler. He was interested in scale and propor-

tion, and he produced both large and miniature works. The painter of the Berlin Foundry Cup was obviously familiar with bronze workshop procedures, and it is tempting to suggest that he may himself have had some experience as a sculptor.

The bronze statues that we have are all by unknown artists. Antenor is the only bronze sculptor whose work we know we have, but the surviving statue is a marble kore, not his famous bronze Tyrannicides. Statue bases in Athens tell us that Gorgias made bronze horses and marble humans. Here we have support for the literary testimonia that artists were not bound to a single medium. The sources cite eleven sixth- and fifth-century artists who worked in two distinct media. Polykleitos is mentioned for modeling in clay but is known as a bronze sculptor, and it was probably common knowledge that he prepared his models in clay.

No doubt a sculptor was expected to work in any material his patron requested. Both Polykleitos and Phidias, the best-known artists of their day, worked in three media: bronze, marble, and chryselephantine. But Kalamis must have been just as versatile technically, for he worked in the same three materials, and Kanachos worked in bronze, wood, and chryselephantine. And, to judge from the records for Phidias's Bronze Athena, a successful artist was not solely responsible for the production of a work, but hired a staff of both workmen and supervisors.

The Aeginetans were not unusual in their working of bronze, and we should no longer attempt to identify the style of a stone sculpture as Aeginetan because it looks the way we think a bronze may have looked. Yet we can see in their use of bronze attachments on marble pedimental sculptures (fig. 5.4) that these people, like the Greeks in general, were growing more and more interested in bronze during the latter part of the Archaic period. Among the advantages of the new medium which the Aeginetans obviously were exploring in their pedimental sculptures were the visual contrast of its color and gleam to stone and the possibility of including attributes that would have been too heavy and cumbersome to carve in stone. By the fifth century, bronze had outstripped stone in popularity for the production of freestanding statuary.

No colossal bronzes are preserved today, with the exception of the Delphi Serpent Column (fig. 5.6), which stands to a height of 5.35 meters. A few bronze eyelashes have survived from the Archaic and Classical periods, the largest of which allow us to reconstruct statues of perhaps 5.5 meters in height.

From statue bases we can reconstruct a horse and a bull that respectively stood 3.5 and 3.0 meters at the withers. In literary sources we find reference to bronze statues that were 5.6, 14.6, and 16.9 meters in height. The names of the artists who made colossi include Kalamis, Alkamenes, Phidias, Onatas, Anaxagoras, and Myron. The artists whose works brought the highest prices were, predictably, Phidias, whose Bronze Athena apparently cost more than eighty talents, and Polykleitos, whose Diadoumenos sold for one hundred talents, in a transaction that evidently occurred long after his death.

Certain artists are noted in the literary sources for having made unusual works—works that departed from the set types of the Archaic and Classical periods to explore the possibilities of the new medium. A few individual works stand out: the first triple-bodied Hekate, made by Alkamenes; a wounded dying man by Kresilas; a boy burning incense and another blowing on the embers of a dying fire, both by Lykios; a slave blowing on his fire while cooking entrails, by Styppax; some fine cattle by Myron and Strongylion; and a boy with a whip, a nude holding apples, a lame man, and a winged Perseus, all by Pythagoras.

A pair of athletes from Delphi who stand on a single base (fig. 5.16) come the closest to the groups of bronze statues for which many sixth- and fifth-century artists are remembered. We also have copies of the Tyrannicides (figs. 6.2, 6.3), who stood simply, back to back, both in the attacking pose so familiar to us from works of the sixth century. Together, however, they make an interesting variant to the standard, having two sets of spread legs and active arms. Highly evocative to the imagination are the groups mentioned in the literary sources. Many groups were simply rows of figures standing on bases, such as the Eponymous Heroes of the Athenians which Phidias made for Delphi, but others were more complex. For instance, Kalamis made a group of praying boys, Hegesias/Hegias a group of boys on racehorses, and Kallon a bronze chorus accompanied by a trainer and a flutist. Onatas made the Trojan heroes casting lots and a group that included a dead king, hoplites, horsemen, heroes, and a dolphin.

Rhoikos and Theodoros, having built the Heraion, wrote a book about it. Evidently they had some teaching ability, for they further demonstrated their skill in this area by instructing their countrymen in the casting of bronze statues. Once these artists were aware of the technical possibilities, they were free to vary the process according to their own needs and preferences.

Among the other bronze sculptors who were also teachers were Hageladas/Ageladas, Klearchos, Myron, Polykleitos, and Phidias. We can assume that Hageladas/Ageladas was the greatest of these later teachers, for he trained Myron, Polykleitos, and Phidias. Myron evidently trained his own son, Polykleitos's seven students are not particularly noteworthy, but Klearchos trained Pythagoras, and Phidias trained Alkamenes and Agorakritos, all of whom became well-known bronze sculptors. Collaboration formed strong bonds among artists, as between Kritios and Nesiotes and among Kanachos, Aristokles, and Hageladas/Ageladas. Onatas too may have worked with Hageladas/Ageladas. Phidias is said to have been physically attracted to Agorakritos, and, according to tradition, may have allowed his own name to be associated with one of his student's works.

The techniques the Greeks employed to cast the thousands of bronze statues that stood in their cities and sanctuaries have aroused curiosity for as long as Greek bronzes have been known and have been a subject of study since the late nineteenth century. With the excavation of ancient foundries and analysis of the bronzes themselves, we are now able to reconstruct the ancient processes with a high degree of accuracy.

The processes we identify today as the direct and indirect methods of lost-wax casting were used in a variety of combinations during antiquity. For large works, a form of the indirect process was clearly preferred: casting in pieces allowed for the melting of manageable quantities of bronze and for extensive working over of the model. Still, details were added and worked before investment in what must be described as the direct process. Small bronzes, though often cast solid, could also be cast hollow and in more than one piece. A series of small bronzes, such as protomes, might be cast from a single basic model by the indirect lost-wax method specifically for ease of reproduction. Details added to each wax model prevented exact duplication. This process may also have been used for groups of large bronzes.

After the pour, surface details might be retooled or freshly engraved in the metal. Eyes and such details as lips, nipples, and teeth were inset. Individually cast parts were joined either mechanically or metallurgically. Imperfections were corrected by the addition of patches, and, as we see on the colossal statue represented on the Berlin Foundry Cup (fig. 5.7), the surface of the statue was smoothed and polished. Finally the statue would be attached to its base, perhaps a rectangular bronze plinth,

which in turn was set into a stone base that might be round or rectangular, high or low.

Pliny has told us that artists chose particular alloys, citing Aegina, Corinth, and Delos as the sources of the most popular mixtures. The evidence that is coming to light through recent studies of ancient bronzes supports Pliny's statement. Alloys can be seen to vary significantly, the evidence so far indicating the use of copper-tin bronze on the mainland and the addition of lead to bronzes cast in the western colonies.

We still need to know whether the casting techniques used during the sixth and fifth centuries were refined in later years. Did the introduction of new and more complex types of statuary signal as well the institution of variations on established processes? As so often in the scholarship on Greek sculpture, the ancient literary testimonia have provoked modern investigations. Pliny may be telling us where to begin next when he states that Lysistratos of Sikyon, the brother of Lysippos, developed a means of casting a likeness by first molding in plaster from the face itself, "for before this they had tried to make individuals as beautiful as possible."[1]

1. *NH* 35.153.

APPENDIX # ANCIENT EVIDENCE OF THE LOST-WAX PROCESS

Ancient workshops and their debris and Greek vase paintings yield considerable evidence of the lost-wax casting process. Some of these sites and objects must be dated later than the fifth century B.C., but as basic methods of casting did not change radically, the evidence they provide may be considered representative of the process as it was employed during the sixth and fifth centuries. The following catalogue of evidence provides dates, if known, for pieces not discussed in the text. The evidence detailed here is representative only; it is by no means intended to be exhaustive. Material that is not discussed here at all, such as the master molds used in indirect casting, is not yet represented by archaeological evidence.

Armature An armature (*kanabos*) was the framework within the core of a statue.[1] Armatures preserved inside statues of the sixth and fifth centuries B.C. consist of nonjoining iron rods.

1. *Piraeus Apollo* (fig. 4.19). An armature, consisting of iron rods, square in section, was distributed in five separate pieces throughout the statue. One heavy piece (ca. 0.02 m. thick) ran vertically through the torso, from neck to groin; two similar rods were found inside the legs and two smaller ones inside the arms. The iron rods were not joined to one another.

2. *Delphi Charioteer* (fig. 6.6). The excavators reported that bits of an iron armature were found inside the statue, apparently within the skirt. See T. Homolle, "Statue de bronze découverte à Delphes," *CRAI* 24 (1896): 368; F. Chamoux, *L'Aurige de Delphes*, FdeD 4, no. 5 (Paris, 1955): 61.

1. Pollux, *Onomasticon* 10.189. See C. Mattusch, "Pollux on Bronze Casting: A New Look at *Kanabos*," *Greek Roman and Byzantine Studies* 16 (1975): 309–16.

3. *Riace bronzes* (fig. 8.3, 8.4). Both statues contained armatures consisting of hollow iron rods, square in section, with wooden cores also square in section, and distributed in unconnected pieces, two in *A* and three in *B*. See E. Formigli, "La tecnica di costruzione delle statue di Riace," in *Due bronzi*, p. 113 and fig. 7, p. 114.

Core

Clay, sometimes coating an armature, formed the core of a bronze.[2] The imprint of the core of a statue cast by the direct lost-wax method was transmitted by the layer of wax that the bronze replaced to the interior of the finished bronze. The interior surface of a bronze statue cast by this method may have pockmarks from air bubbles in the clay or irregular projections and depressions from cracks and protuberances in the clay core.

A bronze cast by the indirect method normally had a core of fine liquid clay poured into the wax that lined the master mold. The consistency of the core thus may be fine and dense. The clay core is often preserved inside a finished statue, perhaps because it had proved too difficult to remove or because it was left there to permit its weight to help stabilize the statue.

1. *Chatsworth head* (fig. 7.1). The thickness of the bronze, ranging from 0.003 m. to 0.013 m., suggests that the wax was built up over the core and became thicker in front owing to the extra wax needed to mold the face and its projecting features. On the interior, the exterior contours are only roughly discernible: the ears and eyes are convex and the nose is concave.

2. *Mold and core for indirect casting of arm*(?) (fig. A.1), from a foundry of ca. 350–325 B.C. A core of fine scorched clay extends into the mold. The complete end of the mold section and part of its wall, probably the end of a mold for part of an arm, were separately cast. The inner surface of the mold is scorched, with numerous bits of bronze adhering to imperfections. See Mattusch, "Agora," C9, pp. 354–55.

3. *Piraeus Apollo* (fig. 4.19). Parts of the core were removed when the statue was cleaned. The innermost layer, coating the armature, is rough and porous, with shell inclusions. The out-

A.1 Mold and core for the casting of an arm(?), ca. 350–325 B.C. Max. pres. diam. 0.185 m. Athenian Agora B 1189a. Courtesy of American School of Classical Studies at Athens: Agora Excavations.

2. For general observations regarding variations in core materials, see Bol, *Grossplastik,* p. 73.

a *b* *c*

A.2 Fragments of bronze statue, interior. Max. pres. dim. (*a*) 0.042 m., th. 0.002–0.003 m.; (*b*) 0.071 m., th. ca. 0.003 m.; (*c*) 0.033 m., th. 0.002–0.003 m. Corinth MF 7935 b, e, h. Courtesy of American School of Classical Studies at Athens: Corinth Excavations.

ermost layer is fine and powdery, and follows the contours of the bronze.

Wax The wax used in casting was burned out of the molds and thus is not preserved. Nonetheless, there is plentiful evidence for its application. The layer of wax coating the core contained the final details of the statue, and its surface was reproduced as the surface of the finished casting. The inside of the walls of a bronze may preserve traces of the way the wax was applied over the core or inside the mold. Smooth, poured surfaces, brush marks, drips, or the marks of a spatulate tool are often identifiable on the interior of the metal exactly as they occurred in the wax when it was applied to the master mold used in the indirect process. The walls of a statue may vary in thickness if the core was unevenly coated with wax; that is, when more wax was applied in some areas than in others, the contours of the core do not correspond exactly to those of the finished work.[3]

1. *Fragments of bronze statue* (fig. A.2). Brush marks visible on the interior surface of the fragment seen in figure A.2*a* were left when the wax was brushed into the master mold. A smooth, spreading drip on the inside surface of the fragment seen in figure A.2*b* was formed when the wax was poured into the mold. The inner surface of the fragment shown in figure A.2*c* shows brush marks beneath poured wax. Evidently the preliminary layers of wax were brushed on to ensure thorough coating of the mold; thereafter, wax was poured in to thicken the walls. See Mattusch, "Corinth," pp. 384–85.

A.3 Fragment of bronze statue, interior. Max. pres. dim. 0.153 m., th. 0.003 m. Corinth MF 1390 a. Courtesy of American School of Classical Studies at Athens: Corinth Excavations.

2. *Fragment of bronze statue* (fig. A.3). The inner surface is deeply scored with marks of a small spatulate instrument

3. See Chatsworth head, "Core," no. 1, above.

(width of blade 0.004 m.) that was used to press the wax into the clay mold. See Mattusch, "Corinth," p. 385.

3. *Fragment of bronze statue* (fig. A.4). Two wide raised areas on the inside of the bronze may reproduce strips of wax that were pressed onto a layer of poured wax, perhaps to join sections of wax that lined the mold. See Mattusch, "Corinth," p. 385.

Funnels and Gate System

Funnels received the molten bronze, gates channeled the bronze into the mold, and vents allowed the escape of gases. The gate system for a large bronze may be preserved either in the baked clay investment mold or in the bronze itself.

1. *Funnel* (fig. A.5), from a workshop of ca. 350–325 B.C. The interior of the large ovoid bowl is scorched at the bottom, with embedded spots of bronze. See Mattusch, "Agora," C1, p. 354.

2. *Funnel*, from a workshop of ca. 350–325 B.C. Athenian Agora B 1456. Diam. 0.12 m. This fragment of the lip and bowl of a small ovoid funnel is scorched inside. See Mattusch, "Agora," C2, p. 354.

3. *Funnel and gate* (fig. A.6), from a workshop of ca. 350–325 B.C. Profile complete. An outer layer of coarse red clay surrounds a finer layer that in turn folds over the central layer. See Mattusch, "Agora," C3, p. 354.

4. *Gate with mold fragment*, from a workshop of ca. 350–325 B.C. Agora B 1189d. Max. pres. dim. 0.199 m.; diam. of gate 0.013 m. The gate enters a mold that has a smooth blackened inner surface with traces of bronze. See H. A. Thompson, "Activities in the Athenian Agora: 1956," *Hesperia* 26 (1957): pl. 28a.

5. *Funnel and y-gate* (fig. A.7), from a workshop of the late fourth century A.D. The small, roughly modeled oval funnel with a forked y-gate has a scorched interior. See Mattusch, "Agora," M1, p. 371.

6. *Bronze y-gate* (fig. A.8), from a manhole containing fill of the first century B.C. The piece of solid bronze, left over from within a y-gate, was discarded or forgotten. See Mattusch, "Agora," I2, p. 364.

A.4 Fragment of bronze statue, interior. Max. pres. dim. 0.128 m., th. 0.003 m. Corinth MF 6319 a. Courtesy of American School of Classical Studies at Athens: Corinth Excavations.

A.5 Funnel, ca. 350–325 B.C. Diam. 0.225 m. Athenian Agora B 1189g. Courtesy of American School of Classical Studies at Athens: Agora Excavations.

7. *Vent* (fig. A.9), from a workshop of ca. 350–325 B.C. The external outlet of a conical vent. See Mattusch, "Agora," C7, p. 354.

8. *Bronze gate system*, found in 1880 west of the Echo Stoa. H 0.094 m. Olympia Br. 10455. This funnel, with complex gate system still attached, was at first identified as a set of antlers. See W.-D. Heilmeyer, "Giessereibetriebe in Olympia," *JdI* 84 (1969): 12, n. 66, fig. 16.

9. *Bronze funnel with two gates*, from a dump near the Temple of Poseidon. H ca. 0.05 m. Isthmia IM 3252. See W. Rostoker and E. R. Gebhard, "The Sanctuary of Poseidon at Isthmia: Techniques of Metal Manufacture," *Hesperia* 49 (1980): 351, pl. 104c (upside down): "bronze riser with two runners."

Molds

Master molds, used to produce working models in the indirect process, have so far not been identified among foundry remains. As they did not need to be baked, the clay could be used again.

The cored, completed wax was invested with clay. This investment mold (*ligdos* or *miligdos*) was constructed of two or three layers of clay.[4] The outer layers are coarse, with sandy, pebbly, and organic inclusions; the innermost layer is fine and smooth, with hair, grass, and straw inclusions.

The terms for clay and hair (*ge kai triches*) are restored a number of times in an inscription recording the items purchased and the costs of production for Phidias's Bronze Athena, made between 460 and 450 B.C.[5] The clay was no doubt used for core or mold material, and the hair was probably mixed with the clay as temper to reduce shrinkage.

Striations, which seem to indicate rasping of the wax model, perhaps to smooth it, sometimes appear on the fine inner mold surface. Cracks in that surface resulting from rapid heating and cooling of the clay may be filled with bronze. Often the inner mold surface is lost altogether, presumably because it pulled away with the bronze when the mold was broken up after casting. Where the inner surface is preserved, it is scorched from contact with the molten bronze.

As investment molds were baked to terra-cotta, many of

A.6 Funnel and gate, ca. 350–325 B.C. Max. pres. dim. 0.089 m.; recon. diam. of funnel ca. 0.080 m. Athenian Agora B 1462. Courtesy of American School of Classical Studies at Athens: Agora Excavations.

4. See Pollux 10.189.
5. See chap. 7.

a

b

A.7 Funnel and y-gate, late fourth century A.D. Max. pres. dim. 0.062 m.; diam. of funnel 0.020–0.025 m. Athenian Agora B 1153. Courtesy of American School of Classical Studies at Athens: Agora Excavations.

A.8 Bronze y-gate, first century B.C. (?). Max. pres. dim. 0.105 m., diam. 0.010 m. Athenian Agora B 1249. Courtesy of American School of Classical Studies at Athens: Agora Excavations.

them are preserved, but most are fragmentary, and it is usually difficult to recognize what they were used to cast. One notable exception is a small but complete mold from Olympia. The mold had never been broken away from its bronze, a figurine that had been intended to be a rim attachment for a cauldron.[6]

1. *Molds for statue of kouros*, nonjoining fragments from the Athenian Agora: funnel (B 1536), recon. diam. 0.15 m.; gate (B 1537), interior diam. 0.01 m.; and see figures 4.4, 4.6, 4.7. These molds were constructed in three layers for a standing male figure of about one meter in height, left leg advanced and hands clenched at the sides (fig. 4.5). See Mattusch, "Agora," A1–4, pp. 343–47, for earlier publications. See also Mattusch, *Bronzeworkers in the Athenian Agora*, Athenian Agora Picture Book 20 (Princeton, 1982), pp. 11–15.

2. *Mold for hand* (fig. A.10), from a workshop in the Athenian Agora of ca. 350–325 B.C. The inner mold surface preserves the imprint of four fingers, with joints and nails clearly marked. From the ends of the first two fingers, small vents (diam. 0.004 and 0.007 m.) lead to the curved end of the mold. See Mattusch, "Agora," C10, p. 355.

The Berlin Foundry Cup (fig. 5.7) provides proof in another medium for the practice of piece casting, and is also a useful parallel for the mold for the hand from the Agora. On one side of the cup we see a workman hammering together the pieces of a bronze statue. The piece that he is actively joining is the hand, shown by a line across the wrist to be separately cast from the rest of the arm. Otherwise, the statue is nearly complete, with the exception of the head, which lies on the ground. See Mattusch, "BFC."

3. *Molds for drapery* (fig. A.11), from a workshop of ca. 350–325 B.C. The interior surface of figure A.11*a* shows wide, gently undulating drapery folds with diagonal rasp marks. Some bronze adheres to the scorched interior surface. Figure A.11*b* perhaps represents a peplos overfold. The inner surface is smooth and scorched. See Mattusch, "Agora," C12 and C11, p. 355.

6. H. Born and A. Moustaka, "Eine geometrische Bronzestatuette im orginalen Gussmantel aus Olympia," *AM* 97 (1982): 17–21.

A.9 Vent, ca. 350–325 B.C. Max. pres. dim. 0.092 m.; diam. of vent 0.007 m. Athenian Agora B 1189h. Courtesy of American School of Classical Studies at Athens: Agora Excavations.

4. *Mold*, from a workshop of ca. 350–325 B.C. Athenian Agora B 1476. Max. pres. dim. 0.141 m. The scorched, rasp-marked inner surface has many cracks, all filled with bronze. See Mattusch, "Agora," C15, p. 355.

5. *Molds for partially draped statue* (fig. A.12), two nonjoining fragments from a workshop of the sixth century A.D. The smooth mold surface with undulating contours seen in figure A.12a suggests a nude chest or back. Figure A.12b shows a mold for a series of narrow, deeply cut vertical drapery folds. See Mattusch, "Agora," N1, p. 373.

Chaplets

Metal pins called chaplets anchored the core within the mold during casting. Bronze chaplets that fused with the bronze of the statue during casting may sometimes be observed on the insides of statues. The locations of iron chaplets, which did not fuse with the bronze, are sometimes recognizable as red-brown spots of corrosion on the exterior of a statue. Molds for statues rarely show evidence of the chaplets, probably because molds being dismantled would have broken at these pins.

1. *Piraeus Apollo* (fig. 4.19). Remains of about six iron chaplets are among the core fragments that were removed from the statue. Some are embedded in the core; others are separate but still surrounded by a thin layer of clay.

2. *Mold with iron chaplet* (fig. A.13), from a workshop of ca. 350–325 B.C. A badly corroded bit of iron at one broken edge appears to be the remains of a chaplet. See Mattusch, "Agora," C19, p. 355.

A.10 Mold for hand, ca. 350–325 B.C. Max. pres. dim. 0.134 m. Athenian Agora B 1189f. Courtesy of American School of Classical Studies at Athens: Agora Excavations.

3. *Mold with bronze chaplet* (fig. A.14), from debris of the late third to fifth centuries A.D. This coarse red clay fragment is part of a mold for a small, roughly cylindrical object. A tapering chaplet, round in section, is embedded in the end of the mold. See Mattusch, "Agora," L1, p. 369.

4. *Molds for statue of kouros* (fig. 4.4), from a workshop of ca. 550 B.C. The chaplets have broken away, leaving small rectangular holes extending well into the clay from the heel of each foot and from either hand.

A.11 Molds for drapery, ca. 350–325 B.C. Max. pres. dim. (*a*) 0.179 m., (*b*) 0.247 m. Athenian Agora B 1189l, s. Courtesy of American School of Classical Studies at Athens: Agora Excavations.

a

b

Casting Pit

Casting pits were temporary establishments dug to accommodate the pieces that were to be cast (*chōneuō*)[7] in them, and usually dug below ground level to facilitate the pouring of the heavy molten bronze. After use, the pits were filled in with the debris from the project. Finds from casting pits usually include pieces of molds and of the gate system, mud brick, charcoal, bronze, bellows nozzles, crucible fragments, and pumice.

1. *Workshop of Phidias, Olympia.* Excavations in 1956 and 1982 revealed that a bronze casting shop was installed inside the workshop of Phidias after 440 B.C. and before work on the chryselephantine Zeus was begun. The complex consisted of two casting pits, a crucible oven, and a mud-brick structure. The larger, keyhole-shaped casting pit was deep enough (1.4 m.) to have been used to cast the body of a lifesize statue. The crucible oven, with a reconstructed crucible diameter of 0.48 m., would also have been large enough to contain the bronze for a casting of this size. To judge from the metal drips found in the workshop, the bronze alloy melted in the crucible oven contained copper, tin, and lead. The fire was fueled with charcoal, and bellows were directed toward it through right-angled clay nozzles. Molds found in the workshop were made of local clay. Some of them look as if they produced a draped figure, a type of statue that, unlike a nude, is likely to have been produced in a series of piece castings. Molds from the smaller, oval casting pit were used to cast a large flat object, perhaps a bronze stele to set beside the statue. The brick structure, measuring 2.02 × 2.70 m., may have been a working platform or even

7. For use of this term, see Pausanias 8.14.8.

a

b

A.12 Molds for partially draped statue, sixth century A.D. Max. pres. dim. (*a*) 0.369 m., (*b*) 0.250 m. Athenian Agora S 1860a–b. Courtesy of American School of Classical Studies at Athens: Agora Excavations.

perhaps a base on which to set the bronze statue and stele. See Heilmeyer/Zimmer/Schneider, pp. 239–99. For the earlier report, see A. Mallwitz, "Die baugeschichtlichen Ergebnisse der Ausgrabungen, 1954–1958," in *Die Werkstatt des Pheidias in Olympia*, OF 5 (Berlin, 1964), pp. 42–45.

2. *Athens: House H Foundry* (fig. A.15). This characteristic and particularly well-preserved pit was excavated in 1947 and 1973. It was dug on the west slope of the Areopagos in the second half of the second century B.C. At one end three steep, narrow steps descend 1.28 m. to the floor of the pit. At the other end the pit opens out in the general shape of a keyhole. On a base in this end of the pit a mold was erected for baking and was then packed around with earth for casting. To facilitate the process, this area was evidently partitioned off from the entrance: a groove with a central circular depression (perhaps for a post) was cut across the floor and continued up the wall at either side. A slot circling the pit halfway up the walls may have served to anchor a horizontal partition to reduce further the space that had to be packed with earth around the molds.[8] See Mattusch, "Agora," pp. 365–67.

3. *Akropolis, Athens.* A casting area on the south slope of the Athenian Akropolis was identified in 1877. When it was reexcavated in 1963, it was suggested that bronze statues were cast here during the fourth century B.C. Overall measurements: L 20.9 m.; W 8.2 m.; D ca. 3.0 m. Among the finds from the area are unidentifiable mold fragments, a clay prop to support a

A.13 Mold with iron chaplet, ca. 350–325 B.C. Max. pres. dim. 0.133 m. Athenian Agora B 1467. Courtesy of American School of Classical Studies at Athens: Agora Excavations.

8. A brick cross-wall and two mold bases are also preserved in a large keyhole-shaped casting pit (4.69 × 2.85 m.) excavated by John Travlos in 1939 outside the southwest corner of the precinct wall of the Olympieion. The pit has not been published, but Mr. Travlos kindly showed me photographs and drawings of it in 1976.

A.14 Mold with bronze chaplet. Max. pres. dim. 0.037 m. Athenian Agora MC 915. Courtesy of American School of Classical Studies at Athens: Agora Excavations.

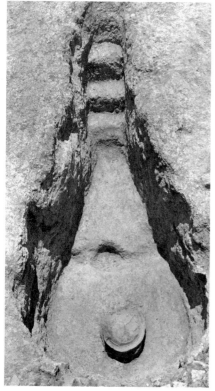

A.15 House H Foundry, Athens, 150–100 B.C. L at ground level 3.78 m.; max. W of floor 1.70 m. Courtesy of American School of Classical Studies at Athens: Agora Excavations.

mold, one or more possible crucible fragments, bricks from a furnace, and possibly some bronze slag.[9] A large mold base and part of the mold for a flat-bottomed object were also reported to have been found. See Mattusch, "Casting Techniques of Greek Bronze Sculpture: Foundries and Foundry Remains from the Athenian Agora with Reference to Other Ancient Sources" (Ph.D. dissertation, University of North Carolina, Chapel Hill, 1975), pp. 173–76; N. Platon, "Chronika," *Deltion* 19 (1964): 32–34. S. Koumanoudes reported on the 1877 excavations in *Praktika* (1878), pp. 8–9.

4. *Pantikapaion.* Finds of the 1980s on the akropolis of Pantikapaion on the north coast of the Black Sea attest to the casting of lifesize bronze statuary there during the second half of the fourth century B.C. Objects recovered include clay molds, a funnel, part of a crucible, a stone eye, and a slag heap. A workshop of the first half of the fourth century B.C. was also found to contain pumice that had been imported from Melos and Thera. See M. Yu. Treister, "Noviye danniye o chudozhyestvennoi obrabotke metalla" (with English summary: "New Data on Artistic Metalwork in the Bosporus"), *Vestnik drevnei istorii* (Journal of Ancient History) 1 (1984): 146–60.

Recent publications of other casting pits and workshops used for the production of large bronzes include the following:

ATHENS. Kerameikos, four fifth-century B.C. and three first-century A.D. installations (see Zimmer, "Giessereieinrichtungen"); Agora, six installations dating between the sixth century B.C. and the sixth century A.D. (see Mattusch, "Agora").

KASSOPE. Second-century B.C. crucible furnace. See Schwandner/Zimmer/Zwicker.

CORINTH. Forum area, first-century A.D. installation (see Mattusch, "Corinth"); Gymnasium area, first-century A.D. installation (see J. Wiseman, "Excavations in Corinth: The Gymnasium Area, 1967–1968," *Hesperia* 38 [1969]: 64–106).

NEMEA. Casting pits and furnace from the second half of the fifth century B.C. See S. Miller, "Excavations at Nemea, 1976," *Hesperia* 46 (1977): 19–20, and "Excavations at Nemea, 1977," *Hesperia* 47 (1978): 72.

9. I am grateful to G. Dontas for permitting me to examine this material in 1974.

Mold Base

A base or platform of clay, brick, tiles, and stones was constructed in the casting pit to hold the mold during baking. A channel sometimes seen on the upper surface may have been intended to collect wax that drained out of the mold during baking.

1. *House H Foundry, Athens* (fig. A.16), a casting pit of the second half of the second century B.C. on the west slope of the Areopagos. The mold base (0.44 × 0.43 m.; H 0.25 m.), made of tiles and terracotta, was located on the axis of the pit in its widest portion. The base consisted of a thin outer wall of coarse baked clay around a core of tile fragments and earth packing. A concave, scorched terra-cotta channel, 0.06 to 0.07 m. wide, encircled the top edge of the base, sloping down toward the south. Around this base the floor of the pit was burned. Pieces of scorched terra-cotta found to one side of the base may have been part of a mold. See Mattusch, "Agora," pp. 364–66.

Other mold bases that have been identified include the following.

OLYMPIA. Workshop of Phidias, 440s B.C. See Heilmeyer/Zimmer/Schneider; Mallwitz (see "Casting Pit," no. 1, above), p. 45.

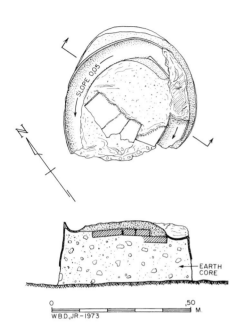

A.16 Mold base in House H Foundry. Drawing by William Bell Dinsmoor, Jr. Courtesy of American School of Classical Studies at Athens: Agora Excavations.

ATHENS. Kerameikos, fifth century B.C. and first century A.D. (see Zimmer, "Giessereieinrichtungen," pp. 63–83); Agora, late fourth century A.D. (see Mattusch, "Agora," pp. 370–72; south slope of Akropolis, fourth century B.C. (see N. Platon, "Chronika," *Deltion* 19 [1964]: 34).

CORINTH. Gymnasium area, first century A.D. See Wiseman (above, "Casting Pit," Corinth).

Props

Clay props used to support molds during baking are often found in ancient bronze casting workshops. Props, hand-modeled in the early periods, take a wide variety of forms, depending on the molds that needed to be supported. Later props may simply be reused amphora handles.[10]

10. For props, see G. Zimmer, "Giessereieinrichtungen," p. 78 (Athens, Kerameikos, and Demetrias, second century B.C.); J. Wiseman (above, "Casting Pit," Corinth). These props differ little from those used to support cooking pots over a period ranging from the sixth century to ca. 300 B.C. For the use and appearance of these supports, see S. P. Morris, "ΛΑΣΑΝΑ: A Contribution to the Ancient Greek Kitchen," *Hesperia* 54 (1985): 393–409, pls. 101–5.

A.17 Props, ca. 350–325 B.C. Athenian Agora B 1458, B 1461. (*a*) H 0.082 m., (*b*) max. pres. H 0.142 m. Courtesy of American School of Classical Studies at Athens: Agora Excavations.

a

b

1. *Props* (fig. A.17), from a workshop of ca. 350–325 B.C. Figure A.17*a* shows an accordion-shaped prop flattened at both ends. Figure A.17*b* shows a flattened resting surface and part of a diagonal support for a mold. Impressions made by fingertips are preserved on the outer surface. See Mattusch, "Agora," C21 and C23, p. 356.

2. *Prop* (fig. A.18), from a workshop of the late fourth to early third centuries B.C. This roughly modeled hollow support, broken at either end, is made of coarse reddish clay with finger marks on the exterior. A latex impression taken from the interior shows that the clay was pressed around a rough stick with dry, peeling bark. See Mattusch, "Agora," H8, p. 363.

3. *Prop* (fig. A.19), found inside a casting pit at the Gymnasium Foundry, first century A.D. The vertical scorched amphora handle is surrounded by clay that still has part of a flat resting surface at one end.[11]

Baking Coal (*anthrakes*) and firewood (*chsula kausima*) for the furnace (*es oikodomian kaminon*) are mentioned in an inscription recording the production of Phidias's Bronze Athena over the years between 460 and 450 B.C.[12] These materials would have been needed to build the fire in the casting pit to bake the molds and burn out the wax, and to fuel the furnace used to melt the alloy. Excavations of a fifth-century-B.C. bronze foundry in the workshop of Phidias at

11. On the shoulder of an Archaic hydria from Italy, attributed to the Ribbon Painter and now in the Villa Giulia Museum, a youth scoops wine from a large vessel that is supported by props resembling this one. For a bibliography, see Morris, "ΛΑΣΑΝΑ," p. 397n15, and fig. 104*a–b*.

12. See chap. 7.

Olympia have revealed molds made of local clay and charcoal for firing a crucible furnace.[13]

Theophrastos (ca. 370–285 B.C.) refers to the fuel that was used at Olympia: "Among the substances that are dug up because they are useful, those known simply as coals are made of earth, and they are set on fire and burnt like charcoal. They are found in Liguria, where amber also occurs, and in Elis as one goes by the mountain road to Olympia; and they are actually used by workers in metals."[14]

Furnace

The metallurgical furnaces that were used by the Greeks are not yet fully understood. Tall shaft furnaces are often represented in vase paintings, but only traces of actual furnaces are preserved, and these may be crucible furnaces, unlike those shown in the paintings. There is no doubt that the furnace was installed right beside the casting pit, and that both were temporary installations. A wide bowl received the metal. First the copper was melted (*diacheō* or *tēkō*), then the tin was added, and finally the bronze alloy was poured into the mold from crucibles that could be lifted by one or two men.[15]

1. *Berlin Foundry Cup* (fig. 5.7), ca. 490–480 B.C. On one side of the cup a bearded workman wearing only a skullcap sits on a stool and uses a long hooked rod to stoke the coals in a tall cylindrical furnace surmounted by a round pot with a lid. Wavy painted lines around the base of the pot represent flames. Behind the furnace, a youth works the bellows. See Boardman, *ARFVAP*, pp. 136–37. For publication of this furnace and of theories about the use of such furnaces, see Zimmer, *Werkstattbilder*, pp. 8–16; Mattusch, "BFC," pp. 435n7 and 442n41; P. T. Craddock, "The Composition of the Copper Alloys Used by the Greek, Etruscan, and Roman Civilisations," pt. 2, "The Archaic, Classical, and Hellenistic Greeks," *JAS* 4 (1977): 113.

2. *Workshop of Phidias, Olympia,* 440s B.C. A crucible oven, with a reconstructed crucible diameter of 0.48 m., could have

a *b*

A.18 Prop, with latex impression from hollow interior, late fourth to early third centuries B.C. Max. pres. dim. 0.14 m. Athenian Agora B 1439. Courtesy of American School of Classical Studies at Athens: Agora Excavations.

13. Heilmeyer/Zimmer/Schneider.

14. *Theophrastus on Stones*, ed. and trans. E. R. Caley and J. F. C. Richards (Columbus, O., 1956), 16:21, 48; see p. 86 for identification of this coal as lignite, a material still mined today in Greece.

15. *Diacheō*: Pausanias 8.14.8, 9.41.1; *tēkō*: Pausanias 10.38.6. For recent discussions of furnaces, see Heilmeyer/Zimmer/Schneider; W. A. Oddy and J. Swaddling, "Illustrations of Metalworking Furnaces on Greek Vases," in *Furnaces and Smelting Technology in Antiquity*, ed. P. T. Craddock and M. J. Hughes, British Museum Occasional Paper no. 48 (London, 1985), pp. 43–52; Schwandner/Zimmer/Zwicker, pp. 57–80; and Mattusch, "Agora," pp. 378–79.

A.19 Prop, first century A.D. Max. pres. dim. 0.151 m. Corinth MF 68-333. Courtesy of American School of Classical Studies at Athens: Corinth Excavations.

provided enough bronze to cast a lifesize statue and would not have been too heavy for two men to lift. See Heilmeyer/Zimmer/Schneider and "Casting Pit," no. 1, above.

In 1936–37, German excavators reported having found traces of ten metallurgical furnaces in a sandy streambed at the base of the Hill of Kronos, northwest of the Stadium. These furnaces were assumed to have resembled those represented in sixth- and fifth-century vase paintings. Some were dated between the late seventh and the early fifth centuries B.C., others to the first half of the fifth century. It was suggested that, in a single operation, each furnace had been used both to produce the alloy in its shaft and to cast the statue by way of a canal leading from its base to the mold, packed close by in the sand of the streambed. See R. Hampe and U. Jantzen, "Bericht über die Ausgrabungen in Olympia: Die Grabung im Frühjahr 1937," *JdI* 52 (1937): 25–48: G. M. Young, "Archaeology in Greece, 1936–37," *JHS* 57 (1937): 129. For a practical description of such a process, see Theophilos, whose treatise *On Divers Arts*, ca. 1100 A.D., contains a lengthy chapter (85) on the casting of bells.

3. *Red-figure oinochoe* (fig. A.20), late fifth century B.C. A youth carries an offering tray to a bearded grotesque who stands in front of a tall shaft furnace. A large stoking hole can be seen at the base of the shaft, a lidded crucible on top of it. See Burford, pl. 35; Mattusch, *Bronzeworkers in the Athenian Agora*, Athenian Agora Picture Book 20 (Princeton, 1982), jacket illustration.

4. *Brick from furnace lining* (fig. A.21), from a workshop of the late fourth century A.D. The curved rectangular brick is heavily vitrified on the concave surface. One edge is concave, probably to fit over a ridge on an adjacent brick. See Mattusch, "Agora," M12, p. 372.

5. *Crucible furnace*, Kassope. Second century B.C. Max. l. ca. 2.2 m.; max. W ca. 1.4 m.; max. pres. H of walls 0.4 m. The crucible furnace is keyhole-shaped, entered by steps at the narrow end. The broad end of the furnace is shown to have been large enough to accommodate two crucibles at one time. See Schwandner/Zimmer/Zwicker, pp. 57–70 and figs. 1–4.

Bellows Bellows (*physa*)[16] were made of animal skins, like the wineskins that satyrs are often shown carrying in vase paintings. A pair of

16. *Iliad* 18.372.

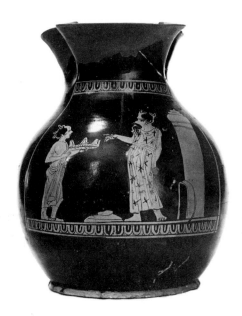

A.20 Red-figure oinochoe, late fifth century B.C. Athenian Agora P 15210. Courtesy of American School of Classical Studies at Athens: Agora Excavations.

A.21 Brick from furnace lining, late fourth century A.D. Max. pres. dim. 0.127 m. Athenian Agora B 1497. Courtesy of American School of Classical Studies at Athens: Agora Excavations.

skins was used: while one was inflated, the other was deflated. Air from the bellows was forced into the furnace through the legs of the animal skin, which were protected by clay nozzles against the extreme heat of the furnace. Nozzles were at first modeled by hand in clay. During the Roman period, however, broken amphora necks were evidently used.

1. *Fragment of black-figure kantharos* (fig. A.22), from the Akropolis, late sixth century B.C. The bellows of Hephaistos are shown as two goatskins, with legs, hoofs, and stippled hair marked; one skin is deflated and has a nozzle attached to its lower end; the other skin bulges with air, and Hephaistos presses the two wooden handles together to close the opening. Beazley, *ABV* 347. See B. Graef and E. Langlotz, *Die Antiken Vasen von der Akropolis zu Athen*, vol. 2 (Berlin, 1925), pl. 94; P. Hartwig, "Une Gigantomachie sur un canthare de l'Acropole d'Athènes," *BCH* 20 (1886): 364–73.

2. *Siphnian Treasury* (fig. 2.2), detail of Gigantomachy at east end of north frieze; before 525 B.C. As Hephaistos bends over a pair of bellows, the inflated skin reaches nearly to his waist. In the background is the deflated skin, and Hephaistos reaches for it with his left hand. See K. A. Rhomaios, "Ho Hephaistos epi tēs Gigantomachias tou thesaurou tōn Knidiōn," *ArchEph* (1908), cols. 245–54; F. Brommer, *Hephaistos. Der Schmiedegott in der antiken Kunst* (Mainz, 1978), pp. 101, 139, 160, 166, 242.

3. *Berlin Foundry Cup* (fig. 5.7) Late Archaic, the Foundry Painter. On one side a seated young man, partly concealed behind the furnace, works the bellows. See "Furnace," no. 1, above.

4. *Red-figure column krater*, from the nekropolis of Sabucina. Caltanissetta inv. no. 20371. The Harrow Painter, ca. 480–470 B.C. Hephaistos, wearing a skullcap wreathed with ivy, sits at a furnace, working a piece of metal. In front of him a satyr holds a mallet while behind him another satyr raises a bellows bag with nozzles attached to the hind legs and wooden handles at the neck. See R. D. Gempeler, "Die Schmiede des Hephäst— Eine Satyrspielszene des Harrow-Malers," *Antike Kunst* 12 (1969): 16–21; Boardman, *ARFVAP*, p. 112, fig. 174.

5. *Red-figure kylix* (fig. 2.1), ca. 470 B.C., showing the return of Hephaistos to Mount Olympos on foot, assisted by Dionysos. Hephaistos wears a short chiton, a chlamys, and a skullcap, and

A.22 Black-figure kantharos, late sixth century B.C. Athens, National Archaeological Museum no. 2134. Photo by Carol C. Mattusch.

carries a mallet. Satyrs carry wine and a maenad dances. One satyr assists Hephaistos, carrying not a bulging wineskin but a mallet, as well as a furry deflated bellows skin, two nozzles on the hind legs, wooden handles above. See P. E. Arias and M. Hirmer, *A History of 1,000 Years of Greek Vase Painting*, trans. B. Shefton (New York, 1962), pp. 342–43, fig. 148; Boardman, *ARFVAP*, fig. 295.2.

6. *Bellows nozzle* (fig. A.23), from an Archaic foundry of the mid–sixth century B.C. The fragmentary clay surround is roughly modeled, with heavy vitrification and traces of bronze on the exterior. See Mattusch, "Agora," A5, p. 347.

7. *Bellows nozzle* (fig. A.24), from the southwestern Forum area. The complete clay nozzle is hand-modeled. See Mattusch, "Corinth," p. 387.

8. *Bellows nozzle* (fig. A.25) of the third to fourth centuries A.D., from the "Heliaia" metalworks. The nozzle (the neck and part of the rim of a burned amphora) is encrusted with vitrification; some bronze clings to the rim. See Mattusch, "Agora," K2, p. 368.

9. *Bellows nozzle* (fig. A.26) of the late third to fifth centuries A.D., found in South Square debris. The nozzle (the upper shoulder and tapering neck of an amphora) has a hole near the base; the upper neck and rim are encrusted with slag and bronze. See Mattusch, "Agora," L3, p. 369.

10. *Right-angled bellows nozzle*, from the workshop of Phidias at Olympia. See Heilmeyer/Zimmer/Schneider, Catalog II.1, p. 281 and figs. 33–34.

A.23 Bellows nozzle, ca. 550 B.C. Max. pres. dim. 0.103 m. Athenian Agora B 1533. Courtesy of American School of Classical Studies at Athens: Agora Excavations.

Crucibles

The clay crucible (*choanos*)[17] from which the molten metal was poured into the mold is usually found in very fragmentary condition. Typically it is a broad-mouthed shallow bowl that is badly scorched and partly vitrified by the molten metal. A large deposit of bronze usually remains within.

17. *Iliad* 18.470.

A.24 Bellows nozzle. L 0.09 m. Corinth MF 10107. Courtesy of American School of Classical Studies at Athens: Corinth Excavations.

1. *Crucible fragment* (fig. A.27), from fill in the area of a fourth-century B.C. foundry southwest of the Hephaisteion. The fragment, part of a rim, is made of coarse red clay, heavily burned. The rim is mostly covered with a thick irregular layer of bronze, dripping toward the edge. See Mattusch, "Agora," H10, p. 363.

2. *Crucible fragment* (fig. A.28), from a fourth-century A.D. workshop south of the Roman Bath. The flat-bottomed bowl with wide, sloping walls and a vertical rim is of coarse red clay; the interior is a vitrified dull black. See Mattusch, "Agora," M8, p. 372.

Drips Bronze that spilled during the pour was often overlooked when metal was collected for remelting. Consequently, bronze drips are frequently encountered in ancient foundries.

1. *Bronze drips* (fig. A.29), from the region of a bronze foundry for statuary dating to the first century A.D., near the west end of the Corinth Gymnasium South Stoa, excavated in 1967 and 1968. For reference to the excavation of the foundry, see J. Wiseman, "Excavations in Corinth, The Gymnasium Area, 1967–1968," *Hesperia* 38 (1969): 64–106, and "Ancient Corinth: The Gymnasium Area," *Archaeology* 22 (1969): 222.

Tools The bellows and the crucible might be defined as some of the tools of the metalworker's trade. But if we look again at vase paintings, we see also the hammer or mallet (*raistēr*),[18] the anvil, tongs, rasps, and pumice for polishing, and saws, rasps, and drills. Vase painters often did not carefully distinguish one form of metalworking from another, so that the tools shown for ironworkers may be similar to those shown for bronze casters.

1. *Berlin Foundry Cup* (fig. 5.7), ca. 490–480 B.C. On one side of the cup a workman stirs the coals in a furnace with a long

18. *Iliad* 18.477.

A.25 Bellows nozzle, third to fourth centuries A.D. Max. pres. H 0.159 m. Athenian Agora P 30198. Courtesy of American School of Classical Studies at Athens: Agora Excavations.

A.26 Bellows nozzle, late third to fifth centuries A.D. Max. pres. H 0.238 m. Athenian Agora B 1598. Courtesy of American School of Classical Studies at Athens: Agora Excavations.

A.27 Crucible fragment, fourth century B.C. Max. pres. dim. 0.155 m. Athenian Agora B 1562. Courtesy of American School of Classical Studies at Athens: Agora Excavations.

hooked pole. In the background hang mallets with short and long handles and a long two-handled saw.[19] See above, "Furnace," no. 1; "Bellows," no. 3. On the other side of the cup metalworkers apply strigil rasps to cold-work the surface of a monumental statue of a warrior.[20] Another strigil rasp and a mallet hang on the wall. The interior of the cup (fig. A.30) shows Hephaistos with Thetis and the armor for Achilles. Hephaistos is seated on a stool, with mallet and helmet in his hands. Thetis stands over him, holding the finished shield. Greaves hang on the wall between them. At the right is an anvil; a mallet hangs behind it.

2. *Nolan amphora* (fig. A.31), first half of the fifth century B.C. Thetis is in the workshop of Hephaistos, awaiting delivery of the armor for Achilles. The helmet and greaves, already completed, hang on the wall, as do various tools of the metalworking trade: tongs, mallet, and a bowed saw. Hephaistos, wearing a stippled (leather?) cap and draped from the waist down, bends over to polish the surface of the shield with a small dotted piece of pumice. Although the shield would have been hammered and not cast, the numerous pieces of worn pumice from Greek foundries attest to its use for polishing cast bronzes as well. In fact, the pumice often has bits of bronze stuck in its porous surface. See Beazley, *ARV²*, 306, 2: the Dutuit Painter.

3. *Pumice*, from a workshop of ca. 350–325 B.C. Max. dim. 0.047 m. Agora ST 657. The small piece of pumice is worn from use as a polisher. See Mattusch, "Agora," C25, pp. 353, 356, pl. 86.

4. *Red-figure kylix*, interior (fig. A.32), ca. 500 B.C. A metalworker sits on a stool, wearing only a cap and a short pleated wrap around his waist. Holding a piece of iron with tongs over an anvil, he raises a mallet to hammer the heated metal into shape. Extra tongs and a file or drill hang in the field behind him. See Zimmer, "Der Schmied in der Schale," *Jahrbuch der Berliner Museen* 24 (1982): 5–16; *Werkstattbilder*, p. 33.

19. For a bowed saw, as well as a drill and a drill bow, see Berlin F 2415, ca. 480 B.C., illustrated in Zimmer, *Werkstattbilder*, pl. 1 and p. 34; see also fig. 10 and p. 41 (Leningrad, Hermitage no. 2229, ca. 460 B.C.) for another bowed saw and an anvil.
20. For straight rasps and an anvil, see Oxford 1911.620, illustrated in Burford, fig. 31.

A.28 Crucible fragment, fourth century A.D., and reconstructed drawing by Abigail Camp. H 0.044 m. Athenian Agora B 1506. Courtesy of American School of Classical Studies at Athens: Agora Excavations.

5. *Black-figure amphora*, ca. 530 B.C. Boston, MFA 01.8035. The scene is one of ironworking, yet both a furnace and an anvil are represented, as well as tongs, mallets, a bow saw, a knife, and a drill. See Burford, pl. 30; Mattusch, "Casting Techniques of Greek Bronze Sculpture" (Ph.D. dissertation, University of North Carolina, Chapel Hill, 1975), p. 268.

Patches

When the investment molds were broken, the bronzes that emerged had a variety of imperfections. The bronze gate system and the chaplets, if they too were of bronze, had to be cut off and filed smooth. Iron chaplets left holes in the bronze, and bubbles in the clay mold or gases in the molten metal left holes or depressions. The bronze surrounding such imperfections was cut down to form neat rectangular or polygonal holes, into

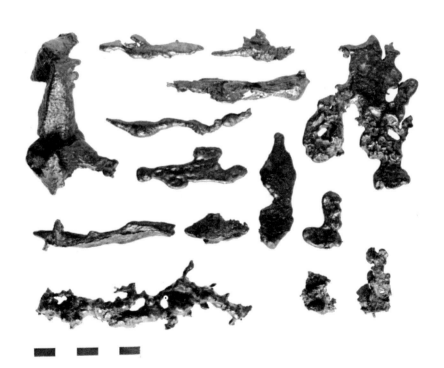

A.29 Bronze drips, first century A.D. Corinth MF 13080 a and b, 13083 a and b, 13086 a, 68-325, 13081, 13087, 13101, 13090, 13089 a, 13067, 13078. Courtesy of American School of Classical Studies at Athens: Corinth Excavations.

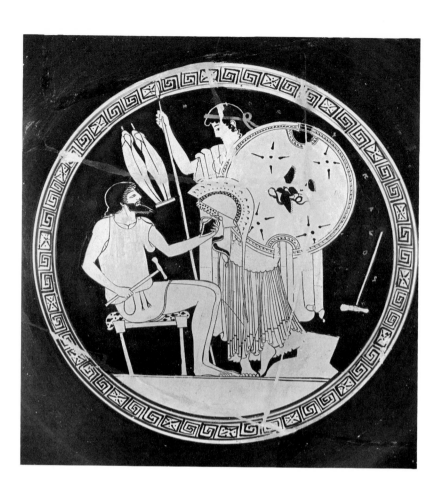

A.30 Berlin Foundry Cup, ca. 490–480 B.C., interior. Berlin, F 2294. Courtesy of Antikenmuseum, Staatliche Museen Preussischer Kulturbesitz, Berlin.

which cut or cast bronze patches were set and hammered tight.[21]

1. *Fragments of statues* (fig. A.33), unstratified finds from Corinth. Two empty patch holes in figure A.33*a* reveal flaws within. Parts of six empty patch holes are preserved in the fragment seen in figure A.33*b*, and seven patches are still *in situ* (at arrows). See Mattusch, "Corinth," p. 386.

2. *Nine bronze patches* (fig. A.34), from the area of the Central Shops, Corinth. See Mattusch, "Corinth," p. 385.

21. For sectional drawings illustrating the insertion of patches, see Bol, *Grossplastik*, pp. 78–81, and *Bronzetechnik*, pp. 139–41.

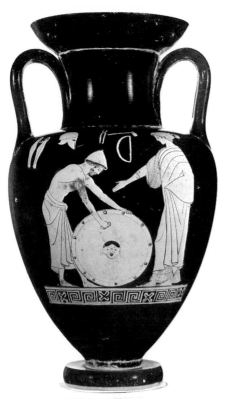

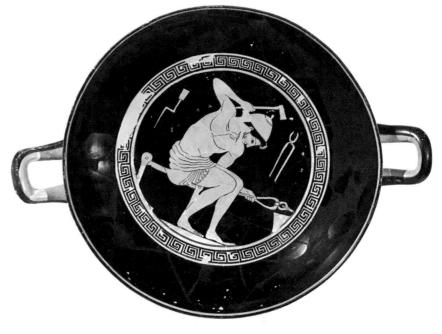

A.31 Nolan amphora, first half of fifth century B.C. Boston, MFA 13.188. Courtesy of Museum of Fine Arts, Boston.

A.32 Red-figure kylix, ca. 500 B.C., interior. Berlin, F 1980.7. Courtesy of Antikenmuseum, Staatliche Museen Preussischer Kulturbesitz, Berlin.

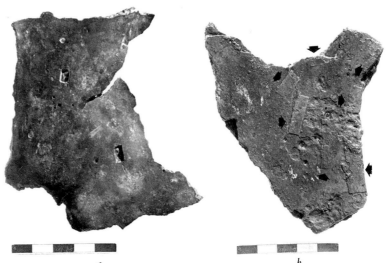

A.33 Fragments of bronze statues. Max. pres. dim. (*a*) 0.128 m., (*b*) 0.117 m. Corinth MF 6319 a, 7935 k. Courtesy of American School of Classical Studies at Athens: Corinth Excavations.

a *b*

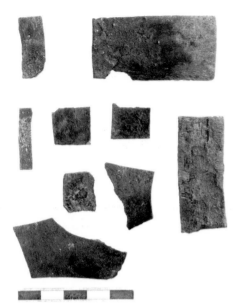

A.34 Nine bronze patches. Corinth MF 7935. Courtesy of American School of Classical Studies at Athens: Corinth Excavations.

A.35 Fourteen bronze patches. Corinth MF 13004, 13086 a, 13062, 13024, 13063, 13061, 13065, 13027, 12933, 13066, 13060, 13032, 13091, 13025. Courtesy of American School of Classical Studies at Athens: Corinth Excavations.

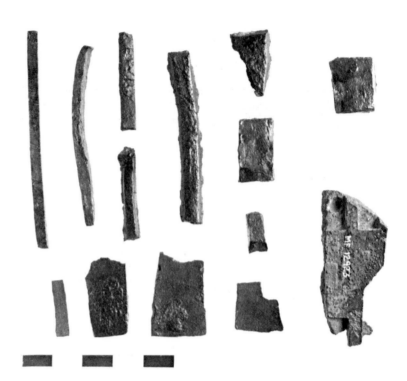

3. *Fourteen bronze patches* (fig. A.35), from the Gymnasium Foundry, Corinth, first century A.D. Some patches were evidently never used, for their edges were not filed off but remain irregular where molten bronze escaped the small molds into which it was poured.

INDEX

Page references to illustrations appear in italics.

Library of Congress Cataloging-in-Publication Data

Mattusch, Carol C.
 Greek bronze statuary.

 Includes index.
 1. Bronze sculpture, Greek. 2. Bronzes, Greek.
 1. Title.
NB140.M38 1988 733′.3 88-47737
ISBN 0-8014-2148-9